Spectacular Wealth

~ LISA VOIGT ~

Spectacular Wealth

THE FESTIVALS OF COLONIAL
SOUTH AMERICAN MINING TOWNS

University of Texas Press AUSTIN

Research for this book was funded in part by several grants from the
National Endowment for the Humanities. Any views, findings, conclusions,
or recommendations expressed herein do not necessarily reflect those of
the NEH.

LIBRARY OF CONGRESS CATALOGING-IN-PUBLICATION DATA

Names: Voigt, Lisa, author.
Title: Spectacular wealth : the festivals of colonial South American mining
 towns / Lisa Voigt.
Description: First edition. | Austin : University of Texas Press, 2016. |
 Includes bibliographical references and index.
Identifiers: LCCN 2015050872 | ISBN 978-1-4773-1050-2 (cloth : alk. paper) |
 ISBN 978-1-4773-1097-7 (pbk. : alk. paper) | ISBN 978-1-4773-1098-4
 (library e-book) | ISBN 978-1-4773-1099-1 (nonlibrary e-book)
Subjects: LCSH: Festivals—Social aspects—South America. | South
 America—History—To 1806. | South America—Social life and customs.
 | South America—Ethnic identity. | Mining districts—South America.
Classification: LCC GT4830 .V65 2016 | DDC 394.2698—dc23
LC record available at http://lccn.loc.gov/2015050872

doi:10.7560/310502

To Pedro and Benvindo

Contents

Acknowledgments

This book has benefited from the encouragement and feedback of many colleagues and friends, beginning with my dissertation advisor, Stephanie Merrim, who planted the seeds for this project a long time ago and whose work continues to inspire me. At different moments Ralph Bauer and Richard Gordon suggested that I turn this project into a book, and I am deeply appreciative of their long-standing intellectual support and friendship. The Chicago-Area Colonial Latin American Working Group (especially Jovita Baber, Karen Graubart, Kittiya Lee, Laura Matthew, Yarí Pérez-Marín, and Cristián Roa-de-la-Carrera) provided valuable input at an early stage.

I am particularly grateful to the National Endowment for the Humanities for funding this project at several key junctures, beginning with the stipend to attend the NEH's Summer Institute "Ritual and Ceremony from Late Medieval Europe to Early America" at the Folger Shakespeare Library in 2010. Thought-provoking discussions with the visiting faculty and participants made the institute the perfect venue to begin thinking about this project as a book, and I thank Claire Sponsler and the Folger staff, especially Kathleen Lynch, for organizing it. An NEH Summer Stipend and a Virginia Hull Research Award from the Ohio State University allowed me to conduct research in Bolivia in 2011, and an NEH Long-Term Fellowship at the John Carter Brown Library in 2012 was instrumental in getting the writing under way. I enjoyed the support and camaraderie of a wonderful group of JCB fellows and colleagues at Brown, and I extend special thanks to the festival writing group—Derek Burdette, Andrea Doré, James Robertson, and Linda Sturtz—for illuminating cross-disciplinary conversations and feedback on my first completed chapter. For their practical assistance, I thank the

staff at the JCB, as well as at the Arquivo Histórico Ultramarino in Lisbon, the Archivo y Biblioteca Nacionales de Bolivia in Sucre, and the Casa Nacional de Moneda, Archivo Histórico in Potosí.

I am grateful for invitations to speak on this project—some dating to long before it was a book manuscript—from David Boruchoff, María Elena Martínez, Lucy Pick, Josiah Blackmore, Frederick Aldama, Rosi Song, Eyda Merediz, Ray Hernández, Carla Zecher, Ryan Giles, Anna More, Ivonne del Valle, Cécile Fromont, and Merry Wiesner-Hanks. Special thanks to Heather Allen, Catalina Andrango-Walker, Ray Ball, Anna Brickhouse, Mariana Dantas, Richard Gordon, Fredrika Teute, and members of the Americas before 1900 Working Group (especially Molly Farrell, Lúcia Costigan, Alcira Dueñas, and Byron Hamann) for their comments on specific chapters. Thanks also to Jessica Rutherford and Miguel Valerio for last-minute, long-distance research assistance; to my tremendously supportive department chairs, Fernando Unzueta and Glenn Martínez; and to Rebecca Haidt, Isis McElroy, and Leah Mirakhor for the excellent writing company, conversations, and cocktails while working on revisions. I am deeply indebted to Anna More for her incisive, thorough reading of the complete manuscript and invaluable suggestions. *Muito obrigada* to my beloved sister-in-law, Eunice Pereira, for allowing me to complete this book in her home—it was a true delight to do so in the presence of my Portuguese family, in beautiful Vila do Conde and Azurara. Finally, none of this would have been possible without the love and support of Pedro and Benvindo, to whom I dedicate this book.

Early versions of portions of this book appeared in the following publications: "Creole Patriotism in Festival Accounts of Lima and Potosí," *Romance Notes* 45.2 (Winter 2005): 159-169 (parts of chapter 1); "Spectacular Wealth: Baroque Festivals and Creole Consciousness in Colonial Mining Towns of Brazil and Peru," in *Creole Subjects in the Colonial Americas: Empires, Texts, Identities*, ed. Ralph Bauer and José Antonio Mazzotti (Chapel Hill: University of North Carolina Press for the Omohundro Institute of Early American History and Culture, 2009), 265-290 (parts of chapters 1 and 2); and "Imperial Celebrations, Local Triumphs: Festival Accounts in the Portuguese Empire," *Hispanic Review* 79.1 (Winter 2011): 17-41 (parts of chapter 2). I thank the editors for permission to reprint the material here.

Spectacular Wealth

Introduction

At the end of his "Letter to Santángel" (1493) describing his first voyage, Christopher Columbus alludes to the important function of public festivals in promoting imperial expansion, by calling for "grandes fiestas" [great feasts] throughout all of Christendom, "por el tanto enxalçamiento que avran, en tornandose tantos pueblos a nuestra santa fe, y despues por los bienes temporales; que no solamente a la españa mas a todos los cristianos ternan aqui refrigerio y ganancia" (Columbus 16-17) [for the great exaltation which may accrue to them in turning so many nations to our holy faith, and also for the temporal benefits which will bring great refreshment and gain, not only to Spain, but to all Christians].[1] Indeed, when Columbus arrived in Spain, the Catholic sovereigns ordered what Bartolomé de Las Casas would call a "solemne y muy hermoso recibimiento" [solemn and very beautiful reception] that packed the streets of Barcelona with people amazed to see the gold- and jewel-bedecked Amerindians with parrots accompanying him (1:478).[2] Six years later, upon Vasco da Gama's arrival in Lisbon following his own, more successful voyage to India, King Manuel I also ordered the celebration of public festivals to commemorate the event. Writing around the same time as Las Casas, the Portuguese historian João de Barros describes in the first volume of his *Décadas da Ásia* (1552) how Gama's arrival in Lisbon was celebrated with "grande solemnidade" [great solemnity], including bullfights, games of reed spears, and "outras festas" (83v–84r) [other festivities]. And Iberians brought such festive practices with them as they sought to colonize the lands reached in these and subsequent voyages. If language was always the "compañera del imperio" [companion of empire], according to Antonio de Nebrija's famous dictum, so too were festivals, whether cel-

ebrating imperial achievements at home or disseminating Iberian culture abroad.[3]

The *festas* described by Barros were reproduced more than a century later in a theatrical work entitled *Real tragicomedia del descubrimiento y conquista del Oriente*, which was performed at the Jesuit college of Saint Anthony during a solemn entry of another sort: King Philip III's entrance into Lisbon in 1619, during the period of Iberian union under the Hapsburg Crown.[4] The performance is described in João Sardinha Mimoso's *Relacion de la real tragicomedia*, published in Lisbon in 1620. In his account, Mimoso interweaves the play's dialogue with a description of the performance and the king's entry as well as a history of Portuguese conquests. Writing in Spanish, the Portuguese author seeks to impress "el curioso lector español" [the curious Spanish reader], to whom he dedicates the prologue, with a display of Portuguese grandeur in both deeds and manner of commemoration. Here we see imperial celebration turned to the purpose of national self-promotion rather than to exalting the broad Christian public mentioned by Columbus.

The *Real tragicomedia del descubrimiento y conquista del Oriente*, performed over two days at the Jesuit college, contributes to this effort by representing the "valerosos hechos" (Mimoso 11) [valorous deeds] of Vasco da Gama, Francisco de Almeida, and Afonso de Albuquerque in India—as well as a Brazilian "king" and his retinue, putting the full geographic range of the Portuguese Empire on display before Philip III. In the theatrical performance, as he did in life, King Manuel I orders "fiestas publicas" [public festivities] to commemorate Gama's successful voyage to India (Mimoso 49v). Yet in this idealized reenactment (a festival within a festival, or rather a festival within a play within a festival), it is not an Iberian public but foreign, conquered subjects who perform the celebration. A figure representing the Orient offers to celebrate the fiestas with fifteen "provinces" that Gama has just presented to King Manuel "por subditas suyas tributarias" (49v) [as his tributary subjects].[5] In their subsequent dances, each of the provinces offers its own form of tribute (pepper from Malabar, sugar from Bengala, bezoar stones from Malacca, myrrh from Sumatra), a gesture signifying humiliation and subjection in the Iberian context, as Patricia Seed has analyzed.[6] The figurative representation of tribute has a physical counterpart in the figures' lavish costumes with "innumerable" jewels, which Mimoso can only partially quantify: "solo en algunas pocas dellas se pudo contar lo siguiente, 1090 diamantes, 2000 perlas de grande precio, 248 esmeraldas finissimas, 1139 rubies . . . treinta grandes collares de mucho valor, y

mas de cien botones de oro, y perlas esmaltados" (51v–52r) [only on a few of them could the following be counted: 1,090 diamonds, 2,000 pearls of great value, 248 very fine emeralds, 1,139 rubies . . . thirty large necklaces of great value, and more than 100 gold buttons and enameled pearls]. Mineral wealth functions as both medium and message of the festive performance. According to José Antonio Maravall, who calls fiestas a "characteristic aspect" of the society he analyzes in *The Culture of the Baroque*, such ostentation was meant to provoke "people's wonder in the face of the 'magnificence' of the rich and powerful" (243–244).[7]

Earlier in the play, the Orient had expressed gratitude for the arrival of the Portuguese, "pues por su medio alcaçaria presto el conocimiento del verdadero Dios" (Mimoso 46v) [for by this means it would soon reach the knowledge of the true God]. Yet it is the "temporal benefits" of conquest that are most spectacularly put on display in the performance as well as in the text, inverting the priority of evangelization in Columbus's explanation of the reason to celebrate the discoveries (17). Indeed, the exhibition of precious jewels had to be partially curtailed, "porque sobraba recaudo y recelo de sacar tanta riqueza junta en un mismo tiempo, por medio de innumerable pueblo . . . , por no arriscarse pieças de grandissimo precio" (114r) [because there was so much caution and fear about taking out such wealth together at the same time, amidst the innumerable crowd . . . , in order not to risk losing such expensive pieces]. The physical presence of the "innumerable crowd" reminds us that the play was performed before not only the king but also what Elizabeth Maddock Dillon calls the "embodied public sphere" and "performative commons" ("Coloniality" 180; *New World Drama*).[8] The limit that the audience's embodied presence places on the display of "innumerable" jewels illustrates one of the ways in which, as Dillon argues, the "mimetic" meaning of theatrical performance—"referential, immaterial, gesturing toward a scene located elsewhere"—is challenged or altered by its "ontic" dimension ("thingly, material, resolutely present") ("Coloniality" 181; *New World Drama* 50). Clearly the public's response to the ostentation could exceed awestruck respect for the powerful, as Maravall would have it (241), inciting instead their own appetite for appropriation.

For Mimoso as well, the jewels are quantifiably, even dangerously, present and do not only represent or "gesture toward a scene located elsewhere"—the incalculable wealth of overseas conquests. But two triumphal arches erected for the royal entry work on a mimetic level to evoke what was by then the world's most famous source of precious metals, the Cerro Rico [Rich Hill] of Potosí in the Viceroyalty of Peru, where abun-

dant silver lodes were discovered by the Spanish in 1545. The Arco de los Joyeros [Jewelers' Arch] explicitly connects imperial expansion and mineral wealth by juxtaposing the figures of Vasco da Gama and Columbus, with the latter shown "descubriendo la cara a [una] figura morena, vestida a lo Peruano" (153v) [uncovering the face of a dark-skinned female figure, dressed in the Peruvian way]. For its part, the Arco de los Monederos [Minters' Arch] features statues that represent "Oriental" and "Occidental" mines in the act of uncovering their own interior riches: "tenian las entrañas rasgadas, y mostravan abrirlas con las manos, la del Oriente las tenia llenas de barras de oro . . . , y la del Occidente de plata: estavan vestidas al modo de las naciones que las habitan, y ellas una negra y otra parda" (152v) [they had their entrails torn, which they were shown opening with their hands; the Orient's hands were full of golden bars . . . , and the Occident's with silver: they were dressed in the manner of the nations that inhabit them, one black and the other brown]. Eduardo Galeano paints a similar image of Potosí when describing how the "viscera" of the Cerro Rico "substantially fed the development of Europe" (15). Indeed, nearly five centuries of mining have gutted the Rich Hill, with almost 23,000 metric tons of silver extracted between 1545 and the end of the colonial period—some 60 percent of the world's total silver production.[9] As the most significant source of silver in the early modern period, Potosí not only financed the Spanish Empire but fueled the rise of global capitalism. Given the role of China as the largest consumer of the precious metal after its conversion to a silver-based economy in the 1570s, the triumphal arch could have more accurately portrayed the Occidental mine supplying the Orient with silver, even if Europeans usually served as the intermediary in that trade.[10]

The native woman's torn, fecund belly on the Minters' Arch recalls the real violence inflicted on and labor extracted from indigenous bodies through the Potosí *mita*, the system of draft rotational labor established by Viceroy Francisco de Toledo in 1573 to revitalize silver production through a cheap, compulsory workforce after the highest-quality and most accessible ores had been exhausted. Based on an Inca practice—the Andean counterpart to Iberian tribute, as Maria Rostworowski points out (183)—the *mita* required thousands of men from designated provinces to come to Potosí one out of every seven years to perform grueling and often lethal work, sometimes deep in the mines for a week at a time.[11] The abuses of the *mita* were well known to contemporaries but never outweighed Spanish dependence on Potosí's silver. When the viceroy Pedro Antonio Fernández de Castro Andrade y Portugal, Conde de

Lemos, wrote a letter decrying the *mita* to Charles II in 1670, he identified the substance that poured from the entrails of Potosí as not silver but the blood of indigenous workers: "tengo por cierto que las piedras de Potosí y sus minerales están bañados en sangre de indios y que si se exprime el dinero que de ellos se saca ha de brotar más sangre que plata" (Fernández 158) [I am certain that Potosí's stones and minerals are bathed in the blood of Indians, and if the money that is extracted from them is squeezed, more blood would flow than silver]. The torn entrails of the brown body on the Minters' Arch operate in the reverse direction by substituting silver for blood, but the symbolism in both cases highlights the extractive, laborious origin of mineral wealth. As Nicholas A. Robins observes in a recent book on the disastrous, ongoing human and ecological consequences of silver and mercury mining and amalgamation in the Andes, the *mitayos* and those who fled their communities to escape the *mita* were "some of earliest victims of globalization" (12).

So too, of course, were the enslaved Africans who were permanently displaced to serve as the mining labor workforce in Minas Gerais [General Mines], the interior Brazilian region so named after gold and diamonds were discovered in the late seventeenth and early eighteenth centuries, partially as a result of expeditions searching for another mountain of silver like that of Potosí.[12] Slave labor enabled Brazil to produce nearly half of the world's gold in the eighteenth century, shifting the epicenter of South America's extraordinary mineral and human exploitation from Potosí to Minas Gerais.[13]

Besides the forced influx of Andean *mitayos* and African slaves, the prospect of quick riches also drew willing immigrants from all over the world, creating extraordinarily diverse and chaotic boom towns. Among these were the Villa Imperial de Potosí [Imperial Town of Potosí]— "world history's most spectacular boom town," in Kendall Brown's words (46)—and Vila Rica do Ouro Preto [Rich Town of Black Gold], as well as other towns founded during the gold rush in Minas Gerais. In 1590 the Jesuit writer José de Acosta acknowledged silver's magnetic force in populating Potosí "de la mayor población que hay en todos aquellos reinos" (167) ["with the largest number of inhabitants in all those realms"] (173). A census from 1611 cited by eighteenth-century Potosí historian Bartolomé Arzáns de Orsúa y Vela placed the number of inhabitants at 160,000, making it perhaps the most populous city in the world at the time.[14] According to Arzáns, this population consisted of 76,000 Amerindians, 40,000 Spaniards and other foreigners, 35,000 *criollos* (Americans of Spanish descent) from other realms of the Indies, 6,000 blacks,

mulattos, and *zambos* (those of mixed African and Amerindian heritage), and 3,000 *criollos* native to Potosí, "españoles . . . nacidos en esta Imperial Villa" [Spaniards . . . born in this Imperial Town] (1:286). A century later, in a description of Brazil published in 1711, near the beginning of the gold rush, the Jesuit Andre João Antonil claimed that it was impossible to count the inhabitants in Minas Gerais, though he went on to include an estimate of 30,000: "A sede insaciavel do Ouro estimulou a tantos a deixarem suas Terras, & a meterem-se por caminhos tam asperos, como saõ os das Minas; que difficultosamente se poderá dar conta do numero das Pessoas, que actualmente lá estaõ" (136) [The unquenchable thirst for gold motivated so many to leave their lands and follow the very rough roads, as they are in Minas, that only with difficulty is it possible to count the number of people who are currently there (152)].[15]

As Arzáns does throughout his extensive history, Antonil likewise emphasizes the region's resulting diversity—and not only in a racial or ethnic sense:

> Cada anno vem nas Frotas quantidade de Portuguezes, & de Estrangeiros, para passarem às Minas. Das Cidades, Villas, Reconcavos, & Certoens do Brasil vaõ Brancos, Pardos, & Pretos; & muitos Indios, de que os Paulistas se servem. A mistura he de toda a condição de Pessoas: Homens, & Mulheres: Moços, & Velhos: Pobres, & Ricos: Nobres, & Plebeos: Seculares, & Clerigos: & Religiosos de diversos Institutos, muitos dos quaes naõ tem no Brasil Convento, nem Casa. (136–137)

> [On the fleets each year come masses of Portuguese and foreigners to head for the mines. From the cities and towns, bays and backlands of Brazil come whites, *pardos*, *negros*, and many Indians serving the *Paulistas*. This mixture is composed of all sorts of people: men and women; young boys and old men; rich and poor; nobles and peasants, as well as secular and clerical figures. Religious figures come from diverse institutions, many of which do not have a monastery or house in Brazil. (152)]

Like other European observers, Antonil certainly did not interpret this "mistura" [mixture] positively. He goes on to describe the lawlessness that resulted from a lack of both temporal and spiritual institutions of authority, such that crimes went unpunished and "aquelles novos Rebanhos" (137) [those new Flocks] could not identify their pastor. As An-

tonil's characterization of Minas Gerais suggests, social disorder arose from not only the racial mixture but also the European immigration, economic mobility, and competition incited by the presence of precious metals. For his part, Arzáns points out that Potosí was founded "sin orden, concierto ni medidas de calles" (1:42) [without order, concert, or measured streets]—a physical manifestation of the moral disarray recounted in his scandal-filled history of what Stephanie Merrim calls a "Sin City" (*Spectacular City*, 265). In Potosí and Minas Gerais, the lure of mineral wealth led to social diversity and dissension, which were only exacerbated by the regions' remoteness.

Thus when Potosí and the towns in Minas Gerais hosted lavish public festivals like those celebrating Columbus's and Vasco da Gama's returns to Iberia or Philip III's royal entry in Lisbon, both mineral wealth and the people involved in its production were not only symbolically represented but physically present. Indeed, residents of indigenous and African descent—real black and brown bodies instead of the figurative ones on the triumphal arches in Lisbon—participated in public festivals through song, dance, processions, and even the sponsorship or creation of ephemeral architecture. And for all groups—especially those of Spanish and Portuguese descent who were born in or migrated to the Americas and who were the ones most likely to be involved in organizing the festivals and writing the accounts—festivals afforded opportunities for responding to and revising the unfavorable image of boomtown residents evident in texts like Antonil's.

The embodied presence of different "American" subjects far surpassed the mimetic role of allegorical figures like the painting in a 1794 festival in Vila Real do Sabará, Minas Gerais, that depicted America offering tribute to the queen. The anonymous account *Relação das Festas, que fez a camara da Villa Real do Sabará* (1794) describes the gifts and the painting's inscription as "os cofres, e mais preciosidades do Paiz, com a seguinte letra, 'Com o ouro, com a fina pedraria / Recebe os votos, que o Brazil Te envia'" (7) [the coffers and other precious things of the country, with the following motto, "With gold and precious stones, receive the well wishes that Brazil sends you"]. Describing the celebrations of the birth of Princess Maria Teresa—the daughter of another Iberian union, that of João VI of Portugal and Carlota Joaquina of Spain—the *Relação das Festas* calls them a testament to the people's fidelity, love, and respect for the royal family (6). As in the performance of the Oriental provinces in the Lisbon entry, the tribute of mineral riches, festival, and text all seem to converge in a single purpose: to glorify the Iberian sovereigns

and demonstrate their vassals' submission. Yet in the Brazilian mining town, the people whose labor produced the gold and precious stones also managed to take advantage of some of it to celebrate festivals in their own spaces and for their own purposes. Around the same time as the 1794 festival, several black lay religious brotherhoods in the jurisdiction of Sabará were petitioning for the right to hold celebrations of the feast day of Our Lady of the Rosary in chapels that they had built without royal permission.[16] Such festivities raised the suspicions of ecclesiastical authorities, who complained in a 1793 report to the king about how scandalous and detrimental the black confraternities were to "a Igreja e ao Estado" [to the Church and to the State].[17] The predominantly slave members of these black brotherhoods introduced their own agendas— and sometimes practices of African origin—into the Christian festivals that they celebrated. In both Potosí and Minas Gerais, the presence of new communities as a result of migration, whether forced or voluntary, changed the way that mineral wealth was used and celebrated, allowing it to signify more than an American tribute to imperial European power.

Before beginning to mine the festival accounts of Potosí and Minas Gerais, we can return briefly to Mimoso's *Relacion de la real tragicomedia* to see another example of the way in which the ontic presence of performers' racially marked bodies inflects the meaning of festivals. The dedication of the play to Philip III, transcribed by Mimoso, refers to the theatrical work's display of the "fruit" that their efforts had reaped in terms of the student-performers who were educated at the college: "Na Representaçaõ (que toda sera pella juventud que nas Escolas deste Collegio se cria) vera V. Magestade parte do fruito que esta Cidade & Reyno colhe do trabalho que a Companhia emprega na cultura & educaçaõ dos sogeitos que as frequentaõ" (in Mimoso n.p.) [In the Play (which will all be performed by the youth that are raised in this College's schools) your Majesty will see part of the fruit that this City and Kingdom harvests from the work that the Company employs in the culture and education of its students).[18] Among the fruits of imperial expansion is the student playing the part of the Brazilian king, who enters the stage on a crocodile, accompanied by native animals (parrots and monkeys) and peoples (Tapuia and Aimoré), and wearing a feathered headress, clothing, and cape—all elements long used in European iconography to represent the Tupinambá Indians of Brazil (Mimoso 57r).[19]

The king and his companions also don tight, dark clothing that is

meant to feign nudity, but Mimoso does not limit his description to the mimetic aspect of the performance. His reference to the actor's skin color suggests that he may actually be of African origin: "El Rey era de su natural pardo, y sobre manera agraciado, que de muy lexos no se pudiera hallar mas pintado a lo que pedia la obra y el lugar; estudiante ansi mismo, Philosopho y Canonista" (58r) [The King was naturally dark, and so attractive, that from afar you could not find anyone more appropriate to what the play and the place required; yet he was a student of philosophy and canon law]. Mimoso may be mistaken about what would be "most appropriate to what the play and the place required," given the student's role representing an indigenous Brazilian. Nevertheless, the presence of a "naturally dark" student was not unusual for Lisbon at this time, when blacks and mulattos constituted between 10 and 20 percent of the population as a result of the Portuguese voyages to Africa and development of the African slave trade in the fifteenth century.[20] Mulattos were not officially excluded from Jesuit colleges in Portugal, and the most famous Luso-Brazilian Jesuit, Padre Antonio Vieira, was the son of a mulatto woman.[21]

The Brazilian king orders a dance performed in response to King Manuel's inquiry regarding "que nuevas le dava de si, y de los suyos; que habilidades tienen los monstruos que consigo trae" (58r) [what news he could give of himself and of his subjects; what were the abilities of the monsters that accompanied him]. However, the royal order becomes the vassals' offering when the Brazilian figures sing, "Se bos mostra cofianza / Y Rei frugá de nos be / I fara nozo un merçe / Por isso façamo un danza" (58v) [If you show courage, the King will take pleasure in seeing us, and he'll do us a favor, for this reason we do a dance].[22] Like the gift economy of archaic societies described by Marcel Mauss—in which the gift entails the obligation to reciprocate and is meant to bring honor and status to the giver—the display of music and dance is supposed to reap benefits for the performer.[23] The festive economy may appear to be one of "unproductive expenditure" and loss, as in Bataille's "general economy," but as we will see throughout this book, the spectacular consumption of wealth is intended to generate either symbolic or material rewards.[24]

Although Mimoso specifies the performer's identity as a student, he describes the king as being proud of his ability to speak Portuguese "por deprender la lengua en la nave" (58r) [for learning the language on the ship], which would explain the *bozal*, or Africanized Spanish, in

which he and his companion sing as well as his choice to accompany the song by playing "una vihuela al modo de los negros rudos y boçales" (58r) [a vihuela in the manner of rough, new black slaves].[25] The call-and-response song is followed by another "compuesta en toda proprie-dad de lengua Brasilica" (58v) [composed with all propriety in the Bra-silica language]—the lingua franca standardized by the Jesuits from the various Tupi-Guarani languages spoken in coastal Brazil that Mimoso transcribes along with a translation into Portuguese. The slippery iden-tity of the black "Tapuias" continues on the following pages, where Mi-moso transcribes a song in which the "Negros" seem to acknowledge ap-propriating an indigenous identity in the chorus, "Robamo Tapua" (62v) [We steal the Tapuia].

On one hand, we might understand this performance of indige-nous and African identities to corroborate the lesson of Portuguese im-perial and evangelical triumphs that the Lisbon elite sought to commu-nicate to Philip III. Carolyn Dean has described how the presence of conquered non-Christian peoples was a necessary component of Cor-pus Christi celebrations in the Spanish-speaking world. Referring to Corpus Christi festivals in the colonial Andes, she writes, "For Span-iards, it was not only important to include native Andeans in Corpus Christi celebrations, but it was essential that they perform *as natives*, as the people over whom Christians had triumphed. In performing alter-ity—usually through Andean costume, song, and dance—they provided the necessary festive opponent whose presence affirmed the triumph" (15). Whether they were associated with African or American culture, the Brazilians of the *Real tragicomedia del descubrimiento* performed the role of "festive opponent" in the Jesuit representation of Portuguese im-perial triumphs.[26]

On the other hand, the naturally dark student-actor surely had other objectives than underscoring Iberian imperial victories. Indeed, Mimoso's narration suggests a concern with displaying his and his com-panions' musical and linguistic talents and even with vying for attention with the white dancers who sang "al modo Portugues" (60v) [in the Por-tuguese manner]. When the latter entered the stage, Mimoso explains,

no era aun bien recogidos los Tapuias, que aun su maioral se estava a la puerta, y echando de ver que gente blanca salía a hazer fiesta, como quien havia gustado el primero, à prisa llama los suios, salgan a mante-ner su partido, que el quiere a porfia conpetir con gente blanca, dando muestra de su arte. (61r)

[the Tapuia were not entirely withdrawn, for their foreman was still at the door, and seeing that white people were coming out to do their fiesta, as someone who had first pleased [the audience], he hurriedly calls his own people, so that they would come out and defend their team, because he obstinately wants to compete with white people, showing off their skills.]

Surely the desire to compete for prestige and recognition was not only part of the performance but just as genuine as the actor's dark skin color.[27] Anthropologist David M. Guss describes the "ethnic cross-dressing" of modern festive practices as part of a purposeful redefinition of identity ("Whose Skin" 8), and we should not exclude the possibility that festive participants made deliberate choices to perform in different ethnic guises in the early modern period as well.

The festive display of mineral wealth; of the feats and fruits of evangelization and conquest; of royal authority and ethnic difference, both feigned and real; of intergroup competition and rivalry (again, both feigned and real)—Mimoso's *Relacion de la real tragicomedia* has already served well to introduce many of the themes that will be taken up in the chapters of this book. Two others deserve mention, both of which in different ways serve as guiding principles for this study. One is the conjunction of Spanish and Portuguese imperial scenarios, visually depicted on the Minters' and Jewelers' Arches designed for the royal entry and textually rendered in Mimoso's Spanish-language account of the history of Portuguese conquests. Although the period covered in this book extends beyond that of the union of the Spanish and Portuguese Crowns (1580–1640), the symbolic appearance of Portugal and Castile, both dressed "gallardamente con la misma riqueza en su adorno" (1531) [gallantly with the same riches in their adornment], serves to remind us of the similarities as well as the links between these two mining regions, even when they belonged to separate empires. Without neglecting the historical, social, and cultural factors that distinguish Potosí and Minas Gerais, we can and should study these regions not just through a traditional, side-by-side comparative approach but with an eye to the interconnections experienced by their contemporaries, whether as a reader of Portuguese texts in Potosí or a spectator of Spanish plays performed in the festivals of Minas Gerais.[28] A book inventory from 1591 in Potosí's regional capital, La Plata, reveals the presence of a Portuguese account of another Philippine entry into Lisbon (Isidro Velázquez's *La entrada que en el reino de Portugal hizo la S.C.R.M. de Don Philippe*, published in

1583), suggesting that the similarities in festive repertoires may be due in part to shared textual sources.[29]

With respect to mineral wealth, the physical, symbolic, and textual geographies of the Portuguese and Spanish Empires intersect in multiple ways: while Arzáns de Orsúa y Vela used (or invented) as one of his primary sources a Portuguese *Historia de Potosí*, published in Lisbon in the seventeenth century, the Portuguese writer Francisco Tavares de Brito would call one of the mountains of Minas Gerais a "Potosí de ouro" (18) [golden Potosí] in his *Itinerario Geografico* of 1732, a work purportedly published in Seville.[30] The *Relação das Festas, que fez a camara da Villa Real do Sabará*, which refers to the visual depiction of "as Armas de Portugal e Castella unidas en hum só escudo" (7) [the Arms of Portugal and Castile united on one shield], also reminds us that festive publics would continue to witness and celebrate efforts at Iberian political union throughout the eighteenth century.

Finally, the *Relacion de la real tragicomedia* points up the key role of texts within and beyond the performances that festival accounts describe. The complex relationship between texts and festivals, writing and performance—the former far from a transparent record of the latter, in the case of festival accounts—is another major axis of this book. Written texts were abundantly on display in festivals; alongside the black and brown figures representing the mines on the Minters' Arch were "tarjas con letra" [sign boards] that reiterate the statues' tributary gesture, declaring "como cada qual offrecia a su Magestad sus riquezas para le hazer poderoso su nombre y Monarchia" (152v) [that each one offered his Majesty their riches to make his name and Monarchy powerful].[31] Mimoso also reminds us of another text-performance relationship with respect to public celebrations. Mimoso concludes his account of the first day of the Jesuit performance (whose length, further exacerbated by the delay of the king's arrival, required it to spread out over two days) thus:

> [A]caecio que pasandose cierto punto por parecer convenia, y era mas a proposito, por quedarse el tiempo libre para otros, mirava su Magestad con tanta atencion el librito del extracto que tenia en la mano, conferiendo lo que vehia, con lo que leya escrito, que hallando diversidad mandò recoger el personage que avia salido, y que fuesse todo por el orden que la obra prometia. (63r)

> [It happened that when passing over a certain point because it seemed convenient and more appropriate, and in order to leave time for others,

his Majesty was looking with such attention at the little book of the extract that he had in his hand, conferring what he was seeing with what he was reading, and finding it different he ordered the character who had come out to go back in, and it all to go in the order that the work promised.]

Alluding to the texts that prescribed the festivities rather than describing them afterward, the anecdote dramatizes the power of writing not merely to reflect the performance but to shape it.[32]

All festival accounts do more than serve as transparent records of events, constituting their own rhetorical performance intended not just to inform but to persuade readers. Part of the rhetorical performance of Mimoso's text, seeking to convince Spanish readers of Portuguese grandeur, derives from his self-conscious incorporation of other written works—from the Latin text of the Jesuit play, to canonical histories of Portuguese conquests by João de Barros and others, to a contemporary, eyewitness Jesuit relation about hostilities (and Portuguese bravery) in Cambodia that had just been received in Lisbon "en este mismo año" (124r) [in this same year]. Indeed, he describes the process of composition as one of drawing on both textual and oral sources, and he refers to the other texts written about Philip III's entry, humbly positioning his own work within a corpus that included more extensive and illustrated works.[33] Self-consciously woven from other texts and oral accounts as well as the performance, the ambiguous genre of the *Relacion de la real tragicomedia*, like so many festival accounts, lies between the narrative of a performed event and its own rhetorical performance. In this book I focus on festival accounts not just because they are one of the only ways to access ephemeral events but because an analysis of their performative strategies can help to elucidate the multiple meanings and functions of festivals for early modern publics.

Just as the Brazilian king—or rather, the dark-skinned student representing him—redefines his tributary performance as a way to gain rewards and status, and just as Mimoso redirects the object of acclaim from Philip III to the city of Lisbon and Portuguese imperial expansion, so too do the festivals and festival accounts in South American mining towns transmit multivalent messages regarding power and prestige. Indeed, the distance and heterogeneity of Potosí and Minas Gerais allow the varied and conflicting agendas of those participating in festivals to come into focus more sharply than in those planned and performed at the centers of power, including the viceregal capitals of Mex-

ico City, Lima, and Salvador da Bahia. These agendas, as we will see, generally involve strategic negotiation rather than carnivalesque subversion: the public festivals and (usually) published festival accounts studied in this book are decidedly part of what James C. Scott has called the "public transcript," not a "hidden transcript" in which the hegemonic account of power relations is surreptitiously contested out of view of those in control.[34] While the powerful may use festivals to display their authority and wealth, festivals also represent an opportunity for subordinate groups to represent, create, or earn their own, as when the Tapuia dance for King Philip in order to receive a favor.

As Teófilo Ruiz writes in his book on festive traditions in Spain from the Medieval period to the reign of Philip II, early modern festivals were "inextricably linked to the exercise and experience of power" (7). Ruiz is one of the more recent in a long line of scholars (including Roy Strong, José Antonio Maravall, Clifford Geertz, and James C. Scott) who have linked festivals to the expression and consolidation of power and authority.[35] Particularly influential in the Hispanic context has been Maravall's discussion of urban fiestas as "an instrument, even a weapon, of a political nature" (*Culture* 245). He asserts that the extravagance and ostentation of urban festivals were an integral part of the Baroque culture of seventeenth-century Spain, serving the goals of absolutist power and Counter-Reformation ideology: to impress the masses with the power and splendor of the court and Church, to attract their political loyalty or religious devotion, and to distract them from their material needs and social concerns (241–247). Many critics have made similar claims about festivals in the American colonies, where geographic distance and cultural heterogeneity heightened the urgency for the Church and Crown to ensure the submission and indoctrination of indigenous and African neophytes, and even *criollos* (Americans of Spanish descent) with suspect allegiances.[36] Yet just as historians of the Spanish Empire have shown that absolutism was much more an aspiration than a reality, Ruiz and other recent critics, including Carolyn Dean and Stephanie Merrim, have emphasized that festivals often failed to achieve their objectives and that they are thus, in Ruiz's words, "sites for complicated and unpredictable performances open to a multiplicity of readings" (8).[37]

Nevertheless, Ruiz echoes earlier scholars like Maravall when he suggests that festival accounts most often tell a univocal, hegemonic story, for "those who wrote, who had their works printed, and whose

works survived were almost all imbricated into the structures that under-pinned and justified royal and municipal power" (31).[38] In this book I ar-gue that festival accounts often do, in fact, illuminate the multiplicity of agendas pursued by different participants in festivals.[39] This multiplicity is particularly evident in the colonial mining towns studied in this book, for several reasons. First, both Potosí and Minas Gerais were distant from the centers of royal and viceregal power and indeed from cultural institutions like the university and printing press that "underpinned and justified" that power, in Ruiz's terms.[40] Neither festivals nor festival ac-counts in these regions were limited to the veneration of the power and splendor of the institutions and individuals of colonial authority.

Furthermore, as I have already suggested, these towns experienced great ethnic and social diversity. The festivals of both regions involved the participation of those who profited from the mines but also of those who were forced to work in them. Despite the exploitation of Amer-indians and Africans, even they contributed to the festive ostentation. Arzáns writes admiringly of the eighty to one hundred tall candles car-ried by black slaves in processions, and he attributes the same to "el más triste indio, . . . el más pobre baladí, que ninguno gasta otra cera que la blanca traída de Europa y del Tucumán" (2:325) [the most miserable In-dian, the poorest and least significant, for no one uses other than white wax imported from Europe or Tucumán].[41] In response to the accusa-tions of barbarism and impiety leveled, for different reasons and with different consequences, at mining towns' residents, festivals were ways for diverse sectors of the population—including those of indigenous and African descent—to defend their reputations and to represent them-selves and their cultural practices in favorable ways. This self-defense and self-promotion played out in the festivals as well as in the written accounts that were meant to make them known to distant, European readers. Indeed, I do not circumscribe my analysis of the festive partici-pation of any particular group to the realm of performance, or what Di-ana Taylor calls the "repertoire" of embodied practice in distinction to the "archive" of enduring materials. As we will see, at least one corporate body composed primarily of Afro-Brazilian slaves helped to shape the meaning of a festival in print.[42]

This book is divided by theme and approach rather than geogra-phy and corpus, with part 1 focusing on specific texts and part 2 using those texts as well as others to focus on specific groups of festival par-

ticipants. In part 1 I explore festival accounts in Potosí (chapter 1) and Minas Gerais (chapter 2) in order to illuminate the agendas of mining-town residents of European descent in the celebrations as well as those of the authors in their writing of the texts. The first chapter, "In Praise of Follies: Creole Patriotism in the Festivals of Bartolomé Arzáns de Orsúa y Vela's *Historia de la Villa Imperial de Potosí*," explores how Arzáns represents the spectacular wealth of and in Potosí's festivals in his massive history of the town, completed by his son in 1737. Arzáns's frequent incorporation of festivals into his narrative shows them to lead to personal and collective advantage or misfortune and to offer venues for the self-promotion of individuals and groups—especially creoles (individuals of Spanish descent born in the Americas). The chapter focuses on three festive occasions that Arzáns uses to showcase creole abilities and merit: the 1608 Corpus Christi celebrations, the 1622 commemoration of the death of Philip III and the coronation of Philip IV, and the 1716 solemn entry of Archbishop-Viceroy Diego Morcillo Rubio y Auñón. In these cases, narratives of festivals intended to exalt religious or political authority come instead to celebrate a specific American locale and, in particular, its creole residents.

Chapter 2, "Celebrating Minas Gerais in *Triunfo Eucharistico* and *Aureo Throno Episcopal*," brings the issue of spatial relations and the particular place of American mining regions within a transatlantic empire to the forefront of the analysis of festival-account rhetoric. I do so by focusing on two eighteenth-century accounts of festivals in Minas Gerais, Brazil, that were published in Lisbon: Simão Ferreira Machado's *Triunfo Eucharistico* (1734), describing the festivities surrounding the transfer of the Eucharist to a new parish church, and the anonymous *Aureo Throno Episcopal* (1749), relating the entry of the bishop into a newly created diocese in Minas Gerais. The multipolar context of production and reception affords another avenue to appreciate the multiplicity of meanings transmitted in and by festivals, for it is in response to the towns' marginal positions within an imperial geography that the accounts displace the festivals' objects of celebration. Similar to Arzáns's work but more directly and overtly addressed to a metropolitan audience, *Triunfo Eucharistico* and *Aureo Throno Episcopal* transform the celebratory installation of the central symbols and representatives of the Catholic Church into the exaltation of a remote mining region and the Portuguese who sought their fortunes there.

Using the same texts as part 1 but complementing them with other

published and unpublished accounts of festivals, part 2 turns to the "black and brown bodies" whose labor produced the spectacular wealth of Potosí and Minas Gerais and whose participation enlivened its wealth of spectacles. In chapter 3, "Festive Natives in Potosí, from Audience to Performance," I consider the ambivalence with which Spanish and creole authorities viewed indigenous festive participation in Potosí, on one hand as a necessary demonstration of Catholic devotion yet on the other hand as a threatening indication of the persistence of such pre-Hispanic "idolatrous" practices as dancing. I focus first on Diego Mexía de Fernangil's *El Dios Pan*, an early seventeenth-century dialogue about a Corpus Christi celebration that features an indigenous interlocutor, but one who remains in the position of festival observer rather than participant. I then turn to Arzáns's representation of indigenous audiences and performances in his *Historia de la Villa Imperial*. Rather than the binary options of Christianization or conservation—festivals as means of indoctrination and acculturation or as avenues for resistance to such efforts—Arzáns's depiction of indigenous festive participation points to more complex forms of negotiation, as when Amerindians incorporate Inca costumes and practices into Christian festivals. The native responses to and interventions in festivals that can be glimpsed in Arzáns's text exemplify the ways in which subordinate groups borrowed, reinterpreted, and altered the goals of Spanish and Christian celebrations.

In the final chapter, "'Nos Pretos como no Prelo': Afro-Brazilians in Festivals, from Performance to Print," I return to the texts studied in chapter 2, Simão Ferreira Machado's *Triunfo Eucharistico* and the anonymous *Aureo Throno Episcopal*, to investigate the festivals that they describe from another angle, that of Afro-Brazilian participation. I begin by focusing, as in the previous chapter, on their festive performances and in particular on a group of mulatto dancers disguised as Amerindians in *Aureo Throno Episcopal*. I show the connections between this performance and the festive coronation of African sovereigns as celebrated by the Black Brotherhood of the Rosary, a lay religious confraternity composed of slaves and free blacks. This context illuminates the possible motivations and meanings of the performance for Afro-Brazilians.

The second part of chapter 4 moves from performance to print through an examination of the Black Brotherhood of the Rosary's role as sponsors of *Triunfo Eucharistico*. By sponsoring the account's publication in Portugal, the members of the Black Brotherhood used the medium of print as a means of self-promotion—an objective that diverged

from, without overtly contradicting, that of its Portuguese-born author, Simão Ferreira Machado. This case allows us to consider the involvement of non-elite groups in not only festive performance but print publication. As this case shows, festival accounts are just as complex and contradictory in their expression of different agendas as the festivals that they describe.

Texts

In Praise of Follies

CREOLE PATRIOTISM IN THE FESTIVALS OF ARZÁNS'S *HISTORIA DE LA VILLA IMPERIAL DE POTOSÍ*

Silver and other precious metals sometimes went beyond embellishing public festivals to become the very cause for celebration. In the conclusion to his *Arte o cartilla del nuevo beneficio de la plata* (1738), Lorenzo Felipe de la Torre Barrio y Lima describes the festivities held in Lima to celebrate a method of refining silver that had been developed in Potosí in the 1670s by Juan del Corro y Zegarra.[1] Barrio y Lima describes how the demonstrations of joy "passaron a quererse hacer eternidades en las Fiestas Sagradas, y Reales, con que . . . se solemnize aquella invención" (49–50) [went on to try to become eternal in the Sacred and Royal Festivals with which . . . that invention was solemnized]. The religious and civic celebrations include a procession of Our Lady of the Rosary, streets adorned with magnificent altars that seemed like "Zodiacos de riqueza, en que cada uno era una Constelacion de Plata, de Oro, y de Diamantes" [Zodiacs of wealth, in which each one was a constellation of silver, gold, and diamonds], and the usual chivalric games: "Corridas de Toros, con Juegos de Cañas, y Alcancías, executados por Quadrillas de Cavalleros, que fueron el más plausible objeto de la admiración" (50) [Bullfights, with Games of Reed Spears and Alcancías,[2] performed by Squadrons of Knights, who were the most praiseworthy object of admiration]. In sum, as Barrio y Lima concludes his otherwise rather dry metallurgical treatise, these were "regocijos, a que correspondió el aprecio con que admitió aquel sabio Virrey las condiciones de las grandes Mercedes, que pidió aquel Inventor" (50) [rejoicings matched by the appreciation with which that sage Viceroy granted the great favors requested by that Inventor]. The discovery of silver (and of novel techniques to produce it) may generate capital, but festivals were still part of the gift economy that Marcel Mauss attributed to

archaic societies; through the celebrations, the public expresses its gratitude for the invention to the same degree that the viceroy rewards the inventor for his services. Or so the author advertising his own metallurgic invention would hope.

Bartolomé Arzáns de Orsúa y Vela's *Historia de la Villa Imperial de Potosí* alludes to another festival celebrating Corro y Zegarra's new method of refining silver in Potosí (2:303). In their introduction to Arzáns's comprehensive history of the mining town, Lewis Hanke and Gunnar Mendoza call the fiesta the "institución simbólica a través de la cual se apreciase mejor el *ethos* de esta ciudad argentífera" (lxxix) [symbolic institution through which one can best appreciate the *ethos* of this silver city], and as they suggest, Arzáns documents this institution "admirably." Elaborate descriptions of religious and civic, calendrical and noncalendrical festivals fill page after page of the *Historia de la Villa Imperial,* and as we will see, these festivals form a key part of Arzáns's portrait of Potosí's grandeur and the defense of his hometown. The reference to the celebration of Corro y Zegarra's invention is comparably very brief, but it reveals another dimension of Potosí's ethos as represented by Arzáns.

After describing various festivities of 1681, Arzáns concludes the chapter by alluding to those that "se hicieron para un nuevo beneficio de metales que inventó el maestre de campo don Juan del Corro y Zegarra, caballero de la orden de Calatrava, que después no sirvió (aunque él es muy bueno y seguro de pérdidas), por lo cual tuvo este caballero con la invención grandes aplausos y esperanzas de mayores premios" (2:303) [were done for the new method of refining metals invented by coronel Don Juan del Corro y Zegarra, Knight of the Order of Calatrava, which later did not work (even though he is a very good man and safe from loss), for which this gentleman received great applause and hoped for greater reward]. Arzáns echoes Barrio y Lima's allusion to the applause and rewards reaped or at least sought by Corro y Zegarra, but the object of admiration is much less clearly defined in Arzáns's doubly qualified description of the invention and its inventor: the new method did not end up working, even if Corro is "a very good man" and has not been punished economically. Unlike in Barrio y Lima's text, here the "great applause" earned by Corro for his invention is not matched by greater rewards from the king or his representatives in Peru.

The subsequent narration continues to put into question the worthiness of the invention and the festival. The festival, we learn, is occasion for an accident resulting in the death of one Pedro de Contreras,

"minero de este rico Cerro" (2:303) [miner of this rich Mountain], and this accident appears to be the real source of Arzáns's interest in the episode. Dressed as a Turk with many jewels and pearls—clearly in preparation for the evening masquerade, a standard element of the early modern festive repertoire—Contreras was "lozaneándose con su caballo" [showing off with his horse] among other mine owners near the main square when his horse was startled and began running "con gran furia" [with great fury] to a ruined bridge along the canal known as the Ribera, where the silver refineries were located (2:303).[3] Contreras was caught under his horse when it jumped into the river, and he drowned immediately, despite the crowd's attempts to save him.

Arzáns concludes the tale and the chapter by moralizing on the wealth, rather than the life, lost in the accident: "Rompiéronse muchos hilos y cadenas de perlas y perdiéronse con algunas joyas, que estas infelicidades se acarrean las fiestas, vanidades y locuras de los hombres" (2:303) [Many strings and chains of pearls were broken and some jewels lost, for these misfortunes are brought about by the festivals, vanities and madness of men] (whether "fiestas" is the first term in a series or is being qualified as "vanidades y locuras" is unclear). While the squadrons of knights were the most praiseworthy object of admiration in the Lima festival, here the masquerading mine owner is the object of disgrace, his inability to control his horse symbolic of the way men— particularly in a mining boomtown like Potosí—can be carried away by vanity and greed.[4] Even Corro's discovery of a new amalgamation technique "que después no sirvió" [that later did not work] is implicated in Arzáns's condemnation: the invention is another source of wealth that— like the pearls and jewels in the river—comes to naught, just as Corro's pretensions to nobility (as knight of the Order of Calatrava) may be as hollow as Contreras's Turkish costume for the masquerade. And yet, the episode contributes to the portrait of Potosí's grandeur that is Arzáns's objective, as is clear from the work's full title: *Historia de la Villa Imperial de Potosí, riquesas incomparables de su famoso cerro, grandesas de su magnanima poblacion, sus guerras civiles y casos memorables* [History of the imperial town of Potosí, incomparable wealth of its famous hill, grandeur of its magnanimous population, its civil wars and memorable episodes].

Arzáns's festivals feature incomparable wealth and magnanimous grandeur, but even a festival that ends in tragedy does so in a spectacular way; *Historia*'s extravagant, unrepentant sinners, Hanke and Mendoza affirm in their introduction to the work, "tienen proporciones dignas de Potosí, y siempre tienen una nota de grandeza" (lxxviii) [have

proportions worthy of Potosí, and always a note of grandeur]. Building on Hanke and Mendoza's characterization, Stephanie Merrim identifies the "predominant cast" of *Historia* as "marvelous, prodigious, beyond belief—in sum, spectacular" (277), to the extent that "when Arzáns weighs the marvelous against moralizing, the marvelous wins" (278).[5]

Yet the marvelous also contributes to Arzáns's moralizing; after all, he concludes his account of Contreras's spectacular death with the exhortation "estas infelicidades se acarrean las fiestas" (2:303) [festivals bring about these misfortunes]. Festivals afford opportunities for Arzáns to showcase good and bad conduct and character through the ways participants and events are represented as well as the way the festivities are incorporated into the larger historical narrative. Arzáns integrates the descriptive mode typical of the festival account genre—detailed depictions of processions, costumes, games, triumphal arches, and so forth—with narratives of individual and collective actions that, as the moralizing narratorial interventions are meant to ensure, elicit praise or blame from readers. In so doing, he repurposes the performative dimension of the festivals he relates.

In this chapter I explore how Arzáns represents the spectacular wealth of and in Potosí's festivals and to what extent he redefines their objects of celebration. Although religious and civic festivals of the early modern period may have been primarily designed to demonstrate and promote the power of God, the king, and their representatives, this was not their only function or effect, and Arzáns "admirably documents" many others, as well. By relating festivals in narrative rather than merely descriptive form, he shows them to lead to personal and collective advantage or (as in Contreras's case) misfortune, and to offer venues for competition and rivalry among individuals and groups. As Teófilo Ruiz argues,

> It is certainly accurate to view these festivities through ideological
> lenses as attempts to reiterate and display royal authority, but they give
> witness as well to dialogues with authority and challenges to it. . . .
> Different social groups intermingled, a large variety of messages—
> sometimes clear, often subtle, rarely comprehensible to all—were
> hurled back and forth between participants and audience. (8)

Arzáns may emphasize his own particular interpretation of a festive event, as in the Contreras anecdote. But he also incorporates what Ruiz calls "complicated and unpredictable performances" (8)—sometimes

bringing about as much disorder and disaster as Contreras's horse—that allow us to see festivals in Potosí as sites of contestation and negotiation.

The social group with which Arzáns identifies is that of the *criollos* of Potosí, whom he describes:

> Los criollos de ella [Potosí], hablando sin pasión alguna y con la verdad que a todos es notorio, son de agudos entendimientos y de felices memorias (menos el mío que sobre no darme más naturaleza que el que manifiesto, mi corta suerte también me hizo carecer de estudios). . . . Sobran en los de esta Imperial Villa, habilidades, valor y letras, y por estar lejos faltan la ventura y el premio. (2:333–334)

> [Potosí's creoles, speaking without any bias and with the truth that is well known to all, have sharp minds and excellent memories (except mine, which besides nature not giving me any more than what I manifest here, my ill luck also deprived me of studies). . . . Abilities, valor, and learning abound in those of this Imperial City, and because they are far away, they lack good fortune and rewards.]

Arzáns uses three festive occasions in Potosí to showcase creole "abilities, valor, and learning" as well as his own "sharp mind and excellent memory": the 1608 Corpus Christi celebrations, the 1622 commemorations of the death of Philip III and the coronation of Philip IV, and the 1716 solemn entry of Archbishop-Viceroy Diego Morcillo Rubio y Auñón.[6] For Arzáns, these festivals are not simply demonstrations of praise—of God, the king, or their representatives—but are worthy of commendation themselves.

The distance of Potosí from the Crown may complicate creole attempts to obtain rewards, whether for these festivals, for Corro y Zegarra's invention, or for Arzáns's historical tomes, his rhetoric of humility notwithstanding. Yet this very distance makes the unpredictable, multivalent nature of festivals more palpable than in those organized and described at the center of empire, under the shadow of the Crown. Whereas Ruiz finds that "moments of contestation, subtle conflicts, and . . . the culture of specific social groups" can only be seen "almost 'through a glass darkly'" in some of his sources describing Iberian festivals (30), such moments shine—like so much dazzling silver—in Arzáns's account of Potosí's festivals. In these moments, narratives of festivals intended to exalt religious or political authority come in-

stead to celebrate a specific American locale and, in particular, its creole residents.

THE BODY OF CHRIST AND THE BODY POLITIC, 1608

The tension between Arzáns's tendency to moralize about or marvel at Potosí's festivals is evident in the apostrophe to his hometown in part 1, book 10, chapter 1, "De la suma veneración que tiene esta Imperial Villa de Potosí al culto divino y la grandeza con que celebra sus festividades entre año" (2:321) [Of the supreme veneration that this Imperial Town of Potosí has for divine worship and the grandeur with which it celebrates its festivals in the course of the year]. The moralizing inclination manifests itself in his ironic invocation of the Baroque themes of ephemerality and decadence: "Oh gran Potosí, ¡qué de lauros mereces por el trueque tan admirable que has hecho! Precipicio dichoso ha sido el tuyo pues por él te has levantado hasta llegar a emplear tus fuerzas en servicio de Dios y de sus santos" (2:322) [Oh great Potosí, how much praise you deserve for the admirable transformation you have undergone! Your fall has been fortunate, since because of it you have risen up to employ your strength in the service of God and his saints].[7] Here Potosí's decline is evaluated positively, as something that has resulted in greater piety and a praiseworthy transformation.[8]

Yet as the apostrophe continues by drawing on the motif of *ubi sunt*, the change seems less admirable than what has been lost:

> Dime, famosa Villa de Potosí, ¿qué se ha hecho tu antigua grandeza, riqueza y pasatiempos tan gustosos? ¿Qué se han hecho tus lucidas fiestas, juegos de caña, justas, torneos, sortija, máscaras, comedias, saraos y premios de tanto valor? ¿Dónde están las invenciones, letras y cifras con que entraban a las plazas de regocijo tus famosos mineros? ¿Qué se ha hecho el valor de tus criollos, su gallardía, caballos, jaeces y galas tan costosas con que se hallaban en las fiestas? . . . ¿Qué se han hecho, oh ilustre Villa, aquellas admirables barras de plata que con ostentación admirable cubrían el suelo de los altares, todo el espacio de la Casa de Moneda y cajas reales el día de Corpus, y las piñas que servían de candeleros? . . . ¿Qué se ha hecho toda esta grandeza y otra mucho mayor que no digo?
>
> Todo se ha acabado, todo es pena y fatiga, todo llantos y suspiros. (2:322)

[Tell me, famous Town of Potosí, what has happened to your ancient grandeur, wealth, and such pleasurable amusements? What has happened to your brilliant festivals, games of reed spears, jousts, tournaments, running of the ring, masquerades, plays, soirées, and valuable prizes? Where are the inventions, mottos, and figures with which your famous mine owners entered the plazas of festivities? What has happened to the valor of your creoles, their gallantry, horses, trappings, and such costly finery with which they attended festivals? . . . What has happened, oh illustrious Town, to those admirable bars of silver that with such admirable ostentation covered the floor of the altars, the whole Mint and the royal coffers on the day of Corpus Christi, and the silver cones that served as candlesticks? . . . What has happened to all this grandeur and so much more that I do not speak of?

Everything has finished, everything is sorrow and hardship, everything is weeping and sighing.]

The passage serves as a veritable summary of the festive practices and paraphernalia described in copious detail throughout Arzáns's work. Here the marvelous appears to win out over the moralizing, as Arzáns expresses full-throated admiration for the city's former festive magnificence—its spectacular wealth, in all senses—and grief at its disappearance. Ruiz comments on a remarkably similar passage in Jorge Manrique's fifteenth-century "Coplas por la muerte de su padre":

¿Qué fué de tanto galán,
Qué fué de tanta invención,
Como traxéron?
Las justas y los torneos,
Paramentos, bordaduras,
Y cimeras,
¿Qué fueron sino devaneos? (Manrique 46–47)

[Where are the courtly gallantries?
The deeds of love and high emprise
In battle done?
Tourney, and joust, that charmed the eye,
And scarf, and gorgeous panoply,
And nodding plume;
What were they but a pageant scene?]

Ruiz contends that Manrique's intent may have been to show "the vanity of such exercises and their ephemeral nature," but his verses "resonate with the awe that such displays evoked in contemporaries and succeeding generations" (225).[9] Certainly we could say the same of Arzáns.

However, Arzáns quickly returns to a moralizing interpretation of Potosí's fall— "¿Es posible, oh grandiosa Villa de Potosí, que tal ruina hayan causado tus pecados?" (2:323) [Is it possible, oh grandiose Town of Potosí, that your sins have brought about such ruin?]—and praises the piety now displayed by the city's residents: "haces muy bien de venerar el culto divino y gastar liberalmente los efectos riquísimos de su Cerro en tanta solenidad de fiestas de Jesucristo nuestro bien, su santísima madre y santos de su gloria" (2:323) [you do very well in venerating the divine service and spending liberally the rich products of the Cerro on so many solemn festivals in honor of Jesus Christ our Lord, his holy mother and the saints]. Although Arzáns qualifies these acts as "humilde rendimiento" [humble submission], he proudly shows how Potosí's wealth has been rechanneled into spiritual celebrations (2:323). In subsequent pages, Arzáns highlights the artistic and architectural grandeur of Potosí's numerous churches as well as the "afecto, devoción, aseo y gastos" [affection, devotion, cleanliness, and expenses] of the many religious festivals that, according to Arzáns, exceed those of all Christendom (2:325). Potosí's festive luster has hardly faded; rather, its redirection to spiritual ends reflects even better on the city's residents.

Among these festivals, the first mentioned is Corpus Christi, whose grandeur "ha sido antigua en esta Villa, pues dicen varios autores que sus gastos pasaban de 30,000 pesos, pero al presente no llegan a 10,000" (2:325) [has been long-standing in this town, for some authors say that its expenses used to exceed 30,000 pesos, but now they don't amount to 10,000]. The celebration of the Eucharist, a moveable feast day occurring between late May and mid-June, was officially integrated into the Catholic calendar by papal decree in 1311 as an affirmation of the doctrine of transubstantiation (Dean 8).[10] Corpus Christi became increasingly important in Spain and its American viceroyalties during the Counter-Reformation, when it acquired theological and political significance as a celebration of triumph over heresy as well as over non-Christian peoples (Dean 12). Corpus Christi festivals incorporated defeated pagans via costumes, mock battles, and dances, with indigenous peoples in Peru taking the symbolic place of Moors and Turks in Spain. The celebration of Corpus Christi was mandated for Spaniards and Amerindians alike

in the First Provincial Council of Lima (1551–1552) as well as in subsequent councils.

Arzáns's narrative of the Corpus Christi celebrations in 1608 confirms the festival's "antigua grandeza" [ancient grandeur] in Potosí. Occupying chapters 9 and 10 of part 1, book 6, this is the most extensive account of a Corpus Christi festival in his *Historia*, comparable only to the "breve relación" [brief account] of the 1737 Corpus Christi by Bartolomé's son, Diego, who continued the history briefly after his father's death in 1736. Although Diego calls the 1737 celebrations "ni sombra" [not a shadow] of those held in "tiempos prósperos" [prosperous times] like 1608 (3:417), his account describes six elaborate triumphal arches constructed for the occasion and eight days of festivities. Among the festive activities he describes are fireworks and six dancing giants since, he reports, there are no longer *tarascas*, the dragons traditionally paraded on Corpus Christi). However, Diego concentrates mainly on the Corpus Christi procession itself, which featured the devotional statues of fifteen indigenous parishes ("cada imagen con su baile o invención de indios" [each image with its dance or invention of the Indians]), members of the religious orders and clergy, a chariot carrying the Holy Sacrament, the town council, the Inquisition tribunal, and, lastly, "infinidad de mujeres" [infinite women] (3:417–418).

In contrast to his son, Bartolomé Arzáns emphasizes the secular rather than the religious dimensions of the 1608 Corpus Christi festivities. Although he avers that "la fiesta del día de Corpus a lo divino [fue celebrado] con el mayor culto, veneración y grandeza que hasta aquí se había visto en Potosí" [the sacred festival of Corpus Christi was celebrated with the greatest worship, veneration, and grandeur that had been seen until now in Potosí], he quickly turns his attention to the "regocijos humanos" [human festivities] that followed the religious holiday (2:268). These include six days of comedies and another six of bullfights, four days of tournaments and jousts, and six masquerades. Even the mock battle between Spaniards and Indians, a traditional element of Corpus Christi festivals, was staged within one of the masquerades and carried no religious overtones (1:276). The religious procession—described in detail for the 1737 Corpus Christi festival—is passed over in favor of painstaking descriptions of the chivalric performances: the "juego de cañas y sortija" [game of reed spears and running of the ring], which Arzáns claims to be the only part of the festival that he would narrate "con alguna prolijidad" [with some prolixity] in order to avoid

boring his readers (1:268). He thus devotes most of the rest of the chapter and the following one to detailing the competitors' "invenciones" [inventions], including their elaborate, symbolic costumes and accompanying troupes, horses, floats, sculptures, and music—a true festival for the eyes and ears.

Arzáns insistently highlights the audience's favorable response to the extravagant spectacle, generally using the verb *admirar* in the sense of "to amaze, to cause admiration" in order to attribute agency to the performers rather than the observers: "Admiró a todos la invención" (1:272) [The invention amazed everyone].[11] These *invenciones* earned as much praise as Corro y Zegarra's scientific invention, and Arzáns's goal is clearly to elicit the same reaction from readers. Indeed, rather than the body of Christ, the bodies and minds of the performers are the true object of celebration, and Arzáns's framing of the festival reveals why. As he explains at the beginning of the chapter, the festivities were organized by the "nobleza, y juventud criolla" [creole nobility and youth] as a response to an affront to their honor:

> Dicen, pues, los dichos autores que habiendo celebrado el año pasado todas las naciones que en Potosí se hallaron con varios regocijos la venida del general don Pedro de Córdova Mesía, entre éstas la nobleza y juventud criolla quiso demostrar sus riquezas en unas justas y juego de cañas. Pero como la nación criolla en aquellos tiempos estaba mal mirada de las otras de España (y particularmente de la vascongada) quisieron éstas desacreditar con sus lenguas a los nobles criollos, notándolos de poca destreza en la gallardía y mando de los caballos y que no sabían de invenciones curiosas. (1:267)

> [The said authors write, then, that when all the nations in Potosí celebrated with various festivities the arrival of the general Don Pedro de Córdova Mesía the previous year, among all of these the creole nobility and youth wanted to demonstrate their wealth in some jousts and game of reed spears. But as the creole nation in those times was looked on badly by others of Spain (and particularly the Basques), they tried to discredit the noble creoles with their tongues, pointing out their little skill at gallantry and horsemanship, and saying that they didn't know anything about curious inventions.]

The assertions of creole inferiority in both body (lack of horsemanship skills) and mind (ignorance of curious inventions) recall European accu-

sations of creole degeneration. The effort—through the festival as well as Arzáns's narrative of it—to challenge these assertions and vindicate the worth of Potosí's native-born sons (i.e., those of European descent) is similar to that of creoles elsewhere in the Americas.[12]

Arzáns distinguishes between his various sources on this point here and in the preceding chapter, which describes the festivities for the entry of Potosí's new *corregidor* (Crown-appointed town magistrate), Pedro de Córdova Mesía (1:266). The historians Pedro Méndez and Antonio de Acosta and the poet Juan Sobrino apparently approve of the opinion held by Basques and other Spaniards regarding the creoles' lack of skill and inventiveness, while Juan Pasquier, Bartolomé de Dueñas, and another unidentified poet ("cuyo nombre se ignora, que también escribió en verso" [whose name is unknown, and who also wrote in verse]) defend Arzáns's position, that the rumors resulted from "mal afecto de las contrarias naciones [antes] que defectos que hubiesen tenido en aquellos regocijos" (Arzáns 1:267) [the antipathy of the contrary nations, rather than any defects in those festivities].[13]

In the preceding chapter, Arzáns is more circumspect in his characterization of the creoles' festive skills, admitting that "es verdad (como quieren el capitán Pedro Méndez y don Antonio de Acosta) que por ser las primeras que hizo la noble juventud no se vieron en ellas la destreza y gallardía que se experimentan en otras más cursadas" (1:266) [it is true (as the captain Pedro Méndez and don Antonio de Acosta would have it) that because these were the first that the noble youth did, there was not the skill and gallantry that can be found in other, more accustomed ones]. Even when he admits the possibility of festive inferiority, he attributes it to youth and inexperience. By the following year, however, the creoles would overcome this apparent disadvantage: "Mas éstos tomaron tan de veras (viéndose notados) su desempeño, que (como veremos en el siguiente año) hicieron unas riquísimas y admirables fiestas cuales hasta allí no se vieron semejantes en Potosí" (1:266–267) [But seeing themselves criticized, these [creoles] took so seriously their execution, that (as we will see in the next year) they performed very rich and admirable festivals, the likes of which had never before been seen in Potosí]. The creoles' festival goes from being the first to being the foremost.

Arzáns thus places the rivalry and animosity between what he calls the "nations" of Potosí—creoles, Basques, Andalusians, Castilians, Portuguese, and others—at the center of a religious festival, Corpus Christi, which throughout the Spanish Empire was meant to demonstrate the robust unity of the Church's body of worshipers and of the Spanish body

politic, whether in the face of Protestant heresy, Islamic threats, or indigenous idolatry.[14] The tension between the "contrary nations" evident in and through the festivities foreshadows the bloody violence of the War of the Vicuñas and Basques of 1622–1625, which, according to Arzáns, was one of the three principal causes of Potosí's decline. The parenthetical references to the Basques' special animosity toward creoles in chapters 8 and 9 evoke the context of these wars; various non-Basque nations (whose nickname derived from their distinctive vicuña wool hats) united to oppose the Basques, who since the late sixteenth century had been steadily taking over much of the silver industry and the local government (1:266–267).[15] When introducing this conflict in book 7, Arzáns attributes its origin to the "pasión demasiada de sus naciones, como también . . . la infernal codicia y ambición de la plata" (1:322) [excessive passion of its nations as well as . . . the infernal greed for silver]. Potosí's silver is thus both the cause of interethnic rivalry and the means of expressing it, through the display of spectacular wealth.

The alignment of contrary nations in the 1608 Corpus Christi resembles not the subsequent conflict between Vicuñas and Basques, but the emergence of an American identity distinct from that of peninsular Spaniards, as many scholars have traced in the seventeenth and eighteenth centuries.[16] Leonardo García Pabón finds in Arzáns "la exaltación—por el relato de la fiesta—de un sujeto colectivo en formación" (424) [the exaltation—through the festival account—of a collective subject in formation], and that subject is proudly announced in the title of the chapter: "En que se refiere la grandeza y riqueza de unas famosas fiestas que hicieron en esta Imperial Villa sus nobles criollos" (1:267) [Which recounts the grandeur and wealth of some famous festivals that the noble creoles performed in this Imperial Town].[17] This title echoes that of book 10, chapter 1—"Of the supreme veneration that this Imperial Town of Potosí has for divine worship and the grandeur with which it celebrates its festivals in the course of the year" (2:321)—but here the festive grandeur is specified as creole and noble. In effect, the 1608 Corpus Christi festivities may be the very ones evoked in Arzáns's nostalgic lament in book 10, chapter 1: "What has happened to the valor of your creoles, their gallantry, horses, trappings and such costly finery with which they attended festivals?" (2:322).

Arzáns exalts this local, collective identity through the effusive description of each creole's "invención," an allegory depicted visually and textually through the costumes, props, and floats with which they enter

the plaza to compete in the *sortija* (running of the ring). García Pabón points out that the participants are nearly all named Nicolás, after the saint attributed with the survival of the first child to be born in Potosí, thus designating a common identity that distinguishes them from peninsular Spaniards (428).[18] For each creole Arzáns details the material opulence and the intellectual ingenuity of his "invención" as well as performative skills. Even the one creole to lose in the *sortija* is a victor in Arzáns's narration. Nicolás Eugenio Nárvaez enters in a "gran carro" [great carriage] pulled by twelve richly adorned horses (1:272). On the carriage is a blue globe surrounded by clouds and the elements air, water, and fire, all of which direct their fury at the globe with special effects, "cosa de grandísima admiración" [a thing of great admiration]. After entering the plaza, the globe opens to reveal men engaged in occupations such as agriculture and mining as well as a miniature Cerro de Potosí, "sobre el cual venía sentado un caballero mozo armado de todas armas, y sobre la cota un peto cubierto de muchas joyas y perlas" (1:272) [upon which there was seated a young gentleman who was armed with all weapons, and breastplate covered with many jewels and pearls on his coat of mail].

Arzáns explains the meaning of the symbols and motto on his shield— "Cuán desgraciado nací, pues cielo y tierra es contra mí" [I was born so unlucky, for earth and sky are against me]—by citing Méndez and Acosta: "este caballero fue siempre de muy contraria fortuna" [this gentleman always had very bad luck]. Arzáns's sources attribute that misfortune to God's punishment for Nárvaez's misdeeds and those of his parents. Yet the marvelous once again wins out over the moralizing in this passage, and Nárvaez experiences the contrary fate of Pedro de Contreras or Juan del Corro y Zegarra. Nárvaez exits the plaza "dejando contentísimos a todos, que igualmente alabaron su invención" (1:273) [leaving everyone very content, for they all praised his invention equally]. The praise is earned not for moral propriety but for festive ingenuity, which in this case involved losing at the ring in order to reinforce the *invención*'s theme of misfortune. Arzáns contends that he and his creole compatriots—whom he also attributes with a lack of "good fortune and rewards" (2:333–334)—are deserving of the same response.

If the marvelous has the upper hand in Arzáns's elaborate, awe-inspiring descriptions of the individual performers and their *invenciones*, his moralizing propensity asserts itself in the narrative frame in which he presents the festival. Arzáns opens chapter 9 with the classic trope of instruction mixed with delight:

Piden las historias alguna variedad, pues se escriben no sólo para divertimiento y gusto de los humanos mas también para tener alguna muestra de enseñanza, y así escribiré las famosas fiestas que en este año de 1608 celebró la nobleza, y juventud criolla de esta Imperial Villa de Potosí, motivándolas solamente el pundonor y vanidad, en que no falta que reprender, porque la vana ostentación de los hombres enfada mucho a Dios, aunque sean señores y reyes. (1:267)

[Histories require some variety, for they are written not only for human entertainment and pleasure but also to have some kind of instruction, and thus I will write of the famous festivals that in this year of 1608 the creole youth and nobility celebrated in this Imperial Town of Potosí, which were motivated only by honor and vanity, in which there is much to reproach, for the vain ostentation of men angers God greatly, even if they be lords and kings.]

Here the festival account is not solely identified with the realm of the marvelous—variety, entertainment, and pleasure—but attributed with instructional value. The apparent aim is to censure the creoles' "vain ostentation," an error that evokes Arzáns's occasional critique of festivals as "vanities and madness," as in the Pedro de Contreras episode.

Nevertheless, in the next paragraph the moral critique is quickly redirected to the other nations of Spain:

Si fue . . . una murmuración liviana, con todo eso no parece bien entre la nobleza, pues de cualquier modo que sea la murmuración (liviana o pesada) al cabo es una plática nacida de envidia o malquerencia, que procura deslustrar y oscurecer la fama, vida y virtud ajena, y toda murmuración es un mortal veneno de la amistad; además que el murmurar es oficio de mujeres y no de varones. (1:267)

[If it was . . . a frivolous rumor, even so it does not seem well among nobility, because any sort of rumor (frivolous or serious) in the end is gossip born of envy or ill will, which seeks to darken and obscure the fame, life, and virtue of others, and any rumor is a mortal poison for friendship; besides which gossip is the office of women and not men.]

The blame is displaced from the creoles' "vain ostentation" to the "envy or ill will" of the other nations—and even worse, to the gendered vice of

rumormongering. With this moralizing commentary, Arzáns fully excuses the creoles from any hint of critique.

Just as the creoles substitute the spiritual intent of the Corpus Christi festival with the self-aggrandizing demonstration of material and intellectual riches, Arzáns displaces his originally declared motive for writing about it. The goal of offering moral instruction about the sin of vanity is overshadowed by his attempt to delight and awe his readers with the ingenuity and grandeur of the creole festival—and, by extension, with the author's own ingenious and grandiose depiction of such splendor. In this sense, Arzáns follows the Baroque precepts outlined in his prologue—a more extreme version of the Horatian dictum to instruct with delight: "todo será para deleite y provecho del ánimo, atendiendo también a que lo narrativo agrade por nuevo, admire por extraño, suspenda por prodigioso, por ejemplar exhorte" (1:clxxxv) [everything will be for the delight and benefit of the soul, also making sure that the narrative pleases through novelty, provokes admiration through strangeness, astonishes through prodigiousness, exhorts through exemplarity]. In seeking to provoke admiration for the derided creoles, Arzáns's narrative reflects the spectacular nature and the objectives of the festival itself. Lewis Hanke, in an extended footnote to the chapter, comments that the wealth and extravagance described by Arzáns are difficult to reconcile with what we know about Potosí from contemporary documents, which suggest a serious economic crisis at the time (274n7). Nevertheless, it would be wrong to seek in accounts like Arzans's an accurate picture of the city or the festival. Instead, his description extends and amplifies the creoles' own intentions in offering the festival, which already reoriented Corpus Christi's primary purpose by transforming the commemoration of the Eucharist into an act of self-celebration.

FESTIVE COMBAT AND CIVIL WAR, 1622

The creole patriotism evident in Arzáns's narration of the 1608 Corpus Christi festival finds a pointed echo in his account of the 1622 celebrations in honor of the coronation of Philip IV. The account of these festivities and the funeral ceremonies for Philip III that preceded them is interpolated into his narrative of the War of the Vicuñas and Basques (1622–1625), which occupies a full nineteen chapters of part 1, book 7 (1:321–407). Gunnar Mendoza annotates Arzáns's version of these festi-

vals much as his co-editor, Lewis Hanke, treats Arzán's account of the 1608 Corpus Christi, calling one example of the writer's frequent divergence from the archival record "una de las superposiciones típicas de la *Historia*" (1:331n5) [one of the typical additions of the *Historia*]. Yet these fictionalizations make sense within Arzáns's project of exalting his hometown and in particular its creole residents.

First, Arzáns greatly exaggerates the cost of the funeral ceremonies for Philip III, claiming that it amounted to 80,000 reales (1:331)—nearly three times the highest figure, 30,000 reales, that Arzáns attributes to Corpus Christi festivals in Potosí (2:325) and twice the cost of the most expensive ceremonial entry of the viceroy into New Spain in the early seventeenth century, according to figures provided by Linda Curcio-Nagy (19).[19] The *Libros de acuerdos del cabildo de Potosí*, the records (*acuerdos*) of Potosí's town council (*cabildo*) meetings, suggest that the cost was much less: the *cabildo* recommended borrowing only 4,000 pesos to carry out the funeral rites "con la mayor solemnidad y autoridad posible" (336v) [with the greatest solemnity and authority possible].[20] The *cabildo* also sought to limit excessive expenditures in other ways, such as by prescribing the cost of different qualities of black cloth from Lima, England, and Flanders as well as punishments for those who attempted to inflate prices to profit from the situation.

The preparations discussed in the *acuerdos* well reflect the submission to royal authority that the *cabildo* members physically and verbally demonstrated in their reception of Philip IV's letter announcing his father's death and mandating the ceremonies: "pusieron [la carta] sobre la cabeza y dixeron que la resçivian y obedecian con el respeto y acatamiento devido como carta çedula y provision real" (338v) [they put the letter on their heads and said that they received and obeyed it with the respect and obedience owed to it as a royal letter, document, and provision]. After demonstrating their own respect and obedience, the members of the *cabildo* ordered that "se pregone publicamente que todas las personas hombres y mugeres españoles y mestiços y mulatos de qualquier estado calidad y condicion sean que dentro para el domingo que biene cinco de este mes todos salgan con luto" (338v–339r; crossed-out words in the source) [it be proclaimed publicly that all people—Spanish men and women and mestizos and mulattos, of whatever quality and condition they be—dress in mourning before on next Sunday, the fifth of this month].[21] Arzáns may echo this act of united submission and reverence by emphasizing the sorrow felt by "toda la Villa" [the whole Town] at the news of the king's death, but he also reveals the self-interested

source of this sentiment among Potosí's elite: "cayó por tierra muchas esperanzas de los señores azogueros y otros nobles vecinos de esta Villa que pretendían algunos premios por sus servicios" (1:331) [it dashed many of the hopes of the mine owners and other noble citizens of this Town who sought some rewards for their services]. And as we will see, Arzáns is careful to distinguish between the different nations that the *acuerdos* present simply as "hombres y mugeres españoles" [Spanish men and women].

Besides inflating the amount of money spent on the royal exequies, Arzáns also gives the arrival of the news of Philip III's death as June 1622; according to the *Acuerdos del cabildo*, the news actually arrived in November 1621. Arzáns thus places the celebration of Philip IV's coronation at the end of the year—December 1, 1622, when the hostilities between Vicuñas and Basques were in full swing—rather than January 6, 1622, when the town council records show the festivities to have taken place. This displacement allows Arzáns to emphasize Potosí's widespread notoriety, to which he attributes the delay in the arrival of the news (1:331). The exaggeration of details about the timing as well as the cost of the solemnities conforms to Arzáns's efforts to aggrandize his hometown, even when this is accomplished through the aggrandizement of its troubles: "pues en todo el Perú se sabían de sus alborotos" (1:331) [for in all Peru they knew of its disturbances]. Arzáns highlights the extraordinary suspension of these disturbances for the duration of the funeral ceremonies: "Celebráronse sus reales exequias con las grandezas siempre acostumbradas en esta Villa y con mucha paz y conformidad de todas las naciones que en ella habitaban, pues durante el tiempo en que se celebraron no llevaron los hombres armas ningunas (ni siquiera un puñal) que parecía no haber sido jamás enemigos los unos de los otros" (1:331) [They celebrated the royal exequies with the customary grandeur of this Town and with much peace and conformity among all the nations that inhabited it, for during the time in which they celebrated the men did not carry any arms (not even a dagger) such that it seemed that they had never been enemies of one another].

This idealized moment of peace and unity is short-lived, however. Although Arzáns coincides with the *acuerdos* in presenting the royal exequies as an event that unified the nations of Potosí in mourning for their sovereign, the chapter (part 1, book 7, chapter 3) in which he interpolates the episode does just the opposite by emphasizing ethnic differentiation and discord. Earlier in the chapter Arzáns relates the killing of a Basque captain, San Juan de Urbieta, described as "enemigo de

andaluces, criollos y extremeños" (1:329) [enemy of Andalusians, creoles, and Extremadurans]. The ever-moralistic Arzáns does not condone the murder, but he certainly offers a justification by referring to Urbieta's pride and loose tongue, which had led him to assert that he would not stop until he had put all creoles and Andalusians to work for him in the mines and refineries (1:329). Arzáns also relates how after his death, a Basque compatriot of Urbieta decries the murderers as "unos moros blancos (por los andaluces), unos judíos traidores (por los extremeños) y unos mestizos bárbaros (por los criollos)" (1:330) [white Moors (for the Andalusians), treasonous Jews (for the Extremadurans), and barbarous mestizos (for the creoles)]. Arzáns excuses himself for mentioning such slurs by attributing them to his written sources: "es preciso referir algunas palabras de niñería, por estar así escrito, porque se vea la locura de estos hombres pues por ellas se mataban los unos a los otros" (1:330) [I must recount such childish words because that is how it is written, so that one may see the insanity of these men since because of those words they killed each other]. Here we are very far indeed from the unity of the "españoles" presumed in the *acuerdos*, where they were distinguished from mestizos and mulattos yet united with these groups in deference to the king. According to the Basques, creoles as well as Spaniards from Extremadura and Andalusía are tainted by mixed blood, making them even worthy of forced labor in the mines.

Despite his disclaimer, some of the "childish words" resurface at the end of the chapter and point to a redefinition of the Basques' ascription to the creoles of inferior, tainted social identity. Just after he describes the royal exequies, Arzáns refers to a meeting in which the Potosí-born Juan Suárez invokes this insult as a rallying cry in a speech to his fellow Vicuñas:

> Nuestra nación criolla siempre ha sido muy fiel a sus reyes, . . . y en todas ocasiones nos han estimado andaluces, extremeños y castellanos, no sólo por ser hijos y deudos suyos, mas también porque todos hallan piadosa acogida en este Perú y particularmente en este Potosí. Mas estos vizcaínos, ¿por qué, pues, se quieren alzar contra nosotros y contra los que no sois de su nación, aborreciendo el nombre de criollos, injuriándonos, pues no tienen otro título que darnos más de sólo mestizos bárbaros? Como si (dado caso que esto fuera rigor) la mixtura de la sangre fuera cosa vista sólo en este reino, cuando en todo el mundo es lo mismo, y las más veces una real sangre se mixtura con otra de otro rey muy distinto en costumbres. Obligación tenían estos vizcaínos de

conservar nuestras amistades, lo uno porque en nuestra patria han ad-
quirido los tesoros y estimación que tienen, y lo otro porque nuestros
padres les han dado en los pasados años sus hijas en matrimonio . . .
aunque ahora ellos son causa de que no se mixture nuestra sangre con
la suya. No nos pesa de estos, y sólo me pesa de que tanto tarde la ven-
ganza. Mueran, mueran los vizcaínos. (1:332)

[Our creole nation has always been very faithful to its kings, . . . and
on all occasions Andalusians, Extremadurans, and Castilians have es-
teemed us not only because we are their sons and relatives but also be-
cause they all find a cordial reception in this Peru and especially in
this Potosí. But these Basques, why do they want to rise up against us
and against those who are not of their nation, hating the name of cre-
oles, and insulting us, because they have no other title to give us than
that of barbarous mestizos? As if (if this were in fact true) the mix-
ture of blood was something that was only seen in this kingdom, when
in all the world it is the same, and often a royal bloodline mixes with
another very distinct in customs. These Basques had an obligation to
conserve our friendship and not mistreat us in deeds and words: first
because in our homeland they have acquired the wealth and esteem
they now enjoy, and second because in the past our fathers have given
them their daughters in matrimony . . . even though now they are the
reason that our blood does not mix with theirs. Let us not be pained
by this; it only pains me that revenge comes so late. Death, death to
the Basques.]

This defense of the creole nation does not involve denying any possible
mixture with indigenous blood. More important to Suárez, and by ex-
tension Arzáns, than holding a supposedly pure European ancestry is
to identify "this kingdom," the viceroyalty of Peru, as one's *patria*, or
homeland. *Mestizo* is no longer associated with *bárbaro* (barbarian) and
is not incompatible with wealth, with such qualities as generosity, hospi-
tality, and fidelity to the king, or even with noble blood.

The creole identity marker—so important to the chapter as a whole
and to Juan Suárez's speech in particular—vanishes when Arzáns relates
how the group subsequently agreed to call themselves Castilians, "aun-
que eran de diferentes naciones" (1:332) [even though they were of differ-
ent nations]. Arzáns then describes the vicuña wool hats that the group
adopts as a different sort of identity marker, and he states that there-
after he would refer to them as "castellanos o vicuñas" (1:332) [Castilians

or Vicuñas]. In what Gunnar Mendoza might call one of the *Historia's* "superposiciones," Arzáns overlays Suárez's speech with his own concerns as a creole writing in the early eighteenth century. As the rest of the chapter (part 1, book 7, chapter 3) makes clear, during the War of the Vicuñas and Basques the identity conferred by an American or Iberian birthplace was subordinate to the identity of Basque or non-Basque.

In Arzáns's account of the festivals celebrating Philip IV's coronation, we can see a similar use of past events to articulate contemporary concerns. As explained, the exequies for Philip III were actually held in Potosí on December 22, 1621, and the *cabildo* scheduled the celebration of Philip IV's coronation for Epiphany, January 6, 1622. The *cabildo* meeting on December 6 prescribed the usual festive elements for the celebrations: a procession of two companies of soldiers; an evening masquerade with four squadrons of sixteen people each; the raising of the royal standard, accompanied by the scattering of coins; *luminarias*, or festival lights, and firework displays; two days of bullfights; a public feast; a pontifical mass and sermons, and more. The *acuerdos* insist that the celebrations continue to exhibit the grandeur that Potosí typically manifested on such occasions and that this one should even be greater than the ones that came before.[22]

Arzáns's account of these festivities does not diminish their grandeur, even though he includes it after three chapters of bloody battles between the Vicuñas and Basques in the year 1622, leading to no fewer than 732 deaths of "hombres de varias naciones" [men of various nations], as well as more than 500 deaths of "mestizos, indios, negros y mulatos" (1:350) [mestizos, Indians, blacks, and mulattos]. Consistent with his reported timing of the royal exequies, Arzáns situates the celebrations for the new monarch not on January 6, 1622, the date given in the *acuerdos*, but at the end of that year, on December 1, when they are combined with the nine-day celebrations of the Immaculate Conception. Arzáns justifies his inclusion of these festivities amid his narration of the civil wars by asserting the need to distract his readers "con el cuento de estas fiestas, que a ellas se le seguirán nuevas lástimas" (1:346) [with the story of these festivals, since after them new tragedies will follow]. Yet in Arzáns's rendition the festival not only is the occasion for mock battles but also contributes to the real hostilities, and once again fails to unite Philip IV's subjects in celebrating his ascension to the throne.

Arzáns's narration of the festivities centers on the bullfights mentioned in the *acuerdos* but extends them over five days and adds other chivalric games to the mix, such as games of reed spears (1:348). Accord-

ing to Arzáns, the *cabildo* and the *corregidor* agree to exclude the Basques from participation, recognizing the real violence that might ensue from the mock festive competitions; they are not mistaken, for Arzáns relates that two Vicuñas were killed in a swordfight on the first night and a Basque was found headless the next day (1:346–347). The exclusion of the Basques is probably another one of Arzáns's "superposiciones," however. The name Pedro de Berazategui mentioned in *Acuerdos del cabildo* as one of the deputies in charge of the festival—unanimously elected by the *cabildo*—suggests a Basque origin.

The exclusion of the Basques allows Arzáns to present the celebrations for Philip IV as an echo of the 1608 Corpus Christi festival. Unlike the festivities of 1608, the chivalric games in 1622 included other non-Basque nations—Andalusians, Castilians, Galicians, Extremadurans, and Portuguese—but Arzáns once again highlights the participation of creoles. Francisco Castillo, "natural de esta Villa" (1:347) [native of this Town], is the first to be described in the games, and Pedro de Andrade, a Galician who is nevertheless identified as the "capitán de la cuadrilla criolla" (1:349) [captain of the creole squadron], is the last. The shield of this "enemigo de la nación vascongada" [enemy of the Basque nation], as Arzáns describes Andrade, boasts the motto "Si se alzaron, ya cayeron" (1:349–350) [If they rose up, they have already fallen], and he enters the plaza with an elaborate *invención*: a float involving a richly adorned Cerro of Potosí, with all of its mines labeled in letters of gold. The symbolic appropriation of the silver mountain by the creole squadron,[23] as well as the implicit threat in the captain's motto to those who previously controlled its wealth, are easily deciphered by the Basques. While everyone else delighted in the performance, Arzáns asserts, "sólo los vascongados . . . reventaban de cólera por ver los enigmas y letras contra su nación" (1:350) [only the Basques . . . exploded in rage when they saw the enigmas and mottos against their nation].

Here the division and rivalry between the various nations of Potosí not only serves to contextualize the festival, as in the funeral ceremonies for Philip III, but is a central component of the celebrations. If at the beginning of the chapter (part 1, book 7, chapter 6) Arzáns claims to include the story of these festivals as a digression from the civil war, he in fact continues to interweave the narratives of mock and real battles: "si ordinariamente al placer le sigue el llanto, mézclese uno con otro en esta ocasión pues jamás se desamparan entrambos" (1:346) [if ordinarily pleasure is followed by sorrow, let them be mixed on this occasion because they never abandon each other]. For Arzáns such mixtures should

not be condemned as barbarous. Rather than portraying a single body politic united in its reverence for the former sovereign and subservience to the new one, Arzáns shows how different social groups—in particular, Potosí's creoles—use the festivals to assert their own identities and agendas.

CELEBRATION AND CRITIQUE
IN A VICEREGAL ENTRY, 1716

Even when the figure of authority being acclaimed is physically present in Potosí, as in the solemn entries of *corregidores* or viceroys, Arzáns still manages to reorient the festival's goals to celebrate instead his hometown and his creole compatriots. Such is the case in his account of the 1716 entry into Potosí of Archbishop Diego Morcillo Rubio y Auñón, who was on his way to Lima to assume his post as the newly appointed viceroy. As in the 1608 and 1622 festivals, Arzáns converts the entry into a platform for the city's self-celebration. In this case, however, the contrast is drawn not between different nations but between the representatives of Spanish civic and ecclesiastical authority, on one hand, and the city's residents and their local governing body, the *cabildo*, on the other. Arzáns contextualizes the festival in such a way that it highlights the spiritual and moral qualities of the latter group, putting the marvelous again in the service of the moralizing narrative.

Besides Arzáns's version, two other records of the archbishop-viceroy's entry into Potosí are extant: the official account by Fray Juan de la Torre, *Aclamacion festiva de la muy noble Imperial Villa de Potosí*, published in Lima in 1716, and a commemorative painting by Melchor Pérez Holguín, *Entrada del Arzobispo Virrey Morcillo en Potosí* (fig. 1.1).[24] Arzáns contends that de la Torre composed the songs performed for the occasion before the archbishop-viceroy and wrote an account of the festivities, at the behest of town officials.[25] Both the painting and *Aclamacion festiva* were produced the same year as Morcillo's entry, and Arzáns was aware of at least the latter.[26] Although he could have drawn on either source in his version of events, he surely also witnessed the festival himself; Lewis and Hanke cite internal evidence that he wrote the chapters dedicated to the year 1716 "prácticamente en simultaneidad con los acontecimientos" (xciv) [practically simultaneously with the events].

The archbishop-viceroy's entry occupies a full chapter of part 1, book 10, which opens with an autobiographical, self-reflexive discus-

FIG. 1.1. *Melchor Pérez Holguín,* Entrada del Arzobispo Virrey Morcillo en Potosí *(ca. 1716). Courtesy, Museo de América, Madrid.*

sion of his own project.[27] Book 9 concludes with events from 1684, and Arzáns (presumably born in 1676) states that from that year forward he would draw from eyewitness experience, assuming the dangers of those who "gastan su tiempo en escribir cosas que todos las han visto pasar" (2:321) [spend their time writing only things which they have seen happen].[28] As mentioned earlier, the title of chapter 1 in book 10 underscores "the supreme veneration that this Imperial Town of Potosí has for divine worship and the grandeur" of its festivals (2:321). Arzáns claims that as a result of Potosí's financial decline, the festivals of Potosí had become overwhelmingly religious rather than secular: "Con la falta de aquella antigua riqueza no hay festejos humanos pero hay festividades suntuosas para el culto divino y veneración de los santos, porque evitadas aquellas superfluas y vanas fiestas todos emplean ahora mucha parte de sus caudales en divinos y verdaderos festejos" (2:322) [With the lack of that ancient wealth there are no human festivities, but there are sumptuous festivals for divine worship and the veneration of saints, because now that those superfluous and vain festivals are avoided, everyone spends a large part of their resources on divine and true festivals]. Arzáns echoes here his equation of secular festivals with follies at the end of the Pedro de Contreras anecdote. Yet although annual religious holidays like Holy Week receive more attention in his narrative beginning with this chapter, Arzáns continues to relate civic, noncalendrical festivals such as the solemn entry of Archbishop-Viceroy Morcillo.

In a description that corresponds quite closely to both Holguín's painting and Juan de la Torre's account, Arzáns recounts how Potosí received the archbishop-viceroy with eight days of magnificent festivities, including a procession under two triumphal arches and an elaborate masquerade that Morcillo deemed to be better than anything he had seen in Madrid: "Alegre y admirado su excelencia ilustrísima dijo haber visto en la corte de Madrid varias máscaras de caballeros, pero que ninguna de semejante riqueza, curiosidad y propiedad de papeles, y el mismo modo la engrandecieron y alabaron todos los de la Europa, y a la verdad fue cosa admirable que tan en breve se dispusiese en tiempo tan calamitoso" (3:50) [Much pleased and impressed, His Excellency remarked that he had seen a number of masques performed by gentlemen of the court at Madrid but that none had equaled this one in sumptuousness, ingenuity, and appropriateness of roles; and all the other Europeans were equally complimentary (194)].[29] We are very far indeed from the European reaction to the festivities for the entry of the *corregidor* more than a century earlier, in 1607, when the creoles' inexperience was condemned by the other nations of Spain (1:266).

Holguín's large and remarkably detailed painting depicts three moments of the celebrations. On the far right of the canvas we see the first triumphal arch, erected before the Church of San Martín at the eastern entrance of the town, on a road leading straight to the main plaza. Adorned with gold-framed mirrors, ribbons, and emblems, the arch is topped by a large statue of Fame; also visible is a folded cloud hanging from its first tier, which both Arzáns and de la Torre describe as opening up just as the archbishop passed underneath, dropping a tiara over his head while beaten silver and gold showered down from above (Arzáns, *Historia* 3:47; Arzáns, *Tales* 186; de la Torre 9r). In the procession, the archbishop is led under a canopy before balconies adorned with paintings, tapestries, and admiring observers, and accompanied by richly attired officials, musicians, and infantry. In the foreground is a self-portrait of the painter alongside two elderly onlookers who marvel at the spectacle; the speech scroll emanating from the woman's mouth states that "en cientoitantos años no e bisto grandeza tamaña" [in one hundred and some years I have not seen such grandeur]. In the upper left inset, Holguín portrays the procession's entry into the church in the main plaza after passing under the second triumphal arch. In the right inset, we see the same plaza at night during the masquerade, featuring another procession of costumed figures and a float with a miniature Cerro de Po-

tosí and several performers—including one representing the archbishop-viceroy himself—as the real Morcillo gazes down from a balcony above.

The grandeur depicted in the painting as well as the texts seems to belie the loss of wealth that Arzáns claims in book 10, chapter 1, to limit Potosí's festive extravagance. And despite the new viceroy's status as archbishop, this is very much a "human festival" rather than a "divine and true," that is, sacred one (2:322). In this regard, Arzáns invokes a common theme in this part of the *Historia*, that the staging of magnificent festivities in spite of present financial difficulties makes Potosí worthy of even greater admiration: "a la verdad fue cosa admirable que tan en breve se dispusiese en tiempo tan calamitoso. . . . Todo fue como siempre lo es, propio influjo de los astros predominantes en esta Villa que no siente su descaecimiento tanto como el no poder ejectuar mayor grandeza en todo" (3:50) ["Indeed, it was a most remarkable thing that it had all been accomplished so quickly and in a time of economic distress. . . . But Potosí accomplished it all as she has ever done, under the influence of the predominant stars of this city, regretting her decline less than the fact that she can no longer display greater magnificence in all things" (194)].[30]

Potosí's material decline may be inextricably linked to moral decadence in Arzáns's Baroque worldview, but in chapter 1 of book 10 he impugns the virtue of royal administrators—and even of the archbishop himself—more than the town's residents. Arzáns alludes to the economic crisis when he praises the *cabildo* for taking responsibility, together with "algunos gremios más descansados" [some of the wealthier guilds], for the festival's expense instead of raising the money through collections: "aunque por ministros particulares se comenzó a echar una derrama en toda la Villa para los gastos y ya se empezaba a recoger, el ilustre cabildo como benigno padre y prudente cabeza de la república lo impidió considerando la fatiga en que se hallaban los oficiales y demás pobres" (3:47) ["Although private persons had begun to make collections everywhere in the city for the expenses of the visit and money was already being gathered in, the illustrious cabildo, like a wise father and prudent head of the republic, gave orders that such collections must cease, taking into consideration the hardship to artisans and other poor folk" (185)]. Arzáns had already dedicated a full paragraph to the *cabildo*'s merit, declaring that "sus buenos senadores son los ministros primeros de una república . . . son ellos hombres de crédito . . . hónrelos mucho el rey nuestro señor porque ellos son los atlantes de república que tiene por suya" [3:45] [its

good senators are the prime ministers of a republic . . . they are men of credit . . . may the king our lord honor them, for they are the Atlases of their own republic].[31] He concludes by insisting that Potosí's *cabildo* sustains not only the king but because of Potosí's silver mountain, the whole world: "El rey es el que lo hace todo, pero ellos tienen en los hombros al rey, a que también podemos añadir que un monte de plata como el de Potosí, si no tiene en sus hombros al cielo tiene en ellos a toda la tierra, y así merece esta ilustre Villa y su cabildo toda estimación" (3:45) [The king is the one who does everything, but they have the king on their shoulders, to which we could add that a mountain of silver like this one of Potosí has the whole world if not the heavens on its shoulders, and so this illustrious Town and its council deserve the greatest esteem].

In contrast, blame for Potosí's material woes is squarely attributed elsewhere: "aunque los españoles han cargado con infinidad de aquella riqueza y la han dado a los franceses, con todo eso no faltó para continuación de la grandeza de esta Villa" (3:48) ["although the Spaniards have made away with an enormous amount of wealth and have given it to the French, yet enough is left to maintain the grandeur of this city" (189)]. The critique of Spanish appropriation of Potosí's wealth—with a jab at French influence in Spain under the Bourbon dynasty—is complemented by a more explicit condemnation of court-appointed administrators in contrast to locally elected ones. The exclusion of creoles from the former offices under the Bourbon reforms, an issue frequently protested by Arzáns's compatriots, surely subtends his moralizing stance against higher authorities and in favor of the *cabildo*.[32] If Arzáns opens the chapter by attributing Potosí's financial decline to the sins of its inhabitants—"las repetidas calamidades de esta Imperial Villa de Potosí los acarrean los pecados" (3:42) [sins have led to the repeated calamities of this Imperial Town of Potosí][33]—he quickly adds that "lo que más agrava tanto mal es que los mayores pecados se hallan en las mayores cabezas" (3:42) [what makes such adversity even worse is that the greatest sins are found in the highest leaders]. More specifically, he complains of the greed and poor administration of the royally appointed *corregidores*: Potosí "no se experimenta otra cosa sino la peoría en la sucesión de los unos a los otros . . . porque sólo se hallan enfrascados en la codicia de riquezas, de suerte que si no administraran los alcaldes ordinarios de la manera que se puede acabara de perecer de una vez esta Villa" (3:42) [experiences nothing but deterioration from one to the next . . . because they are only caught up with the desire for riches, such that if the *alcaldes*

ordinarios did not administer things as best they could this town would perish once and for all].

Indeed, it was the *alcaldes ordinarios* (municipal judges) Francisco Gambarte and Pedro Navarro who bore the enormous expense of the archbishop's entry, which Arzáns underscores was usually the responsibility of the *corregidor*. In this case, he complains, the *corregidor* Francisco Tirado shrewdly fled to La Plata when he learned of the archbishop's appointment instead of staying to receive him, "[no ignorando] que de irse allá podría mucho más medrar, que estándose acá no podía sino experimentar algún menoscabo su riqueza" (3:46) ["not unmindful of the fact that by going to La Plata he could improve his position considerably, whereas if he remained in Potosí he would only have experienced a diminution of his wealth" (184)].[34] Arzáns's critique of the *corregidor's* behavior, reinforced by the subsequent soliloquy on the evils of ambition and greed ("Oh ambición, y qué mala guía eres porque de errores llenas al que te sigue" [3:46] ["Oh ambition, how bad a guide you are, for you overwhelm with errors any man who follows you!" [184]), represents a stark contrast to his praise of the generosity and nobility of the *cabildo* throughout the chapter.

The sin of greed is eventually also attributed to the Archbishop Morcillo, who by the end of book 10, chapter 1 becomes an object of criticism rather than one of celebration. In addition to the lavish sum spent on the festivities and gifts—at least 150,000 pesos (3:51), nearly twice the already exaggerated sum expended on the funeral ceremonies for Philip III—the archbishop also leaves with 100,000 pesos from the royal treasury. The sum had been earmarked to pay back part of the mining guild's debt incurred through restoring the mercury mines of Huancavelica that had been "perdidas por el descuido de los que gobernaban" (3:52) [lost through the neglect of those who governed].[35] Although the mine owners warned the archbishop that mercury supplies would cease if the debt was not paid, thus contributing to the crisis in silver production, he took it anyway, claiming that he would resolve the problem later, but he never does: "respondió que por allí pasaba y todo lo compondría, mas no pasó y sucedió lo que luego diremos, conque por varias maneras fue su venida de gravísimo daño a esta Villa" (3:52) [he responded that he would go there and fix everything, but he did not go and we will later tell what happened, such that in various ways his coming was the cause of grave damage to this Town]. What happened was that the archbishop found out that the new viceroy—Carmíneo Nicolás Caracciolo, the prince of

Santo Buono—was on his way to Lima and would arrive shortly thereafter; only here do we learn that Morcillo's was an interim appointment. Morcillo thus decided to return to La Plata, and Arzáns's critique of this turn of events is unrestrained:

> Gran comedia se representó aquí de las del mundo, pues pocos días antes estuvo Potosí en grandes fiestas habiendo gastado en todo (como ya dije) 150,000 pesos que fuera mejor gastarlo en otras buenas obras. Túvose por desgracia de esta Villa, pues cuando con tanta liberalidad regaló e hizo presentes a su excelencia ilustrísima [fue] con confianza de su remedio . . . y todo salió al contrario. (3:52)

> [A great comedy of those of this world was represented here, for a few days before Potosí was celebrating great festivities, having spent in all (as I have already said) 150,000 pesos, which would have been better spent on good works. This Town took it for a misfortune, for when they gave presents with such generosity to his Excellency, it was with the confidence in their remedy . . . and everything came out the reverse.]

Although elsewhere Arzáns attributes his compatriots' misfortune and lack of reward to their distance from the Crown (2:333–334), here the generosity of the residents of Potosí goes unrewarded even in the presence of the viceroy. The interested nature of their munificence seems to matter less to Arzáns than the failure of the king's representative, the viceroy, to reciprocate according to the rules of gift-giving.[36]

Fray Juan de la Torre's official account of the entry also refers to this situation, alluding to the divided opinions about what the archbishop should do and whether their hopes for resolving their financial difficulties would be disappointed (30r). De la Torre, however, emphasizes how "resignaron todos como leales à su mandato y determinación de la Real Magestad" [they all resigned themselves to the order and decision of his Royal Majesty], demonstrating their "lealtad, y amor reverencial à su Rey y natural Señor" (31r) [loyalty and reverential love for their King and natural Lord]. When de la Torre relates how the archbishop learned of another delay in the new viceroy's arrival and went to Lima to assume the post after all, he concludes in the obsequious tone that dominates the account: "O! aumente la piedad Divina la prosperidad à su viaje" (32r) [O! May Divine Piety augment the prosperity of his journey]. In striking contrast, Arzáns returns to the theme of the world as theater,

concluding with a moralizing discourse on the illusory nature of authority and a not so subtle critique of the powerful who lack virtue, which he has just demonstrated in the case of Archbishop Morcillo:

> Al fin el "Ya voy, ya no voy" con la variación de otros sucesos acreditó (como ya he dicho en otra parte) la farsa de este mundo. Los representantes están haciendo en el teatro los papeles de los reyes y príncipes de la tierra. ¿En qué se diferencian estos señores de los comediantes? En la generosísima singularidad de las virtudes: en faltándoles éstas, tan comediantes se quedan como los otros. (3:53)

> [In the end the "Now I'm going, now I'm not going," with the variation of other events, corroborated (as I have said elsewhere) the farce of this world. The actors in the theater are performing the roles of kings and princes of the land. In what are these lords different from the actors? In the generous singularity of their virtues: in lacking these, they are just as much actors as the others.]

These virtues are evident not in the "representantes" of civic and ecclesiastical authority but in the residents of Potosí. Earlier in the chapter, Arzáns offers an example of the "buenas obras" (3:52) [good works] in which he thinks the 150,000 pesos would have been better employed than in the festival. Arzáns describes there how, before the entry, an Augustinian missionary came to town with five newly converted Chiriguano Indians, requesting alms for the construction of a church in order to better propagate the faith among the remote tribe (3:43–44). While the "caritativa Villa" [charitable Town] liberally gave everything necessary for "tan buena obra" [such a good work] (3:52), the missionary's request was surprisingly rebuffed by the archbishop: "quién dijera que petición tan santa había de merecer desabridas respuestas, y nuevas instancias un 'No se puede'?" (3:51) [who could say that such a saintly petition would warrant rude responses, and new requests the reply, "It cannot be done"?]. Arzáns condemns the response in no uncertain terms, invoking his earlier diatribe against "ambición" [ambition or greed] in relation to the *corregidor* Francisco Tirado: "no se puede dudar que siendo esta tan fea mancha entre los seglares, es infamia vilísima que deslustra y obscurece el honor de los eclesiásticos, y mucho más de las altas dignidades" (3:52) [one cannot doubt that since this is such an ugly stain among laypeople, it is a vile infamy that tarnishes and obscures ecclesiastical honor, even more so that of high dignitaries]. Perhaps be-

cause of the force of this critique, Arzáns is careful to establish the credibility of his sources: "ahora digo no lo que el vulgo desenfrenado sabe de ordinario referir de las personas ilustres, sino lo que vieron personas buenas y de crédito y como infalible verdad la manifestaron" (3:51) [now I am saying not what the unbridled common people are wont to say about illustrious personages, but what good people of credit saw and manifested as infallible truth]. This critique, therefore, is unlike the one perpetuated by the Basques and other nations of Spain about the creoles in 1608 that Arzáns earlier condemns as "gossip born of envy or ill will" (1:267).

The archbishop-viceroy's blatant disregard for the spiritual well-being of his indigenous subjects, as well as the material welfare of his creole ones, clearly makes him an unfit object of adulation and his appointment as viceroy a cause for consternation rather than celebration. What Arzáns's narrative displays and celebrates is not the power, authority, and virtues of this representative of the Catholic Church and the Spanish Crown, but the nobility and generosity of the residents of Potosí, who are capable of putting on such a spectacular festival even in times of economic woe. The festival is contextualized in such a way that the *potosinos* are the only possible targets of readers' admiration, in contrast to the morally suspect representatives of the Church and Crown.

Like those held in other areas of the Iberian empires, the 1608, 1622, and 1716 festivals in Potosí were ostensibly aimed at showing veneration and provoking admiration for figures of authority, whether religious or secular. According to Arzáns, however, these festivals managed to redirect the admiration not only at the mineral wealth displayed in the celebrations but also at the generosity and religious devotion of a city often associated—even in Arzáns's own history—with sin and greed. It is here, in Potosí's festivals, that we can see the convergence rather than the contradiction between Arzáns's dual propensity to moralize and to amaze. Arzáns presents the spectacular festivals of Potosí's grandiose past not as profligate, profane wastefulness but as an act of service to God and Crown that reflects more favorably on the king's subjects than on the object of celebration, whether religious (Corpus Christi) or secular (the viceroy). By the time he wrote in the early eighteenth century, Potosí was far past the peak of its silver production. What Potosí's local elite—and Arzáns himself—by then had to offer was not silver ingots but the ingenious display of the remaining vestiges of mineral wealth. If the creoles' festive finery had vanished, as Arzáns laments—"¿Qué se ha hecho el valor de tus criollos, su gallardía, caballos, jaeces y galas tan

costosas con que se hallaban en las fiestas?" (2:322) [What has happened
to the valor of your creoles, their gallantry, horses, trappings, and such
costly finery with which they could be found in festivals?]—he has re-
covered and redefined creole *valor* [valor/value] in the pages of his spec-
tacular account.

Celebrating Minas Gerais in Triunfo Eucharistico *and* Aureo Throno Episcopal

Some three decades after Archbishop Morcillo's entry into Potosí, the new bishop of Rio de Janeiro, Antonio do Desterro Malheyro, entered that city on January 1, 1747. Although not yet capital of the state of Brazil (it would become so in 1763), Rio de Janeiro had gained greater economic and political prominence during the first half of the eighteenth century as a result of the gold rush in Minas Gerais. Throughout this period Minas Gerais had been subject to Rio de Janeiro's episcopal jurisdiction, but Bishop Malheyro's appointment coincided with the creation of another diocese, seated in the newly designated city of Mariana (formerly Vila do Ribeirão do Carmo). The account of Malheyro's ceremonial entry—*Relaçaõ da Entrada que Fez o Excellentissimo, e Reverendissimo Senhor D. F. Antonio do Desterro Malheyro, Bispo do Rio de Janeiro*, written by Luiz Antonio Rosado da Cunha—was published that same year in Rio by Antonio Isidoro da Fonseca, a Portuguese-born publisher who had recently relocated to Brazil and opened his "segunda officina" [second workshop] there. Like Fray Juan de la Torre's *Aclamacion festiva de la muy noble Imperial Villa de Potosí*, this was an official account of a ceremonial entry, full of lofty praise for the newly appointed figure of authority; but unlike de la Torre's work, the *Relaçaõ da entrada* was an illegal imprint. Until the establishment of the Portuguese court in Rio de Janeiro in 1808, printing was prohibited in Brazil—part of the mercantilist restriction on not only "colonial economic initiative," as Laurence Hallewell argues in *Books in Brazil*, but also intellectual initiative.[1] Fonseca's publishing house was quickly shut down by order of João V, the printer, with all of his materials, was obliged to return to Lisbon the same year.[2] The *Re-*

laçaõ da entrada is famous today as the first book, and one of very few, printed in Brazil in the eighteenth century.

The solemn reception of Friar Manuel da Cruz, the new bishop in Mariana, Minas Gerais, was also recorded in print, in this case in an anonymous account published in Lisbon in 1749: *Aureo Throno Episcopal, collocado nas Minas do Ouro, ou Noticia breve da Creação do novo Bispado Marianense, da sua felicissima posse, e pomposa entrada do seu meritissimo, primeiro Bispo, e da jornada, que fez do Maranhão, o excellentissimo, e reverendissimo Senhor D. Fr. Manoel da Cruz*. The more grandiose title of *Aureo Throno Episcopal* is matched by its content; whereas Malheyro's voyage to and solemn entrance into Rio de Janeiro is related in a succinct 20 pages, the account of Manuel da Cruz's journey to and entry into Mariana extends over 116, followed by 127 pages of the "Oração académica e congratuloria" proffered on the occasion by the Reverend José de Andrade e Moraes. The texts' shared subject matter—an episcopal entry—is belied by another difference. While Fonseca had only obtained authorization from Bishop Malheyro himself for the publication of the *Relaçaõ da Entrada*—as the title page avers, it was printed "com licenças do Senhor Bispo" [with licenses of the Lord Bishop]—*Aureo Throno Episcopal* was printed in Lisbon "com todas as licenças necessarias" [with all of the necessary licenses], the religious ("do Santo Officio" and "Ordinário") as well as the royal ("do Paço") permissions required for publication.[3]

Neither Bishop Malheyro's approval, printed more discreetly at the end rather than the beginning of the account, nor the ephemeral format, "por ser obra volante" [Cunha 29] [because it is a pamphlet], were enough to grant Antonio Isidoro da Fonseca special dispensation to print in Brazil. In line with João V's regalist, centralizing policies, books written in Brazil had to acquire authorization to be published in Lisbon, and because the final copy had to be checked against the approved manuscript, sending versions back and forth for final confirmation was deemed too risky, onerous, and costly (Morães 140). Even one transatlantic journey for a text to be published in Lisbon could be hazardous.[4] In a note to the reader in the *Relaçaõ Panegyrica das Honras Funeraes* (1753), an account of the funeral ceremonies for João V in Salvador da Bahia, author João Borges de Barros excuses both the tardiness and the brevity of the imprint because of the loss of the original manuscript in a shipwreck, as well as the "pouca demora da presente nao, em que segunda vez se transporta" (vii) [short stay of the present ship, which for a second time carries it]. By printing the *Relaçaõ da Entrada* in Rio de Janeiro, Fonseca did not run this risk, but he played an even more dangerous game by flouting a royal

prohibition, even though he had the consent of the bishop. Fonseca's decision points up the acute tensions between royal and religious authority in the Americas, particularly in mineral-rich regions.[5] In Minas Gerais, for example, the Crown prohibited the establishment of religious orders in the region for fear of the power and wealth they might accrue; and as we will see, oversight of the lay religious brotherhoods that were allowed to form were the source of power struggles between ecclesiastical and Crown-appointed authorities.[6]

Unlike the *Relaçaõ da Entrada*, both *Aureo Throno Episcopal* and *Relaçaõ Panegyrica* went through the necessary channels of approval for publication in Lisbon, and their inquisitorial licenses were even approved by several of the same individuals. Both texts, however, raise the issue of geographic distance from the metropole that the author and publisher of *Relaçaõ da Entrada* tried to circumvent through its publication in Rio. And those distances are multiplied in the case of *Aureo Throno Episcopal*, which relates public ceremonies in a remote region of interior Brazil rather than the port and capital city of Salvador da Bahia. If the hazards of travel over great distances delayed the publication of *Relaçaõ Panegyrica*, they hindered the bishop's arrival in Mariana for almost three years.[7] Papal bulls confirming the appointments of Antonio do Desterro Malheyro to Rio de Janeiro and Manuel da Cruz to Mariana were issued in December 1745, and Malheyro traveled from his appointment in Luanda, Angola, seemingly as soon as he received the news (albeit a year later), in a voyage that goes practically unremarked by João Borges de Barros in *Relaçaõ Panegyrica* (12). In contrast, Manuel da Cruz was forced to postpone his departure from Maranhão in northern Brazil, where he was then bishop, until August 1747. He arrived in Minas Gerais six months later, after what the author of *Aureo Throno Episcopal* calls a "derrota tão laboriosa, e arriscada" (353) [route so laborious and risky] through the interior of Brazil. For this bishop, the transcontinental trip was harder than a transatlantic one. Indeed, in Portugal's vast transoceanic empire, overland travel was sometimes dependent on overseas transport; the main reason for the delay in Manuel da Cruz's departure was that he could not leave until the *frota* (fleet) arrived in Maranhão with the supplies necessary "para a digressão de caminho tão largo" (352) [for the foray of such a long road].

Stuart Schwartz has suggested that despite the frequency of public festivals in colonial Brazil, the scarcity of "commemorative reports of public ceremonies that became a genre of some importance in Early Modern Europe and in Spanish America" is due to the lack of a printing

press in the colony ("King's Processions" 186–187). It is true, as Schwartz notes, that the accounts that survive date mainly from the eighteenth century (187), but they number more than the "few" he acknowledges. Besides the *Relaçaõ da Entrada* and *Relaçaõ Panegyrica*, dozens more are included in the six volumes of "festejos públicos comemorativos" [commemorative public festivals] edited by José Aderaldo Castello in *Movimento academicista no Brasil, 1641–1820/22* (vol. 3, parts 1–6). Some occasions, like the funeral exequies for João V in the town of Minas Gerais that bears his name, Vila de São João del-Rei, even merited two publications, Mathias Antonio Salgado's *Oraçaõ Funebre* and Salgado and Manoel Joseph Correa e Alvarenga's *Monumento do Agradecimento*, both published by Francisco da Silva in 1751. Among this not insignificant corpus of festival publications, two accounts from Minas Gerais stand out for their length and the scholarly attention they have received: *Aureo Throno Episcopal* (1749) and its predecessor in Minas Gerais, Simão Ferreira Machado's *Triunfo Eucharistico*, published in Lisbon in 1734.[8]

In part, these texts earned their renown when they were republished together in two volumes in facsimile form by Affonso Ávila in 1967 in *Resíduos seiscentistas em Minas: Textos do Século do Ouro e as projeções do mundo barroco*; they are thus more widely available than the seventeenth- and eighteenth-century editions that exist only in specialized libraries. Ávila emphasizes their documentary value as reflections of a belated Baroque mentality and lifestyle, describing *Triunfo Eucharistico* as "quase roteiro cinematográfico de um acontecimento singular da vida social e religiosa da incipiente sociedade mineradora, eflúvio barroco da alma ibérica seiscentista empolgada pela aventura do ouro" (23) [nearly a film script of a singular event in the religious and social life of the incipient mining society, Baroque outpouring of the seventeenth-century Iberian soul, stimulated by the adventure of gold]. Like the festivals in Arzáns's *Historia de la Villa Imperial*, those described in *Triunfo Eucharistico* and *Aureo Throno Episcopal* represent, for Ávila, what Lewis Hanke and Gunnar Mendoza call, with respect to Potosí, the "symbolic institution through which one can best appreciate the *ethos*" of a mining town (lxxix).

Yet these accounts have more than the documentary value highlighted by Ávila. If Arzáns's temporal distance inflects the representation of many of the festivals in the *Historia de la Villa Imperial*, geographic distance—between the festival and the account's place of publication—shapes the festive discourse of *Triunfo Eucharistico* and *Aureo Throno Episcopal*. Although all festival accounts reflect the concerns of the or-

ganizers and the authors, Fernando R. de la Flor underscores the particularly complex variety of interests that arise from the "multipolar" situation of print publication in supranational monarchies like Spain and Portugal (173), involving a transatlantic space of production and reception. While festival accounts like those of Mimoso and Arzáns represent the global products and peoples that appear—at least in disguise—in Lisbon's and Potosí's festivals, the texts at hand illuminate the transatlantic circulation of festivals in Minas Gerais. The multipolar context of production and reception affords another avenue to appreciate the multiplicity of messages and meanings transmitted in and by festivals, for it is in response to their position within an imperial geography that the textual accounts displace the festivals' object of celebration. Similar to Arzáns but more directly and overtly addressed to a metropolitan audience, *Triunfo Eucharistico* and *Aureo Throno Episcopal* transform the celebration of the central symbols and representatives of the Catholic Church into the exaltation of a peripheral American town and its residents.

TRIUNFO EUCHARISTICO: RELIGION AND CULTURE IN THE BACKLANDS

As its full title indicates, *Triunfo Eucharistico . . . na Solemne Trasladaçaõ do Divinissimo Sacramento* describes the festivities surrounding the solemn transfer of the Holy Sacrament to the newly built Church of Our Lady of the Pillar in Vila Rica do Ouro Preto on May 24, 1733. Although this date probably fell a few days or weeks before the feast of Corpus Christi, the transfer was modeled on the "Eucharistic Triumph" of a Corpus Christi procession.[9] *Triunfo Eucharistico* relates how, as in that procession, the Holy Sacrament was carried in a monstrance beneath a canopy through festooned streets and under triumphal arches, accompanied by musicians, dancers, allegorical floats, and costumed figures as well as members of the religious brotherhoods, clergy, government officials, infantry, and noblemen. The celebration of Corpus Christi had been restored by King João V (1707–1750) to its traditional grandeur in the Portuguese realm, as Ignacio Barbosa Machado explains in a history of the feast day and account of the procession in Lisbon on June 8, 1719.[10]

In his *Historia Critico-Chronologica da Instituiçam da Festa, Procissam, e Officio do Corpo Santissimo de Christo*, Machado explains that Joaõ V "resolveu neste fausto anno de 1719 dar remedio aos antigos descuidos, e fazer hum Triunfo ao Sacramento, qual naõ viraõ os passados seculos,

e naõ saberá explicar toda a eloquencia dos presentes" (140) [resolved in this fortunate year of 1719 to remedy the ancient carelessness, and hold a Triumph for the Sacrament unlike anything seen in past centuries, and beyond reach of the eloquence of the present ones]. By the time the *Historia Critico-Chronologica* was published in 1759—in order to once again promote the restoration of the festival's grandeur after the destruction wreaked by the Lisbon earthquake of 1755—the account of the "Eucharistic Triumph" in Vila Rica had already challenged that primacy, its author claiming that "mayor exaltação da Fé, e veneração dos Catholicos . . . nem a antiguidade vio primeira, nem a posteridade verá segunda para gloria desta nobilissima Villa" (281) [greater exaltation of the Faith and veneration of Catholics . . . was not seen before in antiquity nor will be seen again in posterity, for the glory of this very noble Town]. The pomp, grandeur, and wealth on display seem to confirm the title's reference to Vila Rica as "Corte da Capitania das Minas" [Court of the Captaincy of the Mines], even if it could not equal the "magnificencia, ornato, e sumptuosos edificios . . . nesta Corte de Lisboa" [magnificence, ornateness, and sumptuous buildings . . . in this Court of Lisbon], as extolled on the title page of the *Historia Critico-Chronologica*.

Vila Rica do Ouro Preto was in fact only a few decades old, having been founded as a township by Governor Antônio de Albuquerque in July 1711. Prior to this it was one of the many mining camps that had sprung up with the discovery of gold at the end of the seventeenth and beginning of the eighteenth century, in the rugged inland to the north of São Paulo and northwest of Rio de Janeiro. Albuquerque, previously governor of Rio de Janeiro, was appointed in 1709 to the newly formed Capitania de São Paulo e Minas de Ouro [Captaincy of São Paulo and Gold Mines]; this appointment as well as the establishment of Vila Rica and two other towns and their municipal councils were part of the Crown's effort to assert control over the remote and unruly backlands. Indeed, Albuquerque was charged with bringing a peaceful end to the Guerra dos Emboabas, a civil war that erupted in 1708 between the *paulistas* (white or mixed-blood inhabitants of São Paulo) who claimed proprietary rights over the gold mines based on their status as "discoverers" and first settlers and the *emboabas*, a derogatory term applied by the *paulistas* to the "foreigners" who were flooding into the region as news of the mineral wealth spread, whether they came from other parts of Brazil, Portugal, or beyond. Charles Boxer has noted how this conflict recalls the War of the Vicuñas and Basques in Potosí some seventy-five years earlier, with a group from a single place of origin (São Paulo or

Basque country) opposed to "the rest" (*emboabas*, Vicuñas) (63).[11] Although a consciousness of the rights of native sons, *criollos* or *paulistas*, can be found in both regions, neither conflict followed a strictly American versus European opposition that might be viewed as a precursor to independence. Instead, the conflicts emerged from the competition for control over the regions' mineral wealth among Iberians and Iberoamericans of different origins, all of them dependent on the forced labor of other groups, principally Amerindians in Potosí and Africans in Minas Gerais, who also contributed to the ethnic diversity.

In an economic treatise published in 1711 in the wake of the Guerra dos Emboabas, the Jesuit who published under the pseudonym André João Antonil points out the obvious reason behind the large and rapid influx of so-called foreigners that triggered the conflict: "[a] sede insaciavel do Ouro" (136) [the unquenchable thirst for Gold] (152)]. Antonil cites an estimate of thirty thousand inhabitants in the region as a result of the gold rush, a number that would continue to grow over the following decades; *Triunfo Eucharistico* claims hyberbolically that "meyo Portugal" [half of Portugal] had migrated to Minas Gerais, which was "já celebre por todo o Mundo" (174) [already famous throughout the whole World]. One measure of this fame is Francisco Tavares de Britos's reference, in a work contemporary to *Triunfo Eucharistico*, to the Tapanhuacanga Mountain that flanked Vila Rica as a "Potosí de Ouro" (19) [golden Potosí].

Triunfo Eucharistico's author, Simão Ferreira Machado, was one of those Portuguese who migrated to Minas Gerais in response to the "eccos, levados nas azas da fama sobre os mares" (173) [echoes, carried on the wings of fame over the seas]; the title page identifies him as "natural de Lisboa, e morador nas Minas" [native of Lisbon, and resident of the Mines], which is the only biographical information we have of him. It is the population boom in Minas Gerais, to which Machado contributed, that inspired the festivities related in *Triunfo Eucharistico*. Machado explains in the "Previa Allocutoria" [preliminary address] that Vila Rica's most opulent neighborhood had outgrown its mother church (Igreja Matriz), Our Lady of the Pillar, requiring that a new structure be built, "cuja sumptuosidade desempenhasse a sua devoçaõ, e fosse competente a toda a multidaõ do mayor concurso" (185) [whose sumptuousness would show their devotion and would be adequate to the whole multitude of the larger congregation]. During the construction, the Divine Sacrament was housed in the church of the Black Brotherhood of the Rosary, located in the same parish (185). We will return to the extraordinary par-

ticipation of this Brotherhood not only in housing the Eucharist but in the festivities and their account's publication.

In a biographical note on Simão Ferreira Machado, Affonso Ávila identifies *Triunfo Eucharistico* and Antonil's *Cultura e opulencia do Brasil* as two of the first printed works to describe the mineral wealth of Minas Gerais (1:297). Yet the opulence in Antonil's title is a more ambiguous cause for celebration than it is in *Triunfo Eucharistico*. Although the Jesuit author concludes (after summarizing in four parts the different sources of Brazilian wealth: sugar, tobacco, gold, and cattle) that Brazil is undoubtedly "a melhor, & a mais util Conquista" (193) [the best and most productive colony] of the Portuguese Empire, his condemnation of the sinfulness motivated by gold lust resembles Arzáns's moralizing about the decadence of Potosí. In a chapter entitled "Dos danos, que tem causado ao Brasil a cobiça depois do descobrimento do Ouro nas Minas" [The damages done to Brazil by greed following the discovery of gold in the mines], Antonil inveighs against the consequences of greed and the sirenlike lure of the mines' fame:

> Que maravilha pois, que sendo o Ouro tam fermoso, & tam precioso metal, tam util para cōmercio humano, & taō digno de se empregar nos vasos, & ornamentos dos Templos para o culto divino; seja pela insaciavel cobiça dos Homens, continuo instrumento, & causa de muitos danos? Convidou a Fama das Minas tam abundantes do Brasil homens de toda a casta, & de todas as partes: huns de cabedal, & outros vadios. (179)

> [How strange, then, that although Gold is so beautiful and so precious a metal—so useful for human commerce and so worthy of use on cups and ornaments in churches for divine services—it is constantly the instrument and cause of great harm because of the insatiable greed of Men? The Fame of the abundant mines of Brazil beckoned men of all castes and from all parts: some with means, and others vagrants.][12]

Antonil proceeds to list the undesirable qualities of the migrants: pride, arrogance, lasciviousness, vengefulness, prodigality, and a fondness for gambling among those with means and treasonousness and violence among those without. Their crimes go unpunished because of the lack of judicial institutions, and ecclesiastical authorities are unable to rein in the clergymen who "escandalosamente por lá andaō ou Apostatas, ou fugitivos" (180) [scandalously wander those parts as apostates or fugitives].

Acknowledging the recent appointment of Governor Albuquerque, Antonil writes, "só agora poderá esperarse algum remedio indo là Governador, & Ministros" (180) [only now can we hope for some remedy, with a governor and officials going there].[13]

Antonil's troubling portrait of an iniquitous and unruly mining region echoes Arzáns's condemnation of the vice and lawlessness caused by the "infernal codicia y ambición de la plata" (1:322) [infernal greed and avarice for silver] in Potosí; the public and private crimes that Arzáns indulgently describes in the *Historia de la Villa Imperial* constitute what Stephanie Merrim calls a "scandal-sheet criterion" ("Spectacular Cityscapes" 50). Introducing the War of the Vicuñas and Basques, Arzáns cites another Jesuit author, Alonso de Ovalle, who corroborates the association between the presence of gold and the violent resistance of the natives in Chile with a reference to Potosí: "los que viven en la Villa de Potosí y se crían junto a aquel prodigioso Cerro de la plata tienen unos ánimos tan intrépidos y levantados, como se ha experimentado en las inquietudes y revoluciones que allí ha habido" (in Arzáns 1:323) [those who live in the town of Potosí and grow up next to that prodigious silver mountain have such intrepid and rebellious spirits, as can be seen in the unrest and revolutions that have happened there]. Arzáns concludes that "la abundante riqueza que gozaba esta Imperial Villa era en gran parte motivo de tanta inquietud" (1:323) [the abundant wealth that this imperial town enjoyed was in great part the reason for so much unrest]. Surely Antonil would say the same of Vila Rica, especially if he had lived to witness the revolt led by Felipe dos Santos in 1720 in response to the governor's efforts to establish smelting houses in order to increase the amount of gold duties—the *quinto*, or royal fifth—collected for the Crown.

Certainly Antonil would also concur with the sentiment expressed in a report about the uprising, *Discurso histórico e político sobre a sublevação que nas Minas houve no ano de 1720*, which articulates the same association between mineral wealth and insubordination: "os motins são naturais das Minas, que é propriedade e virtude do ouro tornar inquietos e buliçosos os ânimos dos que habitam as terras onde ele se cria" (60) [revolts are natural in the Mines, for it is a property and virtue of gold to make the souls of those who inhabit the lands where it is found agitated and restless]. For the author—generally assumed to be the governor at the time, Pedro de Almeida, the count of Assumar—the roots of revolt extend beyond the presence of gold to the nature and climate of the region as well:

[Minas Gerais] é habitada por gente intratável, sem domicílio, e ainda que está em contínuo movimento, é menos inconstante que os seus costumes: os dias nunca amanhecem serenos: o ar é um nublado perpétuo; tudo é frio naquele país, menos o vício, que está ardendo sempre. Eu, contudo, reparando com mais atenção na antiga e continuada sucessão de perturbações que nela se vêem, acrescentarei que a terra parece que evapora tumultos; a água exala motins; o ouro toca desaforos; distilam liberdades os ares; vomitam insolências as nuvens, influem desordem os astros; o clima é tumba da paz e berço da rebelião; a natureza anda inquieta consigo, e amotinada lá por dentro, é como no inferno. (59)

[Minas Gerais is inhabited by undomesticated people, homeless, who even though they are continuously moving, are less inconstant than their customs; the days never dawn serenely; the air is perpetually cloudy; everything is cold in that country, except vice, which is always burning. However, paying more attention to the ancient and continued succession of disturbances that can be found there, I will add that the land seems to exhale tumults; the water breathes revolts; gold rings with brazenness; the air distills freedoms; the clouds vomit insolence; the stars provoke disorder; the climate is the tomb of peace and the cradle of rebellion; nature goes about restlessly and mutinous there, it's like hell.]

In a poetic version of the discourse of climactic determinism, the *Discurso histórico* echoes pseudoscientific claims of creole degeneration on American soil and under American stars, here used specifically to explain the natural origins of seditiousness in Minas Gerais.[14] Later on, the propensity toward rebellion is attributed to "distância e defeito dos vassalos (o que tudo se dá nestas Minas)" (147) [distance and the defects of the vassals (which can all be found in Minas)], thus suggesting that the absence of the sovereign contributes to his subjects' lack of both fealty and fear of his punishment.[15]

Rodrigo Bentes Monteiro has argued that Almeida's government (1717–1721) initiated a period of greater administrative and monarchical control over the region, which would eventually allow the passage from the "tempo de motins" [time of the rebellions] to the "tempo de festas" [time of the festivals] exemplified in *Triunfo Eucharístico* (R. Monteiro 299, 321). According to Monteiro, the distance that favored the emergence of rebellions did not detract from the celebration of festivals in honor of the Crown, as can be seen in the royal license of Sebastião

da Rocha Pita's *Breve Compendio e Narraçam do funebre espectaculo* (1709), which narrates the funeral ceremonies for King Pedro II in Salvador da Bahia:

> a fidelidade Portugueza, & o amor com que esta fidelissima nação ama aos seus Principes, he tam constante, & invariavel, que nenhuma distancia, & nenhuma differença de clima, por mais estranho, & apartado que seja, he poderoso a diminuirlhe o ardor do seu affecto, & a grandeza da sua veneração; antes parece que quanto os Portuguezes mais se afastão da sua origem, & do berço em que nascèrão, tanto mayor he o obsequio que tributão à Magestade, imitando nesta parte a natureza dos rios, que quanto mais se apartão das suas fontes, tanto mayor tributo, & veneração rendem ao Oceano donde recebèrão o ser. (N.p.)

> [Portuguese loyalty, and the love with which this most faithful nation adores its Princes, is so constant and invariable, that no distance nor difference in climate, however strange and far away it is, is powerful enough to diminish the ardor of their affection, and the grandeur of their veneration; rather, it seems that the more the Portuguese distance themselves from their place of origin and the cradle in which they were born, the greater is the tribute that they render to his Majesty, imitating in this sense the nature of rivers, which render greater tribute and veneration to the Ocean (from whence they derived their being) the more distant they are from their source.]

Despite his initial assertion of the lack of effect that geographical and climactic difference have on an invariable Portuguese character, the license's author, Antonio Rodriguez da Costa, ends up affirming the benefits of remoteness: the farther Portuguese subjects are from their king, the more grandiose the manifestations of their devotion.[16] Rather than a natural consequence of distance from the sovereign, however, the claim of greater festive grandeur and devotion is surely more of a rhetorical performance designed to combat associations of the remote location with a lack of (Portuguese) civilization. Rather than an act of ritual or social humiliation, as in other Iberian contexts, the "tribute that they render to his Majesty" is rewritten as a sign of superiority.[17]

Costa's equation—the farther away from the Crown, the greater the tribute and veneration—would be put to the test in accounts of festivals in Minas Gerais, given the region's reputation of impiety, lawlessness, and rebellion that was promoted in Portugal by authors like Antonil

and authority figures like the count of Assumar. Whereas the creoles of Potosí sought to respond to allegations of inadequacy and prove their worth through performance and pageantry, *Triunfo Eucharistico* does so by representing a festival in print to a European audience. The obligation to publish in Portugal, that is, becomes an opportunity to address and impress a metropolitan readership.[18] The ecclesiastical license (Ordinário) by Father Fernando de Santo Antonio reveals the region's reputation and the success of Simão Ferreira Machado's efforts at revising it. After praising the lay brotherhoods' participation in the festivities as a "já mais vista demonstração de Christandade" (150) [never before seen demonstration of Christianity], the license states that the account would serve to glorify "todos os moradores Parroquianos de Villa Rica, que com tão crescidas, e excessivas ventagens adquirirao tanto credito, e tanto louvor; pois sendo habitadores de terras taõ longinquas, como incultas, teve o seu amor tanto que manifestar, e tributar á nossa Santa Fé" (151–152) [all the inhabitants of the parish of Vila Rica, who with such great and excessive profits acquired so much credit and so much praise; since as inhabitants of lands as distant as they are uncultured, their love had so much to show and tribute to our Holy Faith]. Here distance is equated with a lack of civilization, making the religious veneration demonstrated in the festival all the more praiseworthy, in a similar rhetorical move to that of Antonio Rodriguez da Costa. Despite his invocation of Minas Gerais's "uncultured" image, Santo Antonio has clearly absorbed the lesson of *Triunfo Eucharistico* regarding its spiritual culture: he redefines the wealth of Minas Gerais not only by referring to the "vantagens" [profits] and "crédito" [credit] of the celebrants but also by describing their "diligencia de adquirir" [diligence in acquisition] and "ambição de gastar" [ambition in spending] as occurring in the service of God and the veneration of his saints (152).

This is just the sort of revision of Minas Gerais's reputation—and that of Vila Rica in particular, given the recent rebellion—that Simão Ferreira Machado seeks to achieve in *Triunfo Eucharistico*. On one hand, he does so by emphasizing the first half of Santo Antonio's characterization of Minas as "lands as distant as they are uncultured." In the preliminary address, Machado contextualizes the narration of the festivities within a history of the Portuguese Empire that emphasizes its vast extension. The preliminary address begins by referring to the Portuguese duty to "dilatarem a Fé entre as gentes barbaras, e remotas de todo o Mundo" (158–59) [spread the Faith among the World's barbarous and remote people], a call received by King Afonso Henriques from no less

than the mouth of Christ at the twelfth-century Battle of Ourique, according to legend. Evoking Luís de Camões, Machado portrays Portuguese navigation to the East over "mares incognitos, nunca vistos, nem de alguma gente navegados" [unknown seas, never before seen or by any navigated] and through "climas, por immensa distancia differentes" (160) [climates that are different because of immense distances].[19]

Machado employs the same expansive, hyperbolic vocabulary when relating the "discovery" of Brazil ("taõ remota, e dilatada regiaõ do Mundo" [162] [such a remote and vast region of the World]), for which he offers a climatalogical and a providential explanation: "desviados com huma horrivel, e dilatada tempestade . . . sendo guia a Divina Providencia" (162) [diverted by a long, horrible storm . . . with Divine Providence as a guide]. He continues to characterize Portuguese imperial expansion in Brazil—always presented as the expansion of the faith—in terms of the action of conquering hostile and distant lands: "penetrando asperos, e amplissimos sertões," "investigando dilatados, e asperissimos caminhos," "vencendo innumeraveis difficuldades" (164–165) [penetrating rough, immense backlands; exploring extensive and very harsh roads; conquering innumerable difficulties]. Even where he presents the natural world of interior Brazil as amenable, Machado stresses its vastness: the "superabundance" of remote lands and unknown territories ("superabundaõ ainda remotos, e incognitos paizes") where the Portuguese can establish their "dilatado senhorio" (167) [expansive dominion]. The "vastissismas campinas dos sertoens" [vast countryside of the backlands], he concludes, are "por sua fertilidade, e grandeza, terreno capacissimo para huma dilatada Monarquia" (169) [for their fertility and grandeur, a terrain perfectly suited to a vast Monarchy].[20]

If the emphasis on geographical expansiveness in the preliminary address concords with Santo Antonio's description of Minas as "lands so far away," Machado's representation of Vila Rica and its festivities challenges the license's characterization of the region as "inculta" [uncultured], in all of that word's civilizational implications. When he finally arrives at the present moment in the history of Portuguese expansion, Machado depicts Vila Rica not as a remote backwater but as a center of government and commerce: "hoje ordinariamente residem [os governadores] na principal, e mais populosa, que he Villa Rica, situada no centro de todas as Minas; aonde ficaõ as distancias sem queixa iguaes a todos, para os requerimentos da justiça" (180) [today the governors ordinarily reside in the principal and most populous town, which is Vila Rica, situated at the center of all the Mines; where for the requirements of jus-

tice the distances are the same for everybody, leaving no room for complaint].[21] Machado's subsequent praise of Vila Rica is reminiscent of the bombastic opening paragraph of the *Historia de la Villa Imperial*, where Arzáns calls Potosí "honor y gloria de la América; centro del Perú; emperatriz de las villas y lugares de este Nuevo Mundo" (1:3) [honor and glory of America, center of Peru, empress of the towns and cities of this New World]. Machado writes of Vila Rica,

> Nesta villa habitaõ os homens de mayor comercio, cujo trafego, e importancia excede sem comparaçaõ o mayor dos mayores homens de Portugal: a ella, como a porto, se encaminhaõ, e recolhem as grandiosas sommas de ouro de todas as Minas na Real casa da Moeda: nella residem os homens de mayores letras, seculares, e Ecclesiasticos: nella tem assento toda a nobreza, e força da milicia: he por situaçaõ da natureza cabeça de toda a America, pela opulencia das riquezas a perola preciosa do Brasil. (180–181)

> [In this town live the chief merchants, whose trade and importance incomparably exceed the most thriving of the leading merchants of Portugal. Hither, as to a port, are directed and collected in the Royal Mint the grandiose amounts of gold from all the Mines. Here dwell the best educated men, both lay and ecclesiastic. Here is the seat of all the nobility and the strength of the military. It is, by virtue of its natural position, the head of the whole of America; and by the wealth of its riches it is the precious pearl of Brazil. (In Boxer, 162-163)][22]

Mindful of his metropolitan readership, Machado points out the primacy of Vila Rica within not only the Americas but the Portuguese Empire, stressing how it provides "grandiosos auxilios, e quantiosos redditos; sem duvida os mayores a Coroa do Monarcha" (183) [great assistance and copious incomes, without doubt the greatest to the Monarch's Crown]. And if America and Portugal owe their glory to Vila Rica, "the whole world" is indebted to it for the "copioso, e fino ouro, que recebe em seus Reynos" (183) [copious and fine gold that is received in its Kingdoms]. Echoing a frequent complaint in Arzáns's *Historia de la Villa Imperial*, Antonil offers a less positive spin on this debt: "E o peyor he, que a mayor parte do Ouro, que se tira das Minas, passa em pó, & em moedas para os Reynos estranhos: & a menor he a que fica em Portugal, & nas Cidades do Brasil" (180) [And the worst part is that the majority of

the gold extracted in the mines leaves for foreign kingdoms as gold dust or coin, and it is the smallest amount that remains in Portugal and the cities of Brazil].[23] No such complaint about the foreign appropriation of American mineral wealth is registered in *Triunfo Eucharistico*, since in any case the export that Machado most seeks to emphasize is Vila Rica's spiritual exemplarity: "mas sobre tudo deve Portugal ao Brasil, e todo o Mundo hum continuado, e de presente novo exemplo de Christandade" (183–184) [but above all what Portugal and the whole World owe Brazil is a continuous and now renewed example of Christianity].

Indeed, Machado coincides with Arzáns in highlighting not only the town's mineral riches but also its spiritual, cultural, and intellectual wealth. Besides being the seat of the regional government, Vila Rica is home to "os homens de mayores letras, seculares, e Ecclesiasticos . . . toda a nobreza, e força da milicia" (180–181) [the best educated men, both lay and ecclesiastic . . . all the nobility and the strength of the military]— a claim that pointedly counters the stereotype of uncultured, rebellious backlands in Antonil's and the count of Assumar's texts, among others. Indeed, Machado's encomium of Vila Rica highlights its "lettered city," in Ángel Rama's sense of the term: the group of intellectuals, administrators, and church officials that fulfilled the colonial city's civilizing mission and its concentration of power in the service of an absolutist monarchy (16–28). Rama asserts that Baroque festivals were an effective means for the lettered city to demonstrate and promote its own power and prestige.[24]

Absent from the portrait of elite, urban culture in the preliminary address are the Africans and Afro-Brazilians who constituted the majority of Vila Rica's population, even though it was the Black Brotherhood of the Rosary that temporarily housed the Eucharist and played a significant role in the transfer as well as the account's publication. Native Brazilians are also excluded from the lettered city, only appearing in Machado's account of early Portuguese encounters with "barbaras naçoens . . . gente só na figura humana distincta das sylvestres feras" (163) [barbarous nations . . . people only in the human figure distinct from wild beasts] who were either subjected by the violent force of arms or voluntarily subject themselves to the Catholic faith (163).[25] Dean has noted that an essential component of Corpus Christi celebrations is the participation of "the people over whom Christians had triumphed" (15). Indigenous Brazilians play this role in *Triunfo Eucharistico*'s preliminary address if not in the Eucharistic Triumph of the procession. There, it is

the "dança de Turcos, e Christãos" (203) [dance of Turks and Christians] that fulfills this function, as is typical of Corpus Christi festivals of the Spanish and Portuguese Empires.[26]

The preliminary address's account of Portuguese triumph over the barbarism of remote lands and uncivilized peoples culminates in the description of a courtly commercial capital as well as in the subsequent narration of the festivities entitled "Narração de Toda a Ordem, e Magnifico Apparato da Solemne Trasladação." In the account of the fireworks, music, costumes, triumphal floats, street adornments, and ephemeral architecture, *Triunfo Eucharistico* emphasizes the "magnificent ostentation" of mineral wealth—what Machado calls at one point the "contencioso triunfo de ouro, e diamantes" (201) [contentious triumph of gold and diamonds]—but also the artistic skill and effort that went into their creation. References to "artificio" [artifice] abound, as when he describes five triumphal arches "em cujo artificio ajudou a preciosidade do ornato a arte, e competencia dos artifices" (200) [in whose artifice the preciousness of the adornment was aided by the art and competence of the artificers]. The elaborate costumes of each of the allegorical figures in the procession as well as those of their pages and horses attest to this artistic competence as much as to the precious raw materials of which they are made. Multiple days of masses, tournaments, theatrical performances, bullfights, and banquets following the procession compound the manifestations of religious, artistic, and courtly culture on display in the "Narração."[27] Even the spectators are praised for their gravity and *policia* (politeness, good breeding) (202), so necessary to a civilized polity.[28] And unlike the preliminary address, the "Narração" portrays blacks participating in the demonstration of order and culture: "vinhaõ a pé oito negros, vestidos por galante estillo: tocavaõ todos charamellas, com tal ordem, que alternavaõ as suas vozes com as vozes do clarim, suspendidas humas, em quanto soavaõ outras" (214–215) [eight blacks came on foot, dressed in gallant style: they all played hornpipes, with such order that their voices alternated with the voices of the clarion, some suspending while others sounding]. Vila Rica may have been distant, but it was far from uncultured.[29]

As the quotations from his text illustrate, Simão Ferreira Machado employs a great deal of artifice in his own writing. Fernando de Santo Antonio, author of one of Triunfo Eucharistico's licenses, offers equally pompous praise for Machado's "grato estilo, e elegante primor da erudita eloquencia" (148) [pleasing style and elegant perfection of erudite eloquence]. In this sense his rhetorical strategy differs from that of the

other Machado—Ignacio Barbosa Machado, who in his account of the 1719 Corpus Christi in Lisbon claims that "o que em si he grande, e he lustroso, naõ necessita do ornato das vozes, nem do artificio da Rhetorica, sendo a narraçaõ verdadeira o mais elegante elogîo da sua grandeza" (167) [what is grandiose and illustrious in itself does not need the ornament of words, nor the artifice of Rhetoric, since truthful narration is the most elegant praise of its grandeur].

For the Lisbon Corpus Christi, the rhetoric of accumulation suffices to communicate the festival's and the city's grandeur; Barbosa Machado can simply enumerate the abundant brotherhoods, religious orders, noblemen, government officials, and even members of the royal family participating in the procession. Ferreira Machado also lists the lay brotherhoods and authority figures who process in Vila Rica, but the numbers and titles of nobility pale in comparison. Only ten brotherhoods are mentioned in *Triunfo Eucharistico* (251–266), whereas they amount to well over one hundred in Barbosa Machado's *Historia Critico-Chronologica*: "Depois destas cento e dezasete Irmandades, Confrarias, e Congregações, se seguião outras Irmandades" [174] [After these 117 Brotherhoods, Confraternaties, and Congregations, there followed other Brotherhoods]. And while the *palio* (canopy) over the host is carried only by six unnamed confraternity members in Vila Rica, Ferreira Machado reports (266), in Lisbon it changes hands eight times to allow for enough members of the royal family, nobility, and government to participate in the honor—all mentioned by name and title, including the second governor of Minas Gerais, Braz Balthazar da Silveira (1713–1717) (Barbosa Machado 199). In contrast, Simão Ferreira Machado must rely on the accumulation not of names and numbers but of artifice and opulence, describing the costume and retinue of each allegorical figure such as the four winds and the seven planets over an indulgent forty-plus pages (204–246). With its complex syntax and accretion of adjectives, images, and metaphors, Ferreira Machado's Baroque style would elicit the comment from the modern Brazilian poet Manuel Bandeira in a chronicle published in 1929 that his "requinte verbal . . . é de meter inveja aos atuais artífices da prosa" (21) [verbal sophistication . . . would be the envy of today's authors of prose].

Despite Machado's invocation of the insufficiency of language to capture the magnificence of the celebrations—a standard trope of festival accounts—*Triunfo Eucharistico* manages to transform the "glorioso triunfo do Eucharistico Sacramento" (246) [glorious triumph of the Eucharistic Sacrament] into a glorious image of the city and its residents.

Machado acknowledges in the conclusion to the preliminary address that the written account is a corrective not only to earlier texts such as Antonil's and Almeida's but to oral reports of the festival: "A magnificencia de toda esta solemnidade, ouvida em confusa, e defectuosa voz da fama, agora por escripto com universal, e certa individuação fica exposta á publica noticia dos presentes, e futuros" (187) [The magnificence of all this solemnity, which has been heard in the confused and defective voice of fame, is now exposed to the public notice of those in the present and the future, with universal and true written specification]. The printed account will remedy the defective "echoes, carried on the wings of fame" (173) that until then had publicized only Minas Gerais's riches and rebellions in the metropolis.

That *Triunfo Eucharistico* is conceived as a response to European (mis)perceptions of Minas Gerais is confirmed in the conclusion of the work. Machado writes that although this was the greatest religious festival ever celebrated in America (a pretension that Arzáns would certainly dispute), it was far from unique:

> Se a brevidade desta relaçaõ o permittisse, poderiamos individuar os festivos applausos que em diversos tempos nesta parte da America se tem visto; e entaõ ficaria manifesta a grande piedade, e religiaõ, com que os seus moradores resplandecem; e entre as demais naçoens com singular ventagem se fazem conhecidos; dismentindo a malidicencia daquelles, que os pertendem infamar de ambiciosos. (278-279)

> [If the brevity of this account permitted it, we could enumerate the festive applauses that in diverse times in this part of America have been seen; and thus would the great piety and religion with which its inhabitants shine and among the rest of the nations with singular advantage are known be manifest; disproving the slander of those who mean to defame them as greedy.]

Although Machado here only refers to the slander of greed, we have seen other ways in which Minas Gerais's fame—and distance—have contributed to the defamation of its residents. Even if he does not have space to relate other festivals here, the previous hundred-plus pages of *Triunfo Eucharistico* should suffice to make the "great piety and religion" of its inhabitants shine.

Machado concludes by definitively decoupling the association between distance and barbarism in the ecclesiastical license, which called

Minas Gerais "terras taõ longinquas, como incultas" (151–152). Instead, he follows the rhetoric of the royal license for Pita's *Breve Compendio*, in which itinerant Portuguese are compared to rivers that render greater tribute the farther they are from their oceanic source (xxiii), by turning geographical marginality into a source of admiration. Machado affirms that if the Portuguese exceed all other nations in the world in religious fervor,

> agora se vem gloriosamente excedidos dos sempre memoraveis habitadores da Parroquia do Ouro Preto, naõ só pelo Catholico zelo, e excessivos dispendios, com que . . . edificaõ sumptuosos Templos, e erigem Altares, guarnecendo-os de custosas fabricas, e adornando-os de primorosos, e riquissimos ornamentos; mas tambem pela magestosa pompa, e magnifico apparato, com que (em glorioso triunfo) trasladáraõ o Sacramento Eucharistico. (279–280)

> [they are now gloriously exceeded by the memorable inhabitants of the Parish of Ouro Preto, not only in the Catholic zeal and excessive expenses, with which . . . they build sumptuous Temples, and erect Altars, decorating them with costly fashions, adorning them with exquisite and very rich ornaments; but also by the majestic pomp and magnificent ostentation with which (in glorious triumph) they transferred the Eucharistic Sacrament.]

Beyond the splendor made possible by the region's mineral wealth, Machado once again highlights its religious and artistic culture. He continues by hyperbolically boasting of the residents' superiority to all the nations of the world in spite of their remote location:

> [S]ó com pasmos, e admiraçoens se podem dignamente applaudir; pois estes fidelissimos Catholicos vivendo taõ apartados da communicaçaõ dos povos, e no mais recondito do sertaõ, se empregaõ com tanto disvelo, e com inimitavel generosidade em festejar a Divina Magestade Sacramentada para mayor exaltaçaõ da Fé, e veneraçaõ dos Catholicos, . . . fazendo assim mais conhecida, e dilatada na terra do Soberano Senhor Sacramentado a devida veneraçaõ, e eterna gloria. (280–281)

> [Only with astonishment and admiration can they justly be applauded; for these most faithful Catholics, living so far from the communication of people, in the most hidden part of the interior, work with such

zeal and incomparable generosity to celebrate the Divine Sacrament for the greater exaltation of the Faith and veneration of its Catholics, . . . thus making the proper veneration and eternal glory of the Sovereign Holy Sacrament better known and spread throughout the land.]

Triunfo Eucharistico resembles Arzáns's account of the creoles' Corpus Christi festival by explicitly celebrating the town and its residents as much as the Eucharist itself. Whereas in Arzáns's text the chivalric pageantry counters Spanish maligners by serving as evidence of creole nobility and ingenuity, in *Triunfo Eucharistico* it is the festival account that targets Portuguese readers, whom it seeks to convince of Vila Rica's grandeur as well as piety in spite of its distance from even the colonial centers of culture. *Triunfo Eucharistico* does more than propagate the "proper veneration and eternal glory" of the Holy Sacrament; it also makes Vila Rica's religious exemplarity and cultural accomplishments "better known and spread throughout the land."

AUREO THRONO EPISCOPAL: GOLDEN THRONE OF THE LETTERED CITY

As with the entry of Archbishop-Viceroy Morcillo into Potosí, the textual reorientation of the object of celebration becomes even more evident when the festival revolves around a human rather than a divine figure. Such is the case of the anonymous account of Bishop Manuel da Cruz's entry into Mariana in 1748, *Aureo Throno Episcopal, collocado nas Minas do Ouro, ou Noticia breve da Creação do novo Bispado Marianense, da sua felicissima posse, e pomposa entrada do seu meritissimo, primeiro Bispo, e da jornada, que fez do Maranhão, o excellentissimo, e reverendissimo Senhor D. Fr. Manoel da Cruz.* The superlative title well reflects the grandeur of the festivities in the gold-rich mining town, including such extravagances as an elevated garden on the city's main street replete with native flora, as well as twenty-two sculpted nymphs and a multijet fountain (388–389). In the procession, magnificent triumphal floats alternated with allegorical figures, musicians, dancers, and members of the local brotherhoods, clergy, and nobility (393, 431–461). During the following days the celebrations continued, with masses, musical and theatrical performances, fireworks, and, significantly, poetic competitions (396–427).[30]

José Pedro Paiva describes how episcopal entries like this one grew

in importance after the Council of Trent (1545-1563), "becoming key moments for asserting episcopal authority not just over the local clergy but also over secular authorities (e.g. local government, governors or viceroys, secular magistrates, military officers, local nobility) residing in the seat of the bishopric" ("Liturgy" 138).[31] And Iris Kantor has pointed out that Bishop Manuel da Cruz's entry into Mariana followed the prescriptions for such entries to the letter; *Aureo Throno Episcopal* is unusual, she writes, for its inclusion of all six required stages (178).[32] Yet like Arzáns's narrative of the archbishop-viceroy's entrance into Potosí, the rhetorical force of the narrative lies in the glorification of an American town and its inhabitants—in particular, its lettered city—more than in a demonstration of subservience to the new bishop, whose tenure was marked by conflicts with secular authorities.[33] In this sense it continues a tradition of self-celebration inaugurated sixteen years earlier by Simão Ferreira Machado, to whom authorship of the anonymous *Aureo Throno Episcopal* has sometimes been attributed.[34]

If the attribution to Machado is correct, his loyalties would seem to have shifted from Vila Rica to Mariana, just seven miles to the east. *Aureo Throno Episcopal* celebrates the fact that in 1745 Vila da Nossa Senhora do Riberão do Carmo (or Vila do Carmo) was renamed Mariana and promoted to the category of city and seat of the new diocese of Minas Gerais. The narrative opens with an announcement of regional pride similar to that found in *Triunfo Eucharistico*. The author of *Aureo Throno Episcopal* likewise declares Minas Gerais to be "o mais util à Lusitania entre os vastos dominios da sua Coroa" (347) [the most useful to Lusitania among the vast dominions of its Crown]. But the geographic focus quickly narrows, and in the fourth paragraph the author declares Vila do Carmo to be the "mais antiga povoação" (349) [most ancient settlement] of the region, even though its founding on April 8, 1711, only anticipated that of Vila Rica by two months.[35] If this is one of the reasons for its selection as the bishopric's capital, so too is Vila do Carmo's greater loyalty to the Crown. In contrast to Vila Rica, the site of the 1720 rebellion, the city provided safe haven for Governor Pedro de Almeida, count of Assumar, who "achou na lealdade Carmelitana a segurança, que não tinha nas outras Villas do seu governo; e esta fidelidade para com o Principe secular habilitava o Carmo para merecer o throno do Ecclesiastico" (349) [found in the Carmelite loyalty the safety that he did not have in the other towns of his government, and this loyalty to the secular Prince made Vila do Carmo worthy of the Ecclesiastic throne]. Finally, there is a geographic justification: "Fica esta no meio, ou no coração daquelle

novo Bispado, e por isso mais commoda para se participar a todo o seu ambito com igualdade o vital alento da graça com a doutrina do seu sagrado, venerando Pastor" (349) [This is at the center, or the heart of the new bishopric, and for this reason better situated for spreading equally through its whole extent the vital breath of grace with the doctrine of its sacred, worshipful Shepherd]. *Aureo Throno Episcopal* grants to Mariana the centrality attributed to Vila Rica in *Triunfo Eucharistico.*

Despite the laudable qualities ascribed to Mariana, *Aureo Throno Episcopal* opens with an acknowledgement that it was still part of a distant, uncultured land:

> O paiz das Minas . . . não só se acha falto das utilidades temporaes, que convidavão aos Portuguezes a soffrer hum desterro voluntario naquelles sertões, mas não tinha ainda toda a cultura espiritual necessaria para a salvação das almas. A causa principal deste defeito era a extensão do Bispado do Rio de Janeiro, ao qual desde a sua creação pertencia aquelle aureo, e dilatado Emporio. Fica este em grande distancia da Capital do mesmo antigo Bispado, e por isso chegava às Minas com menos vigor do que era necessario a disciplina Ecclesiastica. (347)

> [The country of Minas . . . is not only lacking temporal goods, which invited the Portuguese to suffer a voluntary exile in those backlands, but it did not yet have all of the spiritual culture necessary for the salvation of souls. The principal cause of this defect was the extension of the Bishopric of Rio de Janeiro, to which this extensive, golden emporium had belonged since its creation. Because Minas Gerais lies at such a great distance from the capital of the old Bishopric, ecclesiastical discipline arrived with less vigor than was necessary.]

The creation of the new diocese and the bishop's entry thus represent the extension of ecclesiastical power into what are once again characterized as remote and uncivilized backlands—one of those "key moments for asserting episcopal authority," as Paiva would have it ("Liturgy" 140).[36] Indeed, Frei Manuel da Cruz was surely chosen for this reason, since he had already risen to the challenge of establishing "a disciplina eclesiástica" (Trindade 1:91) [ecclesiastical discipline] in the vast northern territory of Maranhão, where he had been bishop since 1739.[37]

The narrative frame for the description of the celebrations—parallel to the preliminary address's history of Portuguese exploration and expansion in *Triunfo Eucharistico*—here centers on an individual voy-

age, that of Manuel da Cruz to Mariana recounted over the first forty pages. Distance, difficulties, and delays in this journey—"por caminhos tão distantes, como desertos, por tão remotos, e ardentes climas, como são aquelles sertões" (352) [along such distant and deserted roads, through such remote and scorching climates, as can be found in those backlands]—contribute to the characterization of Minas Gerais's remoteness.[38] As described earlier, his departure was postponed for more than two years. The initial journey by boat along the Itapicurú River was "cheia de sustos" [full of frights] because of the many waterfalls and "molesta" [bothersome] because of the many mosquitos (355–356). At Aldeias Altas the bishop was delayed fifteen days and at Piauhy seven months, in part because of the onset of winter and to rest their horses but also because of a "molestia" [illness] he suffered that required him to be bled (358). An even graver illness ("molestia grave") delayed the bishop's journey on two other occasions (376–377, 381). A severe thunderstorm even caused one of their ships to wreck while traveling along the São Francisco River. Such "accidentes, que sempre se offerecem em semelhantes derrotas" (374-375) [accidents, that always happen on similar routes] confirm the portrait of a remote, hostile terrain while also diminishing the triumphal force of the bishop's journey. His voyage both reflects and inverts the idealized version of undeterred Portuguese expansion in the preliminary address of *Triunfo Eucharistico*.

In fact, *Aureo Throno Episcopal* introduces its own delay in the narration of the bishop's journey. At the first incident of the bishop's illness, the narrator turns to events and individuals in Minas Gerais related to his appointment, introducing a ten-page digression involving multiple festivities that predate the episcopal entry. After a cleric, Alexandre Ribeiro do Couto, delivers letters to the bishop while he is recovering in Canavieira, Piauhy, the messenger's unusually quick voyage back to Minas Gerais—two months instead of the usual four—is related in more victorious terms than the bishop's travels: "da qual podia dizer com mais pasmo, que o outro, que dizia: *Vim, vi, e venci*, porque excede quasi a fé humana o maravilhoso deste successo" (359) [of which one could say with more wonder than the other one who said, 'I came, I saw, I conquered,' because the marvelous nature of this enterprise almost exceeds human faith].

News of Couto's miraculous voyage inspired public celebrations with "luminarias, e outras demonstrações públicas do gosto" (359) [fireworks, and other public demonstrations of approval], as did the bishop's selection of Lourenço José de Queirós Coimbra, vicar of Vila Real do Sabará,

to serve as provisional governor of the bishopric until Frei Manuel arrived (360). The text relates the hesitation over whether Coimbra had the requisite papal and royal authority to do so, but the doubt was quickly resolved, and the "Reverendissimo Governador" [most reverend governor] made his solemn entry into Mariana on February 27, 1748, "para o que estava a terra preparada com o maior alvoroço" (362) [for which the town was prepared with the greatest commotion]. In effect, the author shows a member of the local clergy to preempt the new bishop's entrance, and exalts the city's festive grandeur—"O luzimento ainda não se vio maior" (363-364) [Never before had greater splendor been seen]— even before narrating Frei Manuel's arrival in the region. Even the poetry that figures so prominently in the narration of the bishop's entry was part of the festivities prior to Cruz's arrival: "mostrarão em vistosos outeiros as aureas Musas daquelles montes, que tambem Apollo presidia no Carmo" (366–367) [the golden Muses of those mountains will show in splendid competitions that Apollo also reigned in Vila do Carmo]; "as metricas vozes dos Poetas . . . explicavão em discretos metros o elevado motivo de tanto jubilo" (386) [the metric voices of the Poets . . . explained in discreet meters the lofty motive of such jubilation]). As an abbreviated version of the celebrations to follow in the episcopal entry, the episode reveals that it was not the bishop who would bring ceremonial splendor, order, and culture to the remote mining district; they already could be found there in abundance.

The bishop, in fact, sought to avoid such festive splendor by concealing his arrival in Mariana until the night before, "para não dar lugar aos excessivos gastos da pompa, e lustre, com que os habitadores daquelle dourado Emporio da America costumão ostentar-se em semelhantes funções, sem embargo de ser tanta a decadencia do mesmo paiz, que por acaso se acha nelle quem possa com o dispendio necessario para a conservação da sua pessoa, e fabricas" (381) [so as not to allow the excessive expenses of pomp and glory with which the inhabitants of that golden Emporium of America usually vaunt in such functions, despite the same country's decadence, to the point where hardly anyone can be found with enough resources to support himself and his industry].[39] His illness and another delay prevented the bishop from realizing this goal. However, the narrative succeeds in turning the difficult situation of Minas Gerais, economically as well as geographically, into a source of greater admiration. The declining gold production and generalized poverty in the region meant that the festive pomp was even more worthy of astonishment.[40] Arzáns had made similar arguments, especially for the festiv-

ities narrated in the latter chapters of *Historia de la Villa Imperial*, when Potosí's economic decadence was most acute.[41]

The rhetorical celebration of Mariana and Minas Gerais more broadly is directed at readers abroad not only because of the prohibition on publishing in Brazil. As with *Triunfo Eucharistico*, the author of *Aureo Throno Episcopal* sought to persuade metropolitan readers of the region's cultural and spiritual wealth despite its remote location. We read in the conclusion to the narrative about the bishop's entry,

> Assim se celebrou a solemne entrada de S. Excellencia; e no desvelo daquelle glorioso triunfo, para que privativamente concorrêrão os moradores seculares desta povoação, se veio no conhecimiento da Christiandade, e veneração com que elles costumão receber os Prelados da Igreja, desvanecendo o diverso, e injusto conceito, que em outro tempo os pertendeo desluzir. (461–462)

> [In this way the solemn entrance of His Excellency was celebrated; and in the zeal of that glorious triumph, to which the secular inhabitants of this village privately contributed, the Christianity and veneration with which they usually receive the prelates of the Church were revealed, thus dispelling the different and unjust notion with which in another time they were denigrated.]

Even if texts like Antonil's *Cultura e opulência do Brasil* and the anonymous *Discurso histórico e político sobre a sublevação que nas Minas houve no ano de 1720* date from "outro tempo" [another time], the "injusto conceito" [unjust notion] that they promoted—of Minas Gerais as rebellious backlands and its "secular inhabitants" as impious and materialistic— was still widespread and in need of dispelling in mid-eighteenth-century Portugal.

Pedro Correa, who granted the royal license for the publication of *Aureo Throno Episcopal*, attests in the document to the author's efforts in this regard:

> A acção da solemnidade por este relatorio bem mostra ser a mais solemne, a mais luzida, e apparatosa; e o Author a descreve, e a representa com tão meudas circumstancias, com taes expressões de palavras, com tanta clareza de discurso, com tanta propriedade de vocabulos, que a está pondo à vista, e fazendo presente aos que por estarem distantes não tiverão a fortuna de se acharem em tão luzida função. (344)

[The act of solemnity, according to this report, well shows itself to be the most solemn, the most luminous and sumptuous; and the Author describes and represents it with such fine detail, with such clarity of discourse, and with such propriety of vocabulary, that he is putting it before the eyes, and making it present to those who, because they are distant, did not have the good fortune to find themselves at such a resplendent function.]

Correa's glowing appraisal of the work, however formulaic, substantiates his claims about the writer's rhetorical skills in reproducing festive brilliance for distant readers. If ceremonial splendor is an index of piety, the resplendent function represented in *Aureo Throno Episcopal* can effectively combat the representations that were intended to denigrate Minas Gerais.

The primacy of visual description that Ávila calls the "sensibilidade ótica" (1:88) [optic sensibility] of *Aureo Throno Episcopal* and *Triunfo Eucharistico* serves well to put the festivities before the eyes of distant readers. The text describes in overabundant detail all the gold, silver, diamonds, plumes, and rich cloths adorning the costumes, horses, triumphal floats, and ephemeral architecture. Yet the narrator of *Aureo Throno Episcopal* also highlights the recital of music and poetry, acknowledging the festival's appeal to multiple senses: "ficavão os sentidos em tanto pasmo, que na gostosa attracção, em que se elevavão, só rendião admirações à magnificencia, e esplendor de tão glorioso objecto" (394–395) [the senses were so astonished that, in the pleasing allure that elevated them, they only rendered admiration for the magnificence and splendor of such a glorious object]. Here the narrator articulates the Baroque aesthetic objectives studied by José Antonio Maravall.[42] In this case, however, the glorious object seems not to be the arriving figure of authority, as a Maravallian interpretation of the propagandistic role of festivals would have it, but the richly adorned figures on horseback and two triumphal chariots that greet the bishop upon his entrance into the Cathedral, "na importante riqueza, de que se compunha tão vistoso concurso" (394) [in the important riches with which such a showy assembly was composed].

Although *Aureo Throno Episcopal* cannot reproduce the auditory experience of those who were in attendance, the transcriptions present the discursive portions of the festivities—mottos, poetry, songs, sermons— more directly to distant readers "who did not have the good fortune to find themselves at such a resplendent function." For example, the text

includes two of the entries in the poetry competition held on December 8, the feast day of the Immaculate Conception, when—two weeks after the bishop's entry on November 24—the townspeople were "ainda não satisfeitos . . . com as successivas demonstrações de affecto, que geralmente tributavão a S. Excellencia" (403) [still not satisfied . . . with the successive demonstrations of affection that they generally tributed to His Excellency]. The inclusion of the poetry interrupts the narrative for some twenty pages, delaying its conclusion; the narrator expresses regret at not being able to include, for the sake of brevity, all those that were "merecedores de estampa" (410) [worthy of print]. Two nights later, the author of the winning acrostic poem, José de Andrade e Moraes, presided over a "nobre Academia" (427) [noble Academy] whose proceedings—Moraes's opening speech and poems by ten other writers—are included in the "Oração Academica e Congratulatoria" that constitutes the second part of *Aureo Throno Episcopal* (463–534). The third and final part of the volume consists of Andrade's sermon on December 9, 1748, celebrating the construction of the Cathedral of Mariana. Roughly half of *Aureo Throno Episcopal*, then, is dedicated to the discursive and literary production of the lettered city, which takes Mariana as its object of praise as much as if not more than the bishop himself.

For example, Andrade e Moraes's "Oração" begins by repeating the "breve letra" [brief lyrics] sung by a chorus during the entry:

Feliz Mariana,
Amante, triunfante
Na gloria, que tem,
Festiva, e ufana,
Em plectros, e metros
Se dá o parabem. (465)

[Happy Mariana
loving and triumphant
in her glory,
festive and proud,
she congratulates herself
in meters and rhymes.]

The lyrics, like the narrative as a whole, ascribe the triumph not to the new bishop but to Mariana, whose music and poetry once again challenge the notion of an uncultured city. More important than the qual-

ity of the poems recited in the academy are the quantity and diversity of cultural and literary production represented in the narrative. The work of ten poets, all named except for the pseudonymous and curiously quixotic Sancho Pansa de Apollo (534), they contribute to an image of a society that is just as rich in intellectual and artistic wealth as it is in gold and diamonds.[43] The ecclesiastical license by José da Madre de Deos highlights this very aspect, in praise as Baroque as the poetry included in the volume:

> Assim nas obras, que neste livro se achão escritas em prosa, como nas que nelle se contém em verso, mostrárão os seus Authores a agudeza dos seus engenhos, subtileza de seus conceitos, e elegancia de seus discursos, porque compoz cada hum delles huma harmoniosa musica de diversas figuras rhetoricas, e fabricárão todos juntos hum delicioso favo de erudição tão deliciosa, que ministra com doçura huma grande affluencia de sublimes ideas. (342)

> [In the works of prose that are found in this book, as well as those of poetry, the Authors have displayed the sharpness of their wits, the subtlety of their conceits, and the elegance of their discourse, because each one of them composed a harmonious music of diverse rhetorical figures, and together they created a delicious honeycomb of erudition so delightful that it sweetly ministers a great affluence of sublime ideas.]

Perhaps it is precisely in order to highlight this multiple authorship that the volume's overall author is listed as anonymous on the title page. What the creoles of Potosí demonstrated through their spectacular *invenciones* in the 1608 Corpus Christi festival, the authors of Mariana displayed in their literary creations—prepared less for the episcopal entry than for the celebration of the city as the capital of the new diocese. Ávila notes in an analysis of *Aureo Throno Episcopal*'s Baroque stylistics, "Ressalta, com efeito, de tôda a diversificada programação, mais do que o mero objetivo da diversão pública e do regozijo religioso, uma notória preocupação com o brilho intelectual, com a introdução de elementos e formas cultos nas várias solenidades" (1:31) [what effectively stands out in the diverse program, more than the mere objective of public diversion and religious celebration, is a notable preoccupation with intellectual splendor, with the introduction of erudite elements and forms in the various solemnities].

It is in fact the intellectual and literary affluence, celebrated through-

out the text, that the author of *Aureo Throno Episcopal* seeks to display with its own spectacular Baroque prose. As in Arzáns's descriptions of festivals in Potosí, *Aureo Throno Episcopal* offers more than an "exacta narração" [exact narration] of the reception of the bishop, as Pedro Correa's royal license refers to it (343). Ultimately more performative than documentary, the work diverts the festival's rhetorical aims by celebrating the cultural authority of Mariana's lettered city rather than the arrival of ecclesiastical authority in the region. In so doing, the narrative adds to, if not alters, where Mariana's true wealth lies.

The results of the spectacular performances represented in and by *Aureo Throno Episcopal* are mixed. For bishops, Paiva explains, "public entrances provided a moment in which their prestige was acknowledged, their authority asserted, and their receptivity assessed among the different stakeholders" ("Liturgy" 156). But such a moment was short-lived for Bishop Manuel da Cruz. Kantor relates that the bishop immediately encountered "dificuldade de toda ordem, cabido rebelde, confronto freqüente com os vereadores dos senados da câmara de Mariana e disputas acérrimas com a ouvidoria" (178) [difficulties of all orders, a rebellious cathedral chapter, frequent confrontations with the aldermen of Mariana's town council, and bitter disputes with the magistracy]. Even the sponsor of *Aureo Throno Episcopal*'s publication, Francisco Ribeiro da Silva, was expelled from the diocese only two years later, and he subsequently sued Manuel da Cruz for reimbursement of his expenses involved in the bishop's arrival in a lawsuit that would last seventeen years (Kantor 178). Kantor thus finds in *Aureo Throno Episcopal* a case of transgression not in the ceremony per se but in its textual representation: "na forma como os colonos e o clero local registraram as festividades, pois, por debaixo do brilho da festa, sabe-se que não foi menor a resistência que estes ofereceram ao exercício da autoridade do novo bispo desde os primeiros momentos de sua gestão" (178) [in the form in which the settlers recorded the festivities since, underneath the festive brilliance, we know that they offered no less resistance to the new bishop's exercise of authority from the first moments of his administration]. Yet if the festive brilliance was principally a form of self-promotion by the lettered city of Mariana rather than an expression of deference, then their subsequent resistance to the bishop's authority poses little contradiction.

The power struggle with the *ouvidor* Caetano da Costa Matoso, whose arrival in 1749 coincided with that of the bishop, manifested itself particularly in the dispute over the control of the accounts of lay brotherhoods, a question of royal versus episcopal jurisdiction.[44] In a statement

about the bishop's income included in the *Códice Costa Matoso*, a collection of documents about Minas Gerais and Brazil more broadly that the *ouvidor* compiled during and shortly after his tenure as magistrate, Matoso denounces the bishop's greed and lack of charity with the poor:

> [S]ou obrigado a dizer que aquele bispado necessita de uma cuidadosa e pronta reforma, acudindo-se a tanta desordem quanto padecem os moradores daquela capitania, evitando-se assim os escândalos que se originam de matérias temporais e os maiores nas espirituais, pois na verdade tudo passou a pior estado do que estava antes de haver bispo e governava o do Rio de Janeiro. (In Campos and Figueiredo 1:742)

> [I am obliged to say that that bishopric needs a careful and prompt reform, taking care of the great disorder that the residents of that captaincy suffer, preventing in this way the scandals that originate in temporal matters—and even greater in spiritual ones—for truthfully everything went to a worse state than it was before having a bishop, when the one from Rio de Janeiro governed.]

Like Archbishop-Viceroy Morcillo for Arzáns, for Matoso Bishop Manuel da Cruz's arrival had only harmful consequences for the region, as the bishop himself set a poor example of spiritual and moral rectitude; far from ecclesiastical discipline, his arrival brought scandals and disorder to Minas Gerais.

The episcopal entry may have failed in its objective of asserting the new bishop's power and prestige over at least part of the population, as Matoso's accusation attests, however self-interested his claims might have been. But Matoso reveals the success of another dimension of the festival: the self-promoting agenda of the account. The collection of documents known as the *Códice Costa Matoso* includes a description of the bishop's entry into Mariana that could have been derived from *Aureo Throno Episcopal*. Despite its brevity, this text displays the city's cultural prowess in the amusements offered by "os moradores daquela cidade, que constaram de bailes, óperas, academicas, parnasos, comédia, sonatas e vários saraus" (in Campos and Figueiredo 1:664) [the residents of that city, which consisted in dances, operas, academies, Parnassuses, a comedy, sonatas and various soirées]. What is more, in Matoso's own "Informação das antiguidades da Cidade Mariana" [Information about the Antiquities of Mariana City], a brief history and "descrição elogiosa" [eulogistic description] of the city, he clearly draws on the fes-

tival account and even cites it by name when referring to the "especial-íssima pompa, que refere a história desta criação [do novo bispado] inti-tulada *Áureo Trono Episcopal, colocado nas Minas do Ouro*, autor anônimo" (in Campos and Figueiredo 1:253) [very special pomp, which is related in the history of this creation [of the new bishopric] entitled *Golden Epis-copal Throne, placed in the Gold Mines*, anonymous author].[45] The *ouvi-dor*'s personal and political difficulties in Minas Gerais did not make him immune to *Aureo Throno Episcopal*'s rhetoric of praise for the city. Indeed, Matoso clearly shared the literary and political aspirations of Mariana's lettered city, as evidenced by the many and diverse works that he wrote and collected in the *Códice Costa Matoso*—"exata expressão do alcance [da] produção intelectual letrada" (1:154) [the exact expression of the reach of lettered intellectual production], in the words of its modern-day editors.[46] Thanks to *Aureo Throno Episcopal*, Mariana's fame contin-ued to echo in other texts and archives on both sides of the Atlantic.[47]

The brilliant display of cultural activity and spiritual devotion in *Triunfo Eucharistico* and *Aureo Throno Episcopal* is all the more admira-ble because of the very distance of the region highlighted in the nar-ratives. Far from a simple documentary record of the festivals, the ac-counts themselves constitute rhetorical performances that reorient the spectacular wealth they describe away from the mineral riches—and the moral consequences these wrought—with which the region was associ-ated in metropolitan readers' imaginations. The writers and sponsors of both accounts thus sought to intervene in one venue of the debate about the moral, spiritual, and cultural inferiority of the inhabitants of the New World, even those of European descent. Simão Ferreira Machado's narrative of the festive transfer of the Host to a new church transfers the object of celebration from the Eucharist to the mining town and its in-habitants in order to dispute—like Arzáns's narrative of the 1608 Cor-pus Christi festival—perceptions of Minas Gerais. Similarly, the anon-ymous *Aureo Throno Episcopal* shifts the focus from the "golden episcopal throne" of the newly appointed bishop to the gold-mining city that wel-comes him, just as Arzáns praises Potosí's local government over the archbishop and newly appointed viceroy in his account of the 1716 en-try. The authors of these narratives replace the original propagandistic intent of the festivals—to celebrate the triumphs of Church and Crown in these distant boomtowns—with the goal of attesting to local intellec-tual and cultural grandeur, rendered all the more spectacular by their re-mote locations.

Celebrants

Festive Natives in Potosí, from Audience to Performance

La dicha prosecion . . . en estas tierras de nueva convercion es tan inperante maiormente quando los Indios son llevados mas por la serimonia y demostracion . . . y apariencias materiales que por la dotrina intellectual y berbal.

[The said procession . . . in these lands of recent conversion is so imperative, especially when the Indians are more persuaded by ceremony and demonstration . . . and material appearances than by intellectual and verbal doctrine.]

LIBRO DE ACTAS DE LOS CABILDOS ANUALES, 1663

Some 130 years after the conquest of the Inca capital of Cuzco and nearly a century after the defeat of the last stronghold of Inca resistance at Vilcabamba, Monsignor Juan Bautista del Campo Cano, dean of the Metropolitan Church in La Plata, Alto Perú (present-day Bolivia), would still refer to the region as "tierras de nueva conversión" [lands of recent conversion] in a letter to Francisco de Burgos, a priest in the indigenous parish of Santa Bárbara in Potosí. A copy of the letter, dated 1663, is included among records from the 1730s in the *Libro de actas de los cabildos anuales* of the confraternity of Our Lady of Solitude, which was responsible for the procession of the Santo Entierro (Holy Burial) on Good Friday. The annual meetings of this confraternity assigned to its members—mostly merchants in Potosí—the insignias to be carried in the procession.[1] Although the minutes usually indicate the chosen individuals' consent "sin contradicción alguna" (175v) [without any contradiction], they also attest to occasional acts of resistance and disobedience, which usually generated a flurry of documents.

Thus following the 1733 *actas*, a copy of Bautista del Campo Cano's letter was included among other documents in order to provide an example of "otro caso semejante a este" (229) [another similar case to this one], in which ecclesiastical and secular authorities responded forcefully to some merchants' attempts to shirk their assigned duties in the procession, preferring instead to pay a fine. Although the documents cite the general "menoscabo" [diminishment] and "desdoro al culto divino" (208v) [dishonor to divine worship] as the reason to swiftly and strictly punish the offenders, they specifically point to the deleterious effects of a botched Good Friday procession on a particular segment of the audience: Amerindians. Whether framed as an "exemplo y enseñanza de los naturales e indios" (240v) [example and lesson to the natives and Indians] or as a way to "evitar el mayor escandalo que podria causar entre los yndios el no salir dicha proseçion" (229v) [avoid the great scandal that could be caused among the Indians if the procession does not take place], the Holy Week procession was more than an act of piety performed by and for Potosí's Iberian and creole residents. Given that the indigenous community was still thought to be "llevados mas por la serimonia y demostracion . . . y apariencias materiales que por la dotrina intellectual y berbal" (240v–241r) [more persuaded by ceremony and demonstration . . . and material appearances than by intellectual and verbal doctrine], the Holy Week celebrations were understood to have rhetorical force among the indigenous population. Despite decades of Spanish campaigns to extirpate of idolatry, Indians continued to be called "neophytes" in 1719, "la populosa gente neophita de los Yndios de esta Villa" [244] [the populous neophyte Indian people of this Town].

The recognition of the evangelizing potential of religious ceremonies among the pagan populations of the Americas can be traced back to the beginning of Spanish colonization. In a study of indigenous Christian pageantry in New Spain, Louise Burkhart cites early sources such as Bishop Zumárraga's letters to Charles V in 1536 and 1540 in which "the rhetorical line is clear: pomp and ceremony are the only means to attract the native people" (371). This principle is pointedly articulated in the decree of the Third Provincial Council of Lima (1582–1583) regarding the "cuidado del culto divino" [care for divine worship]:

> Ultimamente, porque es cosa cierta y notoria que esta nacion de yndios
> se atraen y provocan sobremanera al conoscimiento y veneracion del
> summo Dios con la[s] cerimonias exteriores y aparatos del culto divino;
> procuren mucho los obispos y tambien en su tanto los curas, que todo

lo que toca al culto divino se haga con la mayor perfeccion y lustre que puedan, y para este effecto pongan studio y cuydado en que aya escuela y capilla de cantores y juntamente musica de flautas y chirimias y otros ynstrumentos acomodados en las yglesias. (In Vargas Ugarte 1:374)

[Lastly, because it is certain and notorious that this nation of Indians is especially attracted and provoked to the knowledge and veneration of the supreme God by exterior ceremonies and displays of divine worship, the bishops as well as the priests (in their realm) must seek greatly to perform the divine service with the greatest perfection and luster that they can, and to achieve this result they must studiously and carefully ensure that there is a school and chapel of singers, and with it music of flutes and shawms and other instruments present in the churches.]

Such a perspective on the utility of exterior ceremonies that stimulated all of the senses to convert the indigenous explains the councils' repeated prescriptions regarding which feast days both natives and Spaniards had to celebrate—as well as how they were to be celebrated—beginning with the First Provincial Council of 1551–1552.[2]

Potosí's mine owners resisted such prescriptions for economic reasons, petitioning for and occasionally receiving permission to continue to exploit the labor of indigenous miners on the nights of feast days.[3] But they also made arguments on moral grounds that point to a concomitant and inverse preoccupation regarding native participation in religious festivals: that it would promote not Christianization but the retention of pre-Hispanic traditions and beliefs. Thus the Second Provincial Council of Lima (1567–1568), in the second part, "touching the Indians," recommended that "en las fiestas del corpus xpi y en otras, se recaten mucho los curas y miren que los indios, fingiendo hacer fiestas de xpianos, no adoren ocultamente sus ídolos y hagan otros ritos, como acaece" (in Vargas Ugarte 1:252) [in the feasts of Corpus Christi and others, the priests be very careful and watch the Indians who are pretending to practice Christian festivals, so that they do not worship their hidden idols and perform other rites, as sometimes happens].

The articles that follow express similar concerns regarding continued signs of pagan worship that would inspire the campaigns to extirpate idolatry in the 1570s and again in the early seventeenth century. These articles address indigenous sacred places or objects called *huacas*,[4] "adoratorios de los caminos que los yndios llaman *apachetas*" [temples

on the roads that the Indians call *apachetas*], body-modification prac-
tices (head molding, hair braiding, and ear piercing), burial rites, sac-
rifices, alcohol consumption, and dances called *taquíes* (Vargas Ugarte
1:252–255). Such ceremonial objects and practices suggested the retention
of pagan beliefs, and thus for the Second Provincial Council their de-
struction was as "imperante" [imperative] as the maintenance of Chris-
tian processions would be for Monsignor Bautista del Campo Cano a
century later. The council declares that "el abuso común y de tanta su-
perstición que tienen casi todos los indios de sus antepasados de hacer
borracheras y taquíes y ofrecer sacrificios en onrra del diablo a tiempos
de sembrar y del coger, y en otras coyunturas y tiempos . . . todo esto se
quite y destierre totalmente" (in Vargas Ugarte 1:253–254) [the common
and such superstitious abuse that almost all of the Indians have from
their ancestors, of getting drunk and dancing and offering sacrifices in
honor of the devil at times of sowing and harvesting, and other times of
the year . . . must be all taken away and totally abolished]. Enumerating
the many similar edicts prohibiting indigenous ceremonial practices in
New Spain, Diana Taylor comments that "the performance of the pro-
hibitions seems as ubiquitous and continuous as the outlawed practices
themselves. Neither disappeared" (43).[5]

Of particular concern was Corpus Christi, a moveable feast day
celebrated between late May and mid-June, thus coinciding with Inti
Raymi, an Andean fall harvest festival held near the June solstice (Dean
32). Writing in 1571, a few years after the Second Provincial Council, and
sharing some of its concerns, Juan Polo de Ondegardo, who had been
corregidor of Potosí between 1545 and 1549, warned that the festive sim-
ilarities had encouraged the perpetuation of ancient beliefs rather than
their substitution with Christian ones:

> Hase de advertir que esta fiesta [Inti Raymi] cae quasi al mismo
> tiempo que los Christianos hazemos la solemnidad de Corpus Christi,
> y que en algunas cosas tienen alguna apariencia de semejança (como
> es en las danças, representaciones ó cantares) y que por esta causa á
> avido y ay oy día entre los Indios que parecen celebrar nuestra fiesta
> de Corpus Christi, mucha superstición de celebrar la suya antigua de
> Intiraymi. (3:21–22)

> [One must be wary that this festival [Inti Raymi], which falls at nearly
> the same time as when we Christians observe the solemnity of Cor-
> pus Christi, and that in some things there is some appearance of sim-

ilarity (as in the dances, performances or songs), and that for this rea-
son among the Indians who seem to celebrate our festival of Corpus
Christi, there has been and still is today much superstition that they
are celebrating their ancient feast of Inti Raymi.][6]

As the former seat of the Inca Empire and the site at which the main
Inti Raymi festival used to occur, Cuzco's Corpus Christi festival would
elicit the most attention from colonial administrators and authors as well
as from modern scholars, the latter in part due to the extraordinary se-
ries of sixteen paintings depicting a Corpus Christi procession in Cuzco,
produced around 1680, five of which feature standard-bearers of indige-
nous parishes dressed in royal Inca attire.[7]

 Polo de Ondegardo's description of indigenous festivals demon-
strates how they continued to be practiced beyond Cuzco as well, high-
lighting their presence in Potosí in particular: "También aunque no sea
por la misma orden ni por el mismo tiempo, usan en muchas partes,
especialmente en Potosí, y en las tierras al rredor, hazer la dicha fiesta
llamada raymi, al tiempo de sembrar, y también por Corpus Christi
vistiéndose y comiendo y beviendo y baylando, y haziendo diferentes sa-
crificios al modo antiguo" (3:19) [Furthermore, although it may not be
in the same order or at the same time, they still practice the said festival
called *raymi* in many places, especially in Potosí and the lands around it,
at the time of sowing, and also during Corpus Christi, dressing up and
eating and drinking and dancing, and doing different sacrifices in the
ancient way].[8] Indeed, archaeological evidence attests to Cerro de Potosí
being a *huaca*, a sacred place and cultic center for the Qaraqara and Inca
indigenous groups that inhabited and controlled the region prior to the
Spanish arrival.[9] Although local pre-Hispanic traditions surely infused
the indigenous celebration of Christian holidays in Potosí, so too did
the ethnic diversity that resulted from increased migration to the region,
particularly after the establishment of the *mita* in 1573.[10] As a result, in-
digenous festive participation in colonial Potosí was not limited to the
continuation of a pre-Hispanic *raymi* specific to that locale, as Polo de
Ondegardo implies; even he notes that the indigenous ceremonies might
not be performed "in the same order or at the same time."[11]

 The archival record, including published festival accounts, histories,
and paintings, offers ample evidence that the indigenous residents of Po-
tosí were both observers and participants in the city's frequent and lav-
ish festivals, from the religious processions of Corpus Christi and Holy
Week to solemn entries and royal funerals or acclamations. Although a

century separates Polo de Ondegardo's concern about native participation in Corpus Christi from Bautista del Campo Cano's worries about the indigenous response to the suspension of Holy Week processions, their perspectives converge in an ambivalence toward native festive participation that was sustained throughout the colonial period—at least, until Inca festive practices and regalia were definitively outlawed after the Tupac Amaru rebellion of the 1780s.[12] What both positions shared was the assumption that Potosí was still a land of recent conversion and that festivals played an important role in Christianization, whether positive or negative.[13]

Although accounts written by Spaniards or creoles inevitably reveal more about the authors' own perspectives, when read against the grain they can also illuminate how indigenous peoples may have interpreted the festivals and their participation in them. Festivals sometimes escaped the control of the powerful, and their representation occasionally eluded the textual agendas of those who recorded them. In these instances we can glimpse native responses to and interventions in the festive wealth of Potosí. These responses and interventions are not limited to what Scott would call the offstage, "hidden transcript" but are part and parcel of the "public transcript" of urban festivals.[14] The festive participation of native Andeans, in other words, corresponds less to a hidden transcript of outright resistance to Spanish rule—or for that matter, to the worship of hidden idols under a thin veneer of Christianity—than to the more subtle ways in which indigenous groups borrowed, reinterpreted, or altered the goals of Spanish and Christian festive practices, ways that cannot simply be categorized as submissive or subversive.[15]

PUBLIC TRANSCRIPTS IN *EL DIOS PAN*

In Diego Mexía de Fernangil's *El Dios Pan*, a dramatic dialogue composed in 1617, two shepherds attend a Corpus Christi celebration in Potosí. The "Gentile" Damón responds to his companion Melibeo's oral description of the Christian God by acknowledging that he must be "Inefable, / grandioso, y admirable" (6) [Ineffable, / grandiose, and admirable]. Melibeo's reply, "I mucho más que os muestro" [And I will show you much more], alludes to the even more powerful rhetorical sway of the visual spectacle of the Corpus Christi procession to which he takes Damón. The public celebration of the Eucharist in Potosí, he knows,

will overwhelm all his companion's senses and thus more effectively persuade him to abandon his pagan deity, Pan, for the one who manifests himself in *pan* [bread], according to Catholic doctrine. Indeed, Damón's reaction to the festival is nothing less than total astonishment:

> Suspenso y asombrado, o Melibeo
> estoi, pues lo que veo, con mis ojos,
> me parecen antojos o ilusiones;
> ventanas y balcones i terrados
> están glorificados con presencias
> de raras excelencias.
> . . . tanto veo
> que se ahita el deseo; pues el oro,
> perlas, plata, y tesoro que esparcido
> columbro y repartido en la ancha plaza,
> me ofusca, turba, embaza. (6)

> [I am astonished and filled with wonder, o Melibeo,
> because what my eyes behold
> seem like fancies or illusions;
> windows and balconies and terraces
> are glorified with the presence
> of rare excellencies.
> . . . I see so much
> that I am bursting with desire,
> for the gold, pearls, silver, and treasure
> that I glimpse spread about the wide square
> blinds, bewilders, and confuses me.]

The marvelous sights of the Corpus Christi procession and the adornment of the city itself are complemented by the music and aromas of the festival, all of which lead to Damón's ultimate conversion. In particular, the gold and silver, pearls and treasure that fill Damón with wonder and desire suggest that a spectacular display of wealth plays a role in Melibeo's spiritual victory over his pagan companion. Festive captivation yields a new "slave to the Holy Sacrament"—a reference to the name of the lay religious Brotherhood of the Holy Sacrament whose foundation *El Dios Pan* was written to commemorate—when Damón confesses at the end of the work,

Yo estuviera
un siglo aquí, si hubiera siempre aquesto.
Pero voy muy dispuesto, caro amigo,
. . . a baptizarme
y a este Pan entregarme por esclavo. (25–26)

[I would stay
a century if this were always here.
But I go very willingly, dear friend,
. . . to get baptized,
and to surrender myself as a slave to this Bread.]

About a century later, in fact, a similar dialogue between a Span-
iard and his indigenous companion was imagined before another festive
procession in Potosí, in Melchor Pérez Holguín's *Entrada del Arzobispo
Virrey Morcillo en Potosí* (ca. 1716) (figs. 1.1 and 3.1). In the foreground,
an old man dressed in Spanish attire asks an indigenous-looking elderly
woman, "Hija pilonga as bisto tal marabilla" [Old girl, have you seen
this marvel?]. Her response, like Damón's, emphasizes the spectacular
nature of the festivities: "Alucho en cientoitantos años no e bisto gran-
deza tamaña" [I swear that in one hundred-some years I have not seen
such grandeur]. Both reactions recall José Antonio Maravall's argument
about the Baroque instrumentalization of the marvelous: "Lo oscuro y
lo difícil, lo nuevo y desconocido, lo raro y extravagante, lo exótico, todo
ello entra como resorte eficaz en la preceptiva barroca que se propone
mover las voluntades, dejándolas en suspenso, admirándolas, apasionán-
dolas por lo que antes no habían visto" (*La cultura* 467) [The obscure and
the difficult, the new and the unknown, the rare and the extravagant,
the exotic, all these were effective expedients in the Baroque precepts
that sought to move the will, leaving it in suspense, provoking its admi-
ration, and impassioning it through what had never been seen before].[16]
As the recommendations of Monsignor del Campo Cano and the Third
Provincial Council of Lima illustrate, in a colonial context these func-
tions would make the festival particularly attractive as a potent tool of
cultural and spiritual conquest.

Corpus Christi, the setting of *El Dios Pan*, was thought to serve
this purpose especially well. Carolyn Dean explains in *Inka Bodies and
the Body of Christ* that since its inception in the thirteenth century and
promotion during the Counter-Reformation, Corpus Christi deployed
a "visual vocabulary of triumph" (for example, triumphal processions,

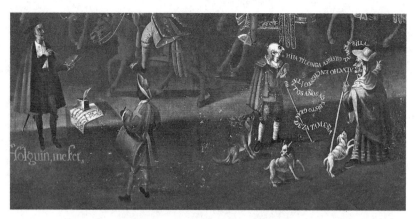

FIG. 3.1. *Melchor Pérez Holguín,* Entrada del Arzobispo Virrey Morcillo en Potosí *(ca. 1716). Detail. Courtesy, Museo de América, Madrid.*

arches) to celebrate multiple victories: of Christ over sin and death, of the Catholic Church over heretics who rejected the doctrine of transubstantiation, and of Spain over non-Christian peoples (9). In accordance with the oppositional structure of Corpus Christi, Dean argues, indigenous participation in the celebrations served to corroborate the public transcript of successful conquest and evangelization. The indigenous presence in Corpus Christi was thus viewed by Spanish authorities as a sign of subjugation as well as resistance—sometimes at the same time—and as a result, native participation was both encouraged and suspected (50).[17]

We can glimpse such ambivalence in the anonymous *Relación de la grandiosa fiesta*, a verse description of a festival dedicated to the Holy Sacrament in Potosí in 1663. The work replicates the vocabulary of grandeur and astonishment invoked by Damón and by the spectators in Holguín's painting, while the only reference to nonwhite participants has an ironic twist.[18] Amid the flower garden and caged animals in the main plaza,

> tres cruces fueron vertiendo
> Por la herida de los clavos
> Vino, chicha y agua á un tiempo,
> Donde, bebiendo á porfía
> Indios, mulatos y negros,
> Fueron blanco de la fiesta,
> Pues que quedaron en cueros. (7–8)

[three crosses were pouring
through the nail wounds,
water, wine, and *chicha* all at once,
from which Indians, mulattos, and blacks
were obstinately drinking.
They were the clear target of the festival,
since they ended up naked].[19]

The English translation does not capture the passage's wordplay:
"blanco" refers to target or objective of the festival—which would be,
presumably, to convert the "Indians, mulattos, and blacks" through the
blood of Christ's sacrifice, rendering them white (*blanco*) in the racial-
ized sense of "honorable" at that time—but it also plays on the expres-
sion "quedarse en blanco," defined in the 1726 *Diccionario de autoridades*
as "quedarse sin lo que se deseaba, no conseguir lo que se pretendía" [to
be left without what one wished for, to not achieve what one was at-
tempting].[20] But who or what is unsuccessful here? The wordplay re-
minds us that the festival's objective, as defined by religious authorities
like Monsignor del Campo Cano—to serve as "example and lesson to
the natives and Indians"—could be counterproductive, since the Indi-
ans, mulattos, and blacks do not simply observe the celebrations in pas-
sive and awestruck submission. Rather, they participate in unruly ways,
exhibiting the drinking and nudity that so preoccupied authorities about
indigenous festivities.[21] The scene also raises the question of what the
Indians, mulattos, and blacks would have viewed as the objective of the
festival; surely it was not only the celebration of the Holy Sacrament,
"aquel Pan divino y bello" [that divine and beautiful Bread] praised in
the *Relación de la grandiosa fiesta* (10).

As a text depicting an idealized festival as well as its ideal results, *El
Dios Pan* avoids the ambivalence evident in the *Relación de la grandiosa
festa*—between the demand for and disavowal of native festive partici-
pation—by relegating Damón's role to that of astonished observer only.
The author is Diego Mexía de Fernangil, a native of Seville who first ar-
rived in Peru in 1581 and traveled extensively in the New World as a book
trader. His only published work in his lifetime is the *Primera parte del
Parnaso Antartico, de obras amatorias*, a translation with commentary of
the *Heroides* and *Ibis* of Ovid, printed in Seville in 1608.[22] As Mexía ex-
plains in the prologue to this work, he did the translation to entertain
himself with the only book at hand during the long overland journey
from the coast of New Spain to the viceregal capital following his ship-

wreck in 1596. He had been traveling from Peru with the "carga infernal" [infernal cargo] of 2,000 *quintales* (20,000 pounds) of mercury as well as much wine and silver (*Primera parte* 1r–1v). Mexía deflects any potential criticism of his work by referring to the physical and intellectual challenges of his remote New World location:

> pues à veinte años que navego mares, i camino tierras, por diferentes climas, alturas, i temperamentos, barbarizando entre barbaros, de suerte que me admiro como la lengua materna no se me à olvidado, pues muchas vezes me acontece, lo que a Ovidio estando desterrado entre los rusticos del Ponto, lo cual sinifica el en el quinto libro de Tristes, en la decia septima, cuando dize que queriendo hablar Romano, habla Sarmatico. . . . La comunicacion con ombres dotos (aunque en estas partes ai muchos) es tan poco, cuan poco es el tiempo que donde ellos estan abito; demas que en estas partes se platica poco desta materia, digo de la verdadera Poesía, i artificioso metrificar, que de hazer coplas a bulto, antes no ai quien no lo professe: Porque los sabios que desto podrian tratar, solo tratan de interes, i ganancia, que es lo que aca los traxo su voluntad; i es de tal modo, que el que mas doto viene se buelve mas Perulero. (4r–4v)

> [for it has been twenty years since I navigate seas and walk lands through different climates, heights, and temperaments, becoming a barbarian among barbarians, such that I am surprised that I have not forgotten my maternal language, for many times the same thing happens to me as happened to Ovid when he was in exile among the rustics of the Pontus, which he expresses in the fifth book of the Tristea, in the seventeenth, when he says that wishing to speak Roman, he speaks Sarmatian. . . . The communication with learned men (although in these parts there are many) is as little as there is time that I live among them; besides, in these parts one talks little about this material, I mean the true Poetry, and artful metrification, since writing couplets in bulk, there's no one who doesn't do it—because the wise men who could discuss this only worry about their own material gain and profit, for that is what brought them here; and it is to such an extent, that the most learned who comes here goes back the most *perulero*.[23]]

The *peruleros'* ambition and greed distracted them from the nobler pursuit of poetry. Like Ovid in exile as well as Simão Ferreira Machado and the anonymous author of *Aureo Throno Episcopal*, Mexía frames his text

in terms of his distance from civilization.[24] Yet the referent of Mexía's "barbarians" is unclear: Are they the Spaniards or creoles who do not speak the language of classical poetry, learned men who have devoted themselves to financial gain and the authors of popular *coplas* composed "in bulk"? Or are they the indigenous inhabitants, akin to Ovid's "barely civilized" Getae on the Pontic shore?

By the time he completed the *Segunda parte del Parnaso antartico de divinos poemas* in 1615, Mexía's long residence in the New World may have sharpened the distinction for him; in this work he has much more favorable things to say about the intellectual climate of Spanish Peru, while barbarism is clearly located on the side of idolatrous natives. In the intervening period Mexía made several trips to and extended stays in Potosí, a city that he describes in the prologue to his *Segunda parte* as being a "seguro puerto" (90) [safe port] for his family after eight years of business dealings that had cost him much of his fortune and where "con quietud he gozado de los bienes del entendimiento, sobre quien no tiene la fortuna dominio ni imperio alguno. He desenvuelto muchos autores latinos, y he frecuentado los umbrales del templo de las sagradas musas" (90) [in peace I have enjoyed the goods of understanding, over which fortune has no dominion nor empire. I have developed many Latin authors, and I have frequented the thresholds of the temple of the sacred muses].[25] In Potosí, Mexía communed with not only sacred muses and Latin authors but also contemporary printed works from Europe, for the *Segunda parte del Parnaso antartico* is primarily composed of one hundred sonnets based on the images of Jerome Nadal's influential *Evangelicae Historiae Imagines*, an illustrated history of the life of Christ that was first published in Antwerp in 1593. Mexía explains in the prologue that he planned to send the sonnets to Antwerp for publication with the original engravings in 1614 but was persuaded by friends to publish it himself, although he never did, and the volume in its entirety remains unedited. Among the works he subsequently added to the sonnets is "Egloga intitulada el Dios Pan en loor del Santísimo Sacramento de la Eucaristia."

El Dios Pan is preceded by a lengthy dedicatory poem to Diego de Portugal, who was the *presidente* (presiding judge) of the Audiencia de Charcas, the administrative and judicial district to which Potosí belonged. As such, José Rodríguez Garrido has argued, the dedicatory poem distances the text from its purported classical setting and inserts it into contemporary debates in Potosí and Peru more broadly. The poem refers to the series of natural and manmade disasters that afflicted Peru

since the civil wars, "donde perecieron / millones de inocentes naturales" (Mexía, "Egloga" 83) [where millions of innocent natives perished], all of which are signs of God's punishment for Spanish sins in the New World, including greed: "Y muchos españoles pospusieron / la vida y honra y cuanto poseían / por su interés y asi se consumieron" (83) [And many Spaniards subordinated / their lives and honor and whatever they possessed / for their own profit, and in that way they were consumed]. Mexía also ties the greed for material wealth to the failure to evangelize the indigenous: "No pretendemos que se vaya al cielo / el indio, mas que saque plata y muera" (87) [We do not seek for the Indian to go to heaven / but rather that he extract silver and die]. Mexía's critique of the exploitation of indigenous mining labor at the cost of evangelization, among other iniquities of the Spaniards in Potosí, contributes to the portrait of a chaotic boomtown: "Veo en lo monacal mil disensiones, / Veo lo clerical mui alterado, / Veo en lo secular grandes traiciones" (83) [I see a thousand monastic conflicts, the clergy very altered, and great treason in the secular realm]. In this portrayal his critique coincides to a large extent with that of Arzáns. Also like Arzáns, Mexía offers the inverse of this depiction in the festive grandeur and magnificence of what his character Damón calls the "argentino pueblo" (*El Dios Pan* 1) [silver town]. Indeed, for this text Mexía must have frequented not only the "temples of sacred muses" (Prologue 90) but Potosí's frequent and lavish festivals, such as the 1608 Corpus Christi celebrations sponsored by the *criollos*.

Clearly a foil for indigenous Andeans, the shepherd Damón's own ceremonies are described by Melibeo as "gentilicios, malditos, perniciosos, torpes, supersticiosos" (2) [gentile, damned, pernicious, clumsy, superstitious]. Although Damón describes his object of devotion, Pan, in the visual terms of the classical pagan deity, he states that "otra gran fiesta nuestra / se parece a la otra: y festexamos / al Dios Pan que adoramos" (1–2) [another great festival of ours is similar to the other one, and we celebrate the God Pan that we adore], invoking the Inti Raymi/Corpus Christi parallel that worried the religious leaders of the Second Provincial Council of Lima and secular authorities like Polo de Ondegardo. At the opening of the text, Damón makes the mistake of identification based on ritual similarities, stating that an "interior force" [*fuerza interior*] is driving him to Potosí:

Por ver deste argentino pueblo, un rato
la pompa y aparato y fiesta rara

que al gran Dios Pan preparan: y aunque adoro
dioses de plata y oro y todavía
sigo la idolatría: el poder suyo
es tal que no rehuyo los cristianos
ritos tan soberanos. (1)

[In order to see, in this silver town, a little
of the pomp and ostentation and extraordinary festival
that they prepare for the God Pan/God of Bread;
and although I adore gods of silver and gold
and still practice idolatry; their power
is such that I cannot shun such sovereign Christian rites.]

Eventually Damón will learn, with Melibeo's help, the "diferencia manifiesta / que va de fiesta a fiesta" (2) [the manifest difference / between one festival and the other] and the distinction between his deity, Pan (contradictorily described by Melibeo as both "sinister" and "imagined," real and unreal), and the God manifested in the *pan*, or bread, of the Eucharist. Damón's idolatry clearly reflects that which Catholic priests were attempting to root out in the freshly invigorated "campaigns of extirpation" of the early seventeenth century, following the discovery of the worship of *huacas* under the guise of Christianity at Huarochirí in 1608.[26]

It is in this context that Rodríguez Garrido reads *El Dios Pan* and its prologue as intervening in a polemical fashion: "En medio de un contexto dominado por la reimplantación de métodos agresivos de extirpación de la idolatría, Mexía eleva su voz y deja correr su pluma para reafirmar la necesidad de una evangelización basada en el ejemplo, el beneficio al prójimo y la predicación" (316) [In the midst of a context dominated by the reimplantation of aggressive methods of the extirpation of idolatry, Mexía raises his voice and lets loose his pen in order to reaffirm the necessity of an evangelization based on example, helping others, and preaching]. As Rodríguez Garrido points out, the methods of evangelization modeled in *El Dios Pan* follow the recommendations of the Third Council of Lima from some three decades earlier (1582-1583), particularly the emphasis on persuasion through word, image, and ritual as well as the separation of pre-Hispanic and Christian practices (315–316). Damón's reaction to the Corpus Christi festival in *El Dios Pan* certainly reflects the Third Council's claim that Amerindians were especially attracted to the "veneration of the supreme God by exterior ceremonies

and the display of divine worship" (in Vargas Ugarte 1:374). At the same time, the dialogue between Damón and Melibeo at the beginning of the text emphasizes the "manifest difference" between pagan and Christian festivals. Melibeo denounces Damón's celebrations thus:

> Como son vuestras Diosas deshonestas
> así son vuestras fiestas . . .
> Los altares, los juegos, los oficios
> A los Dioses de vicios dedicados,
> no pueden ser honrados, vergonzosos,
> honestos, virtuosos; los cristianos
> deven ser soberanos en sus ritos
> i deven ir contritos y modestos,
> y sobre todo honestos. (5)

> [As your goddesses are immoral
> so are your festivals . . .
> The altars, games, services
> dedicated to the Gods of vice,
> cannot be honorable, modest,
> honest, virtuous; the Christians
> should be sovereign in their rites
> and should proceed contritely and modestly,
> and above all honestly.]

In *El Dios Pan* Mexía endeavors as much to model an ideal Christian festival as to critique indigenous ones, and to establish clear distinctions between the two.

With respect to the indigenous role in both sets of festivals, the difference is clear: Amerindians should not practice their own rites; rather, like Damón, they should observe the Spanish celebrations. This is precisely the dynamic at work in *El Dios Pan*. Although Damón is one of the two main interlocutors, the dialogue has been described as theatrically "unrepresentable," for the movements of the characters through crowded streets and plazas as they watch the procession would be impossible to reproduce on a conventional stage of the time.[27] In *El Dios Pan* it is the mimetic rather than ontic register of theater that commands our (and Damón's) attention, to invoke Elizabeth Dillon's terminology once again.[28] Rather than an embodied presence, Damón is above all an audience member before the musical and theatrical performances that

are transcribed in the dialogue: four *villancicos* (carols) and two short plays, one of which is given a cast of characters and the title "Decuria de Santa María Egipciaca." Damón is shown to be quiet before each of the two plays, first hushed by Melibeo—"Callad" (8) [Be quiet]—and then silencing himself: "Yo callo" (10) [I am silent]. The plays evoke the *autos sacramentales,* or short allegorical plays on sacred and biblical subjects represented during Corpus Christi celebrations in Spain and Spanish America, as well as the evangelical theater written and performed for indigenous audiences in the colonial period. For example, the mestizo historian El Inca Garcilaso de la Vega refers to a "diálogo de la fe" [dialogue of the faith] recited in Potosí, "al cual se hallaron presentes más de doce mil indios" [at which there were present more than twelve thousand Indians], and to a play represented in Lima before "innumerables indios, cuyo argumento fue del Santísimo Sacramento, compuesto a pedazos en dos lenguas, en la española y la general del Perú" (*Comentarios* 1:120) [innumerable Indians, whose argument was about the Holy Sacrament, composed piecemeal in two languages, Spanish and the general language of Peru], that is, Quechua. Damón synechdocically representsents the vast indigenous audiences of these spectacles and models the reaction and conversion that the performances were intended to provoke.

Unlike the dramatic works Garcilaso mentions, *El Dios Pan* itself was composed in Spanish and was not directed at the indigenous population. Rodríguez Garrido reminds us that the work was dedicated to Diego de Portugal, *presidente* of the Audiencia de Charcas, suggesting that its intended audience was a narrow circle of elites.[29] In effect, *El Dios Pan* transposes into written form the public transcript, or "self-portrait of dominant elites as they would have themselves seen" (Scott 58), that was enacted through festivals like the Corpus Christi procession witnessed by Damón and Melibeo. On one hand, Damón is spiritually conquered by the sights and sounds of the Corpus Christi festival in a manner similar to that suggested by the spectators in the Holguín painting. On the other hand, Damón is intellectually conquered in the dialogue, verbally outwitted on several occasions by Melibeo, such as when the latter explains how the Christian God is the real God of "Arcadia" (a word derived from "ark") and when he corrects Damón's interpretation of an altar's symbolism. On the latter occasion, Damón concludes the exchange thus:

Yo callo, porque he visto tus razones
ser ardientes carbones, que se pega

su fuego donde llega, te concedo
que replicar no puedo; antes adoro
el inmenso tesoro que he hallado
en este pan sagrado. (10)

[I will be quiet, because I have seen that your reasons
are burning embers that start a fire
wherever they go, and I concede
that I cannot reply to you; rather, I adore
the immense treasure that I have found
in this sacred bread].

El Dios Pan thus represents an idealized performance of the Spanish Christian's rational capacities and pious motivations as well as of the pagan Amerindian's intellectual inferiority, submissiveness, and receptiveness to conversion.

Yet *El Dios Pan* still provides glimpses of the ways in which the embodied presence of performers and participants as well as audience members could complicate the public transcript of real festivals. These glimpses come through the commonplace, corporeal experience of the festival and the city as articulated in the dialogue: the frequent references to pushing, shoving, and the difficulty of passage through the crowded streets, references that increasingly interrupt both the dialogue and the idealized depiction of an orderly procession. Early in the dialogue, Damón remarks, "La apretura es grande y la estrechura en sumo grado" (7) [the congestion is great and the narrowness is exceeding], and he insists at another point, "Resisto cuanto puedo / de esta gente al denuedo" (9) [I am resisting as much as I can / this people's boldness]. By the end of the dialogue, however, it is Melibeo who confesses the most physical perturbation as a result of the crowds: "Con mucho detrimento he yo venido" (11) [I have arrived with much detriment], he states on one occasion; "¡Válgame Jesucristo, qué empellones!" (14) [Christ help me, what shoves!], on another; and finally, after arriving at the church, "Farallones / de encuentros y enviones y borrascas / de danzas y tarascas y tormenta / de nube polvorienta hemos sufrido" (18) [we have suffered / the cliffs of collisions and pushes, / the storms of dancers and dragons, / and the tempest of a dusty cloud].

The shipwreck metaphors are resolved when they enter the church and Melibeo claims to have arrived at "buen puerto" [a good port] (similar to how Mexía described his own refuge from misfortune in Potosí).

But even then, the collisions and shoves, crowds and dust complicate the "concierto, traza y modo / con que está puesto todo" (18) [concert, design, and manner in which everything is arranged], on which Melibeo focuses their attention in the church, and the "concierto que hay en todo" (7) [good order and arrangement that there is in everything] that had so provoked Damón's admiration in the procession outside. The public transcript of order and reverence is disrupted by the corporeal, unruly presence of the thronging masses that are supposedly the intended recipients of the message. Even if it does not subvert the objectives of this particular Corpus Christi procession—after all, Damón ultimately converts to Christianity—the embodied presence of onlookers shows one way in which, Elizabeth Dillon argues, the ontic dimension of theater can challenge its mimetic meaning or "send a script in an entirely new and unexpected direction" ("Coloniality" 182). In a public festival like the one depicted in *El Dios Pan*, which is expected to move its onlookers (literally and physically), such challenges to or redirections of the official script are all the more likely.[30]

Another slippage from the spiritual to the corporeal, the mimetic to the ontic, occurs at the very end of the dialogue in *El Dios Pan*. In the church, Damón and Melibeo witness a discourse and song proffered by a "Pastorcico" [little shepherd] in the church, a sort of self-referential, minipastoral eclogue on the divine sacrament also organized around the theme of "Dios Pan" that concludes by inviting hungry souls to feast on the God of bread:

> Venid a este banquete,
> almas habrientas y terneis hartura,
> comed este sainete,
> gustad desta dulzura
> que puso Dios en pan por criatura. (24)

> [Come to this banquet,
> hungry souls, and you will be filled;
> consume this play,
> and enjoy the sweetness
> that God put in bread as a creature.]

And yet the dialogue between Damón and Melibeo ends with a reference not to spiritual but to physical sustenance: "Asombre a todo el mundo / hecho tan sin segundo, i tu padrino / quiero ser, i en camino

nos pongamos / que son las tres i es justo que comamos" (26) [Let all the world be astonished / at such an unrivaled act; I want to be / your godfather, and let's get moving / because it's three o'clock and it's time we should eat]. No wonder it is the drama "Decuria de Santa María Egipciaca" that actually concludes the work. Damón is no longer content to remain in the passive role of spectator of the God of Bread and has apparently gone to eat lunch.

INDIGENOUS PERFORMANCES IN THE *HISTORIA DE LA VILLA IMPERIAL*

However much *El Dios Pan* allows the crowds to interrupt the idealized portrait of a carefully orchestrated festival, it offers little insight into how those groups may have reacted differently than Damón did and redirected its meaning. For this we must turn to other sources such as the accounts of festivals included in Arzáns's *Historia de la Villa Imperial de Potosí*. For the most part Arzáns depicts a festive splendor that coincides with that of *El Dios Pan* and sometimes is greater than Potosí could possibly have managed,[31] while shifting the object of admiration from the representatives of viceregal and ecclesiastical authority to the town and its creole citizens. However, Arzáns also narrates indigenous participation in festivals, as both onlookers and performers, to a greater extent than the official, published accounts of festivals in Potosí such as the anonymous *Relación de la grandiosa fiesta* or Fray Juan de la Torre's *Aclamacion festiva de la muy noble Imperial Villa de Potosi* (1716), a text to which I will return. Indeed, the "muchísimas fiestas" (2:331) [very many festivals] celebrated by Amerindians are an important part of Arzáns's account of Potosí's festive grandeur in the first two chapters of book 10.[32]

Arzáns's account of the Corpus Christi celebrations of 1608, around the time that *El Dios Pan* was written, depicts Amerindians in far more active and participatory roles than that of the fictional Damón. Arzáns relates how some one hundred richly dressed "indios" added luster to the festival through their participation in a mock battle with creoles who were the protagonists of the festival (1:276). These Amerindians appeared, as Arzáns describes them, "rica y galanamente vestidos a su usanza . . . las cabezas con preciosos llautus de piedras de mucho valor, y en ellos muchas plumas encarnadas, verdes, azules y amarillas; en los hombros, rodillas y empeines de los pies llevaban puestos unos mascarones de oro fino al modo que usaban los ingas del Perú" (1:276) [richly

and gallantly dressed according to their custom . . . their heads with precious *llautus* of very valuable stones, and in them many red, green, blue, and yellow feathers; on their shoulders, knees, and ankles they had maskettes of fine gold in the manner in which the Incas of Perú used to wear them]. Arzáns here refers to two important elements of the costume that designated Inca royalty after the Spanish conquest: the *llautu* (headband) and the *licra*, a golden maskette of a lion's heads.[33] The head wear, as described by Arzáns and depicted in the series of Corpus Christi paintings analyzed by Dean in *Inka Bodies*, is a colonial-era product: the *llautu* was a multicolored woolen braid worn by Inca sovereigns, but in the post-conquest period it frequently is represented or described as a jewel- and feather-encrusted band. Similarly, the golden maskettes were probably not used by the Incas as Arzáns claims, but they did come to signify Inca nobility in colonial-era processions.[34]

Although Arzáns labels the warriors with the generic term *indio*, the costumes were surely intended to designate elite status, as in a 1555 festival in which "la nobleza indiana" [the Indian nobility] carried the *llautus*, *licras*, and other royal insignias in the procession, "imitando el [acompañamiento] que tenían los monarcas ingas en su corte" (1:96) [imitating the accompaniment that the Inca monarchs had in their court]. The Indian nobility of Potosí included descendants of royal Inca lineage as well as *kurakas*, hereditary lords of ethnic groups, some of whom were appointed as *capitanes de mita* to deliver mining workers to Potosí.[35] Tom Cummins has argued that Inca regalia like the *llautu* gradually lost its ethnic specificity and functioned as "general signs of the *kuraka* class" by the seventeenth century ("We Are" 219). In the celebration of Philip IV's coronation in 1622, Arzáns describes the costumes of the "caciques y principales" in strikingly similar terms to those of the "indios" in the 1608 Corpus Christi festival, adding that "los caciques sobresalían en las galas" (1:349) [The caciques stood out in their finery].[36]

In Arzáns's account of the mock battle in the 1608 Corpus Christi festival, the *españoles* (who here include creoles) are eventually triumphant, with the *indios* thus playing the part of the defeated pagans in this version of the mock battle between Moors and Christians traditionally performed on Corpus Christi. Yet Arzáns does not limit the *indios'* role to vanquished pagans. He describes their attire in the same elaborate terms that he dedicates to the depictions of the creoles' costumes, while also narrating the battle in such a way that equates the opponents' skills: "comenzaron españoles e indios una batalla con tanta destreza que

sin lastimar a unos las espadas ni a otros las flechas, dieron mucho gusto a cuantos los vieron. Al cabo de un rato que duró la batalla se retiraron los indios y quedaron triunfantes los españoles" (1:276) [the Spaniards and Indians began a battle with such skill and without hurting one another neither with swords nor arrows, that they gave much pleasure to all those who saw it. After the short time that the battle lasted the Indians withdrew and Spaniards remained triumphant]. According to Arzáns, the *indios* were not defeated but withdrew, and it is only their retreat that allowed the Spaniards to claim triumph. Even if he fails to note their distinct class status on this occasion, he offers a detailed description of a costume that would have signified *kuraka* leadership rather than symbolic paganism for an indigenous public. Moreover, Arzáns's acknowledgement of the participation and performative skills of the Amerindians—whom he never marks as inferior to their Spanish or creole opponents—suggests that their role in the festival was quite different from Damón's passive observation and conversion.

An indigenous performance of festive dexterity and the reaction that it elicited from a multiethnic audience are evident in another account of a mock battle that occurred a few years earlier. The Hieronymite friar Diego de Ocaña, who traveled through Peru between 1599 and 1605 raising alms for the convent of Nuestra Señora de Guadalupe in Extremadura, Spain, confirms Mexía's and Arzáns's portrayals of opulent religious festivals in Potosí in his account of the feast day of the Virgin of Guadalupe in September 1601, which was celebrated "como si fuera día del Corpus" (170) [as if it were Corpus Christi]. Ocaña dedicates several pages to what he identifies as the four best performances in the *juego de la sortija* that began on September 30, the day of Saint Jerónimo (347). The final one features two dozen "salvajes de Tarapaya" [savages of Tarapaya] (a locale near Potosí) who enter the plaza accompanied by "un gran peñasco y dentro un caballo y un caballero que representaba al Inca, monarca y rey de los indios" (343) [a large rock and inside a horse and horseman representing the Inca, monarch and king of the Indians]. As the *cédulas* (leaflets) distributed to the crowds suggest, the performance is one of spiritual conquest along the lines of that enacted in *El Dios Pan*:

> Viene dentro de esta peña
> en medio de su dureza,
> nuestra ignorancia y rudeza.

Esto decían porque venía allí dentro su rey, y ansí él como ellos habían vivido como salvajes, con ignorancia de la verdadera ley, y la serpiente los había tenido engañados. (343–344)

[Inside this mountain,
In the midst of its hardness,
Comes our ignorance and rudeness.

This they said because their king was inside of it, and in this way he, like them, had lived as savages, without knowledge of the true law, and the serpent had deceived them.]

The Inca is rescued twice, first by a Spanish lady ("dama") representing faith, from the mountain in which he is imprisoned, and then, when a dragon subsequently swallows him up, by a knight representing evangelization ("predicación") and twelve armed men signifying Spanish force ("la fuerza de España") (345). Each time, his indigenous followers obey the lady's instructions to publicly renounce their devotion to their god, the sun, in favor of the star symbolizing the Virgin of Guadalupe. Their performance of conversion is reinforced by the Inca, who embraced the knight "que le había librado y le tomó por su padrino para aquellas fiestas" (346) [who had liberated him, and took him for his patron during that festival], thus establishing the same relationship as Damón and Melibeo at the end of *El Dios Pan*. The leaflets now distributed to the crowd read, "Para aquesta estrella / que hemos visto en nuestro polo, / dejo de adorar a Apolo" (346) [For this star / which we have seen in our pole / I stop worshiping Apollo].

Despite the performance of successful evangelization, the subsequent battle between the Inca and the knight elicits a different response from the indigenous audience. The Inca and his *padrino* joust so well that they have to repeat it two extra times, "por la mucha igualdad que había en las pasadas, que no se determinaron a juzgar por el mantenedor. Y a las dos últimas le ganó el Inca, y así se le dio el premio. . . . Y los indios quedaron muy contentos de ver que su rey llevase el premio, y lo celebraron mucho" (346) [because of the great equality in the previous lances, such that the sponsor of the joust could not render judgment. And the Inca won the last two, so he was given the prize. . . . And the Indians were very content to see their King win the prize, and they celebrated it a great deal]. This response does not necessarily contradict the earlier performance of Catholic conversion, but it reinstates the Inca as

the source of contentment and the object of celebration. And like Arzáns, Ocaña confirms the active—and occasionally triumphant—role of indigenous nobility or those representing Inca sovereigns in Potosí's festivals of the early seventeenth century.[37]

In other festivals described by Arzáns, indigenous participation is both more conspicuous and more diverse. In the 1555 celebrations of the newly designated patrons of Potosí (Christ, the Virgin of the Immaculate Conception, and Santiago), Amerindian groups lead and conclude the procession, and their specific identities are more clearly marked, from the fifteen companies of indigenous soldiers and their richly dressed captains at the head of the procession, to the two thousand "indios de su majestad, tributarios en el rico Cerro" [Indians of his Majesty, tributaries in the rich Mountain], to the *cumuris* (transporters of silver) to the "gran número de indios infieles" [great number of infidel Indians] on their way to be baptized at the rear.[38] Arzáns underscores the ethnic as well as class diversity of the indigenous participants; occupying fourth place in the procession are "muchas y varias naciones de toda esta América Meridional, 12 mancebos de cada una, con diversos trajes en el modo de vestir pero iguales en el género" (1:96) [many and varied nations of all this Southern America, 12 young boys each, with diverse costumes in the way of dress but equal in the genre]. In a 1590 festival celebrating the foundation of the new Jesuit church, a similar group of diverse indigenous nations appears near the head of the procession: "varias naciones de indios vestidos a la usanza antigua, cada uno con el traje de su reino o provincia" (1:290) [various nations of Indians dressed in their ancient way, each one with the costume of their kingdom or province]. Such processions have pre-Hispanic antecedents in the public festivals organized by the Incas, in which subject nations displayed their traditional costumes and dances, as described by Spanish chroniclers of Inca history and religion like Bernabé Cobo and Cristóbal de Molina.[39]

Another type of Inca ceremonial procession—that of rulers rather than ruled—continued in modified form in colonial-era festivals. In Cuzco, capital of the Inca Empire, the embalmed bodies of previous sovereigns were processed on litters during the inauguration of a new Inca ruler and other festive occasions.[40] After the conquest, past Inca sovereigns were not corporally present on ceremonial occasions but were represented by individuals who were often of noble Inca descent.[41] The procession of Inca rulers became a stock ingredient of festivals in Potosí and elsewhere in the Peruvian viceroyalty.[42] As early as the 1555 celebrations of the patron saints of Potosí, the opening procession included

a series of performers representing "todos los monarcas ingas hasta el poderoso Atahuallpa" (1:95) [all of the Inca monarchs until the powerful Atahuallpa]. In his account of a later procession in the more than twenty-day festival, Arzáns extends the succession to Sayri Tupac, who continued to resist the Spaniards at Vilcabamba until his capitulation in 1558. At the time of the 1555 festival, Arzáns reminds us, Sayri Tupac "vivía y molestaba a los españoles vecinos del Cuzco y de Huamanga con sagrientas [*sic*] guerras" (1:99) [lived and molested the Spanish citizens of Cuzco and Huamanga with bloody wars].[43] Although Arzáns can relate the inclusion of the defiant Inca ruler from the comfortable distance of the eighteenth century, with the knowledge of his ultimate surrender and conversion, his appearance in the procession surely carried different meanings for indigenous spectators in 1555, when they could still have hoped for his successful resistance.[44]

Indigenous participants of all sorts not only overwhelmed the procession but also shaped other aspects of the festival, such as the ephemeral architecture and theatrical representations. Of the thirty altars on display for the procession, Arzáns claims that half were sponsored and created by "curas, caciques, alcaldes y la demás nobleza Indiana" (1:95) [priests, caciques, mayors, and the rest of the Indian nobility]. Similarly, indigenous nobles were responsible for four of the eight *comedias* represented in the secular portion of the festivities, and it is their plays that Arzáns describes rather than the Spanish ones. The first two pieces are dedicated to the imperial triumphs of the Inca rulers Manco Capac and Huayna Capac; the latter two focus on the two Incas who disputed the throne at the time of the Spaniards' arrival—Huascar, the legitimate ruler, and his half-brother Atahuallpa, who captured Huascar and provoked a civil war that enabled the Spanish conquest. Although Arzáns identifies Atahuallpa as a "usurper" responsible for tyrannical acts against his half-brother, he portrays him in a better light when describing the final play, which represented the "prisión injusta que hicieron de Atahuallpa . . . tiranías y lástimas que ejecutaron los españoles en los indios" (1:98) [unjust imprisonment that they did to Atahuallpa . . . tyrannies and grievances that the Spaniards executed on the Indians].[45]

Arzáns concludes his description of the *comedias* by calling them "muy especiales y famosas, no sólo por lo costoso de sus tramoyas, propiedad de trajes y novedad de historias, sino también por la elegancia del verso mixto del idioma castellano con el indiano" (1:98) [very special and famous, not only because of their costly stage machinery, the propriety of the costumes, and the novelty of the stories but also because of

the elegance of the mixed Castilian and Indian verse]. Unlike *El Dios Pan*, the plays were clearly directed at both a Quechua- and a Spanish-speaking audience, and their message was surely as mixed as the verse. The performance of Inca imperial victories, the staging of the unjust imprisonment of Atahuallpa, and the appearance in the procession of the Inca who continued to resist Spanish rule surely communicated far more to indigenous viewers in 1555 than the official motive for the festivities, the naming of Christ, the Virgin, and Santiago as the patron saints of Potosí.

The reenactment of an imperial Inca past through two of the plays and the procession of Inca sovereigns surely served the interests of present native elites, as Dean and others have argued with respect to the Corpus Christi processions in Cuzco.[46] The *kurakas'* display, through costume and pageantry, of their connection with a triumphant Inca past was a public affirmation of their noble status. The privileges accorded by this status included exemption from tribute and *mita* labor as well as "a preferential place . . . in any church procession" (Cummins, "We Are" 209); in turn, their festive participation as Incas could serve as legal evidence of noble status (Graubart, *With Our Labor* 137).[47] Such public demonstrations of nobility may have been particularly important to *capitanes de mita* as a counter to the public humiliation they suffered when they failed to deliver the mandated number of *mita* workers to Potosí, a frequent occurrence given the natives' flight from the designated *mita* provinces.[48] Native Andean chronicler Felipe Guaman Poma de Ayala describes the punishments—placing in stockades, public whipping, hair shearing—as fit for a "ladrón o traydor" [thief or traitor], certainly not for the "señores deste rreyno de la tierra, que tienen título por su Magestad" (526 [530]) [lords of this kingdom of the land, who have title by your Majesty]. Dressing and processing as Incas provided an opportunity for indigenous nobles to induce public recognition of these royally granted titles.[49]

In effect, the extent of indigenous participation in the 1555 festival in Potosí makes Arzáns's account of it something of a "verso mixto del idioma castellano con el indiano" as well, since his description of the Inca costumes in the processions requires a great deal of Quechua vocabulary (1:99). Arzáns frequently interprets and explains for readers the elements of the elaborate Inca regalia borne by the nobles, such as the *llautu* and *licra*, but he lets the Quechua terms suffice for others, such as *chambe* (1:96).[50] The inclusion of Inca processions as well as other forms of native festive participation hybridizes the language of Arzáns's text,

forcing him to use and translate signs that are primarily meaningful to an indigenous public.

Arzáns further incorporates this embodied public when he describes what are surely unanticipated reactions to the festivities. In a 1641 wedding celebration that included another theatrical work depicting the "Prosperidad y ruina de los ingas del Perú" [Prosperity and ruin of the Incas of Peru], as the piece was entitled, Arzáns states, "Para los indios fue de mucho sentimiento levantando grandes alaridos conforme se declaraban" (2:250) [For the Indians it was very sorrowful, and they raised great cries as it was declared]. The great cries suggest the multilayered nature of the festive soundscape and the participatory dimension of indigenous spectatorship.[51] Arzáns himself was a witness to such responses in the festivals of his own day. When describing Atahuallpa's costume in the 1555 celebrations, he alludes to the continuing relevance of this figure to the indigenous population, precisely because of the public display of his image at festivals like that one: "hasta en estos tiempos es tenido en mucho de los indios, como lo demuestran cuando ven sus retratos" (1:99) [even in these times he is highly respected by these Indians, as they demonstrate when they see his portraits].

According to Arzáns, another visual representation of Inca sovereigns in 1624 almost managed to disrupt the festival itself: "estaba un gran teatro ricamente adornado, y en él (de escultura prima) toda la casa de los ingas monarcas del Perú, sentados por su orden con sus propios trajes, y sus nombres cada uno en unas tarjas con letras de oro, adonde acudió tanta multitud de indios que si de allí no los echaran no pudiera pasar el acompañamiento y procesión" (1:392) [there was a large, richly adorned theater, and in it were (beautifully sculpted) all of the Inca monarchs of Peru, sitting in order with the proper costumes, and each having their names in gold letters on shields, to which such a multitude of Indians flocked that if they were not forced to leave the procession and its company could not have passed]. Whereas in *El Dios Pan* the crowds only interrupt the dialogue and do not obstruct the ultimate goal of Damón's conversion, here we see an indigenous multitude capable of actually suspending the procession.[52] Even if it was unsuccessful in doing so, Arzáns's explanation for the throng of Amerindians reveals their power to manipulate the meaning of the festival; in this instance, at least, the crowd's admiration is not directed at the Christian saint motivating the festival (the canonization of Saint Ignatius of Loyola) but at the former Inca sovereigns.

Both of these examples to some extent justify the fear among Span-

ish authorities that indigenous participants would introduce their own symbols, practices, and meanings into colonial festivals, a fear Arzáns describes in his account of the 1559 exequies commemorating the death of Charles V:

> Acabada la obra y señalado el día para las honras de su majestad, pidieron encarecidamente los indios les permitiesen los españoles ir por delante de su acompañamiento: y aunque lo rehusaron porque no mezclasen en aquel sentimiento algunas ceremonias y supersticiones que en semejantes funciones suelen hacer con sus señores e ingas (por estar recientes en la santa fe y buenas costumbres), como viesen el afecto con que lo pedían estos naturales se les concedió el que acompañasen sin salir del orden que les dieron. (1:111)

> [With the work finished and the day designated for the honors of his majesty, the Indians begged for the Spaniards' permission to lead the accompaniment: and although the request was denied so that they would not mix in their grief the ceremonies and superstitions that in similar functions they do for their lords and Incas (because they were recent in the holy faith and good customs), as they saw the passion with which the natives requested it they allowed them to accompany it without departing from the order that they were given.]

Amerindians here manage to alter the procession to their own liking despite the Spanish officials' reservations.[53] The public transcript of this festival is thus not entirely an imposition of those in power but the result of a dialogue between dominant and subordinate groups. Importantly, the Spanish officials conceded in full knowledge of the different festive practices and traditions that such recent—and by implication, incomplete or imperfect—converts to the Catholic faith may have introduced into the event, which reveals the limits of their public transcript of triumphant evangelization.[54] The Spanish officials could not avoid the mixing of signs and practices any more than Arzáns can when describing such festivals in his text.

Arzáns's frequent and detailed narration of indigenous performances in Potosí's festivals, most of which occurred long before his birth, may have emerged from his interest in those of his own time, as we can see in an episode that inverts the roles of *El Dios Pan*, with an Amerindian as master of ceremonies and Europeans and a creole as observers. In part 2, book 2, chapter 6, Arzáns recounts his visit to the chapel of *cacchas* (un-

authorized silver miners) on the Cerro de Potosí in September 1725 to witness their celebration of the Exaltation of the Holy Cross (3:201).[55] He encounters four Frenchmen, "mis conocidos" [my acquaintances], also there to observe the festival. Arzáns describes how the Frenchmen reject the drinks (*chicha*, wine, or *aguardiente*) offered to them by Agustín Quispe—an infamous and rather violent *caccha* who is the subject of this and the preceding chapter and for whom Arzáns appears to have some sympathy.[56] The Frenchmen's rebuff provokes a bloody fight from which Arzáns himself barely escapes.[57] When Agustín transforms a festive flag, "una bandera que por adorno allí estaba" [a flag that was there for decoration], into a weapon against the foreigners, Arzáns intervenes to keep the peace: "Y yo hice harto en atajar más de 50 de sus compañeros que pugnaban por salir y matarlos a pedradas" (3:202) [I did a great deal to hold back more than 50 of his companions who were trying to go out and stone them to death). Arzáns relates how he was subsequently escorted to the bottom of the hill, confessing that "yo quedé muy alegre en verme lejos de aquellos indios" (3:202) [I was very happy to see myself far from those Indians].

Yet the episode suggests more intercultural approximation than distance on Arzáns's part. In contrast to the Frenchmen, Arzáns is gracious in the depiction of his host: "Hallábase allí el indio Agustín a quien saludé, y me hizo mucha cortesía. . . . Agustín con su natural cortesía me puso en las manos un grande vaso de aquel brebaje suyo que llaman chicha, pidiéndome con dulzura de palabras bebiese, que vendría fatigado del sol" (3:201) [There was the Indian Agustín, whom I greeted, and he treated me with much courtesy. . . . Agustín, with his natural courtesy, put in my hands a large glass of that beverage of theirs that they call *chicha*, urging me with sweet words to drink, for I had arrived weary of the sun]. Arzáns may have misunderstood the nature of Agustín's offer of drink; rather than merely serving to quench the thirst, *chicha* is a central component of Andean sociability and ceremonial practice (Abercrombie 163, 235–236). However, he clearly had a better appreciation of the gesture's significance than the Frenchmen did. Although he did not acknowledge it directly, he seemed to have accepted the *chicha* and the ritual participation it implied.[58] The contrast between Arzáns and the arrogant "extranjeros" [foreigners] could not be greater. Nor is it any less between Arzáns and the anonymous narrator of the *Relación de la grandiosa fiesta*, for whom indigenous drinking in festivals is a source of humor and means of objectification.

As the final example of indigenous festive participation witnessed

by Arzáns, let us return to the entry of Archbishop Morcillo in 1716. Arzáns follows quite closely both Melchor Pérez Holguín's painting *Entrada del Arzobispo Virrey Morcillo en Potosí* (fig. 1.1) and the Augustinian Fray Juan de la Torre's published account, *Aclamacion festiva de la muy noble Imperial Villa de Potosi*. However, Arzáns highlights indigenous participation much differently than either de la Torre's text or Holguín's painting. *Aclamacion festiva* describes the indigenous reception of the archbishop-viceroy on his way to Potosí:

> Dia pues veinte y cinco de Abril, saliò su Exc. . . . para la Villa de Potosi, . . . y en el espacio de quarto leguas bien estendidas, que consta su distancia, se vian coronadas las cumbres de los peñascos mas altivos, de copioso numero de Indios, que admirados esperavan ver su dueño, matizando de varias vanderas, y colores sus alturas, ni era menor la multitud que à la margen del camino real esperava en varias danzas, repetidos à su usanza con rústicos instrumentos, que si bien podia causar àdmiracion su numero crecido, movia à risueña diversion la variedad de sus trages, y figuras, con que cada qual intentava hazer la salva à su Señor, y mostrar con su sencillo amor su regozijo. (7v–8r)

> [On April 25th, his Excellency left . . . for the Town of Potosí, . . . and in the space of four long leagues that makes up the distance, one could see the peaks of the highest crags crowned with a copious number of Indians, who admiringly waited to see their lord, painting the heights with various flags and colors, nor was the multitude who waited on the side of the royal road any less. The latter performed various dances, repeated in their manner with rustic instruments, such that if their large number caused admiration, smiling amusement was provoked by the variety of their costumes and figures with which each one tried to salute their Lord, and demonstrate their joy with their simple love.]

The flags, music, and dancing displayed by the Indians are presented by the author of *Aclamacion festiva* as an expression of their adulation for and submission to the arriving figure of authority. Although their performance is said to evoke "admiration," it is not enough to displace the true object of celebration in the festival and in the text: the arriving dignitary.

Both Arzáns and Juan de la Torre highlight the nocturnal masque organized by the mine owners that is also depicted in one of the Holguín painting's insets (fig. 3.2). The painting shows the archbishop watching

FIG. 3.2. *Melchor Pérez Holguín,* Entrada del Arzobispo Virrey Morcillo en Potosí *(ca. 1716). Detail. Courtesy, Museo de América, Madrid.*

a performance on the float below, which includes a figure of himself sitting on a throne under a canopy, a miniature replica of the mountain of Potosí, and four costumed figures (represented by children, according to the textual sources). Presumably the artist could not fit in the four nymphs and two angels that Juan de la Torre identifies on the float, while Arzáns adds another figure that is absent from de la Torre's account: "otro en figura de niña indiana, o princesa de los ingas, con ricas vestiduras a su uso" (3:50) [another representing an Indian, a princess of the Incas, splendidly dressed after the fashion of that people (*Tales* 192–193)].

There is reason to follow Juan de la Torre here, since he was the author of the *loa* performed by the children on the float, as Arzáns himself points out. Yet Arzáns includes some more specific details about the performance that, like the Inca princess, do not appear in de la Torre. Arzáns writes,

> Llegó el carro . . . a confrontar con el mirador o balcón principal de la plaza donde ya estaba su excelencia acompañado del conde embajador y señores oidores con la nobleza de esta Villa. . . . [S]e detuvo aquel hermoso carro y entonó la música con gran destreza y melodía, y en particular el que hacía papel de princesa indiana alabanzas a su excelencia ilustrísima, y luego representaron dos niños que hacían a Europa y América: la una manifestaba haberle sido su oriente y dádole su cuna, y la otra sus dignidades episcopales y gobierno. . . . A la mitad de aquella

loa cantada salió de la boca de una mina de aquel Cerro, dispuesta al propósito, un indiecillo vestido a la propiedad de cuando labran las minas, con su costal de metal (que llaman cutama) a las espaldas, su montera y vela pendiente de ella (como lo hacen de las minas a la cancha a vaciar el metal) y así lo hizo derramando del costal oro y plata batida, y se tornó a entrar con lindas gracias, que dio mucho gusto esta representación a su excelencia, oidores y demás forasteros. (3:50)

[The float arrived at a position opposite the principal balcony in the plaza, where His Excellency was already seated in company with the count, his ambassador, the judges of the audiencia, and the nobility of this city; . . . the beautiful float stopped and the children sang with great skill and sweet melody; and in particular the child who represented the Indian princess offered praises to His Excellency. Then the two children representing Europe and America performed: Europe spoke of how she had provided his ancestry and been his cradle, America of how she had given him his episcopal honors and government post. . . . Halfway through this song of praise there emerged from the mine entrance provided for the purpose in the representation of the Mountain a little Indian boy dressed after the manner of those who work in the mines, with his ore bag (which they call *cutama*) over his shoulder, his hat with the candle dangling from it (such as they wear when carrying the ore out of the mines), and as if he were performing this work he poured beaten gold and silver out of his bag and reentered the Mountain with charming grace. This part of the performance greatly pleased His Excellency, the judges of the *audiencia*, and the other visitors from outside Potosí.] (193)

The tribute rendered to the archbishop-viceroy and his elite companions moves from the abstract to the concrete: the Indian princess showers him with praise and America sings of giving him his episcopal honors and government post, while the Indian boy performs the labor of silver mining. The whole scene evokes an earlier moment in the festival when beaten silver was literally poured over the archbishop-viceroy's head as he passed under a triumphal arch (3:47; 186), but here the indigenous bodies and labor practices that enabled the tribute are included in the representation.

Juan de la Torre more briefly alludes to the silver offering of this scene: "Abriose el Cerro, y saliò de su concavo un Apiri descargando panes de plata en significacion de sus metales" (22v) [The hill opened up,

and out of its depths came an ore carrier delivering loaves of silver sym-
bolizing its metals].[59] The lyrics of the *loa*, included in de la Torre's text,
confirm the sense of tribute: the character Music sings, "liberal ya le
ofrezco / los metales mas ricos / para tu desempeño" (22v) [liberally I of-
fer you the richest metals for the performance of your duties]. The lyr-
ics also emphasize the archbishop-viceroy's dominion and "desempeño"
[performance] in a much more pointed way than in Arzáns's account.
The figure representing Potosí commands, "Tributad los thesoros à su
invicto dueño / que es Argentum vivum / yman de esse Cerro" (22v)
[Give the treasures in tribute to the invincible owner, / who is the quick-
silver, / the magnet of this Hill], attributing the archbishop-viceroy with
ownership but also with the amalgamative power of mercury used to
produce silver. That is, he does not just take but makes the wealth. The
description of the float places the archbishop-viceroy in a dominant po-
sition with respect to the silver mountain as well. Arzáns simply states
that the Cerro de Potosí was at the feet of the boy representing the arch-
bishop (3:50), while de la Torre emphasizes that the boy was "en la sima
del cerro . . . mostrando que dominaba de aquel argentado obelisco los
metales" (20r) [at the summit of the Hill . . . showing that he dominated
the metals of that obelisk].

Such a laudatory presentation of the new viceroy, which repeats and
magnifies the celebratory, reverential goals of the festival, is not surpris-
ing in Juan de la Torre's official account, dedicated to the archbishop
himself. Arzáns in effect rewrites the performance to emphasize the in-
digenous labor that produced and offered the silver. He does so by iden-
tifying the "little Indian boy dressed after the manner of those who
work in the mines" as well as the objects and practices specific to min-
ing in Potosí: the ore bag "which they call *cutama*" and "his hat with the
candle dangling from it (such as they wear when carrying the ore out of
the mines)" (193). This *apiri* (ore carrier) does not simply signify expro-
priated mineral wealth, as in de la Torre's account (22v); nor is the labor
that goes into its production erased, as in the silver-generating body of
the Occidental mine on the Minters' Arch in Philip III's entry into Lis-
bon. The shift in emphasis from the European owner or consumer to
the indigenous producer of silver accords with Arzáns's strategic reori-
entation of the object of celebration from the archbishop-viceroy to Po-
tosí and its residents. But here the polity admired by foreign observers—
since "the performance greatly pleased His Excellency, the judges of the
audiencia, and the other visitors from outside Potosí" [193]—extends to

mita laborers, who were surely also among the audience and could have recognized themselves on stage.

Arzáns thus acknowledges the materiality of mining labor that was present in the festival but suppressed from the official account of de la Torre, even if he does so as a means to exhibit local knowledge only available to creoles like himself.[60] Creole writers are well known for appropriating pre-Columbian history (Aztec or Inca) as an imperial antiquity comparable to Greece or Rome, particularly in the context of public festivals.[61] There is ample evidence of this in Arzáns, from the frequent processions of Inca sovereigns to the concluding figures in the masquerade for the archbishop-viceroy: "uno de los ingas o rey del Perú con sus ccoyas (que es lo mismo que princesas o reinas) debajo de dosel, con gran majestad y riqueza de apropiados trajes" (3:50) ["one of the incas, or kings of Peru, with his *ccoyas* (a word signifying princesses or queens) under a canopy, dressed with great pomp and magnificence in costumes appropriate to those monarchs"] (193–194).

Perhaps such displays contribute to Arzáns's glorification of Potosí by showing it to rival Cuzco, seat of the Inca Empire and of colonial Inca nobility, in its successful performance of former Inca grandeur. Yet in Arzáns's account, admiration is elicited not only by portrayals of the imperial Inca past but also by representatives of the present indigenous population, such as the ore carrier. And mining is not the only indigenous occupation that Arzáns mentions in his account of the entry; "indias fruteras y tenderas" [indigenous women fruit sellers and shop owners] constructed 120 silver arches that lined the route of the procession (3:47–48).[62] Arzáns reveals that indigenous involvement in the reception of the archbishop-viceroy was greater than the performance of dancing and mining and extended to the expenditure of real mineral wealth. His portrayal of Amerindians in festivals goes far beyond presenting them as admiring observers, as emphasized by Holguín's painting, Juan de la Torre's official account, and Mexía de Fernangil's *El Dios Pan*, and includes moments in which they were the objects of admiration or contributed materially to the festive grandeur.

Whatever Arzáns's own goals in narrating the festivals of Potosí, his account brings to light some of the ways in which Amerindians participated in, helped to shape, reacted to, and occasionally disrupted them. And despite his frequent use of the generic term "indio," Arzáns's painstaking descriptions reveal a range of indigenous identities exhibited and performed in festivals, from Inca royals and *kurakas* to market women

and *mita* laborers. In these ways, the *Historia de la Villa Imperial* shows how the archive—the textual representation of festivals—can illuminate responses and challenges to the hegemonic account of power relations that colonial festivals were meant to display.

Mexía de Fernangil's *El Dios Pan* and Arzáns de Orsúa y Vela's *Historia de la Villa Imperial de Potosí* both emphasize the festive grandeur of the mining boomtown represented in Holguín's painting of the entry of Archbishop-Viceroy Morcillo, and yet each writer's narrative offers distinct inflections of the dialogue between the Spanish man and the Amerindian woman depicted on Holguín's canvas (fig. 3.1). *El Dios Pan* renders the same idealized exchange in an extended dialogue between a Spaniard and an Amerindian, but it also incorporates the on-the-ground, corporeal experience of the festival in ways that interrupt the portrait of order and hierarchy—perhaps like the dogs that, upon closer look, appear to be accosting the elderly observers in Holguín's painting, in marked contrast to the stately procession before them. Arzáns, on the other hand, describes the extensive participation of diverse native groups in processions and performances while he also helps to account for how they may have interpreted that participation, by recording the reactions of indigenous spectators—reactions that included admiration for former Inca rulers as much as for present Spanish, Christian ones. In Holguín's painting, perhaps the elderly woman's expression of admiration was directed at an entirely different source of grandeur than the procession of Spanish officials and the viceroy before her. These reactions and interventions in the festival may not be resistant or subversive in the way that Scott understands the hidden transcript; we must be wary of looking too much for pre-Hispanic "idols behind the altars," as colonial Spanish authorities were wont to do.[63] And yet this participation surely exceeded or evaded what religious and civic authorities expected and desired when organizing the public festivals of colonial Potosí.

"Nos Pretos como no Prelo"

AFRO-BRAZILIANS IN FESTIVALS,

FROM PERFORMANCE TO PRINT

Although individuals of African descent appear in some of the more dramatic tales narrated by Arzáns, he provides few clues as to their participation in the festivals that populate his pages.[1] In his description of the masquerade performed for the archbishop-viceroy's entry in Potosí in 1716, he briefly mentions the appearance of "etíopes con su rey coronado, con muy preciosas galas y jaeces" (*Historia* 3:50) ["Ethiopians and their crowned king, with beautiful costumes and trappings" (*Tales* 192)]. Earlier in the work, while narrating the Holy Week procession of 1685, Arzáns interpolates a reference to the "cofradías de los negros" [black confraternities] that used to lead the processions on Holy Tuesday but that at the time of his writing in the early eighteenth century "no salen por el descaecimiento que han padecido" (2:328) [do not participate today because of the decline they have suffered]. Taking their place at the head of the procession in Potosí are indigenous confraternities (2:328), just as Inca sovereigns are the crowned kings that Arzáns more frequently describes in Potosí's festivals.

The possible connection between these two examples of black participation in Potosí's festivals—black confraternities and crowned African kings—becomes clearer when juxtaposed with Minas Gerais, where the forced labor that produced the region's vast mineral wealth was of African rather than indigenous origin.[2] African slaves and their descendants performed the festive coronation of black kings and queens or election of black governors throughout the Americas, but in Minas Gerais and elsewhere in the Portuguese Empire, the practice was primarily associated with the Black Brotherhood of Our Lady of the Rosary, a confraternity that incorporated it into the celebration of their patron's feast day.[3] Perhaps the festive repertoire of Potosí's black confraternities, how-

ever much they had declined by the end of the seventeenth century, continued to live on in the coronation of African kings like the one who appeared in the masquerade in 1716.[4]

The greater longevity of black confraternities in Minas Gerais is explained not only by the greater presence of Africans and Afrodescendants but also the prominence of lay brotherhoods in the region. As a result of the Portuguese Crown's early prohibition of the establishment of religious orders there, lay brotherhoods of blacks and mulattos as well as whites played a particularly important role in Minas Gerais, where they were responsible for the construction of churches, the hiring of priests for religious services, and the celebration of Catholic holidays. Indeed, Caio César Boschi identifies the social history of Minas Gerais with the history of confraternities in the region, arguing that it is difficult to say which determined which (*Os leigos* 1).[5]

The Black Brotherhood of the Rosary, founded in Portugal by the early sixteenth century, was the oldest and most popular and prestigious of the many black and mulatto brotherhoods in colonial Brazil.[6] From the very beginning of the gold rush, dozens of chapters of the Black Brotherhood of the Rosary sprang up in the various municipalities in Minas Gerais, where they provided essential social services and opportunities to their members, both slave and free, as well as serving as a way for white masters to ensure their practice of Catholicism and supervise their activities.[7] Under the auspices of the Black Brotherhood of the Rosary, the sometimes controversial practice of crowning African sovereigns was for the most part officially sanctioned by religious and secular authorities. The 1715 *compromisso* (set of statutes) of the Caquende chapter of the Black Brotherhood of the Rosary in Vila Rica refers to the yearly election of a king and queen, "ambos pretos de qualquer nassão que sejão" [both black from whatever nation they may be], who were obliged to "assystir com o seu estado ás festividades de Nossa Senhora" (Lopes 195–196) [attend with their government the festivities of Our Lady].[8] Although the position was open to blacks of any ethnic origin (*nação*) in this case, the practice would eventually come to be associated specifically with the kingdom of Kongo, to the extent that the festival became known as the "festa de Rei Congo," or *congado*.[9] The *congado*, involving a coronation ceremony as well as a procession with music and dancing to escort the king and queen, continues to be practiced in Minas Gerais today.[10]

The extensive scholarship dedicated to black and mulatto lay religious brotherhoods in Minas Gerais and elsewhere has alternated be-

tween emphasizing their function as a mechanism of control, as Boschi argues, and highlighting their role in the formation and expression of identity, community, and agency. Much like Baroque festivals themselves (not surprisingly, since the sponsorship of religious celebrations was one of their principal occupations), black and mulatto brotherhoods have been viewed as an instrument of domination or resistance, conversion or subversion—or more frequently, a combination of the two. While their ambiguous nature has been emphasized in recent years, particularly in Brazilian historiography grounded in archival records related to specific confraternities, the early studies of Julita Scarano, A. J. R. Russell-Wood, and Patricia Mulvey in the 1970s and early 1980s already recognized, in Scarano's words, the "fundamentally contradictory" status of these brotherhoods as "strengthening the system, but also creating breaks in it" ("Black Brotherhoods" 13).[11] Marina de Mello e Souza notes in her recent history of the black king festivals that "as irmandades de homens pretos serviam tanto a interesses da sociedade colonial como a interesses dos africanos e seus descendentes" (202) [the black brotherhoods served both the interests of colonial society and the interests of Africans and their descendants]. As with festivals, multiple interests were served and multiple messages communicated through the same institution.

In his classic account of the emergence of black brotherhoods in Lisbon in *Os pretos em Portugal* (1944), António Brásio criticizes nineteenth-century historian Pedro de Azevedo's undocumented claim that as soon as they arrived in Portugal, blacks formed associations "mais ou menos secretas e governadas por reis, conforme consta de documentos ainda inéditos" (in Brásio 73) [more or less secret and governed by kings, as can be shown in documents that are still unpublished]. In fact, Brásio and later historians have drawn upon the wealth of archival documentation produced by and about the black brotherhoods to reconstruct their history and activities, including their practice of festive coronations of African sovereigns. Brásio finds that these institutions "nada tinham de 'secretas'" (75) [were not at all "secret"], belonging instead to what Scott would call the "public transcript" as much as the other entities involved in the festivals analyzed in this book do.

Like indigenous Andeans in Potosí, blacks and mulattos not only performed the mining labor necessary to generate Minas Gerais's spectacular wealth, but also performed in its spectacular festivals. The effort to understand how spectators and performers of African descent may have interpreted this participation often requires reading against

the grain of the texts that record it, since—as in Potosí—they were usually produced by and for white, elite audiences. Usually but not always, for *Triunfo Eucharistico* is a case in which "pretos" [blacks] intervened in the "prelo" [printing press], seeking to preserve and publicize their festive participation. Black and mulatto participation in festivals would seem to belong primarily to what Diana Taylor calls the "repertoire" of embodied practice, but if "performance belongs to the strong as well as the weak" (22), so too does the "archive" of permanent textual and visual records, the other side of her dichotomy. I thus reexamine the festival accounts analyzed earlier in order to foreground Afro-Brazilian celebrants in the realms of both the repertoire and the archive, performance and print.

THE "PRETOS" IN THE "PRELO": THE "MULATTO CARIJÓS" OF *AUREO THRONO EPISCOPAL*

A succinct, anonymous description of Bishop Manuel da Cruz's entry into Mariana, "Descrição das festividades da entrada do bispo de Mariana," is among the papers collected in the *Códice Costa Matoso* (in Campos and Figueiredo 663–664). Besides the two triumphal chariots and the angelic-sounding music, the description highlights two elements to convey the "apparatosa procissão triunfal" [showy triumphal procession]: "onze figuras de cavalo, com várias insígnias na mão, tudo dedicado ao prelado" [eleven figures on horseback, with various insignias in hand, all dedicated to the prelate], and "três danças gravemente ornadas ao próprio do seu sentido" [three dances gravely adorned as appropriate to their meaning] (664).

The much more elaborate descriptions of these dances in the official, published account, *Aureo Throno Episcopal* (1749), suggest that this "sentido" [meaning] may have been different for distinct audiences. According to the anonymous author, two of the dances were performed in disguise, harking back to the "naturally dark-skinned" Jesuit student representing an indigenous Brazilian king in the Lisbon royal entry of 1619. Like the student who performed music "al modo de los negros" (Mimoso 58r) [in the manner of the blacks], the seven masked figures who pull the first triumphal chariot

se occupavão . . . em varias danças, e cantos compostos ao modo dos pretos, que taes representavão nas feições, e cor das mascaras:

vestião-se de branco, e azul com saiotes do mesmo, e bandas bran-
cas guarnecidas de rendas aneladas. A mais passava a destreza dos di-
tos mascaras; porque em outras occasiões formavão gravemente entre si
hum Coro de musica, que a solos, e a cheios respondião, e acompaha-
vão o Coro superior. (*Aureo Throno Episcopal* 441)

[were occupied . . . with various dances and songs composed in the
manner of the blacks, for that is what the features and color of their
masks represented. They were dressed in white and blue, with match-
ing skirts with white bands garnished with curly lace. The skill of
these masked figures surpassed all, because on other occasions they
gravely formed a musical choir which responded to and accompanied
the superior Chorus with solos and in full chorus.]

José Ramos Tinhorão observes that the song is performed in the "es-
tilo responsorial, à base de coro e refrão, até hoje característico dos afri-
canos" (*As festas* 113) [call-and-response style, based on a chorus and re-
frain, even today characteristic of Africans].[12] Echoing the vocabulary of
gravity in the "Descrição das festividades," *Aureo Throno Episcopal* here
presents the music, dance, and masks signifying blackness as contrib-
uting to the solemnity of the bishop's entry as much as they do in Mi-
moso's account of the Jesuit play performed for King Philip a century
and a half earlier.

Aureo Throno Episcopal attributes more levity to one of the other
dances, which was also performed in disguise but this time by individu-
als whose African ancestry is clearly identified in the text. Following the
eleven figures on horseback was a "dança de Carijós, ou gentio da terra"
(454) [dance of Carijó Indians, or natives of the land], which was actu-
ally represented by "onze mulatinhos de idade juvenil" (454) [eleven lit-
tle mulattos of young age].[13] Dedicating a full paragraph to this dance,
Aureo Throno Episcopal describes the young mulattos' appearance—na-
ked from the waist up, with feathered skirts and headdresses as well as
ribbons and rattles tied to their arms and legs—and relates how they
flaunted their bows and sang and danced, accompanied by "outros Cari-
jós mais adultos" (455) [other, more adult Carijós] playing flutes and tam-
bourines. The age, skin color, and feathered costume of the "mulatinhos"
recall Mimoso's Jesuit student playing a Brazilian king, who was identi-
fied with the more flexible (and less stigmatized) but related term *pardo*
(58r).[14] And similar to Mimoso's reference to the "sumo regozijo de los
oyentes" (58r) [supreme enjoyment of the listeners], *Aureo Throno Episco-*

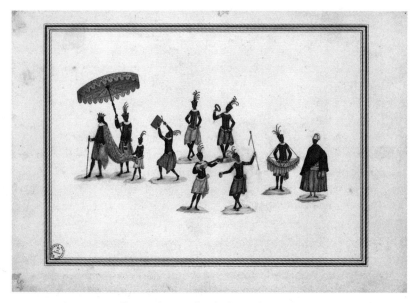

FIG. 4.1. *Carlos Julião,* Riscos iluminados de figurinhos de brancos e negros dos uzos do Rio de Janeiro e Serro do Frio *(ca. 1776–1779). Iconografia, Fundação Biblioteca Nacional, Rio de Janeiro.*

pal highlights the crowd's amusement at the verisimilitude of the performance: "na grosseria natural dos gestos excitavão motivo de grande jocosidade" (455) [the natural coarseness of the gestures provoked great jocularity]. In contrast to the gravity of the masked figures singing like blacks, the mulattos' performance appears to elicit laughter.

The description of the Carijó costume calls to mind the stereotypical images of the Tupinambá of northeastern Brazil—in particular, the feathered skirts and headdresses—that had circulated in Europe since the early sixteenth century.[15] In her study of the Black Brotherhood of the Rosary in Minas Gerais, Elizabeth Kiddy compares the "mulatto Carijós" to another well-known set of illustrations: the late eighteenth-century watercolors by the Italian artist and soldier Carlos Julião in an album entitled *Riscos iluminados de figurinhos de Brancos e Negros dos Uzos do Rio de Janeiro e Serro do Frio.* Several of the watercolors depict the procession of an African king and queen and their court during the festival of the Rosary (fig. 4.1).[16] Cecile Fromont draws another suggestive comparison with the Julião images and their similarities—in terms of dress, regalia, musical instruments, and gestures—to two watercolors representing ritual performances in the African kingdom of Kongo ("Danc-

ing"). There are fewer points of correspondence with the mulatto Carijós of *Aureo Throno Episcopal*, but like them, Julião's male figures wear feathered headdresses and dark clothing that makes their torsos appear naked while they dance and play tambourines, among other instruments.[17]

Kiddy points out the close resemblance of the Julião images to one of the "congado" groups, known as "caboclos" (Amerindians or mixed white-Amerindians) or the diminutive "caboclinhos" in reference to their indigenous costumes, that accompany the African king and queen in the Rosary festivals in some areas of Minas Gerais today (131).[18] Dances of "caboclinhos" appear in colonial festival accounts as well and help to explain the mulattos' indigenous disguise in *Aureo Throno Episcopal*. For example, in the description of a 1745 festival sponsored by a *pardo* brotherhood in Recife, Pernambuco, among the dances performed in the procession was a "graciosa dança de caboclinhos, composta de nove rapazes Índios do Pais, ricamente ornados, e nus da cintura para cima ao modo pátrio" (Ribeiro 33) [amusing dance of *caboclinhos*, composed of nine Indian boys of the country, richly adorned, and naked from the waist up in the manner of their country].[19] Although the costume mainly consists of gold, diamonds, silk, and lace, the headgear featured "tremulante plumagem na parte posterior" (Ribeiro 33) [fluttering plumage on the back], perhaps resembling the "penachos de plumas" [plumes of feathers] of *Aureo Throno Episcopal*'s mulatto Carijós. Although Amerindians accompanied Manuel da Cruz on his journey from Maranhão to Mariana, the relative scarcity of indigenous residents in Minas Gerais at the time—probably no more than 3 percent of the population, in contrast to 75 percent of African descent—may be the reason that the "caboclinhos" were represented by mulattos in the festival for the bishop's entry.[20] Yet the incorporation of the "caboclinho" dance in the *pardo* brotherhood's festival in Recife suggests the availability and appropriateness of an "indigenous" festive repertoire for Afro-Brazilians elsewhere.[21]

The spectators of the bishop's entry—and the readers of *Aureo Throno Episcopal*—may have identified the "dança de Carijós" with black festive performances as well. While the description of the "caboclinhos" identifies their nakedness from the waist up as the "modo pátrio" [native manner], the same lack of costume—or one designed to look like it—was frequently used by those performing as Africans, as seen in the Julião watercolors. In an account of the 1762 celebrations in Rio de Janeiro of the birth of Prince José, a *pardo* dancer in a performance imitating the king of Congo ceremony appears "com vestido nú fingindo África, armada de arco e flecha" [with a naked costume feigning Af-

rica, armed with a bow and arrow], reinforcing the African connotations of this costume (in Pereira 669n26).[22] We find a similar description of black performers in an earlier festival account from Lisbon. In the 1666 account of the celebration of the ill-fated marriage of Afonso VI and Maria Francisca of Savoy, cited by António Brásio, the blacks appear "a seu modo . . . nus da cinta para sima, & com seus arcos, & flechas" (74) [in their manner, naked from the waist up, with their bows and arrows]. Along with the Julião images, these references suggest that the "mulatinhos" of *Aureo Throno Episcopal* were not simply meant to pass as "Carijós" but rather that their costume—naked from the waist up and with bows and arrows—was part of both Amerindian and African festive performances.

Other eighteenth-century festival accounts allow us to draw firmer connections between the mulatto Carijós and the coronation of African kings as celebrated by the Black Brotherhood of the Rosary in colonial Brazil. Another published version of the 1762 festivities in Rio in honor of Prince José's birth, entitled *Epanafora Festiva* (1763), also describes the imitation of the African king's coronation ceremony by the city's *pardo* residents:

> Sahiraõ tambem em hum destes dias, com huma farça á imitaçaõ do estado, de que em ceremonia se serve o Rey dos Congos, esses homens mixtos (natural resulta de duas cores oppostas) a quem com impropriedade, mas por convivencia chamamos *Pardos*. Os gestos, a musica, os instrumentos, a dança, e o traje tudo muito no uso daquelles Africanos, descontentando ao bom senso, naõ deixavaõ de diverter o animo por estranhos. (27)

> [The mixed men (a natural result of two opposite colors), who incorrectly but for convenience's sake we call *pardos*, also came out on one of those days, with a farce in imitation of the state and ceremony of the king of Congo. The gestures, music, instruments, dance, and costume all had much in the manner of those Africans, displeasing to good sense but entertaining because of their strangeness.][23]

More pleasing than strange was the appearance of mulattos earlier in the festival: the Irmandade de São Braz dos Pardos, one of the brotherhoods described as "no modelo agradaveis, e estupendas na preciosidade" (15) [pleasing in form, and stupendous in preciosity]. Yet *Epanafora Festiva*'s reference to the displeasure provoked by the *pardos'* performance of Af-

rican kings is mitigated by the author's acknowledgment of the relativ-
ity of taste—"He outra lá a formosura; muito diverso o bom canto" (27)
[Beauty is different there; good singing is very distinct]—as well as his
recognition of the skill of the simulation, which is just as "natural" as
that of the mulatto Carijós: "Fizeraõ-o pois os nossos Pardos com toda a
propriedade, e agenceáraõ com ella o applauso, que pode franquear-se a
huma imitação" (27) [our *pardos* did it, then, with all propriety, and they
earned the applause that can be granted to an imitation].

Were the mulatto Carijós of Mariana in 1748 evoking the same king
of Congo ceremony as the *pardos* in Rio in 1762? The account of a prior
festival celebrating the marriage of Prince José's parents, Maria I and
Pedro III, Francisco Calmon's *Relação das Faustissimas Festas* (1762), of-
fers evidence of the use of indigenous costumes in the African king cer-
emonies of the eighteenth century.[24] Calmon describes a "dança dos
Congos," a "Reinado dos Congos," and other dances performed by the
goldsmiths of Santo Amaro, Bahia, as part of the city's celebration of the
marriage of Maria I and Pedro III of Portugal in 1760:

> Na tarde do dia dezesseis saiu o Reinado dos Congos, que se com-
> punha de mais de oitenta máscaras, com farsas ao seu modo de tra-
> jar, riquíssimas pelo muito ouro e diamantes de que se ornavam, so-
> bressaindo a todos o Rei e a Rainha. . . . Depois de tomarem ambos
> o assento destinado, lhe fizeram sala os Sobas e mais máscaras da sua
> guarda, saindo depois a dançar as Talheiras e Quicumbis, ao som de
> instrumentos próprios do seu uso e rito. Seguiu-se a dança dos meni-
> nos índios, com arco e frecha. Não foi de menor recreação para os cir-
> cunstantes um ataque que, por último, fizeram os da guarda do Rei
> com seus alfanjes, contra um troço de índios que saíram de emboscada,
> vestidos de penas e armados de arco e frecha, com tal ardor de ambas
> as nações, que com muita naturalidade representaram, ao seu modo,
> uma viva imagen da guerra. (23–24)

> [In the afternoon of the sixteenth the Reinado dos Congos came out,
> which was composed of more than 80 masked figures, with costumes
> in their manner of dress, richly adorned with a great deal of gold and
> diamonds, the King and the Queen foremost among them. . . . After
> both had taken their assigned seats, the Sobas and the other masked
> figures of their guard entertained them, and afterward the Talheiras
> and the Quicumbis came out to dance, to the sound of the instruments
> proper to their custom and rite. There followed a dance of Indian boys,

with bows and arrows. No less entertaining to the spectators was the attack that, in the end, the royal guard with their cutlasses carried out against a group of Indians that ambushed them, dressed in feathers and armed with bows and arrows, with such ardor in both nations that they represented with great naturalness, in their manner, a living image of war.][25]

Incorporating a variety of costumed dancers—African leaders (*sobas*), mulatto women (*talheiras*), and Amerindians (*quicumbis*)—the *reinado dos congos* elicits the audience's unflagging delight on three separate occasions during the festival, "excitando sempre nos que o viam a ánsia insaciável de gozar muitas vezes da sua alegre vista" (25) [always exciting in those who saw it the insatiable longing to enjoy its happy sight many times]. Feathered costumes, bows and arrows, ostensibly native music and dance, a combination of young and adult performers, the naturalness of the representation, the spectators' amusement—all of the elements of *Aureo Throno Episcopal*'s "dança de Carijós" are here, clearly incorporated into the festive performance of the coronation of African sovereigns, even if it is only an imitation of that ceremony by white goldsmiths.[26]

The *quicumbi* also points to the integration of African and indigenous performances in colonial festivals. Oneyda Alvarenga, who introduces and glosses Calmon's text in the modern facsimile edition, suggests that the *quicumbis* are the Indians who attack the king of Congo's guard, while Melo Morais Filho describes the Cucumbis of nineteenth-century Bahia as the "negros, vestidos de penas" [blacks, dressed in feathers] who dance and sing in popular festivals—groups which, he points out, are known in the rest of Brazil as Congos (141). Alvarenga even questions whether the diminutive "caboclinhos" in northeastern Brazil derives from performances like the "meninos índios" [Indian boys] described in Calmon's account (31n32)—a connection we might, like Elizabeth Kiddy, extend to the "mulatinhos" of *Aureo Throno Episcopal* and the "caboclinhos" of modern Minas Gerais (131).[27]

Silvia Hunold Lara has interrogated the meaning of the goldsmiths' performance of the *reinado dos congos* described in Calmon's account by pointing out the farcical dimensions of the imitation and the way the narrative contains the disruptive potential of the performance of African sovereignty:

Nas ruas ou no papel . . . eles constituíam eventos cujo sentido parece ser dado pelo olhar polido dos que organizavam, comemoria-

vam e escreviam esses festejos dinásticos. Longe de serem festas ne-
gras, constituíam festas brancas, nas quais os negros, pardos, caboclos
e índios apareciam para divertir, fazer surpresa e alegrar o ambiente.
(*Fragmentos* 192)

[In the streets or on paper . . . they constituted events whose meaning
seems to be given by the polished gaze of those who organized, com-
memorated, and wrote these dynastic festivities. Far from being black
festivals, they were white festivals in which the blacks, mulattos, mes-
tizos, and Indians appeared to entertain, surprise, and enliven the
atmosphere.]

Yet as Lara concludes by comparing Calmon's *reinado dos congos* to the
festive reception of African ambassadors in Brazil and to the coronation
of African sovereigns as celebrated by the Black Brotherhood of the Ro-
sary, the meaning of the performance may have been very different for
black spectators of the festival, who could have associated it with festiv-
ities in which real Africans were the protagonists: "[Podia] rememorar
outros reis negros, na longínqua África ou bem mais próximos, líderes de
muitos irmãos e confrades pretos" (217–218) [It could have recalled other
black kings, in faraway Africa or much closer, leaders of many broth-
ers in the black confraternities]. She thus emphasizes the ambiguous and
multiple meanings of the festival, including for the white goldsmiths
themselves, who may have used the performance to assert their own sta-
tus within the community (217). Since the "dança de Carijós" of *Aureo
Throno Episcopal* was performed by mulattos, it elicits even more ques-
tions about its significance for the participants and for different audi-
ences on the streets of Mariana as well as on the pages of the text.

Two avenues of interpretation are available to explore these mean-
ings. On one hand, we might take this performance as an example of
the interchangeability of exotic "others" in the European imagination,
such as when an account of travels in the East Indies draws on a Ve-
spucci image of Brazilian Indians to depict inhabitants of India and Su-
matra.[28] For the bishop and the local elite who organized the festivi-
ties surrounding his entry as well as for the Portuguese readers of *Aureo
Throno Episcopal*, mulattos could serve just as well as Amerindians, who
were far less numerous in Mariana at the time, to represent the pagan
savages who had been conquered and evangelized by the Portuguese.
Here we might recall Carolyn Dean's argument, in relation to Cor-
pus Christi celebrations in colonial Cuzco, that the "formal and festive

language of triumph . . . not only encouraged but required the appearance of ethnic subalterns" (2). In Minas Gerais, it is the black and mulatto populations that must assume the representation of ethnic diversity through which subordinated groups were incorporated into Christian festivals, in part, again, due to the relative scarcity of Amerindians in Minas Gerais. Another possibility is that the mulattos performing the "dança de Carijós" were in fact of Amerindian descent but not recognized as such by the author. Maria Leônia Chaves de Resende and Hal Langfur have demonstrated a larger indigenous and mestizo presence in Minas Gerais than previously thought and the slipperiness and flexibility of such markers as *carijó*, *caboclo*, *mestiço*, *pardo*, and *mulato*. Resende even cites cases of baptismal and ecclesiastical records in which *carijó* and *mulato* were used together to identify individuals ("Gentios brasílicos" 165–166). Even so, *Aureo Throno Episcopal*'s description of the dancers as "mulatinhos" would still suggest that the function of the Carijó performance for elite spectators and readers lies in the performance of a generic exoticism, not in ethnic or racial specificity.

In her discussion of the bishop's entry into Mariana, Júnia Furtado offers a similar interpretation that focuses on the white elite's perspective on the festive participation of ethnic or racial "others." Furtado argues that lower classes and slaves, while not entirely excluded from the festivities, were only accorded the role of spectators or, more exceptionally, the minor, ludic role of the mulatto Carijós. For Furtado, *Aureo Throno Episcopal* reveals that such performances were received with laughter and "não com o mesmo respeito com que eram tratados os demais segmentos do desfile" (262) [not with the same respect with which the other segments of the procession were treated].[29] Lara makes the same point when comparing Francisco Calmon's account to other festive performances in disguise, including that of *Aureo Throno Episcopal*: "Eram brincadeiras, traziam diversão, faziam rir: com leveza e graça, contrabalançavam e serviam para evidenciar as cenas mais graves e solenes" (*Fragmentos* 188) [They were jests, they brought diversion, they provoked laughter: with levity and humor, they counterbalanced and served to highlight the graver and more solemn scenes].

This line of interpretation, that the performance of ethnic or racial alterity in festivals primarily served to underscore European supremacy and the triumph of Christianity, is corroborated by another incident in the festival. Earlier, the anonymous author of *Aureo Throno Episcopal* uses a performance by blacks to illustrate the extent of the reverence and subservience rendered to the newly arrived bishop. The bishop is so univer-

sally well loved, he writes, "que até os proprios pretos em sinal do seu sincero reconhecimento, e obediencia se tem convocado com galantaria a virem dos Arraiaes de fóra, e de partes distantes, repartidos pelos dias Santos, a trazer cada hum seu esteio de lenha" (430) [that even the blacks, as a sign of their sincere recognition and obedience, have gallantly agreed to come from the mining camps and distant parts, divided according to the Saints' days, to bring each one their bundle of wood]. The groups divided into saints' days may refer to different black and mulatto brotherhoods active in Minas Gerais named after patron saints and responsible for the celebration of their feast days. Besides Our Lady of the Rosary, the brotherhoods included those of Saint Benedict, Our Lady of Mercy, and Our Lady of Amparo.[30] The text continues to describe this performance in rather more laudatory terms than the "dança de Carijós":

E he para admirar o concurso, que se ajunta de cada repartição, entrando pela Cidade formados em duas alas, com bandeiras, tambores, e instrumentos, e cantos a seu modo, e se encaminhão ao Palacio de S. Excellencia, e em hum pateo largão a lenha, que em grande quantidade tem conduzido. He inexplicavel o contentamento, que recebem, em S. Excellencia lhes apparecer, a cuja vista se põem todos de joelho debaixo das janellas, e com as mãos levantadas ao Ceo pedem com grandes vivas, e alegrias a benção, que Sua Excellencia lhes dá mandando tambem repartir por todos muitas veronicas de Santos, que elle aceitão com grande devoção. (430-431)

[And one must admire the crowd that gathers from each district, entering the City formed in two wings, with banners, drums, instruments, and songs in their manner, and they direct themselves to His Excellency's Palace, and on a courtyard they leave their wood, which they have brought in great quantity. The contentment they receive when His Excellency appears before them is unfathomable, and at his sight they all kneel down under the windows, and with their hands raised to Heaven they ask for a blessing with great shouts of "long live" and "rejoice," which His Excellency gives to them, as well as orders that many images of saints be distributed among them all, which they accept with great devotion.]

In this distant antecedent of modern *alas*, the groups within samba schools that parade with the same costumes during Brazil's *carnaval*, the

blacks offer their musical performance and the fruits of their labor and in return receive a Christian blessing and images of Catholic devotion. For the author of *Aureo Throno Episcopal*, this unequal performative exchange serves to demonstrate the triumph of Christianity, represented by the arrival of the necessary "disciplina Ecclesiastica" (347) [ecclesiastical discipline] in remote lands, and to underscore the devotion of all sectors of the population to the new bishop. More easily legible as an act of tribute and sign of subservience than the "dança de Carijós," it earns greater attention from the author as a performance to admire.[31] White readers of the account and spectators of the festival, including the bishop himself, may have interpreted the dance of the mulatto Carijós in much the same light.

Nevertheless, those performing ethnic or racial alterity may have interpreted their participation very differently. Juxtaposing the "dança de Carijós" with other festivals of the time as well as modern festive practices offers an alternative avenue of interpretation to the one outlined above. As we have seen, eighteenth-century festival accounts from other regions of Brazil provide ample evidence of the use of indigenous costumes and dance by black performers, often in the context of the coronation and procession of African kings, queens, and their courts. The coronation of African sovereigns had been performed in Minas Gerais by chapters of the Black Brotherhood of the Rosary since their founding in the early eighteenth century, and black and mulatto spectators would surely have been reminded of this tradition when viewing the "dança de Carijós" as well as the procession of blacks with flags, drums, instruments, and songs "in their manner" to render an offering to the bishop. Perhaps the mulatto Carijós were even making an intentional allusion to the Rosary festival and its celebration of African kings rather than being subjected to a mistaken identity by white organizers of the festival. Indeed, other mid-eighteenth-century accounts show mulattos incorporating dances of *caboclinhos* and *quicumbis* into their religious celebrations or imitating the coronation of African sovereigns in civic festivals. In the case of the festivities organized by the *pardo* brotherhood in Recife in 1745, the choice of an "indigenous" repertoire evinces more agency on their part than might be gleaned from the reference to the mulatto Carijós in *Aureo Throno Episcopal*.[32] Yet the mulattos in Mariana, like the *pardos* in Recife, may have viewed their participation in the bishop's entry as a proud assertion of a distinct identity and festive tradition—both Christian and African in inspiration—rather than as a sign of comic debasement, misrecognition of mulattos as Indians, or subservience. In ef-

fect, not only did blacks and mulattos participate in the bishop's entry; the bishop's entry also may have participated in the preservation of an Afro-Brazilian festival that itself was sustaining African traditions, as Cecile Fromont has argued.[33]

We might even speculate that the mulattos were appropriating and performing an Amerindian identity for symbolic or political reasons. According to Barbara Browning, the Indian-identified figures in contemporary Afro-Brazilian performance culture, such as the *blocos de índio* in Bahian carnival and the *caboclos* of the Afro-Brazilian religion of *candomblé*, derive in part from a "figural appropriation of the European figure of the 'wild Indian,'" which has come to "represent black resistance—wildness as the refusal to be controlled or contained" ("Daughters" 91).[34] She draws a parallel to other modern-day festive performers whose costumes recall that of the mulatto Carijós: Mardi Gras Indians, the African Americans who parade in extravagant Native American costumes on Mardi Gras and Saint Joseph's Day in New Orleans. Indeed, Jeroen DeWulf has suggested that similarities between Mardi Gras Indians and Afro-Brazilian performers like the mulatto Carijós are owed to shared origins in the Iberian festive tradition of Moors and Christians that was subsequently transformed into mock battles with pagans or Amerindians and intermingled with local practices in the kingdom of Kongo and New Spain, respectively ("From Moors").[35]

Mardi Gras Indians describe their performance as an expression of solidarity with Native Americans who protected runaway slaves, while critics have viewed it as the demonstration of, in Lipsitz's words, "a community of resistance and self-affirmation" (105).[36] Did the Carijó costumes represent the same idea of resistance to slavery for the mulatto performers in *Aureo Throno Episcopal*? The fact that they are referred to as "mulatinhos" rather than "pardos," the more respectable term connoting a free status, could suggest that they were slaves or assumed to be such by the author.[37] Even if *Aureo Throno Episcopal* itself offers little evidence to support such a reading, the visual and performative similarities to modern festive practices indicate the range of possible meanings that could have been ascribed to their performance by mulattos Carijós or their Afro-Brazilian audience. That is, making connections between different festive repertoires can point to meanings and motives that were not recorded in the archive.

The archive does, however, confirm the subversive potential of black and mulatto festivities from the perspective of colonial authorities, who increasingly came to view them with suspicion. In 1711, André João An-

tonil would recommend not only that slaves be allowed to "crearem seus Reys, cantar, & bailar por algumas horas honestamente . . . depois de terem feito pela manhã suas festas de Nossa Senhora do Rosário" (28) [crown their Kings, and sing and dance honestly for a few hours . . . after celebrating in the morning their festival of Our Lady of the Rosary],[38] but even that the masters should pay for the festivals' expenses (since few slaves could gather the funds "licitamente" (28) [licitly], according to the author). Yet such an encouraging and tolerant attitude became less common as the century progressed.[39] In various letters to King João V in 1719, the governor of Minas Gerais, Pedro de Almeida Portugal, claimed that rebellion was being fomented by the elected African kings, who as a result were imprisoned.[40] On some occasions such suspicions led to the banning of the festival, as would eventually occur in Mariana in 1771. That year, Father Leonardo de Azevedo Castro wrote a petition to the governor complaining how "todo aquele fingido aparato não produzia mais efeito que o de persuadirem-se os mesmos negros e alguns do povo que o intitulado rei o era na realidade, gastando-se com bebidas e abomináveis danças o que tiraram de esmolas a título de louvarem a Deus e à Senhora" (in Andrade, "Rosário dos homens pretos" n.p.) [all that feigned ostentation did not produce any effect other than persuading the same blacks and some of the populace that the one who was called king was a real king, spending on drinks and abominable dances what they had raised through alms for the purposes of praising God and Our Lady]. Dances that Antonil had once called "honest" (*Cultura* 28), were now "abominable," according to Castro, surely in part because the feigned kings performing those dances were assuming real authority.[41]

Eventually, the parish priests of Mariana would prepare a long report for Queen Maria I in 1793 denouncing the "corrupção e desordem" [corruption and disorder] of black and mulatto brotherhoods "com grande prejuízo da igreja, da Real Fazenda, do Padroado Régio e da conservação dos povos" [with great damage to the Church, the Royal Treasury, the Royal Patronage, and the conservation of the populace].[42] A similar document prepared by the parish priests in Vila Rica in 1795 denounced the black brotherhoods' illicit engagement in festive practices, specifically that

> aqueles espíritos naturalmente orgulhosos, descomedidos e arrojados perdem o respeito a toda a hierarquia e rompem nos maiores excessos, como têm feito repetidas vezes, e o fizeram em Vila Rica as duas Irmandades dos pretos e crioulos que, conseguindo provimento em um

recurso contra o seu pároco, puseram luminárias, repicaram sinos, e com bombas e foguetes do ar correram tumultuosamente de cruz alçada, fazendo algazarras por toda a freguesia.

[those naturally proud, rude, and brazen spirits lose respect for all hierarchy and break out in the greatest excesses, as they have done repeated times, and the two Brotherhoods of the blacks and creoles did it in Vila Rica, having obtained a provision in an appeal against their parish priest, lighting lamps, ringing bells, and with bombs and fireworks in the air they tumultuously ran around with the cross upheld, raising scandal in the whole parish.][43]

Unlike in official accounts of celebrations, here festive "excesses" are interpreted as signs of subversion rather than subservience. These documents indicate ways in which black brotherhoods used festivals—especially but not only the coronation of African Kings—to assert their own power and prestige and to counteract their subjugation in colonial society. In the words of the Mariana parish priests' complaint about the black brotherhoods' failure to accompany the host during Corpus Christi in the prescribed manner, "se até com o Santissimo disputão izenção, e authoridade, faltão ao Respeito, e veneração devida, não hé muito, que atropelem os seus Ministros" [if even with the Holy Sacrament they dispute exemption and authority, and fail to show the required respect and veneration, it's not far from running over his Ministers].[44] Although the bishop's entry predates the official efforts in Mariana to curtail the black brotherhoods and their festivals, similar fears and concerns in part may explain the obliqueness of the allusions to black festive traditions in the bishop's entry, but such signs may still have been legible to the participants and observers of African descent.

If the mulattos did view their *Carijó* costumes as a symbol of liberty, then there is some irony in the fact that one of the Amerindians who accompanied the bishop on his journey from Maranhão—one João Colomis, whose story Maria Leônia Chaves de Resende and Hal Langfur relate in an article about indigenous resistance in Minas Gerais—actually ended up being enslaved by the priest to whom the bishop had entrusted Colomis's religious education upon their arrival in Mariana. This priest was Francisco Ribeiro da Silva, canon of the new cathedral in Mariana and sponsor of the publication of *Aureo Throno Episcopal*. Or perhaps the joke was on the priest. After many years and a lengthy judicial battle, João Colomis regained his freedom, and it was Francisco Ri-

beiro da Silva who ended up in captivity after he was found guilty of violating legislation prohibiting the enslavement of Indians (Resende and Langfur 212).[45] For Resende and Langfur, the hard-fought legal cases of Indians like João Colomis demonstrate that asserting an indigenous identity could lead to freedom from slavery: "os índios recorreram à justiça colonial, ao afirmarem sua origem nativa, para, sob prerrogativa da lei, assegurar a liberdade" (213) [the Indians resorted to colonial justice and affirmed their native origin in order to, under the prerogatives of the law, assure their liberty]. In other words, these cases demonstrate that "Carijó" was in fact an appropriate model for a festive performance intended to assert a free, nonslave identity.

The two avenues of interpretation that I have outlined for understanding the festive participation of the "mulatto Carijós" in the bishop's entry to some degree fit into a binary opposition of domination and resistance long familiar to colonial studies. Were the young mulattos forced to perform as Indians during the bishop's entry in order to symbolize the Church's triumph over pagan barbarians? This would accord with *Aureo Throno Episcopal*'s depiction of the bishop's entry as the extension of ecclesiastical power and discipline into remote, uncivilized lands: "O Paiz das Minas não tinha ainda toda a cultura espiritual necessaria para salvação das almas . . . e por isso chegava às Minas com menos vigor do que era necessario a disciplina Ecclesiastica" (347) [The Country of the Mines did not yet have all the spiritual culture necessary for the salvation of souls . . . and for this reason ecclesiastical discipline arrived in Minas with less vigor than was necessary]. Do the mulatto Carijós reinforce this narrative of the imposition of colonial order? Alternatively, do they disrupt it—or attempt to disrupt it—by alluding to black festive traditions involving the coronation of African sovereigns and by invoking an indigenous identity as a symbol of resistance and freedom?[46] These alternatives reflect, on a smaller scale, two divergent approaches to the black and mulatto brotherhoods and to colonial festivals more broadly, along with so many other colonial institutions: are festivals and brotherhoods primarily a means of social control and religious indoctrination, or are they outlets for the formation, promotion, and celebration of Afro-Brazilian communities?

These options are not necessarily mutually exclusive; it is more likely that different audiences ascribed distinct meanings to the "dança de Carijós" and even that multiple messages were intended by the performers themselves. Elizabeth Kiddy writes with respect to the Black Brotherhood of the Rosary in Minas Gerais, "Their members learned to

survive through the tactics of negotiation, subterfuge, and endurance, demonstrating that there were a wide range of responses to slavery, responses that push out against the confines of the simple bipolar opposition of resistance and accommodation" (249).[47] Nevertheless, in the case of the "mulatto Carijós" in *Aureo Throno Episcopal*, the "archive" clearly appears to be on the side of the powerful (to invoke Diana Taylor's terminology again); it is only by thinking about continuities and resemblances in festive repertoires that the possible agenda of the performers begins to emerge more clearly. I will now return to the archive to propose another sort of reading, one that problematizes the dichotomy not only between domination and resistance but also between the archive and the repertoire—by emphasizing the performative, rhetorical nature of the archive itself.

THE "PRELO" OF THE "PRETOS":
THE BLACK PUBLISHERS OF *TRIUNFO EUCHARISTICO*

Published in Lisbon in 1734, fifteen years before *Aureo Throno Episcopal*, Simão Ferreira Machado's *Triunfo Eucharistico* describes the celebrations surrounding the transfer of the Holy Sacrament to a new church in Vila Rica do Ouro Preto in 1733. The population boom as a result of the gold rush required that a new church be built to replace the modest original Igreja Matriz da Senhora do Pilar, and until it was ready the Eucharist had been housed in the church of the Black Brotherhood of Our Lady of the Rosary, a branch of the mother church located in the Caquende neighborhood.[48] *Triunfo Eucharistico*, which describes the festivities surrounding the transfer of the Eucharist from the Black Brotherhood of the Rosary's church, includes no allusion to the sometimes controversial celebration with which the brotherhood was more commonly associated: the coronation of African sovereigns. The absence is not due to the Black Brotherhood of the Rosary's limited involvement in the festivities; on the contrary, one of the text's licenses praises it as having "muita parte" [a great part] in the magnificent celebrations: "para a entrega, e despedida da fiel guarda, que até entaõ tinha feito do mesmo Senhor, mitigou a sua saudade no luzimento da sórte, que lhe coube, manifestando com excessos de suas veneraçoens o seu amor, e disvelo" (150–151) [for the delivery and departure of the faithful custody of the very Lord which they had performed until now, they mitigated their wistfulness through the display of the fortune that was granted to them,

demonstrating with excessive veneration their love and zeal]. In the procession, the brotherhood, "numerosa de muitos Irmãos" (253) [numerous with many brothers], was accompanied by no less than two images of saints and one of Our Lady of the Rosary, all elaborately adorned with gold, silver, silk, and flowers (254). In contrast to the complaint proffered by the parish priests of Vila Rica in 1795, here the festive "excesses" are evidence of veneration.

Yet the Black Brotherhood of the Rosary's involvement in the transfer of the Eucharist was not limited to the procession. It also contributed to the expense of the festivities, and even built a new road between the two churches for the procession to pass. In a petition to the Crown in 1769 to confirm their ownership of the land that the city council had granted them in compensation for building the road,[49] the brothers explain that after the new church was built, "se fizera a solene trasladação do Santissimo Sacramento, e por não haver Rua, nem comodidade para hir a Procissão se romperão Morros ingremes, incapazes de habitação, o que os Supplicantes tinhão feito, concluindo huma Rua, que hoje era a milhor, e de mais concurso, que tinha a dita Villa" [they were to perform the solemn transfer of the Holy Sacrament, and since there was no Road nor comfortable way for the Procession to go, the Supplicants broke down steep, uninhabitable hills, finishing a Road, which today is the best and most traveled of the said town]. The town council, they go on to argue, had conceded them the land, "em remuneração do que tinhão feito, em utilidade publica" [in compensation for what they had done for the public utility]. Throughout, the petition continues to insist upon the "public utility" and "public good" ("cómodo público") served by the road as well as the brotherhood's physical and financial sacrifices in creating it.

The *procurador* (Crown's attorney) concurred, explaining that he was persuaded to support the petition as a result of the blacks' poverty and devotion and because they had done "huma tamanha, e tão consideravel obra, em beneficio da Cidade, e do publico" [such a large and considerable work to the benefit of the City and the public].[50] These efforts and the documents that record them demonstrate a concern for public utility that defies the image of slaves at the time. In a 1751 account of the exequies commemorating the death of King João V in São João del-Rei, Minas Gerais, the author includes slaves among the town's inhabitants who lamented the death of the king, but he distinguishes them disparagingly as "pouco inteligentes da pública utilidade" [not very intelligent about public utility], adding that they "não sabem pesar a ruína do cetro

na balança do entendimento" (*Salgado and Alvarenga* 227) [do not know how to weigh the ruin of the scepter on the scale of their understanding]. The black brothers' savvy use of the language of public utility in their petition is striking by contrast and certainly evinces intelligence and understanding enough to make a successful legal argument.

Yet the image of slaves in the 1751 account of the royal exequies was one that circulated widely in the realm of print, and it is in this public sphere that the Black Brotherhood of the Rosary also sought to intervene by sponsoring the publication of the festival account.[51] As the title page of *Triunfo Eucharistico* reads, the text is "Dedicado á Soberana Senhora do Rosario pelos irmãos pretos da sua irmandade, e a instancia dos mesmos exposto á publica noticia por Simam Ferreira Machado" [Dedicated to the Sovereign Lady of the Rosary by the black brothers of her brotherhood, and at their insistence exposed to public notice by Simão Ferreira Machado]. Although the author is identified, the title seems to grant more agency to the text's sponsors by highlighting their "insistence" that the account be exposed to "public notice"—language that mirrors not only that of the petition but also the "pública exaltação" [public exaltation] with which the festival is described at the beginning of the title: *Triunfo Eucharistico, Exemplar da Christandade Lusitana em publica exaltaçaõ da Fé.*

The publication license, granted by Father Manoel de Sá, offers his interpretation of why the black brotherhood sponsored the text's publication: "querendo, que se perpetue na lembrança este circunspecto exemplar daquelles Catholicos moradores, e que *nos Pretos como no prelo* se estampe este Triunfo, e este resplendor Luzitano, para que sua exaltada memoria sirva de gosto, e alegria a toda a Igreja, e a todos os Portuguezes" (151, my emphasis) [wishing that this circumspect exemplar of those Catholic inhabitants be perpetuated in memory and that this Triumph and Lusitanian splendor be imprinted *in the press as on the Blacks*, so that its exalted memory would delight the whole Church and all of the Portuguese]. The wordplay *preto/prelo* evinces an attempt to circumscribe the blacks' role to those on whom the Eucharistic triumph was impressed. Such a role would be similar to that of Amerindians in Corpus Christi festivals that, as Dean argues, "celebrated military triumph and domination over yet another non-Christian people" (7). In a similar vein, some critics would describe the festival of *Triunfo Eucharistico* as a symbol of what Hoonaert calls "o triunfo da ordem colonial" (50) [the triumph of the colonial order].[52] But in the wording used by Father Manoel de Sá in the license, the awkward shift in "pretos" from subject to object does

not quite succeed in erasing the agency attributed to the black brothers in the first part of the clause, where they are the ones seeking to perpetuate the memory of the festival among "the whole Church and all of the Portuguese."

In effect, the Black Brothers of the Rosary redefined the triumph by turning the celebration of the Eucharist into an act of self-celebration. Unlike the Spanish American colonies, Brazil had no printing press at the time, and the account's publication in Lisbon was intended to impress upon European readers the exemplary devoutness of the Catholic residents of Vila Rica, among them necessarily the members of the Black Brotherhood of the Rosary. This concern is clearly stated in the dedication of the work to Our Lady of the Rosary, which precedes the licenses and is signed by "Os Irmãos Pretos da vossa Irmandade do Rosario" (140) [the Black Brothers of your Brotherhood of the Rosary]:[53]

> Do mesmo nosso affecto nasceo o desejo, de que taõ grande solemnidade se publicasse, porque a noticia tem estimulos para o exemplo; e dilatando mais a veneraçaõ, e gloria de vosso Santissimo Filho, tambem dilata este motivo de vosso agrado. Esta consideraçaõ nos obrigou a solicitar esta publica escriptura, em que sempre o nosso affecto esteja referindo em perpetua lembrança, e continua narraçaõ aos presentes, e futuros toda a ordem de taõ magnifica solemnidade. (138–139)

> [The desire was born from our same affection, that such a great solemnity be published, because the news can stimulate by example; and enlarging more the veneration and glory of your Holy Son, this motive of your pleasure will also be made greater. This consideration obliged us to solicit this public writing, in which our affection will always be referred in perpetual memory, and such magnificent solemnity in all of its order will be continuously narrated to those in the present and the future.]

Clearly the brothers see print ("publica escritura") as another means of contributing to the public good, in this case by inspiring religious veneration. In contrast to the passive role expected of and ascribed to neophtyes like Damón in *El Dios Pan*, the brothers here position themselves as providing rather than following an example, as stimulating devotion rather than being stimulated by festive magnificence.

While the writer of *Aureo Throno Episcopal* remains anonymous, *Triunfo Eucharistico*'s author is identified on the title page: Simão Ferreira

Machado, "natural de Lisboa, e morador nas Minas" [native of Lisbon, and resident of Minas Gerais]. Yet the arrangement of the title page and the dedication ostensibly composed by the black brothers suggest a consciousness of, even a dispute over the authorship of the account and urge us to attribute at least equal significance to the text's sponsors—the ones who actually made the work public or "brought it to light," in the words of the title page of *Aureo Throno Episcopal* ("dado à luz por Francisco Ribeiro da Silva"). The title page of *Triunfo Eucharistico* inverts the order of author and sponsor that appears on the cover of *Aureo Throno Episcopal*, in effect giving the black brothers precedence over Machado by mentioning them first and by presenting the name of the brotherhood— "DO ROSARIO"—in the boldest and largest red lettering of the page, dwarfing that of the author in size and matched only by "EUCHARISTICO," "SACRAMENTO," and "VILLA RICA," although the wider spacing of "DO ROSARIO" arguably draws the eyes more (fig. 4.2).[54] In the dedication to Our Lady of the Rosary, the black brothers even refer to themselves as authors of the text at the same time as they disavow their preoccupation with fame: "mais que a gloria de Autores, estimamos o nome de agradecidos veneradores vossos" (139) [more than the glory of authors, we esteem the name of your grateful worshippers]. If the dedication was not in fact written by a member of the brotherhood, among whom literacy was of course quite limited, the statement is just as revealing; perhaps it was included to head off any presumption of authorship on the part of the Black Brotherhood.[55]

For its part, the preliminary address written by Simão Ferreira Machado attributes authorship of the festival itself to the officials of another brotherhood, the white Brotherhood of the Holy Sacrament, which arranged for the transfer of the Eucharist from the Church of Our Lady of the Rosary to its permanent place in their new temple, the Igreja Matriz de Nossa Senhora do Pilar: "concorrêraõ na gloria desta acçaõ, como Autor principal, o Provedor, como segundos Autores, o Procurador, Escrivaõ, e Thesoureiro, e mais irmãos da Irmandade do Divino Sacramento; accessoriamente todos os moradores da Parrochia" (186) [competing in the glory of this action were the Ombudsman as principal Author; the Attorney, Scribe, and Treasurer, and the other brothers of the Brotherhood of the Divine Sacrament as second Authors; and all the residents of the Parish as accessories]. The different attributions of authorship to these two brotherhoods in the dedication and the prologue suggest a sort of dispute over priority and preeminence.[56]

Indeed, brotherhoods often used public festivals to engage in such

TRIUNFO
EUCHARISTICO,
EXEMPLAR DA CHRISTANDADE LUSITANA
em publica exaltaçaõ da Fé na folemne Trasladaçaõ
DO DIVINISSIMO
SACRAMENTO
da Igreja da Senhora do Rofario, para hum novo Templo
DA SENHORA DO PILAR
EM
VILLA RICA,
CORTE DA CAPITANIA DAS MINAS.

Aos 24. de Mayo de 1733.
DEDICADO Á SOBERANA SENHORA
DO ROSARIO
PELOS IRMÃOS PRETOS DA SUA IRMANDADE,
e a inftancia dos mefmos expofto á publica noticia
Por SIMAM FERREIRA MACHADO
natural de Lisboa, e morador nas Minas.

LISBOA OCCIDENTAL,
NA OFFICINA DA MUSICA, DEBAIXO DA PROTECCAÕ
dos Patriarchas Saõ Domingos, e Saõ Francifco.

M.DCC.XXXIV.
Com todas as licenças neceffarias.

FIG. 4.2. *Simão Ferreira Machado,* Triunfo Eucharistico *(1734), title page. Courtesy, the Oliveira Lima Library, the Catholic University of America, Washington, DC.*

rivalry. Caio César Boschi cites eighteen cases of interbrotherhood lit-
igation between 1746 and 1803, nearly half of which concerned disputes
over precedence and sumptuary privileges in processions (*Os leigos* 233).[57]
Julita Scarano writes that "the brotherhoods of the colored were espe-
cially anxious to situate themselves in positions equal to, or superior to,
their rivals." She finds in *Triunfo Eucharistico* a specific example of this
rivalry: the "opas de seda branca" (S. Machado 253) [capes of white silk]
worn by the Black Brotherhood of the Rosary in the procession, "simi-
lar to those worn by the favored socioeconomic group" (Scarano, "Black
Brotherhoods" 10). With this attire, the black brothers may have been
flouting preoccupations like the one expressed in a mid-eighteenth-
century sumptuary law cited by A. J. R. Russell-Wood that refers to "the
great inconvenience caused in the overseas conquests by the liberty with
which blacks and mulattos . . . clothe themselves in the same way as do
white people" (*Black Man* 68). In 1758 the members of the *pardo* brother-
hood of São José in Vila Rica petitioned the crown for the right to bear
swords during "actos publicos da sua Irmandade" [public events of their
Brotherhood] such as processions; without this right, they complained of
the affront to their honor and their resulting lack of enthusiasm to finish
constructing their church: "por cauza da prohibição . . . se achão quasi
todos desanimados, e com menos zelo, e fervor na continuação da dita
obra" [because of the prohibition . . . they find themselves almost all dis-
couraged, and with less zeal and fervor to continue the said work].[58] The
petition reveals not only the *pardo* brothers' preoccupation with public
festivals as an opportunity to display external signs of status but also
their astute use of the language of religious devotion to achieve their
objectives.

João José Reis has observed a similar use of festivals as a means of
self-defense and self-promotion in the 1789 attempt of the Black Brother-
hood of Saint Benedict in Bahia to rewrite their statutes so that the po-
sitions of scribe and treasurer traditionally held by whites could be held
by blacks. Reis cites a document that presents the devotion displayed
in religious processions as evidence of the black brothers' devotion and
self-sufficiency: "os irmãos pretos exerciam 'seus empregos com mani-
festo zelo, e louvor, como é notório nesta Cidade, e bem prova o aparato
de suas Igrejas, e Capelas, e a Religiosa pompa com que fazem as suas
Procissões'" (14) [the black brothers exercised 'their duties with mani-
fest zeal and praise, as is well known in this City, and well proven by the
grandeur of their Churches and Chapels, and the Religious pomp with
which they carry out their Processions']. As the petition suggests, such

religious pomp did not go unnoticed by white observers. In 1721, Frei Agostinho de Santa Maria praised the festivals of the Black Brotherhood of the Rosary in similar terms: "Fazem os pretos a sua festa com muita grandeza; porque em nada se querem mostrar inferiores aos mais, e ainda aos brancos" (244) [The blacks perform their festival with great grandeur; because in nothing do they want to show themselves inferior to others, even the whites]. Santa Maria emphasizes the spirit of competition that motivates the festive grandeur, which can also be observed in their construction of an altar to "igualar, e vencerem, se pudessem, os [altares] da Irmandade da Matriz" (244) [equal and surmount, if they could, the altars of the Brotherhood of the Mother Church].

The members of the Black Brotherhood of the Rosary in Vila Rica sought to demonstrate their religious zeal (and perhaps to extend their competition with the white Brotherhood of the Holy Sacrament) in the festival itself—the realm of the repertoire—but also in the archive, through the publication of the account. Such a demonstration is no less performative in a text than on the street. *Triunfo Eucharistico* does not just refer to the performance of individuals of African descent in the festival; the work itself is also a performance of sorts, representing the devout Catholic identities of the inhabitants of Vila Rica and, particularly, of the Black Brotherhood of the Rosary. Perhaps to compensate for the temporary presence of the host in their chapel, the Black Brotherhood sponsored the publication of a permanent record of the events, making sure that their festive contribution was more enduring than the festival itself.

The concern for archival permanence is also evident in the brotherhood's petition for royal license to "por em livro" [put in a book] its *compromisso* in 1745, which states,

> O Juiz e mais Irmãos da Irmandade de N. Senhora do Rozario dos pretos . . . fizerão petição a V. Magde. por este conselho, em que dizem que elles tem ordenado entre si o compromisso junto para melhor governo da dita Irmandade, aumento della, e ser a mesma Senhora com vigorozo afecto venerada e servida, o qual pertendia o reduzir a livro para perpetuamente ser estavel na dita confraria e Irmandade, sendo por V. Mage. primeiro aprovado e confirmado.[59]

> [The Judge and the other brothers of the Black Brotherhood of Our Lady of the Rosary . . . petitioned Your Majesty, through this council, in which they say that they have ordered amongst themselves their

statutes in order to better govern and augment the said Brotherhood, and so that the same Lady may be venerated and served with vigorous affection, they sought to reduce it to a book in order to perpetually be stable in the said confraternity and brotherhood, after it has been approved and confirmed by Your Majesty.]

The petition, which predates the requirement to obtain royal confirmation of *compromissos* as part of the Crown's increasing fiscalization of brotherhoods in the late eighteenth century, reveals a consciousness about the permanence and power of books on the part of the Black Brotherhood of the Rosary.[60] The brothers may not have been seeking print publication, but the copy of their 1715 *compromisso* now held in the Museu de Inconfidência in Ouro Preto demonstrates an awareness of books as valuable objects that can ensure permanence, counteracting what they describe in the 1745 petition as the "estado em que no tempo presente se acha tanto o Paiz como a Irmandade" [state in which the country as well as the brotherhood now finds itself].[61] Both the *compromisso* and *Triunfo Eucharistico* include illustrations, which also demonstrate a valorization of the book as object—and perhaps, in the latter case, a consciousness of the greater prestige accorded to illustrated festival books in Europe.[62]

Triunfo Eucharistico is an explicit response to negative perceptions of Vila Rica and its residents, in particular to a reputation of impiety, a common accusation leveled at residents of mining boomtowns like those of Minas Gerais. Simão Ferreira Machado concludes *Triunfo Eucharistico* by asserting that if space permitted, he would narrate all of the festivals that had been celebrated in the region, "e entaõ ficaria manifesta a grande piedade, e religiaõ, com que os seus moradores resplandecem; e entre as demais naçoens com singular ventagem se fazem conhecidos; dismentindo a malidicencia daquelles, que os pertendem infamar de ambiciosos" (278–279) [and then the great piety and religion with which its inhabitants shine would be manifest; and among the rest of the nations with singular advantage they would be known; disproving the slander of those who try to defame them as ambitious]. Indeed, what is meant to shine in the account is not the gold- and jewel-laden costumes and floats but the spiritual wealth of the residents. This redefinition of Vila Rica's riches would be important to elite, white residents like the Portuguese-born author, who may have been concerned about accusations of "ambition," but also, certainly, to those who enjoyed less of the mineral wealth generated by their labor. The community invoked and lauded in

the work's final pages—"os moradores do Ouro Preto" [the inhabitants of Ouro Preto], described as "superiores a todas as naçoens do Mundo" (280) [superior to all of the nations of the world]—inevitably includes the members of the Black Brotherhood of the Rosary as well. After all, they provided a home for the Eucharist, played a major role in the festivities, and perhaps most importantly, sponsored the publication of the account, thus making sure that it would become known to a wider audience. *Triunfo Eucharistico* manages to transform the "glorioso triunfo do Eucharistico Sacramento" [glorious triumph of the Sacrament of the Eucharist] into a glorious image of the city and its "fidelissimos Catholicos" [most faithful Catholics]. This was surely just the sort of publicity desired by the Black Brotherhood of the Rosary, who may have been especially keen to promote such an image, given the suspicions of subversion that sometimes plagued the brotherhood and specifically their festivals. The triumph of *Triunfo Eucharistico* also belongs to the Black Brotherhood of the Rosary.

The festivals described in *Triunfo Eucharistico* and *Aureo Throno Episcopal* were primarily designed to exhibit and reinforce the social order of a colonial slave society. For those in control, the festivals were intended to celebrate and physically manifest the power and preeminence of the parish church's white brotherhood (in *Triunfo Eucharistico*) or the European-born bishop (in *Aureo Throno Episcopal*) over the black and mulatto brotherhoods and other residents of color who were called upon to participate in the festivals in clearly subordinate ways. Nevertheless, as Dean argues, "while festivals always appear to be planned and organized by those in control, they are occasions for visual and performative negotiation" (61). While *Aureo Throno Episcopal* can lead us to think about the negotiation of meaning within the festival in the way that Dean suggests—that is, how individuals of European as well as of African descent may have interpreted the "dança de Carijós" performed by mulattos—*Triunfo Eucharistico* extends that negotiation to the writing and publication of the festival account as well. The textual re-creation of festivals affords opportunities for the self-representation or aggrandizement of the author's—and sponsors'—communities and for the disruption or reorientation of the festivals' intended aims. Even if they do not overtly contradict the goals of the author himself, the sponsors' aims in *Triunfo Eucharistico* are clearly self-promoting in a way that we can only speculate about the "mulatto Carijós" of *Aureo Throno Episcopal*.

In an article entitled "Writing Royal Slaves into Colonial Stud-

ies," María Elena Díaz laments the scant attention paid to slaves and their descendants in colonial literary and cultural studies that she attributes to "the lack of recognized 'canonical' colonial texts written by or about slaves and free people of African descent" as well as to the "deep-seated association of African slaves with oral culture" (253–254). She goes on to argue that "as many historians well know, colonial archives are full of texts about—and even by—slaves and free people of African descent" (254). Referring specifically to the extensive documentation created by black brotherhoods in Brazil, João José Reis highlights the irony that the brotherhoods, made up of men and women who came from oral cultures, "produced so much writing"—documents like the *compromissos* that in some cases attested to "uma notável resistência cultural" (5) [a notable cultural resistance].

Yet as *Triunfo Eucharistico* reveals, it is not only in the archives where we can find these texts but in the "archive," in the more abstract sense that I have been using in this book. And this intervention in the public—or published—transcript involves much more subtle forms of negotiation and self-affirmation than outright resistance. Indeed, the sponsors of *Triunfo Eucharistico* must be granted the same consideration accorded to those who commissioned festival books elsewhere, as Helen Watanabe-O'Kelly argues:

> Instead of the festival book telling us what actually happened on the day and providing a straightforward window on the event, it tells us rather about the political aims, the allegiances and rivalries, the fears and anxieties of a particular court or city as they are expressed in that festival. It tells us how the body that commissioned the festival and the festival book wished the festival to be interpreted and how that body wanted to be seen in present and future times. . . . It is precisely this that many festival books seek to influence. (15)

The Black Brothers of the Rosary themselves write in their dedication, "Esta consideraçaõ nos obrigou a solicitar esta publica escriptura, em que sempre o nosso affecto esteja referindo em perpetua lembrança, e continua narraçaõ aos presentes, e futuros toda a ordem de taõ magnifica solemnidade" (139) [This consideration obliged us to solicit this public writing, in which our affection will always be referred in perpetual memory, and such magnificent solemnity in all of its order will be continuously narrated to those in the present and the future]. *Triunfo Eucharistico* reminds us of the importance of not just searching in the ar-

chives for traces of the ephemeral performances of marginalized groups but also of appreciating their purposeful contribution to the archive of permanent textual materials. By doing so, we can learn from the black brothers themselves about how they wished to be seen "in the present and the future"—including by us today.

Conclusion
SPECTACULAR TRIBUTES

In the prologue to his account of Philip III's entry into Lisbon in 1619 and the Jesuit play performed for the occasion, João Sardinha Mimoso conflates Portuguese festive magnificence with imperial achievements, complaining that both are liable to be forgotten due to the Portuguese tendency to be "tan largos en enprender hechos grandiosos, como cortos en escrivillos . . . como quienes nascieron mas para dar materia de cronicas, que para cronistas de sus hechos" [so long in undertaking great deeds as they are short in writing about them . . . like people who were born more to give material to chronicles, than chroniclers of their deeds]. Mimoso continues,

> Y por esta razon estan oy en olvido muchas cosas que devrian estar esculpidas en diamantes para memoria de los siglos venideros. Pues para que no quedase esta sepultada con las otras, es bien sepan los que esto leeren, la magestad, artificio, y apparato con que las escuelas desta ciudad de Lisboa an dado muestra a su Magestad. (N.p.)

> [And for this reason many things today are forgotten that should be sculpted in diamonds for the memory of the coming centuries. And so that this is not buried like the others, it is well for those who read this to know of the majesty, artifice, and ostentation which the schools of this city of Lisbon have shown your Majesty.]

The celebration of praiseworthy deeds is just as praiseworthy as the deeds themselves—the festival just as deserving of memorialization as the conquest. The festive tribute warrants its own textual tribute.

At the South American sources of Iberian mineral wealth, public

celebrations were quite literally sculpted in diamonds as well as silver and gold, but the residents of these mining towns also appreciated the metaphorical sense of Mimoso's expression. Even the Black Brotherhood of the Rosary in Vila Rica, Minas Gerais—whose enslaved members are usually excluded from considerations of the print public sphere—sponsored a publication in order to commit a festival to "perpetua lembrança, e continua narraçaõ aos presentes, e futuros" (in S. Machado 139) [perpetual memory, and continuous narration to those in the present and the future]. A similar acknowledgment of the durability of the written word and its importance in preserving the memory of heroic deeds and their celebration can be found in a festival account from Potosí written nearly two centuries after Mimoso's, at the very end of the colonial period. The anonymous *Fiestas triunfales* (1812) narrates the festivals held in Potosí to celebrate the victory of royalist commander José Manuel de Goyeneche over the 1811 rebellion in Cochabamba, following the more successful revolution of 1810 in Buenos Aires.

The festivities surrounding Goyeneche's entrance into Potosí in 1812 resemble those of Philip III's royal entry into Lisbon nearly two centuries earlier, not only in content—with triumphal arches, street decorations, parades, music, mass, bullfights, fireworks, and feasts—but also in motive, as emphasized in the title's reference to the "fidelísima" [very faithful] town of Potosí: to demonstrate loyalty to the Spanish Crown.[1] The author inscribes the celebrations in the classical tradition of triumphal entries of victorious generals while claiming that Potosí's festivities were in fact superior, since they were not paid for by the general himself: "es de mucho mayor aprecio lo que obró Potosí con su reconquistador peruano; porque sus espectáculos, sus vivas, y sus guirnaldas no fueron compradas con dinero, sino que nacieron de los corazones generosos de Potosí, en prueba de su amor al rey" (46) [it is much more praiseworthy what Potosí did with her Peruvian reconqueror; because her spectacles, exclamations, and garlands were not bought with money, but rather were born from the generous hearts of Potosí, in proof of its love for the king]. This is not a disinterested expense, however; like Marcel Mauss's *potlatch* (53–54, 95), such a gift entails the obligation to reciprocate and is meant to bring honor and status to the giver. As we have seen throughout this book, written accounts play a crucial role in the exchange, reminding readers of the social and material benefits that festivals are supposed to reap for their hosts.

In this sense, the author of *Fiestas triunfales* can claim that the printed word is even more valuable than the spectacular wealth on dis-

play in festivals: "Hubiera importado muy poco que se hubiese consumido todo el inmenso valor de los minerales del mundo en aplaudir los triunfos de este invicto americano, si las prensas de nuestros felices dias no hubiesen de servir de clarin, para inmortalizar su fama" (46–47) [It would have mattered very little if all the immense value of the minerals in the world were used up in applauding the triumphs of this victorious American, if the presses of our happy days would not have served as a trumpet to immortalize their fame]. The printed account is worth more than the festival—the metaphorical diamonds more than the real ones—in the form of festive accounting practiced in this text as well as in Arzáns's *Historia de la Villa Imperial*, Machado's *Triunfo Eucharistico*, the anonymous *Aureo Throno Episcopal*, and many other accounts discussed in this book. These texts are worthy of our attention not so much for immortalizing the celebrations as for how they shape their meaning.

By pointing out that the celebration of Goyeneche's triumph differed from its Roman antecedents by not being bought by "los mismos triunfadores" [the victors themselves] with "las incalculables riquezas que habían robado a todo el mundo" [the incalculable wealth that they had robbed from the whole world] (45-46), the author revises the meaning of Potosí's festive tribute. Rather than a symbol of subjection, humiliation, or social inferiority (Seed 75), the festival is a tribute to "the generous hearts of Potosí" (*Fiestas* 46). The festival account, in turn, serves to define and defend the community that celebrated it, here in terms of generosity rather than greed. In colonial mining towns, this sort of self-promotion emerged in response to European accusations of barbarism and impiety directed not only at Amerindians, Africans and Afro-descendants, and those of mixed race but also at *criollos* and Europeans who were presumed to have migrated there only to enrich themselves. If Potosí's creoles used the 1608 Corpus Christi festival to challenge Spanish critiques of their performative skills (Arzáns 1:267), the author of *Triunfo Eucharistico* expressed regret for not being able to document "American" festive superiority more extensively so that "the great piety and religion with which its inhabitants shine would be manifest . . . disproving the slander of those who try to defame them as greedy" (S. Machado 279). The similar means and messages of these responses to European (mis)conceptions point to common strategies in the adoption, defense, and promotion of an American identity for mining-town residents of European descent. The differences between the principal accounts I have analyzed—in particular, their publication history—are just as revealing. Both the Brazilian texts' publication in Lisbon and

Arzáns's decision not to publish his work in his lifetime—according to his son, primarily because of intimidation from those whose crimes and misdeeds his work exposed—underscore the perceived power of print to shape reputations.[2]

Whether performing before European spectators in Potosí or writing for a European audience in Lisbon, residents of mining boom-towns thus used festivals as a stage to redefine their worth and their cities' wealth. In so doing they represented themselves as a "public" in the sense articulated by Daniel Goldstein in his study of spectacles in modern Bolivia: "Spectacular performance is interesting not merely because it is performed in public, but because spectacular events enable groups of people to establish themselves *as* a public, to define themselves as part of the public or as a special kind of public in a particular society" (19, emphasis in the original). Goldstein notes that such opportunities to perform as a public are particularly important to the marginalized groups "ordinarily excluded from the mainstream of urban public life" (19). Elizabeth Dillon makes a similar argument with respect to the exclusions from Habermas's "public sphere" and Benedict Anderson's "imagined community": "The imagined community of the nation—and the public sphere associated with it—write out of its purview the indigenous peoples and diasporic Africans who inhabit the Americas side by side with creole European functionaries, while nonetheless relying on the land and labor of these peoples to generate the economic wealth that sustains the rise of the European bourgeoisie who find their political voice in the public sphere" (*New World Drama* 17). Dillon proposes instead the concept of the "performative commons" to better account for the "rematerializations and resignifications of enslaved and indigenous peoples that take place through performance" (19).

It is these groups' performances and their resignifications of festivals that I have sought to excavate, albeit in a different geography than the one addressed by Dillon. Some Amerindians and Afro-Brazilians performed as sovereigns—whether Inca monarchs and nobles in Potosí or African kings and queens in Minas Gerais—in order to assert their social status as caciques or elected leaders of religious brotherhoods, even if the meaning of this performance eluded the authors of festival accounts. Even the most marginalized, exploited groups in mining towns could use festivals to display social capital, as when the "indios de su majestad" (Arzáns 1:96) [Indians of your Majesty] processed in Potosí's 1555 celebrations: perhaps these *mitayos* sought to publicly assert their "special status vis-à-vis the king" (Brown 77), as Arzáns's reference to them

implies.[3] At the same time, Arzáns reveals how other indigenous participants in the procession used the occasion to display ethnic origins "con diversos trajes en el modo de vestir" (1:96) [with diverse costumes in their manner of dress]—affiliations that may have been challenged but were not eradicated by their forced relocation through the "general resettlement" and the *mita*.[4]

The embodied presence of these and other marginalized groups, including creole, mestiza, and indigenous women, are acknowledged by Arzáns to be part of the "performative commons" of Potosí, however much they are still excluded from the male creole public that he is most invested in representing and extolling.[5] On the other hand, the members of the Black Brotherhood of the Rosary managed to include themselves in the devout public of Vila Rica represented in *Triunfo Eucharistico*. They even appear as a collective body on the account's title page, which refers to their insistence on exposing the festival to public notice—a wider Portuguese public, in this case.[6] If the creole Arzáns embraced indigenous performance as an important contribution to the portrait of his hometown's grandeur, the Black Brotherhood of the Rosary in Vila Rica embraced print publication as a way of contributing to its own renown as well as that of the mining town. In so doing, the members of the Black Brotherhood, like the other texts and authors studied in this book, helped to redefine the mining town's spectacular wealth as well as their role in its production.

Notes

1. I have modernized my citations from this and subsequent pre-twentieth-century editions only with respect to the letters f/s and u/v, spacing, and most abbreviations. I have done the same with the titles of pre-twentieth-century editions, though I also change most uppercase letters to lowercase; when modern editions exist, I use the modern spelling, accentuation, and capitalization of the titles. I generally give the names of early modern authors and historical figures as they appear in the sources analyzed.

2. On Columbus's and Las Casas's rhetoric of wonder in these passages and inscription of the Colombine voyages in a gift economy, see Vilches 72–74.

3. In his prologue to *Gramática de la lengua castellana*, Nebrija writes, "Siempre la lengua fue compañera del imperio; y de tal manera lo siguió, que junta mente començaron, crecieron y florecieron, y después junta fue la caida de entrambos" (109) [language has always been the companion of empire, and has followed it in such a way that together they began, grew, and flourished, and then their fall happened together]. Throughout this book, translations are my own unless otherwise noted.

4. Philip III's father, Philip II of Spain, gained the Portuguese throne in 1581, ending the succession crisis that began with the young King Sebastian's death in the battle of Alcáce-Quibir in 1578. The Portuguese King João IV of the House of Braganza was acclaimed in 1640, ending the period of Hapsburg rule over Portugal. The purpose of Philip III's visit to Lisbon was to have his son Philip IV proclaimed as his successor as well as to appease Portuguese resentment about his prolonged absence and lack of attention to their concerns. For their part, the authorities in Lisbon who sponsored and organized the festivities sought to demonstrate Portuguese loyalty to the Hapsburg Crown in order to earn the king's favor and patronage and to convince him to relocate his court to Lisbon and make it the capital of his extensive empire. On Philip III's entry see Ana Paul Torres Megiani, "A escrita da festa" and *O rei ausente*, and my "Imperial Celebrations, Local Triumphs."

5. Mimoso writes, "Ordenase celebre su llegada con fiestas publicas, ofre-cesse el Oriente a celebrar las fiestas con sus provincias, formando con ellas una grave y vistosa dança" (49v) [It is ordered that his arrival be celebrated with pub-lic fiestas, and the Orient offers to celebrate the festivals with its provinces, form-ing with them a grave and showy dance]. In his narration of Vasco da Gama's voy-age Mimoso confirms, "Fue recebido del Rey con grande honra, y gusto, mandando se le hiziessen publicas fiestas y processiones por todo el Reyno a nuestro Señor, en hazimiento de gracias por su llegada" (53r) [The king received him with great honor and pleasure, ordering that public festivals and processions be held in honor of our Lord throughout the whole kingdom, in thanksgiving for his arrival].

6. See her chapter 5, "Tribute and Social Humiliation: The Cost of Preserv-ing Native Farmlands" (72–90). Seed shows the Islamic and "reconquest" anteced-ents to the exaction of tribute in exchange for the right to retain land, pointing out how "the word *tributo* in the Spanish-speaking world has always meant more than simply a way of raising revenue. It has signified rendering homage or handing over a token of admiration" (72).

7. See especially chapter 9, "The Social Role of Artifice," in which Maravall shows how fiestas epitomize the guided, mass, urban, and conservative dimensions of Baroque culture. In the chapter, Maravall draws frequently on Jesuit letters and specifically comments on the plays performed in Jesuit convents and schools, like the one transcribed by Mimoso (234).

8. These concepts, evoking theater and its audience as well as other modes of public performance, allow Dillon to attend to social actors in the Atlantic World who are generally excluded from the print public sphere, in particular Africans and Amerindians; see *New World Drama* 17–19 and "Coloniality" 179–180.

9. The figures are from Kendall Brown, who cites John TePaske's calculations based on mining tax data that Potosí and its surrounding mines "officially produced 22,695 metric tons of fine silver between 1545 and 1823. . . . Such figures are only in-formed estimates but nonetheless reveal the size of Potosí's official output, which by itself added to the European silver supply by 60 percent" (17).

10. For China's significant though often overlooked role as a silver consumer see Dennis O. Flynn and Arturo Giráldez, who call silver "the singular product most responsible for the birth of world trade" (201).

11. On the Potosí *mita*, see both Cole and Robins. Under the Incas, *mit'a* labor provided to the state could involve farming, fishing, military service, and the con-struction of public works as well as mining. Historians generally use *mit'a* to dis-tinguish the Inca draft labor system from the Spanish colonial one. Rostworowski explains that "tribute consisted in giving not the products of the parcels of the com-moners but their labor. In other words, in the absence of money, manpower was em-ployed on the lands of those who would have received tribute, whether the Inca, an ethnic lord, or a *huaca*" (185).

12. Charles Boxer characterizes the Portuguese search for mineral wealth in the Brazilian interior as partially inspired by "the (misconceived) geographical pro-

pinquity of silver-bearing Potosí" (30). On the history of the gold and diamond rush in Minas Gerais, see Boxer 30–60, 204–225. See also Holanda 120–171.

13. Cross points out that the "nadir of Peru's output, roughly 1690–1760, co-incided with the gold boom in Brazil; in terms of value, then, Peru's losses in silver production were more than offset by Brazil's new gold discoveries" (404).

14. For another population estimate, see Bakewell 22–23, 191n45. By way of comparison, Bakewell gives the 1600 populations of Seville and Venice as 150,000; Amsterdam, 130,000; and London, 80,000.

15. Here I cite Timothy J. Coates and Charles R. Boxer's 2012 translation.

16. "Requerimento dos irmãos da Irmandade de Nossa Senhora do Rosário dos Pretos da freguesia de Santo Antônio do Rio das Velhas, solicitando a D. Maria I a mercê de anular o embargo da sua capela ereta sem permissão régia," prior to December 22, 1788, Minas Gerais, caixa 130, doc. 59, Arquivo Histórico Ultramarino, Lisbon, hereafter AHU; "Carta de Paulo Fernandes Viana, ouvidor da Comarca do Sabará, dando seu parecer sobre a indevida ereção de capela, fora da Igreja Matriz, pelos irmãos da Irmandade do Rosário dos Pretos do arrayal do Morro Vermelho, freguesia do Bom Sucesso, da Vila Nova da Rainha, da referida Comarca" (June 7, 1793, Minas Gerais, caixa 138, doc. 17, AHU). Throughout this book, archival sources are given in notes only, and information on published sources is in the Works Cited.

17. "Representação dos vigários colados das igrejas paroquiais do bispado de Mariana a D. Maria I, na qual expõem a corrupção e desordem que grassam nas ordens terceiras e irmandades de pretos e pardos de Minas, com grande prejuízo da igreja, da Real Fazenda, do Padroado Régio e da conservação dos povos" (after February 28, 1793, Minas Gerais, caixa 138, doc. 6, AHU).

18. A similar performance of Jesuit students occurred during the celebration of the beatification of Saint Francis Xavier in Luanda, Angola, in 1620 (one year after the royal entry in Lisbon), including a "dansa de mininos japões em agradecimento do insino que do sancto padre Franco de xavier receberão" [dance of Japanese boys in thanks for the instruction that they received from the Holy Father Francisco Xavier] (*Relação das festas* 537).

19. See Voigt and Brancaforte.

20. Saunders cites a parish census of 1551–1552 that counted 9,950 slaves in a total population of 100,000 in Lisbon (55), while James Sweet refers to an English observer in 1770s who "estimated that 'about one fifth of the inhabitants of Lisbon consists of blacks, mulattoes, or of some intermediate tint of black and white'" (159). See also Jordan.

21. The *pardos* (mulattos) of Salvador da Bahia successfully petitioned the Crown in 1689 to force the Jesuits to admit them to the "esscolas publicaz do Collegio dos Relligiosos da Companhia" [public schools of the Company's Religious School], arguing that they were already admitted "nas academias de Vossa Magestade não só de Evora, senão tambem de Coimbra" [to Your Majesty's academies not only in Évora, but also in Coimbra]; "Consulta do Conselho Ultramarino sobre os

moços pardos da cidade da Bahia, que pedem as ordens aos religiosos da Companhia de Jesus os admitam nas suas escolas do Brasil sem embargo do seu nascimento e da sua cor," January 30, 1689, Papéis Avulsos, Bahia, caixa 28, doc. 3517, AHU. See Schwartz, "Formation" 36.

22. The response to King Manuel's request for information recalls Walter Mignolo's description of how a mestizo historian turns the discursive frame of a "command" into one of an "offering."

23. Mauss 53–54, 95.

24. Bataille draws on Mauss's notion of gift-giving to argue for the primacy of expenditure over accumulation; see *Accursed Share* and "Notion of Expenditure."

25. The vihuela is a guitarlike early Spanish stringed instrument. The linguistic features include transposing the sounds for b/v and l/r and dropping the s, among others, while the refrain, repeated throughout, is "Egué," which perhaps is related to "Ègè," a Yoruba word meaning "dirge, anthem, response"; *Church Missionary Society* 86. On *bozal*, see Tinhorão, *Os negros* 221–225. In the song, the performers identify themselves as Tapuia—the king sings, "Bepala cà Tapua" or "Ven para cá Tapuia" (58r) [Come here, Tapuia]—and as black: "Se bos nom bem meu mandados / Sar negros mu negrozente" (58v), that is, "Se vos não obecedeis os meus mandatos, sois negros muy negligentes" [If you don't obey my commands, you are very negligent blacks].

26. Indeed, the characters' ambiguous identity as black or indigenous could be said to corroborate Peter Mason's argument about the "ethnographic interchangeability" of exotic "others" in the early modern European imagination.

27. In a later scene Brazil inserts itself in a procession in a similar way when Portugal's triumphal carriage goes to meet Captain Albuquerque accompanied by all the kingdoms and provinces he has conquered: "No quiso el Brasil quedarse fuera del alegre y magnifico triumpho, y sentado en su cocodrilo truxo sus Tapuyas, y Aymures, con los papagayos en medio" (113r) [Brazil did not want to be left out of the happy and magnificent triumph, and seated on his crocodile he brought his Tapuia and Aimoré, with the parrots in between].

28. On the Portuguese presence in Potosí, which included several Portuguese writers, and the city's economic ties to Brazil through the illegal silver trade, see Hanke, *Portuguese in Spanish America* (esp. 15–29). For Spanish plays performed in Minas Gerais in 1733, see S. Machado, *Triunfo Eucharistico* 274.

29. For the inventory, see Inch C. 515. The book is listed at "trece pesos" [thirteen pesos], making it among the most expensive; a two-part work is listed at sixteen and three others at thirteen—including another festival account, Juan de Mal Lara's *Recibimiento que la muy noble y muy leal ciudad de Sevilla hizo a la Católica Real Magestad de el Rey don Felipe* (Seville, 1570); the rest range from one to twelve pesos.

30. On Arzáns's extensive use of Antonio de Acosta's *Historia de Potosí*—and his possible invention of the text, given the lack of any other evidence of its existence—see Hanke and Mendoza's introduction to their edition of Arzáns, lii–liv.

Despite a fruitless search for the Acosta volume in Portuguese archives, the editors cautiously accept its authenticity (liv).

31. Roger Chartier notes that "writing is installed at the very heart of the most central forms of traditional culture; festivals or entries, for instance, are surrounded by written notices of all kinds and commented on in programs that explain their meaning. . . . The history of cultural practices must consider these interpenetrations and restore some of the complex trajectories that run from the spoken word to the written text, from the writing that is read to gestures that are performed, from the printed book to reading aloud" (170–171).

32. In the prologue to the reader, Mimoso refers to this text as the "breve tratadillo que antes de la representacion salio" [brief little treatise that came out before the performance], which served as his source (n.p.).

33. See Mimoso's prologue "Al curioso lector español" at the beginning of the work (n.p.) and the briefer prologue "Al lector" that precedes the description of the royal entry (125v).

34. Scott writes, "Reading the dialogue [with the dominant public culture] from the hidden transcript is to read a more or less *direct* reply, with no holds barred, to elite homilies. The directness is possible, of course, only because it occurs offstage, outside the power-laden domain. Reading the dialogue from the public oral traditions of subordinate groups requires a more nuanced and literary reading simply because the hidden transcript has had to costume itself and speak more warily" (165).

35. See the works by Geertz, Scott, and Strong listed in the bibliography. For Maravall, see *Culture of the Baroque* (esp. 225–247). Scott writes that nothing conveys what he calls the "public transcript"—the "self-portrait of dominant elites as they would have themselves seen"—more than "the formal ceremonies they organize to celebrate and dramatize their rule. Parades, inaugurations, processions, coronations, funerals provide ruling groups with the occasion to make a spectacle of themselves in a manner largely of their own choosing" (58). These festivals correspond not with Bakhtin's carnival but with "the official feasts of the Middle Ages . . . [which] sanctioned the existing pattern of things and reinforced it. . . . The official feast asserted all that was stable, unchanging, perennial: the existing hierarchy, the existing religious, political, and moral values, norms, and prohibitions" (Bakhtin 9). Bakhtin's discussion of Goethe's description of the Roman carnival makes the contrast explicit: "[Carnival] is a festival offered not by some exterior source but by the people to themselves. Therefore the people do not feel as if they were receiving something that they must accept respectfully and gratefully. . . . This festivity demands no sanctimonious acknowledgment or astonishment such as official occasions usually expect. There are no brilliant processions inviting the people to pray and admire" (246).

36. See, for example, Mínguez 235; López Cantos 20; Ramos Sosa 19; and Acosta de Arias Schreiber 37–38. On festivals as conservative political instruments

in Portugal and colonial Brazil, see Paiva, "Etiqueta e cerimônias públicas," and L. Souza, "Festas barrocas."

37. A 2012 article by Regina Grafe and Alejandra Irigoin offers economic evidence to support many historians' claims that Spanish imperial rule was not as "strong, absolutist, centralist, predatory, extractive, and wasteful" as traditionally represented but rather dependent on negotiation with local stakeholders (609); see also Irigoin and Grafe. Both Dean and Merrim acknowledge the appearance and pretensions of the powerful in festivals, but they also find in them "occasions for visual and performative negotiation" (Dean 61), as well as "fissures and unstable, exploitable spaces" (Merrim, *Spectacular City* 27). For similar perspectives on the dialogical potential of festivals see also Cardim, "Entradas solenes," and Kantor, "Entradas episcopais." With respect to modern festive practices, David Guss argues that focus has shifted from "what festivals mean" to "how their multiple meanings are produced" (*Festive State* 21).

38. Maravall writes that poets and other writers relate *fiestas*, "praising their magnificence and exalting the power of the seigniors and the glory of the monarchy" (*Culture* 244). Strong characterizes the literature printed to commemorate Renaissance court festivals and royal entries as "designed to pass to posterity as monuments of princely magnificence" (21–22). According to Scott, written documents more generally "tend to favor a hegemonic account of power relations" (xii), since the goal of any hidden transcript of resistance "is precisely to escape detection" (87), to not be recorded in the archive controlled by the elite. For Scott, official narratives of festivals would corroborate the public transcript, the hegemonic account of power relations.

39. Stephanie Merrim makes a similar argument when pointing out how authors inserted their own agendas into festival accounts: "festival chronicles held as many benefits for the colonial writer as they did for the colonial state. . . . Having such a prestigious, public venue at their disposal . . . they would not refrain from transmuting the festival chronical into a platform for their personal and political interests" (*Spectacular City* 29).

40. In their introduction to *Historia de la Villa Imperial de Potosí*, Hanke and Mendoza write that Potosí "puede caracterizarse como orgulloso y opulento, piadoso y cruel, pero no como un centro cultural" [can be characterized as proud and opulent, pious and cruel, but not as a cultural center], in contrast to Lima and La Plata, whose *audiencias* and universities made them "focos de empresas culturales" [foci of cultural enterprises] (lxvi–lxvii).

41. Arzáns apparently adapted this passage from one by the Augustinian friar Antonio de la Calancha: "Para gastar cera blanca en cantidad en España ha de ser fiesta Real, y se expresa en las relaciones como circunstancia que pondera ostentación; y acá los negros esclavos sacan sesenta cirios cuando llevan un estandarte, o son priostes de una procesión: no hay indio triste, ni el más pobre baladí, que gaste otra cera que la blanca, porque no se trae otra, y no se trae porque no se gasta acá. En un mes gastan más cera blanca en Lima, o en Potosí, que en un año en Europa"

(176) [In order to use a large quantity of white wax in Spain it has to be a Royal festival, and it is depicted in the accounts as a circumstance of weighty ostentation; and here the black slaves take out sixty large candles when they carry a banner, or they are the stewards of a procession: there is no sad Indian, even the poorest and least significant, who uses anything other than white wax, because they don't have any other, and they don't have any other because no other is used here. In a month they use more white wax in Lima or Potosí than in a year in Europe].

42. I refer to the Black Brotherhood of the Rosary's sponsorship of the publication of *Triunfo Eucharistico* in 1734. On archive and repertoire, see Taylor, who points out that these notions do not correspond neatly to a binary of (writerly) domination and (performative) subversion: if much of the colonial festival's repertoire seeks to constitute or preserve hegemonic power, the archival response, as in the case of some of the texts analyzed in this book, may endeavor to challenge that power (19).

CHAPTER 1: IN PRAISE OF FOLLIES

1. The text describes Barrio y Lima's new method of amalgamation involving a different kind of reagent, copper sulfate, that would require less mercury—a very expensive and hazardous substance—and yield a greater quantity of silver. Juan del Corro y Zegarra's innovation is described in his *Instrucción y forma de beneficiar metales de plata* (1676). Both texts are part of a series of metallurgical treatises in Spanish, beginning with Álvaro Alonso Barba's *Arte de los metales en que se enseña el verdadero beneficio de los de oro, y plata por açogue* (1640), whose title Barrio y Lima's clearly evokes. I thank Alison Bigelow for the reference to the festival in Barrio y Lima's *Arte o cartilla*. See Bigelow 262–275 on the accounts and petitions describing the development of new metallurgic techniques in Potosí and Peru more broadly.

2. The 1726 *Diccionario de autoridades* provides a secondary definition for *alcancía* that explains its use in chivalric games: "Es también cierta bola gruessa de barro, seco al sol, de el tamaño de naranja, la qual se llena de ceniza, o flores, u otras cosas, y sirve para hacer tiro en el juego de caballería, que llaman correr, o jugar alcancías, de las quales se defienden los jugadores con las adargas o escudos, donde las alcancías se quiebran" (179) [It is also a certain thick clay ball, dried in the sun, which is the size of an orange and which is filled with ashes, or flowers, or other things, and it is shot in a game of chivalry called running or playing *alcancías*, from which the players defend themselves with shields, on which the *alcancías* break].

3. On the Ribera canal and its significance to Potosí, see Hanke and Mendoza cxxx-cxxxiv and Robins 27–29. The "famosa fábrica de la Ribera de ingenios" [famous factory of the riverbank of refineries], as Arzáns describes it, was built in 1577, following the construction of lagoons to collect rainwater and provide the hydraulic force necessary to run the refineries (1:166). The conclusion of its construction was celebrated, along with the debut of the new Plaza de Regocijos [Plaza of Festivities]

"que para estas fiestas se había guardado" [that had been saved for these fiestas] on the Friday before Lent in 1577 (1:167). The destruction of much of the Ribera after the 1626 flooding of the laguna of Caracari is the second of three causes of the decline of Potosí, according to Arzáns (2:1–6).

4. Arzáns previously narrated the similar but more fortunate case of a "famous miner," Diego Buitrón; because of his horsemanship skills the accident resulted in the death of the horse but not the rider. Arzáns here defines the horse as "animal nacido para servir a los hombres en las marciales luchas . . . cuanto para mostrar gallardas disposiciones de sus dueños, galas y preciosos paramentos, y muy admirables y diestras habilidades en las plazas y sus regocijos, aunque también para ruina y lástima de muchos" (2:302–303) [an animal born to serve men in their martial battles . . . as much as to show the graceful talents of their owners, their finery and precious trappings, and their very admirable and skillful abilities in the plazas and festivals, even though it also brings about the ruin and shame of many]. *Historia de la Villa Imperial* likewise portrays silver as simultaneously contributing to the festive grandeur of Potosí and leading to the city's ruin.

5. Merrim follows Descartes, who defined "wonder" as a reaction that occurs "prior to moral judgment," in opposing the marvelous to moralizing in this passage (30).

6. In this chapter I deepen and expand my analysis in "Spectacular Wealth" of two of these festivals.

7. The passage echoes Iberian Golden Age poetry about the lost grandeur of ancient or modern cities, as in poems by Rodrigo Caro ("Estos, Fabio, ¡ay dolor!, que ves ahora"), Francisco de Quevedo ("Buscas en Roma a Roma ¡oh peregrino!"), Lope de Vega ("Entre aquestas columnas abrasadas"), and Francisco Rodrigues Lobo ("Fermoso Tejo meu, quão diferente"), and in an American variant, Gregório de Mattos's "Triste Bahia, Ó quão dessemelhante." I thank Elizabeth Davis for the references to the Spanish poems.

8. Arzáns identifies three major causes for Potosí's decline in the seventeenth century: the civil wars between Vicuñas and "vascongados"; the flooding of the Caracari laguna and consequent destruction of many of the refineries; and the devaluation of the coin by the president of the Audiencia de la Plata, Francisco de Nestares Marín (Hanke and Mendoza cxxiv). Arzáns follows his discussion of the effects of the devaluation with an abbreviated account of Potosí's festive grandeur that foreshadows that of book 10 (book 9, chapter 7, 2:158–160).

9. The similarity between Arzáns's text and Manrique's stanzas reveal the remarkable consistency in festive practices—and ambivalent attitudes toward them—in the Hispanic world over four centuries. There is a similar passage in Ginés Pérez de Hita's *Historia de la guerras civiles de Granada*: "O Granada, Granada: ¿qué desventura vino sobre ti? ¿qué se hizo tu Nobleza? ¿qué se hizo tu riqueza? ¿que se hizieron tus passatiempos? ¿tus galas, justas y Torneos, juegos de sortija? ¿qué se hizieron tus deleytes, fiestas de San Juan; y tus acordadas musicas y Zambras? ¿Adonde se escondieron los bravos y vistosos juegos de Cañas?" (444–445) [Oh Gra-

nada, Granada! What misfortune befell you? What became of your nobility? What became of your riches? What became of your pastimes? Your galas, jousts and tournaments, running of the ring? What became of your delights, your feasts of San Juan; and your harmonious music and zambra dances? Where have your magnificent and showy games of read spears hidden?]. On this passage, recalling the chivalric and festive traditions shared between Moors and Christians, see Fuchs 111.

10. Carolyn Dean explains that Pope Clement V fixed the celebration "to the fifth day after the Octave of Pentecost, which is the ninth Thursday after Easter Sunday, or the Thursday following Trinity Sunday" (8).

11. Other examples include "los capitanes hicieron primores tales que admiraron a las naciones" (Arzáns 1:269) [the captains did it so skillfully that the other nations admired them] and "Admiró a toda [la Villa] la costosísima invención de los caballeros potosinos" (1:275) [The very costly invention of the Potosí gentlemen provoked the admiration of the whole town].

12. Anthony Pagden describes how "the criollo elite responded to what they saw as a stain upon their honor by attempting to create, at least among the white community, a model Christian society" (84–85). Pagden elaborates on the use of public festivals by the creole elite as a "vehicle for public commentary on the worth and status of the criollo nation" (90–91).

13. Or as Arzáns puts it in his previous chapter, "no faltan escritores (como don Juan Pasquier y Bartolomé de Dueñas) digan que más fue mal afecto de las otras naciones (y particularmente de los vascongados) que defectos que hubiese que notar en los criollos" (1:266) [there is no lack of writers (such as don Juan Pasquier and Bartolomé de Dueñas) who say it was more the antipathy of the other nations (and particularly the Basques) than the defects that could be noted among the creoles]. On these sources—who may have been inventions of Arzáns, since in most cases there exist no other references to them or their works—see Arzáns's prologue (1:clxxxiv) and Hanke and Mendoza l-lvi. The authors' nationalities, as identified by Arzáns, do not correspond to distinct creole or peninsular perspectives. Acosta was Portuguese and Pasquier was Andalusian, while both Méndez and Dueñas were "peruanos," Peruvians (Hanke and Mendoza clxxxiv). Arzáns does not mention Sobrino in the preface, but he cites his octaves frequently and refers to a theatrical work by Sobrino that was performed during a 1641 festival. Hanke and Mendoza refer to archival documents that mention Sobrino as a minor leader of the "Vicuñas," a group that included creoles, in the War of the Vicuñas and Basques of 1622–1625 (liv–lv).

14. On the "oppositional framework" of Corpus Christi, see Dean 7–14.

15. In his introduction to the translation *Tales of Potosí*, R. C. Padden writes, "There does not appear to have been a consistent pattern to violent rivalry in Potosí until after construction of the Ribera and the spectacular rise of a new and influential aristocracy of silver refiners, whose ranks included a disproportionate number of Basques. . . . By the 1590s non-Basques viewed the scene with alarm, for the Basques now held the lion's share of refineries and a growing number of other en-

terprises; they were taking over the most influential offices in the municipal hierarchy and the royal administration" (xxvii). Padden also refers to Basques' "special contempt . . . for all American-born Spaniards" (xxvii).

16. Examples are the works by Brading, Lavallé, Mazzotti, and Pagden.

17. In her article "Spectacular Cityscapes" and subsequent book *Spectacular City*, Stephanie Merrim has shown how festivals "were instrumentalized as a platform for *criollo* consciousness"; "Spectacular Cityscapes" 37.

18. García Pabón argues, "El nombre funciona no como un nombre propio, particularizador, de un individuo, sino como el denominador de un origen americano común y que separa al grupo criollo de los españoles" (428) [The name functions not as a proper, particularizing name of an individual but as a denominator of a common American origin that separates the creole group from the Spaniards]. The only performers not named Nicolás are Ángelo de Villarroel, grandson of Juan de Villarroel, the Spanish "discoverer" of the Cerro de Potosí, and Ceferino Colón, great-grandson of Cristóbal Colón (Christopher Columbus) (Arzáns 1:275, 276). The creoles Villarroel and Colón have other claims to fame than the name Nicolás, and their *invenciones* boast the "discoveries" of their ancestors; Ángelo arrives in the plaza with a silver-plated Cerro de Potosí (1:275), and Ceferino (only fourteen at the time, and thus too young to participate in the *sortija*) with a giant globe on which are painted "las provincias de toda la América" [the provinces of all America] (1:276).

19. Curcio-Nagy argues that the viceregal entry was the costliest and most extensive celebration in New Spain under the Hapsburgs, far exceeding in extravagance the *jura*, or public oath, to the new king (33).

20. *Libros de acuerdos del cabildo de Potosí*, tomo 16, 336v, Archivo y Biblioteca Nacionales de Bolivia (ABNB), Sucre, Bolivia. These are the town council records of Potosí, of which the ABNB holds an incomplete series.

21. Although Indians are excluded from this list, Arzáns shows them to have participated in the same way as Spaniards in the funeral ceremonies for Philip II: "No fue necesario el que se pregonase a los populares el vestirse lutos, porque al segundo día de la fatal noticia se mostraron la mayor parte de vecinos en aquel funesto traje, y luego generalmente españoles e indios se vistieron de lo mismo" (1:239) [It was not necessary to tell the populace to dress in mourning, because the second day after the fatal news the greater part of the residents showed themselves in that baneful dress, and then Spaniards and Indians generally dressed the same way].

22. "Porque para una cossa tan grave de tanta onrra y estimacion . . . esta ymperial Villa a de continuar las grandezas que siempre en ella . . . a hecho sin descaecer en esta ocassion ansí abentajandose a las demas passadas" (*Acuerdos* 341v, ABNB) [Because for such a grave thing of such honor and esteem . . . this Imperial Town should continue to show the grandeur that she . . . has always done, without diminishing on this occasion, and in this way surpassing all the previous ones].

23. Arzáns reinforces this appropriation in his choice of pronouns; in the conclusion of the performance, we read that "los criollos apeándose de los caballos se

entraron a las minas de su Cerro" (1:350) [after dismounting from their horses, the creoles entered the mines of their Mountain].

24. Holguín was active in Potosí from 1693 to 1724; see Mesa and Gisbert, especially 61–72. Ari Zighelboim notes in "The Painter" (7) that the sponsor's name seems to have been intentionally rubbed out from the cartouche following the phrase "Lo mandó pintar" [It was ordered to be painted].

25. Fray Juan de la Torre is a frequent object of praise in Arzáns's pages. Upon de la Torre's arrival as prior of the Augustinian convent in 1713, he enjoyed "toda la estimación de dicha ciudad por sus grandes virtudes y letras" (3:11) [all the esteem of that city for his great virtues and letters]. Arzáns describes the music in the 1716 entry as "compuesto todo ingeniosamente por el reverendo padre maestro fray Juan de la Torre, prior de San Agustín, de quien mucho hemos dicho, y también añado que a petición de la Villa escribió la relación de esta entrada, recibimiento y fiestas de su excelencia para la ciudad de Los Reyes, que quisiera mi corta pluma parte del colmo de la suya para adorno de estos reglones" (3:48) [all composed ingeniously by the reverend father Master Fray Juan de la Torre, prior of St. Augustine, of whom we have said much, and I also add that at the petition of the Town he wrote the relation of this entry, reception and festivities for the City of the Kings [Lima]; my humble pen would like a part of the heights of his for the adornment of these lines]. In "Teatro recuperado," Zugasti points out that "No Medina" on the title page of the John Carter Brown Library's copy of *Aclamacion festiva* refers to the fact that it is not included in José Toribio Medina's *La imprenta en Lima*.

26. There are corrections in the manuscript of *Historia* held at Brown University's John Hay Library in Providence, RI, that suggest that Arzáns consulted de la Torre's account and amended his own text based on it. The name of one of the *oidores*, Francisco de Sagardia, is corrected three times to the way it appears in de la Torre's work; "Francisco" is written over the top of another, unreadable name (511r, 514v in the Hay Library manuscript); and the number of the men in the squadron in the procession is changed from 200 to 300, the same number given by de la Torre (in this case *dosientos* is still visible underneath *trezientos*; 511v). For a comparison of the manuscript archived at the Hay Library and the other extant manuscript, in Madrid, see Arzáns 3:461–469.

27. Arzáns begins by announcing his arrival "al 10° y último libro de esta dilatada *Historia*" (2:321) [at the tenth and last book of this long *Historia*], even though he and his son will add three books in a much shorter second part.

28. Here Arzáns also acknowledges writing for posterity, justifying his choice not to pursue publication in his lifetime by citing the threats he had received from the friends of an important official whose misdeeds he recounted (2:321).

29. Translations of Arzáns's account of the 1716 entry are from *Tales of Potosí* unless otherwise noted.

30. Arzáns and his son, Diego, frequently refer to the difference of early eighteenth-century festivals due to the city's financial decline (2:461–462, 3:188, 3:416). See also Hanke and Mendoza cxxxiv–cxxxv and Bakewell 16–17.

31. This and the next passage cited are not found in *Tales of Potosí*, which only includes a portion of the chapter describing the entry; the translations are my own.

32. Pagden writes, "The Bourbon reforms of the eighteenth century . . . attempted once again to restrict office to peninsular Spaniards by making it mandatory for all royal officials to have attended one of the Castilian universities" (62).

33. This and the next two passages cited are not found in *Tales of Potosí*; the translations are my own.

34. All three of these individuals are named in the painting's cartouche: "Siendo alcaldes hordinarios don Francisco Gambarte, I don Pedro Nabarro, I corregidor el General don Françsisco Tirado de Quenca" [Being *alcaldes ordinarios* Don Francisco Gambarte and Don Pedro Navarro and *corregidor* General Don Francisco Tirado of Cuenca].

35. This and subsequent passages cited in the present chapter are not found in *Tales of Potosí*; the translations are my own.

36. Earlier in the chapter Arzáns makes a similar allusion to the reciprocity of gift-giving: "aunque se pudiera esperar de todas estas demostraciones algún bien, lo mejor que hizo fue hacer el ánimo a esperar lo peor y no por eso dejó de manifestar en un todo su liberalidad" (3:50) ["though there was hope of some benefit from all those demonstrations, the best thing they did was to prepare men's minds for the worst. And yet this did not prevent the city from displaying the utmost generosity" (194)].

CHAPTER 2: CELEBRATING MINAS GERAIS IN
TRIUNFO EUCHARISTICO AND AUREO THRONO EPISCOPAL

1. Hallewell argues that the "real reason" for the prohibition of the printing press in Brazil was the "fundamental mercantilist assumption that colonies had no role other than that of supplying raw materials (and consuming a modicum of European manufactures in return)" (17). Ralph Bauer has analyzed how this model operated in the sphere of knowledge production in the Spanish and English Atlantic empires. The ban on printing in Brazil is a prime example of this dynamic; the "raw materials" of texts had to be sent to Lisbon to be manufactured into printed books that could be sold in the colonies.

2. The other two works published by Fonseca before his press was shut down are another encomiastic work dedicated to the bishop, *Em aplauso do excellentissimo, e reverendissimo senhor D. Frey Antonio do Desterro Malheyro, dignissimo bispo desta cidade*, and a thesis entitled *Conclusiones metaphysicas de ente reali* by the Jesuit Francisco de Faria. Rubens Borba de Morães cites the *provisão*, dated July 6, 1747, as well as Antônio Isidoro da Fonseca's unsuccessful petition to return to Brazil (137–139nn5–6). Although Fonseca claimed in his petition that he moved his press to Brazil "com o intento de ganhar o que lhe era preciso e a sua mulher" (in Morães 138n6) [with the intent of earning what was necessary for him and his wife], the

stated reason for the prohibition in the 1747 *provisão* was the greater costliness and inconvenience of printing in the colony. On Fonseca see Hallewell 12–18; Morães 136–146; and Dines.

3. *Aureo Throno Episcopal* included all three necessary licenses, as explained by Morães: "a licença do bispo, representando a Igreja (chamada licença do Ordinário), a do Santo Ofício (pela Inquisição) e a licença real (do poder civil, expedida pelo Desembargo do Paço)" (109) [the license of the bishop, representing the Church (called the Ordinário license), that of the Holy Office (for the Inquisition) and the royal license (of the civil power, expedited by the Desembargo do Paço]. Fonseca was clearly aware of the distinction between the two religious licenses but sought to conflate them under the bishop's authority; see Cunha 29.

4. Fear of losing the manuscript during the transatlantic crossing apparently kept Arzáns from seeking publication of his work in Spain, according to his son Diego (Arzáns 3:401); on such hazards see Hanke and Mendoza 1:xl.

5. The tensions between the bishop and the *ouvidor* [magistrate] Caetano da Costa Matoso as an example of royal-ecclesiastical conflicts are well known; see Figueiredo 82-120 and Trindade 1:121–222.

6. Caio Cesar Boschi cites this prohibition as an example of the "cunho acentuadamente absolutista" [particularly absolutist imprint] of royal legislation with regard to Minas Gerais (*Os leigos* 3). See also notes 103 and 114 below.

7. Mariana was designated a city and capital of the new diocese by royal decree on April 23, 1745; the selection of Manuel da Cruz for the post of bishop of Mariana was confirmed by papal bull on December 15 of the same year. The text describes the delay in his departure from Maranhão until August 3, 1747, and arrival in Vila Real do Sabará, Minas Gerais, on February 2, 1748; the public entry took place later that month, on February 27.

8. A summary of the critical reception of these works in Brazilian scholarship can be found in Santiago (13–35).

9. Corpus Christi is a moveable feast that occurs on the Thursday after Trinity Sunday, or the ninth Thursday after Easter Sunday, thus falling in late May or early June. Beatriz Catão Cruz Santos suggests that there may have been a conflation of the calendrical and noncalendrical festival, although she acknowledges that there is no suggestion of that in *Triunfo Eucharistico* (38).

10. The "Advertencia aos que lerem esta obra" [Note to those who read this work] explains that the text was written in 1719 at the request of João V, but that it was only after the catastrophic Lisbon earthquake of 1755, which destroyed the copies of the manuscript in the Royal Library and the convent of St. Domingos, that Ignacio Barbosa Machado decided to publish the work based on his extant personal copy (iii[r], v[v]).

11. On the Guerra dos Emboabas, see L. Souza, *O sol* 120–137.

12. I have amended Coates and Boxer's translation of this passage to retain the sense of the original.

13. These translations are my own. Antonil gives an earlier description of the

lack of civic and ecclesiastical authority that contributed to the general lawlessness (137).

14. A. J. R. Russell-Wood discusses the "charges of physical degeneracy and moral turpitude" leveled against the inhabitants of Brazil ("Centers," 109–110). On the critiques of the vices of Minas Gerais's and São Paulo's inhabitants, specifically, see L. Souza (*O sol* 109–147).

15. On this point, the *Discurso histórico* cites Luís de Camões: "Move a presença real / Uma afeição natural" (147) [Royal presence arouses / natural affection]. The text goes on to affirm that "não há que estranhar que ignorem os mineiros que há rei que domine este país, onde nunca foi visto o seu raio" (148) [It is not strange that the *mineiros* ignore the fact that there is a king who rules this country, where they have never seen his thunderbolts]. Prior to the rebellion, the governor employed a visual rhetoric familiar to festivals to communicate the threat of the king's thunderbolts to the plotters when he created a new emblem for the royal dragoons' standard: "Esta era uma mão com um raio, a qual, saindo de uma nuvem, se mostrava suspensa no ar, como ameaçando a uns montes que lhes estavam embaixo, com esta letra: *Cedere, aut Caedi*. Ceder, ou ser feridos, expressando, neste, desenfadada e gentil resolução, que em seu ânimo galhardo igualmente reinava o valor e a piedade" (80–81) [This was a hand with a thunderbolt, which, coming out of a cloud, was shown suspended in the air, as if threatening some mountains that were below, with this motto: *Cedere, aut Caedi*. Surrender, or be harmed, expressing in this way the calm and noble resolution, with which his brave soul was equally ruled by valor and compassion]. The emblem recalls that used by the captain of the creole squadron to threaten the Basques in the chivalric games for the 1622 festival in Potosí: "Si se alzaron, ya cayeron" (Arzáns 1:349) [If they rose up, they have already fallen].

16. R. Monteiro contrasts the rhetoric employed here with that of the Conde de Assumar, governor of Minas Gerais during the Santos rebellion of 1720, who associated distance with rebelliousness: "[As festividades] possibilitariam, desde que postas em prática nessas terras distantes, maior enaltecimento do soberano inacessível, que por isso mesmo seria mais idealizado e venerado" (321) [The festivals would make possible, as long as they were put into practice in those distant lands, greater exaltation of the inaccessible monarch, who for that very reason would be more idealized and venerated]. Kirsten Schultz makes a similar argument, demonstrating how this question—of whether it was superior to celebrate the king in his presence or absence—was explicitly considered by the Bahian Academia dos Renascidos: "One answer to this question was that celebrating the monarchy in the monarch's absence was more commendable than doing so in his presence because it demonstrated the strength of political bonds" (229).

17. Seed, in her chapter "Tribute and Social Humiliation," argues that during both Muslim rule in the peninsula and during the Christian reconquest, "tribute payment emerged as the central indicator of social inferiority in the Iberian kingdoms" (75).

NOTES TO PAGES 64–67 ~ 171 ~

18. Focusing on festivals celebrating the Portuguese sovereign in Brazil, Schultz notes the "greater investment" (243) in the writing of festival accounts as the eighteenth century progressed and shows how they inserted Brazilian cities "into a larger imperial context": "The lavish celebrations of the royal life cycle, in this sense, allowed the city's residents both to witness the splendor of royalty as it was revealed in processions and festive ephemera, and to participate in a performance intended for an imagined imperial audience" (248).

19. Machado echoes the famous verse in the first stanza of Camões's epic masterwork of Portuguese expansion, *Os Lusíadas* (1572), "por mares nunca dantes navegados" (1) [across seas no man had ever sailed before (39)].

20. The rhetoric of expansiveness in the description of Minas Gerais was not uncommon. See, for example, the "Notícia dos primeiros descobridores das primeiras minas do ouro pertencentes a estas Minas Gerais" included in the *Códice Costa Matoso*, edited by Campos and Figueiredo (1:166-193, especially 172).

21. Elsewhere Simão Ferreira Machado attributes distance not to Vila Rica but to the lands around it, confirming the town's centrality: "Foy . . . tal a expectação da novidade, que das mais distantes partes das Minas, e fóra dellas, houve na villa, e seus arredòres innumeravel, e nunca visto concurso" (186-187) [There was . . . such an expectation of novelty that from the most distant parts of the Mines and beyond, there was an innumerable and never before seen crowd in the Town and its surroundings].

22. Here I use Charles Boxer's translation in his *Golden Age of Brazil*. Regarding this passage, Boxer writes, "The citizens of Mexico City or of Lima would certainly not have agreed that Villa Rica de Ouro Preto was the chief city in all America; but they would not have disputed another contemporary writer's description of this Brazilian mining town as a 'golden Potosí'" (163).

23. Again, I have modified Coates and Boxer's translation. Arzáns makes a similar complaint in the account of the archbishop-viceroy's entry: "los españoles han cargado con infinidad de aquella riqueza y la han dado a los franceses" (3:48) [the Spaniards have made away with an enormous amount of wealth and have given it to the French].

24. Rama writes, "The best examples of this [Baroque] discourse [of the lettered city] are obviously not the mute texts that we have conserved but in these ephemeral festivals of the arts, best represented by the triumphal arches that commemorated great events" (24). See also Merrim, *Spectacular City* 23–29.

25. For the indigenous population in Minas Gerais, see Resende, "Gentios brasílicos" 159–187 and "'Brasis coloniales'"; Resende identifies the indigenous and *mestiço* populations in the towns of Minas Gerais as varying between 0.5 percent and 3.5 percent. She points out that indigenous peoples were frequently classified (and sometimes self-identified) as *mestiço* or mulatto, making an accurate estimate of the indigenous population difficult to obtain (164–165). Langfur as well as Resende and Langfur challenge the exclusion of indigenous peoples from the history

of colonial Minas Gerais, based on the myth that the entire native population was enslaved or exterminated by the *bandeirante* expeditions that led to the discovery of gold and the subsequent settlement of Minas Gerais.

26. See Harris for studies of medieval to modern examples of the dances of Moors and Christians in Corpus Christi festivals of Mexico and Spain.

27. Three seventeenth-century Spanish plays were performed: Pedro Calderón de la Barca's *El secreto a voces*; Agustín Moreto and Juan de Matos Fragoso's *El príncipe prodigioso*; and Francisco de Rojas Zorrilla's *El amo criado*. On the performance of Spanish theater in colonial Brazil, see Brescia and Lino.

28. On the multifaceted sense of *policía* (as written in Spanish) in the early modern period, see Kagan 26–28.

29. Nevertheless, Ávila points out that some of the craftsmen and artists had to come from elsewhere to assist in the festival preparations, according to statements made in the preliminary address (Ávila 20; Machado 30–31).

30. Notably absent are triumphal arches like those described in such detail by Arzáns in his account of the archbishop-viceroy's entrance into Potosí in 1719. Santiago cites a letter from João V criticizing the excessive expenses of festivals in Minas Gerais, in particular the use of triumphal arches for episcopal entries, to which he refers as "tais despesas excessivas e desnecessárias" (55) [such excessive and unnecessary expenses].

31. For similar arguments regarding the episcopal entry, also see Paiva's "Etiqueta" and "Public Ceremonies."

32. According to Kantor, the six stages are the bishop's voyage and preparation for the reception; the bishop's ceremonial reception at the city gates; the speech, kissing of the cross, welcome by government officials, and procession to the cathedral; the ritual in the church; the ceremonial entry into bishop's palace; and the public festivities (178n25).

33. On the conflicts with secular authorities, especially the *ouvidor* Caetano da Costa Matoso, see Boschi, *Os leigos* 86–95; Figueiredo 82–92; Kantor; and Trindade 1:120–122.

34. For the attribution of *Aureo Throno Episcopal* to Simão Ferreira Machado, Affonso Ávila cites literary historian Martins de Oliveira (Ávila 1:297). Oliveira points out the stylistic similarities to *Aureo Throno Episcopal* and suggests that the lack of references to blacks and mulattos in *Aureo Throno Episcopal* is owed to the fact that this publication, unlike *Triunfo Eucharistico*, is not sponsored by the Black Brotherhood of the Rosary (in Ávila 1:297).

35. Citing the founding documents, Boxer gives the dates as April 8, 1711, for Vila do Riberão do Carmo and July 8, 1711, for Vila Rica (82).

36. Boschi notes that the goal in creating the bishopric was to consolidate royal as much as ecclesiastical authority in the mining region: "Era flagrante o intuito da criação dos bispados de Mariana e São Paulo . . . dentro da política metropolitana de manutenção e ampliação da soberania de suas possessões na América. Este fato, simultaneamente, caracteriza bem a necessidade da Metrópole em conso-

lidar sua hegemonia sobre as terras mineiras" (*Os leigos* 89) [The aim of the creation of the bishoprics of Mariana and São Paulo . . . was obviously part of the metropolitan policy of maintaining and increasing sovereignty over its possessions in America. At the same time, this fact well demonstrates the need of the Metropole to consolidate its hegemony over the mining lands].

37. In his letter of acceptance, Frei Manuel refers to his experience in Maranhão in reducing "a alguma ordem de christandade as muitas desordens e relaxaçoins que achei nesta Diocese e a huma boa armonia e socego as parcialidades e inquietaçoins com que o demônio há muitos anos trazia inquieta e perturbada tôda esta terra" (in Trindade 1:96) [the many disorders and laxness that I found in this Diocese to some order of Christianity, and the factions and agitation with which the devil has for many years made all this land restless and disturbed, to some good harmony and peace]. Trindade also cites a letter to the King's cabinet minister Frei Gaspar da Encarnação, in which Frei Manuel expresses his initial resistance to embarking upon the same sort of mission in Minas Gerais: "porque, supposta a quietação e socego em que já estava depois de muitos trabalhos, repugnava-me entrar em outros" (1:96) [because, given the peace and tranquility that I was in after many labors, it was repugnant to me to take up new ones].

38. Cruz refers to the difficulties of his long voyage in a letter to cabinet minister Frei Gaspar da Encarnação: "No que respeita ao meu transporte desta cidade (São Luiz) para a de Mariana, não faltam dificuldades que vencer" (in Trindade 1:96–97).

39. On the actual poverty of Minas Gerais during the gold rush, see Laura de Mello e Souza, *Desclassificados do ouro*. She argues that the festival performed an "ideological inversion" that covered over the region's poverty, which is amply documented in other texts of the period, with a false image of wealth and opulence, thus serving to reinforce the status quo and to neutralize societal conflict (30). Souza emphasizes the exceptionality of *Aureo Throno Episcopal* and *Triunfo Eucharistico*: "Alusões à pobreza, à ruína, ao abandono a que ficavam relegadas as populações mineradoras representam a tônica dominante dos documentos do século XVIII mineiro, sejam eles oficiais ou não. Os dois textos que descrevem as festas barrocas apresentam-se, por tanto, como extremamente destoantes no concerto geral: quase que se poderia dizer constituírem os únicos registros que fazem menção à riqueza e à opulência" (30) [Allusions to poverty, to ruin, to the abandonment to which the mining populations had been relegated represent the predominant theme of the documents in eighteenth-century Minas Gerais, whether they be official or not. The two texts that describe the baroque festivals appear, therefore, as extremely out of tune with the general concert: it could almost be said that they are the only registers that mention richness and opulence].

40. Gold production reached its peak between 1737 and 1746; at all times the wealth produced through mining was only enjoyed by the small percentage of the population that owned a large number of slaves (L. Souza, *Desclassificados* 27–32).

41. In one succinct example, Arzáns writes, "a la verdad fue cosa admirable

que tan en breve se dispusiese en tiempo tan calamitoso" (3:50) [indeed, it was a most remarkable thing that it had all been accomplished so quickly and in a time of economic distress]; see also 3:416. In a similar rhetorical move, when relating how inclement weather nearly ruined the newly built fountain, the author of *Aureo Throno Episcopal* turns the impediment into an occasion for wonder: "supposto esta lhe fizesse alguma destruição, com effeito se renovou para o dia da solemnidade, causando não menos geral admiração, e agrado esta reforma, que o primeiro prospecto" (44) [although this caused some destruction, it was in effect renovated for the day of the solemn entry, the reform causing no less general admiration and pleasure than the first view].

42. Maravall, *Culture* 241–247 and "Teatro, fiesta e ideología en el barroco." Also see Bonet Correa and Díez Borque.

43. This number could not compete with the lettered city of Mexico, capital of New Spain, about which Rama writes that "the number of poets appears extremely large in all the available sources. Balbuena mentions 300 poets participating in a late-sixteenth-century contest held in Mexico City, and Sigüenza y Góngora collected the work of a similarly large number a century later" (18).

44. Regarding the "heated jurisdictional battles between civil and religious authorities" over control of the brotherhoods and oversight of their account books, Elizabeth Kiddy writes, "Crown authorities tenaciously fought to wrest control of the job from them, and for the first half of the eighteenth century, the jurisdictional lines were so unclear that it is impossible to trace any kind of chronology of who oversaw the accounting books" (86–87).

45. Matoso's "Informação" appears to draw on *Aureo Throno Episcopal* in its reference to Almeida's refuge in Vila do Riberão do Carmo at the time of the 1720 rebellion; see the nearly identical wording in Campos and Figuereido 1:252 and *Aureo Throno Episcopal* 349.

46. On Matoso's intellectual and literary activities and their connection with the political ambitions of a *letrado* class—which, *pace* Rama, was not exclusively engaged in the promotion of royal authority—see Figueiredo 138–154.

47. On the circulation of the *Códice Costa Matoso* through various libraries in Portugal, Brazil, and England, see Figueiredo 39; he argues that its trajectory through the libraries of various officials indicates "a força da tradição de sua vinculação corporativa" (154) [the force of the tradition of its corporate connection].

CHAPTER 3: FESTIVE NATIVES IN POTOSÍ,
FROM AUDIENCE TO PERFORMANCE

The epigraph comes from *Libro de actas de los cabildos anuales de la cofradía de Nuestra Señora de la Soledad para la procesión del Santo Entierro de Cristo y repartición de las insignias a las personas* [1668–1747], 240v–241r, Iglesias y Conventos, caja 08, leg. 44/244, Casa Nacional de Moneda, Archivo Histórico, Potosí, Bolivia (CNM-AH).

1. This was one of Potosí's elite confraternities. Pablo Luis Quisbert Condori has found evidence that members of Potosí's *cabildo* (town council) belonged to the Cofradía de Nuestra Señora de la Soledad and were "intimately linked" to its actions, assigning administrative posts in the brotherhood and even determining its transfer to another church for a period in the late sixteenth century: "Así pues, cofradías como la de la Soledad reflejan los pactos y conflictos que protagonizaban las oligarquías municipales" (332) [In this way, confraternities like that of Our Lady of Solitude reflect the pacts and conflicts in which the municipal oligarchies participated].

2. Amerindians had to celebrate "todos los domingos del año, la fiesta de la Circuncisión, la fiesta de los Reyes, los primeros días de las tres Pascuas, la fiesta de la Ascensión de Cristo, la de Corpus Christi, y las cuatro fiestas de nuestra Señora, la Natividad, la Anunciación, Purificación y Asumpción y la fiesta de Sant Pedro y Sant Pablo" (Vargas Ugarte 1:18–19) [every Sunday of the year, the feast of the Circumcision, the feast of the Three Kings, the first days of the three *pascuas*, the feast day of the Ascension of Christ, Corpus Christi, the four feast days of our Lady (Nativity, Annunciation, Purification, Assumption), and the feast day of Saint Peter and Saint Paul]. This set is reaffirmed in the Second (1:251–252) and Third Provincial Council (1:366). *Cristianos* (Spaniards) were required to celebrate three times that number of occasions (1:70–71). See also Vargas Ugarte 1:60–61 on processional order and 1:332 on the appearance of women in and around processions, "para que se hagan las dichas processiones con más orden y devoción" [so that said processions are done with more order and devotion].

3. See Quisbert 353–354 on the permissions granted to mine owners to require indigenous labor on feast days and the occasional revocation of these licenses. Quisbert describes how mine owners argued "que la participación de los indios en las fiestas religiosas no era sincera, que estaba motivada por el afán de ocio y que el espíritu mismo de la fiesta religiosa se pervertía cuando los indios aprovechaban estos días para dedicarlos a sus borracheras" (353) [that the participation of the Indians in religious feasts was not sincere, that it was motivated by the desire for leisure, and that the very spirit of the religious feast was perverted when the Indians took advantage of those days to dedicate them to their drunkenness].

4. Kenneth Mills describes the multifaceted term *huaca* as "most often natural stone forms, although these were occasionally sculpted or painted upon by human hands. The word *huaca* seems to have had a wider meaning as well; to say that an object or place was huaca implied that it was sacred and deserved reverence . . . huacas could be both small figures or idols, as well as peaks of mountains, important places, shrines, ancestor's bodies (*malquis*), or burial sites" (42).

5. Viceroy Francisco de Toledo's ordinances, issued between 1575 and 1580, also both mandated and suspected indigenous participation in Christian festivals: "que en la fiesta de Corpus Christi saquen sus andas y danza en cada parroquia y vayan en procesión con su cruz y banderas y sus hermanos de la cofradía los rijan y el sacerdote con ellos, examinando ante todas cosas las andas que llevan por que no lleven escon-

didos algunos ídolos, como se les han hallado en otras ciudades, y el sacerdote antes que salga les diga en su lengua la razón de aquella fiesta para que la entiendan y honren con la veneración que son obligados" (Toledo 1:414) [in the festival of Corpus Christi they shall take out their image and dance in each parish and go in procession with their cross and flags, and the brothers of the confraternity, with the priest, shall rule them, examining above all the platform on which the image is carried so they carry no idols hidden there, as has happened in other cities. And before they set out the priest shall tell them in their language the reason for that festival, so that they understand it and honor it with the veneration they are obliged to give] (translated in Abercrombie 236). Abercrombie urges us to use caution "as we seek to interpret the priestly denunciations of Andean sorceries and idolatries, [and] to remember that Spaniards were predisposed to find pre-Columbian practices lurking behind apparently Christian indigenous practice" (276). Sabine MacCormack sums up the Spanish ambivalence toward indigenous festive practices: "Andean dancing, music-making, and ceremonial attire were at times recognized as appropriate accompaniments of Christian ritual action; but some missionaries insisted that all forms of Andean self-expression inevitably evoked [pre-Christian] rituals" ("Time" 298).

6. This is an example of a failure of what Joseph Roach has famously called "surrogation" in performance practices, as Diana Taylor explains: "The friars might well have wished that the new approved social behaviors they were imposing on their native population functioned as a form of surrogation. The recent converts, however, may just as readily have embraced these ambiguous behaviors as a way of rejecting surrogation and continuing their cultural and religious practices in a less recognizable form. The performance shift and doubling, in this case, preserved rather than erased the antecedents" (46).

7. Dean offers a thorough analysis and contextualization of these paintings in *Inka Bodies and the Body of Christ*.

8. Polo de Ondegardo refers to indigenous festive rituals practiced in secret since "lo principal y público á ya cessado" (3:23) [the principal and public has already ceased].

9. For summaries of recent research regarding the pre-Hispanic population and silver production in Potosí and its vicinity, see Medinaceli 22–23 and Quisbert 383–384.

10. Quisbert underscores the circulation and exchange of religious practices that resulted from the *mita*'s displacement of different indigenous populations (384). He affirms that Potosí became known for its tolerance of idolatry and even as a "radiant center" of its promotion (395).

11. Carolyn Dean has argued that what Spanish chroniclers like Polo de Ondegardo were finding in Corpus Christi festivals were "imagined raymis": not a set of rites associated with Inti Raymi or any other specific festival but the "generic forms of native songs, dances, and festive regalia" that Spanish expectations themselves created, since the festival's performance "required the presentation of a vanquished opposite" (48–49).

12. See Zighelboim's "Colonial Objects" on the suppression of the use of ceremonial dress such as *mascarones* [masks] and *champis* [maces] following the Tupac Amaru rebellion; there he analyzes the correspondence between Visitador Josef Antonio de Areche and Cuzco Bishop Juan Manuel Moscoso y Peralta in 1781. Zighelboim explains that the exchange was part of an effort to recast the rebellion as exclusively indigenous, which involved reinterpreting "colonial established signs of the Inca past . . . as subversive of the colonial order" (199). On Moscoso's critique of Incaic symbolism in religious festivals by the indigenous elite, see Cahill.

13. Taylor describes a similar ambivalence between "two discursive moves that work to devalue native performance . . . : (1) the dismissal of indigenous performance traditions as episteme, and (2) the dismissal of 'content' (religious belief) as bad objects, idolatry" (33). While the first reflects the privileging of writing over performance, the second "admits that performance does indeed transmit knowledge, but insofar as that knowledge is idolatrous and opaque, performance itself needs to be controlled or eliminated" (34).

14. Similarly, Burkhart emphasizes the public albeit contested dimension of native identity in the Mesoamerican context: "To characterize colonial Nahuas as crypto-pagans operating under a veneer of Christianity is to grant objective reality to the dualistic categories of 'Christian' and 'pagan,' which were highly meaningful to Europeans but foreign to indigenous self-conceptions. Native people who underwent baptism and participated in Christian ceremonies were choosing to represent themselves as Christians, whatever they understood Christianity to be" (362).

15. See Abercrombie for a discussion of modern Christian festive practices in Bolivia and the ways in which they clandestinely incorporate indigenous Andean rites. Although he points out that Counter-Reformation policies and punishments taught Andeans "a new difference between public and private activities," such that "their heterodox practices were channeled into clandestinity" (262), Abercrombie insists that heterodox practices are not a sign that Christianity was being used as a cover to continue indigenous idolatry (109–116, 276). In this sense, Abercrombie's view of public versus private festive practice differs from Scott's public versus hidden transcript: "It *is* possible to distinguish relatively 'more Christian' and relatively 'more Andean' cosmic spheres . . . , a contrast that also seems to correspond roughly to ritual practices in 'more public' as opposed to 'more private' performance contexts. But the qualities and characteristics of 'Christian' and 'Andean' deities seem to have interpenetrated one another so thoroughly that the contrast seems in some ways vacuous" (Abercrombie 110; emphasis in original).

16. The translation is mine, as this sentence is omitted from the English version, *Culture of the Baroque* 231.

17. To explain this ambivalence, Dean uses Homi Bhabha's notion of the menace represented by cultural hybridity: "Inka bodies did indeed occasionally menace colonial authorities precisely because of their compulsory alterity. Because difference is always accompanied by the possibility of subversion, anxiety was generated and it festered. Out of many anxious festive moments rose ambivalence. Even

within the confines of a Christian festival, native dances and regalia became exotic spectacles pregnant with 'pagan' possibilities, for Andean religious converts converted Corpus Christi into something quite different" (50).

18. The rhetoric of wonder appears throughout: "Fué la mayor cosa / Que se ha visto en este reino / . . . / Que fué admiración del gusto / Y suspensión del deseo" (8-9) [It was the greatest thing / that has been seen in this kingdom / . . . / For it was the pleasure of amazement / and wonder of desire]; "Cuando el imperial Cabildo, / Majestuoso y excelso / Con el señor Presidente / Vino ostentando lo regio" (10) [When the imperial Town Council, / Majestic and exalted / With the lord President / Came flaunting magnificence].

19. *Chicha* is a fermented beverage made from corn. In Arzáns's account of a festival organized for the canonization of Saint Rose of Lima in 1670, he describes a similar fountain "en que corrió vino un día entero, alegre licor para los indios y demás vulgo que a porfía daban mil abrazos y besos a un mascarón por cuya boca salía el vino" (2:253) [in which wine flowed a whole day, a happy liquor for the Indians and the rest of the masses who competed to give a thousand hugs and kisses to a mask from whose mouth the wine poured out]. And in his account of the 1658 festival for the birth of Prince Philip, the French traveler Acarete du Biscay attributes the construction of a zoological garden and fountains to the indigenous residents of Potosí: "The Rejoycings of the *Indians* deserve a particular remark, for besides that they were richly cloth'd, and after a different manner, and that Comical enough, with their Bows and Arrows; they in one Night and Morning, in the Chief Publick place of the City, prepar'd a Garden in the form of a Labyrinth, the Plats of which were adorn'd with Fountains spouting out Waters, furnished with all sorts of Trees and Flowers, full of Birds, and all sorts of Wild-beasts, as Lions, Tygers and other kinds; in the midst of which they express'd their Joy a Thousand different ways, with extraordinary Ceremonies" (60, emphasis in the original).

20. In *Diccionario de autoridades* (1726), the third definition for *blanco* as a noun (after the "first form" of a printing press and an ancient coin of Castile) is a target (for shooting), and the fourth is "target" in the symbolic sense: "Metaphoricamente significa el objeto a que se dirigen nuestros afectos, o el fin a que se encaminan con reflexión nuestras acciones, o pensamientos" [Metaphorically it signifies the object to which our affections are directed, or the end to which our actions or thoughts are aimed, with reflection]. "Hombre blanco, Muger blanca" [White man, white woman] is "lo mismo que persona honrada, noble, de calidad conocida: porque . . . los negros, mulatos, Berberiscos y otras gentes que entre nosotros son tenidas por baladíes y despreciables, carecen regularmente de color blanco, que tienen casi siempre los Europeos" (616) [the same as honorable, noble person, of known qualities; because . . . the blacks, mulatos, Berbers and other peoples who among us are taken for inconsequential and worthless, usually lack white color, which the Europeans almost always have].

21. A *real cédula* [royal decree] from 1662, a year before the festival described in *Relación de la grandiosa fiesta*, complains of the "exceso con que los indios de di-

cha Villa celebran las fiestas en las cofradías que tienen" [excess with which the Indians in the said Town celebrate the festivals in their confraternities], noting in particular how a festival "ocasiona la enbriaguez" [occasions drunkenness]. By looking at Spanish complaints of indigenous drunkenness in accounts of Corpus Christi in Cuzco, Dean argues that "placing the blame on consumption of alcohol seems to have become a way of glossing over the menace and minimizing the threat of dancing Indians" (58). On indigenous drinking in colonial festivals, see also Abercrombie 234–236 and Cummins, *Toasts* 221–230. In the chapter on festivals in his *Primer nueva corónica y buen gobierno* (1615), indigenous author Felipe Guaman Poma de Ayala disassociates indigenous singing and dancing from idolatry but still condemns the practice of festive drinking: "no tiene cosa de hechisería ni ydúlatras ni encantamiento, cino todo huelgo y fiesta, rregocixo. Ci no ubiese borrachera, sería cosa linda" (315 [317]) [there is no witchcraft, idolatry, or enchantment, but all play and fiesta, rejoicing. If there were no drunkenness, it would be a beautiful thing].

22. However, the license is from 1604, dated November 28, by Secretario Tomas Gracian Dantisco, and the *privilegio* (patent) from December 14, 1605.

23. The 1737 *Diccionario de autoridades* defines *perulero* as the money made in Peru; he who has returned from Peru to Spain; and "sugeto adinerado" [affluent person].

24. The poem by Ovid to which Mexía refers is known as "Among the Getae": "A few still retain vestiges of the Greek language, / though even this the Getic pronunciation barbarises. / There's not a single one of the population who might / chance to utter a few words of Latin while speaking. / I, the Roman poet—forgive me, Muses!— / am forced to speak Sarmatian for the most part. / See, I'm ashamed to admit it, from long disuse, / now, the Latin words scarcely even occur to me. / I don't doubt there are more than a few barbarisms / in this book: it's not the man's fault but this place" (Ovid n.p.). Rodríguez Garrido points out that in this passage Mexía situates himself at the margins of "los grandes centros productores de la cultura del Humanismo" [the great centers of production of Humanistic culture] at the same time as he tries to invert that position by identifying himself with Ovid (307–308). The loss of maternal language following a prolonged exile from the homeland is a trope not only of classical literature but also New World chronicles. For example, in *La Florida del Inca*, El Inca Garcilaso de la Vega compares himself to a Spanish captive who had lost his mother tongue: "por no haber tenido en España con quien hablar mi lengua natural y materna, . . . se me ha olvidado de tal manera que no acierto ahora a concertar seis o siete palabras en oración para dar a entender lo que quiero decir" (129–130) [for having found no person in Spain with whom I may speak my mother tongue, . . . I have so forgotten it that I cannot construe a sentence of as many as six or seven words which will convey my meaning] (79–80).

25. See Riva-Agüero, "Diego Mexía de Fernangil y la Segunda Parte del 'Parnaso Antártico,'" in his *Obras completas* 2:107–163, especially 109.

26. On the campaigns of extirpation of idolatry in Potosí and its vicinity, see Quisbert 398–402.

27. Kathleen Shelley and Grinor Rojo describe the work as "unrepresentable" (334). See also Rodríguez Garrido, who concludes from an analysis of the work's "peculiar manejo del espacio" (310) [peculiar handling of space] that it was conceived "para la lectura y no para la representación" (310) [for reading and not for performance].

28. Dillon explains that "theater, by its very nature, conveys meaning by operating at the intersection of embodiment and representation—by coupling physical presence and mimetic reference. . . . In other words, the signifying economy of the theater operates in two registers: one that is *ontic* (thingly, material, resolutely present) and one that is *mimetic* (referential, immaterial, gesturing toward a scene located elsewhere)" ("Coloniality" 181).

29. By reading *El Dios Pan* alongside the dedicatory prologue, which has only been published separately from the dialogue, Rodríguez Garrido shows how the public envisioned is not "el múltiple y diverso auditorio propio del drama religioso" [the multiple and diverse audience proper to a religious drama] but "los miembros de la pequeña comunidad entre la que circulaban los poemas de Mexía" (311) [the members of the little community in which Mexía's poems circulated], and specifically the governing elite. See also Gisbert 636.

30. Maravall interprets the task of "moving its addressee" as one way in which Baroque culture reached its objective of "guiding control" (*Culture* 75); however, the transformation of spectators into participants could have unintended consequences.

31. Hanke writes of the 1608 Corpus Christi festival, "Es difícil reconciliar la pintura de una sociedad rica y poderosa, capaz de preparar y pagar ostentaciones tan minuciosa y bellamente descritas en este capítulo y el siguiente, con los hechos tales como se dan en la documentación de estos años, que demuestran una tenaz decadencia en la producción de plata, de suerte que por 1608 Potosí estaba en medio de una severa crisis económica" (in Arzáns 1:274n7) [It is difficult to reconcile the portrait of a rich and powerful society, capable of preparing and paying for ostentations so minutely and beautifully described in this chapter and the next, with the facts as they are given in the documentation from those years, which show a tenacious decadence in the production of silver, so that by 1608 Potosí was in the midst of a severe economic crisis].

32. Arzáns writes, "¿Y qué diré de la devoción y caridad de los indios y aquella veneración que tienen al culto divino? Muchísimas fiestas hacen a Jesucristo Nuestro Señor, a María santísima y a otros muchos santos del cielo en el discurso del año. . . . ¿Qué de arcos cubiertos de plata labrada no ponen por las calles y plazas para que pasen las procesiones; con qué suma grandeza y afecto no celebran la pureza de la Virgen? Gozo y admiración causa ver bajar de todas las minas del Cerro la víspera de la Natividad del Señor, tantas, tan hermosas y adornadas imágenes de Nuestra Señora de la Concepción, trayéndolas a las iglesias cada mina con sus indios, con tantas banderas, cohetes . . . y otros fuegos artificales en que gastan más de 10,000 pesos" (2:331) [And what can I say of the devotion and charity of the Indi-

ans and that veneration that they have to divine worship? They celebrate very many festivals in honor of Jesus Christ our Lord, Holy Mary, and many other saints in heaven in the course of the year. . . . What of the arches covered with wrought silver that they put up in the streets and plazas where the processions pass; with what grandeur and affection do they not celebrate the purity of the Virgin? It causes pleasure and admiration to see so many, and such beautiful and well-adorned images of Our Lady of Conception coming down from all the mines of the Hill on Christmas Eve, brought by every mine with its Indians to the churches, with so many flags, rockets . . . and other fireworks, on which they spend more than 10,000 pesos].

33. The maskettes of lions' heads are surely of European military inspiration. They can be seen in a festive context in *C'est la deduction du sumptueux ordre*, the account of the French king Henri II's entry in Rouen in 1551, in the illustrations of "Les predecesseurs Roys de France," "Trompettes," and "La cinqiesme band."

34. Dean writes, "Zoomorphic maskettes, worn at the shoulders and ankles . . . have less specific pre-Hispanic precedents, although they became a standard element of postconquest Inka ornamentation." She observes that our sources (Arzáns and Cobo) "could well have been based on colonial-period processional garb, rather than on any direct knowledge of preconquest costume" (127). In the same chapter she analyzes the elaborate headdresses (including the *llautu*) worn by the parish standard-bearers in the Corpus Christi paintings (122–147).

35. Ximena Medinaceli divides Potosí's indigenous nobility into two groups, Inca including direct descendants, *pallas* and *yanaconas* and non-Inca "autoridades étnicas" [ethnic authorities] and "capitanes de mita" [*mita* captains] (56–69). Spanish friar Diego de Ocaña describes how the "indias y pallas muy ricas" [very rich Indian women and princesses] had their own "cofradía del Niño Jesús, tan rica que en el mundo no hay cosa semejante" (200) [confraternity of Baby Jesus, so rich that in the world there is nothing like it]. He describes how, as part of their opulent procession on Easter Sunday, they carried the baby Jesus in indigenous dress adorned with pearls and precious stones, and he calls the members of this confraternity "los más ricos de Potosí" (200) [the richest of Potosí].

36. Arzáns highlights the Inca costumes of indigenous nobility in other festivals as well; see 1:210, 240, 244.

37. On this and other examples of the participation of indigenous nobles in mock battles, see Quisbert, who shows that "las cañas y la sortija no eran solo ejercicio de españoles" (344) [the game of reed spears and running of the ring were not only the exercise of Spaniards]. In her classic study of the Huarochirí region, Karen Spalding describes how the "highly competitive" nature of Andean society, in which "rank and prestige were important counters in the struggle for position," manifested itself in festivals: "In the larger communities, the component groups or ayllus were ranked in a hierarchy that determined the order of their participation in feasts, worship, or the division of the spoils of war. . . . Within this ranked order, the ayllus competed with one another in the performance of ritual or other joint activity, testing the established order" (56–57).

38. Leonardo García Pabón enumerates and analyzes the full sequence of the procession (428–431).

39. Cobo writes, "All of the nations that obeyed the Inca, each dressed in the style of their region, participated in this dance. The priests assigned to them would bring out the guacas on litters, and upon reaching the palce where the idols and the Inca were located, they made a reverent gesture to them and went on to take their places. During the rest of this day, each nation performed the dances and songs that were done before they had become subjects of the Inca" (148). Similarly, Molina relates, "The next day in the morning, all the nations that the Inca had subjected would enter [the plaza]. They came with their huacas and dressed in the clothing of their lands, the finest that they could have" (48).

40. Molina describes how "they would also bring out the very richly dressed embalmed bodies of all the lords and ladies. Their bodies were cared for by the descendants of their lineages that were in charge of them. They would place them on their gold seats in the plaza, according to their order, as if they were alive" (38). The account of Peru attributed to Miguel de Estete describes similar practices during the monthlong festivities in Cuzco following the defeat of Atahuallpa's forces: "acord[aron] [los naturales] hacer grandes fiestas en la plaza de la ciudad, de bailes y danzas . . . trayendo a las dichas fiestas todos sus agüelos y deudos muertos . . . embalsamados, como es dicho, y sentados en sus sillas, y con mucha veneración y respeto, todos por orden" (54) [the natives agreed to put on big festivals in the city plaza, with dances . . . bringing to said festivals all their dead grandparents and relatives . . . embalmed, as has been said, and sitting on their chairs, and with much veneration and respect, all in order]. Estete makes the rather dubious claim that the intentions of the ceremony were not to continue traditional Inca practices of honoring ancestors but to "hacernos entender que eran más contentos con la conversación de los españoles" (54) [make us understand that they were more content with the interaction with the Spaniards].

41. MacCormack distinguishes between examples of pre- and postconquest processions of Inca sovereigns: "Manco Inca's procession [in 1534] displayed a political and historical reality: it told the history of past Incas by way of making it concrete in the present. . . . Such was not the case in 1610, when Inca nobles performed the part of their past kings without being those kings, or being like them. They enacted a representation, the reality of which could indeed be brought forward into the present, just as a play, a movie or a novel makes real in the present what in effect is not, or is no longer real" ("History" 350).

42. Romero transcribes the account of the "Fiestas de los naturales" [Festivals of the natives] included in Jerónimo Fernández de Castro's *Eliseo Peruano* (1725). Luis Millones analyzes this account and the Cuzco Corpus Christi paintings.

43. Sayri Tupac also continued Inca ceremonial practices at Vilcabamba, about which Juan de Betanzos reports in 1556: "Y en lo que entienden, allí donde están, es en hacer toda la vida sacrificios y sus ayunos y idolatryas gentílicas a sus guacas e ídolos, y en hacer todas las demás sus fiestas, según que se hacían en el Cuzco en

tiempo de los Yngas pasados, según que se lo dejó ordenado Ynga Yupangue" (353) [And what they are occupied with, there where they are, is offering sacrifices all their lives, and their fasting and heathen idolatries, and doing all the rest of their festivals, according to what they used to do in Cuzco in the time of the Incas, just as Inca Yupanqui ordered it].

44. Manuel Burga doubts that the festival described by Arzáns actually occurred in 1555, suggesting that it more likely reflects one witnessed by Arzáns at the end of the seventeenth or beginning of the eighteenth centuries (*Nacimiento* 409, 412). Cummins's discussion of colonial portraits of *kurakas* and Inca kings confirms the exceptionality of the inclusion of Sayri Tupac in the procession: "These impersonations and portraits all contributed to establishing a clear historical sequence that acknowledged the Andean past but at the same time showed it to be conclusively severed from the present by the juxtaposition of the last Inca ruler and the first Spanish king under whom Peru was colonized. Inca history and an independent Andean identity were, therefore, carefully relegated to a nostalgic period that existed only before Spanish arrival. . . . This is why we find no paintings of the last three Inca Kings who succeeded Atahualpa" ("We Are" 224). However, Cummins's argument that the processions "instilled a sense of resignation the face of an irretrievable past" (222) does not seem tenable in the case of the 1555 procession described by Arzáns. Arzáns also refers to Sayri Tupac and the other Incas who succeeded Atahuallpa in his account of a festival celebrating the marriage of Philip III and Margaret of Austria in 1600, although they are said to occupy "asientos más inferiores" [lower seats] than the performers representing the preconquest Incas and the Spanish successors, Charles V, Philip II, and Philip III (1:244).

45. The play described by Arzáns has been identified with the *Tragedia del fin de Atahuallpa*, a drama in verse form that probably dates to the eighteenth century; see Chang-Rodríguez 49 and Bermúdez-Gallegos.

46. Dean finds that "the performance of ancestry . . . worked against rival Andean individuals and groups and became one of the primary mechanisms by which colonial Inka elites asserted and maintained their positions at the top of the subaltern pecking order" (99). See also Cahill 67 and Burga, "El Corpus Christi" 326. Burga's arguments about the use of festive regalia by the colonial Inca elite could certainly be applied to non-Inca *kurakas*, who were instrumental in organizing and directing indigenous *mita* labor in Potosí; Cummins, "We Are," 208–209. Millones makes a similar argument about non-Inca elites in Lima (64).

47. Graubart contends, "Men dressed as 'incas' were a common sight in Catholic feast day processions, and descriptions of their participation were entered into the legal record as evidence for noble status and exemption from tribute. Such 'Inca' costumes came to include the symbols of Iberian hidalguía—a status that could only be conferred by the Crown—as the parallels between ruling classes were emphasized by the conquered nobility" (*With Our Labor* 137).

48. Many decades later, in 1670, Viceroy Conde de Lemos testified to similar abuse of caciques for failing to meet *mita* quotas: "usan de medios sangrientos

y rigurosos, colgando a los indios de los cabellos y en muchas partes ponen horcas, meten en cárceles rigurosas y azotan con crueldad" (Fernández de Castro Andrade y Portugal 155) [they use bloody and harsh means, hanging Indians by their hair and in many parts they put them in the gallows, or in rigorous jails and they whip them with cruelty]. See also Brown 55 and Robins 50–51.

49. Graubart describes the "hybrid wardrobe" of indigenous elites, which "drew upon the now-symbiotic symbols of European and Andean nobility. These men and women clearly saw their dress as public performance of their status, most importantly in community public events, religious processions, and court appearances, but presumably too in everyday life. Their elegant wardrobes indicate the range of these performances, not to mention the expense that must have supported them" (*With Our Labor* 155–156).

50. Arzáns's detailed description of Atahuallpa's costume, which apparently was originally accompanied by a picture, includes even more vocabulary in Quechua (1:99); on this passage see García Pabón 434. Hanke and Mendoza call attention to some of the phonetic evidence for the linguistic "hybridity" of Arzáns's text (3:463). Anna More analyzes a similar passage in the Mexican creole Carlos de Sigüenza y Góngora's *Glorias de Querétaro* (1680), which uses a great deal of Nahuatl terminology to describe the adornment of indigenous nobility in a procession. According to More, "The value of the words in Nahuatl does not seem to lie in their ability to signify . . . but in the fact that they retain 'the originality of the elegant tongue' (la propriedad de la elegante lengua) that mimics the nobility represented" (99). The "elegancia del verso mixto" [elegance of the mixed verse] may have a similar function in Arzáns, contributing to "the ideal of a syncretic, postconquest alliance between Creoles and indigenous nobility," as More argues with respect to the Querétaro procession (99). However, his incorporation of Quechua terminology also evokes a festive public that would be able to understand the bilingual theatrical performance as well as the symbolic meaning of the royal insignia, just as More acknowledges that such terms would indeed have meaning "for those familiar with Mexica regal attire" (99).

51. Perhaps *alaridos* also refers to *cantares* sung about the deeds of Inca rulers that Estete describes as their most important means of remembering the past (47). Estete explains, "En los cantares trataban de lo que cada uno de aquellos señores había conquistado y de las gracias y valor de su persona" (55) [In the *cantares* they dealt with what each of those lords had conquered and of the grace and valor of his person]. Bernabé Cobo describes "the dirges and sad songs of the heroic deeds that he [the ruler] had done with his weapons, and the victories and trophies that he had achieved, recounting his laudable customs, his virtues and his generosity with everyone" (250–251).

52. About this scene García Pabón writes, "Ésta es, en forma gráfica, una muestra del efecto de la participación indígena en la tradicional procesión española. Aunque no siempre en forma tan directa como en este caso, la participación de los indios altera sustancialmente el 'orden' de la fiesta" (435) [This is, in graphic

form, a demonstration of the effect that indigenous participation had on the traditional Spanish procession. Even though it was not always as direct as in this case, the Indians' participation of the substantially alters the 'order' of the festival]. In his account of the celebration of the *jura* [swearing-in] of Luis Fernando I in 1725, Arzáns writes that "siempre es dificultoso desembarazar [la plaza] de los indios en semejantes fiestas" (3:184) [it is always difficult to rid the plaza of the Indians in such festivals].

53. Commenting on this episode, Hanke and Mendoza remark that "estas precauciones eran necesarias como se vio algunos años después en el famoso incidente del Cuzco cuando los indios participaron entusiastamente en una procesión en honor de San Ignacio de Loyola y aprovecharon la oportunidad para representar una de sus antiguas danzas sin que los españoles se diesen cuenta de ello" (lxxv) [these precautions were necessary as was seen some years later in the famous incident in Cuzco when the Indians participated enthusiastically in a procession in honor of Saint Ignatius of Loyola and took advantage of the opportunity to represent one of their ancient dances without the Spaniards noticing it].

54. On the ceremonies performed upon the death of Inca nobles, see Cobo 250–251.

55. Abercrombie describes witnessing this same festival in Santa Bárbara de Culta, Bolivia (97–102); like Arzáns, he was only invited to partake in some of the libation sessions (100). Arzáns was also present at an Exaltation of the Holy Cross festival in 1714 (3:22).

56. Kendall Brown uses Quispe as an example of how "many miners found ways to resist the operators' demands or to garner greater personal benefit from the labor they were forced to do in the mines" (71): "To the chronicler Arzáns, Quispe was not dangerous or threatening. . . . As Quispe's case shows, Andean mining labor was clearly a more complex subject than might be expected" (72–73).

57. Commenting on Titu Cusi Yupanqui's account of the Spanish priest's rejection of Atahuallpa's offering of *chicha*, Abercrombie writes that from the indigenous perspective, the "spilling of the chicha was a grave breach of sociality"—at least equal to Atahuallpa's famous rejection of the Spanish Bible offered to him at the scene of first encounter (165).

58. Elsewhere Arzáns disavows the persistent association of festive drinking with native idolatry: "Bébese muy a menudo como en sacrificio de la salud ajena; rastro es de la idolatría, pero no es sólo en las Indias, que en todas las partes de Europa es lo mismo" (3:180) [They frequently drink as if in sacrifice to the others' health; it may be a trace of idolatry, but not only in the Indies, rather in all parts of Europe it is the same].

59. *Apiri*, a term that is derived from Quechua, means "operario que transporta mineral en las minas" [worker who transports mineral in the mines] (Real Academia Española).

60. Anna More argues, "Creoles could derive a specific form of authority from the interpretation of non-European objects. What has often been interpreted as a

paradoxical Creole appropriation of pre-Columbian indigenous artifacts and history even as they emphasized their own European roots, therefore, was in fact a bid to establish an authority based on knowledge available only to those who understood both traditions" (13).

61. García Pabón highlights this dimension of Arzáns's festivals (430). On similar festive appropriations of indigenous history by creoles, see my "Creole Patriotism" (regarding the Peruvian Pedro de Peralta y Barnuevo); Pagden 71–75; and More 110–157 (on the Mexican Carlos de Sigüenza y Góngora).

62. For other examples of indigenous women's construction of silver arches for festivals, see Arzáns 3:339 and 3:372. In this sense, Arzáns differs from other creole writers such as Sigüenza y Góngora. More finds that Sigüenza y Góngora pairs "the dignity of the Mexica emperors with the miserable state of present Indians" in his festival-related texts *Teatro de virtudes* and *Glorias de Querétero* (144). See also Pagden 75. The "charming grace" of the miner (Arzáns, *Tales* 193) and the "very pleasant vista" formed by the market women's silver arches (187) are a far cry from the "miserable Indians . . . crushed by poverty" of Sigüenza y Góngora's *Teatro de virtudes* (in More 143).

63. Abercrombie argues against the "thin veneer" resistance paradigm by which scholars look for "pre-Columbian practices lurking behind apparently Christian indigenous practice." After witnessing and studying modern-day participation of Amerindians in Christian festivals in Bolivia, he argues that native Christianity "is as earnest as it is heterodox" (276).

CHAPTER 4: "NOS PRETOS COMO NO PRELO"

1. The tale of Antonio Bran de Brizuela, a violent slave known as El Duende who was ultimately killed for his crimes, is included under the title "The Spook" in Arzáns's *Tales of Potosí* (56–57). Kris Lane sheds light on the historical personages and episode that apparently inspired this tale.

2. Venâncio shows that captive Amerindians were initially part of the mining labor force after gold was discovered in the *sertão* of Minas Gerais in the 1690s, but an elevated mortality rate and the transportation of African slaves to the region meant that indigenous slavery was practically nonexistent by the third decade of the eighteenth century.

3. For celebrations of African kings and governors in other areas in the Americas, see M. Souza 167–179; Piersen 117–128; and Dewulf, "Pinkster" and "From Moors."

4. On black confraternities in Lima, see Graubart; in Mexico, see Von Germeten.

5. Boschi describes the "lay religiosity" of Minas Gerais as characterized by "as pompas das festas e das procissões. Religiosidade barroca, numa palavra" (*Os leigos* 178) [the pomp of festivals and processions. In a word, Baroque religiosity].

For a concise discussion of the role of lay brotherhoods in Minas, see Boschi's "Irmandades." Eduardo Hoonaert also emphasizes the role of confraternities in his account of what he calls "catolicismo mineiro" [miner Catholicism]: "Naquela época, as confrarias reinavam" (95) [At that time, the confraternities reigned]. He calls for a comparison of miner Catholicism in Brazil with that of other mining regions (88). Mancuso and C. M. dos Santos offer such comparisons; Mancuso juxtaposes confraternities in Minas Gerais and Zacatecas, Mexico, while Santos's brief article highlights some of the same festivals in Potosí and Minas Gerais that I treat in this book.

6. The exact origins of the Black Brotherhood of the Rosary in Portugal are unclear. The earliest *compromisso* of a Black Brotherhood of the Rosary in Lisbon was approved in 1565, but the organization had clearly been in existence for some time; the *compromisso* even cites the construction in 1460 of a chapel devoted to Our Lady of the Rosary for "homens pretos vindos das longes terras" (in M. Souza 346n7) [black men coming from faraway lands]. For a summary of the evidence and the different historical interpretations, see M. Souza 163–166.

7. Borges lists forty-six branches of the Black Brotherhood of the Rosary in Minas Gerais that were founded between 1715 and 1820 (225–228). Boschi mentions sixty-two rosary chapters, representing by far the greatest proportion—19.31 percent—of all thirty-three lay brotherhoods in Minas Gerais (*Os leigos* 187, 195–198).

8. Sections of the *compromisso* are transcribed in Lopes (194–197). The *compromisso* goes on to specify that the elected judges were allowed but not obliged to meet the king and queen at their houses and accompany them to the church; if they did so, they should not delay the festival too much "para as festas se fazerem a horas competentes" [so that the festivities are done at the appropriate hours], suggesting that disputes over authority and precedence within the brotherhood were common. An amended version of the *compromisso* in 1745 continues to insist that the king and queen "virão para a dita Igreja só com o seu Estado, sem maior acompanhamento de Irmãos para se evitarem discordias e fazer festividades fora de horas como sempre tem acontecido" [will come to the said church only with their State, without a larger company of Brothers in order to avoid sowing discord and holding the festivities too late, as has always happened]; "Requerimento do juiz e mais irmãos da Irmandade de Nossa Senhora do Rosário dos Pretos, de Vila Rica, solicitando licença régia para por em livro o Compromiso da referida Irmandade," Minas Gerais, caixa 45, doc. 40, AHU.

9. This is in part the result of the general shift in the origins of the slave population in the second half of the eighteenth century from the west African Gold Coast to west central Africa, including Kongo and Angola, a shift that is evident in brotherhood registries. However, it also surely owes to the kingdom of Kongo's association with Christianity ever since the elite adopted the religion in the late fifteenth century; see M. Souza 251–269. Fromont notes, "Although kings and queens of several nations reigned, the great majority belonged to groups associated with west central Africa. . . . In turn, confraternities whose members identified with a

nation linked to that area elected more kings and queens than any other group"; "Dancing" 186. On the kingdom of Kongo's adoption of Christianity, see Fromont's *Art of Conversion* and Heywood and Thornton 49–108.

10. On the history of the Rosary brotherhood's festival as well as its present-day incarnation, see Kiddy.

11. See Scarano, "Black Brotherhoods" and *Devoção*; Russell-Wood, "Black and Mulatto Brotherhoods" and *Black Man*; and Mulvey, "Black Brothers" and "Slave Confraternities." More recent works on black brotherhoods in Brazil include those of Reis, Aguiar, and Silva. On specific black and mulatto brotherhoods in different cities or regions of Brazil, see Amaral, Soares, Quintão, Borges, Kiddy, and Reginaldo. Marina de Mello e Souza presents a summary of scholarly interpretations of black brotherhoods in Brazil, from tools of integration and Christianization to centers of cultural resistance (190).

12. Analyzing the music performed by Mardi Gras Indians, the African Americans who perform in Indian costume in New Orleans's Mardi Gras, George Lipsitz points out their use of the same style of "antiphony, or 'call and response,'" and describes it as a "form which originated in West Africa, but which has become a basic feature of Afro-American and Euro-American popular music" (106–107).

13. John Monteiro has found that at the beginning of the eighteenth century the term *carijó*, which originally referred to a Guaraní indigenous group, acquired a generic sense and could connote "enslaved Indian," derived from the prevalence of captured Guaranis as a result of slaving expeditions in São Paulo (166).

14. Mimoso's full description of the Brazilian king's and his companions' costumes closely resembles that of the "mulatto Carijós": "El Brasil sobre un vestido justo de color de negra carne, trahia en la cabeça una guirnalda de plumas de papagayos, ceñiase con un faldon dellas, y en los braços e piernas trahia lo mismo: en las caderas una rueda de las mismas plumas largas a modo de cola de papagayo. Trahia un arco largo con grandes flechas de caña, al modo que lo usan los Brasiles, a los ombros una capa de plumas de varios colores" (57v) [Over his tight costume the color of black flesh, he wore on his head a garland of parrot feathers, and a skirt of them around his waist, and on his arms and legs he had the same thing: on his hips he had a circle of the same long feathers in the manner of a parrot's tale. He had a long bow with great reed arrows, in the manner that the Brazilians use them, and on his shoulders a feathered cape of various colors]. The "Tapuijas y Aimurés" are described with a similar costume, "todos con vestido justo, y de pardo, que fingia desnudez, al traje de su Rey y patria, y ordenados a la misma arte, caras y manos del mismo color, que el vestido: en las manos arco y flecha" (57v) [all with a tight, brown costume that feigned nudity, in the manner of their King and country, and done in the same way, their faces and hands were the same color as the costume: in their hands, bow and arrow]. Janaína Santos Bezerra explains that the term *pardo* has traditionally indicated skin color and social status as nonslave rather than specifically designating mixed white and black ancestry, as with the term *mulato*, which

held more unfavorable connotations in the early modern period (33–41). See also Lara, *Fragmentos* 136–142.

15. For examples of this iconography, see Voigt and Brancaforte.

16. Fromont contends that although Julião's watercolors are not labeled, there is a text identifying a similar scene in Lisbon's Gabinete de Estudos Arqueológicos de Engenharia Militar as "Black Women of the Rosary" ("Dancing" 191).

17. Cécile Fromont describes how "the Brazilian male performers wear form-fitting black tops, tights, and shoes . . . successfully giving the illusion of bare chests and legs dressed only with the draped cloth around the waist . . . possibly in reference to the African manner" ("Dancing" 193).

18. Kiddy defines *congados* as "the different ritual groups (*guardas* and *ternos*) that participate in the festival of the rosary. . . . Historically the groups were referred to as the 'ambassadors' to the King of Congo, and today they play an important role in escorting the royalty of the festival to different locations" (260). She glosses *caboclo* and *caboclinho* thus: "The term *caboclo* refers literally to a person with mixed Indian and Portuguese heritage. It can also mean a country bumpkin. In Minas Gerais the name refers to one of the congado groups that are found mostly in northern Minas Gerais. The dancers and musicians wear headdresses of brightly colored feathers and snap their bows and arrows in syncopated rhythms as they dance" (259). Dewulf describes *caboclinhos* as "mock war dances without dialogue whereby all dancers are dressed as Native Americans" ("From Moors" 16).

19. The text is Soterio da Sylva Ribeiro's *Summa Triunfal*, an account of the 1745 festival sponsored by a mulatto brotherhood in Recife, Pernambuco.

20. According to Stuart Schwartz, "Slaves made up between one-third and one-half of the total population of the captaincy during most of the eighteenth century and free people of color constituted by 1821 another 40 percent of the total. Together, then, the Afro-Brazilian population—slave and free—eventually made up about three-quarters of the inhabitants" (*Slaves* 118).

21. In *Fragmentos setecentistas*, Lara juxtaposes the *caboclinhos* of *Summa triunfal* with the "mulatto Carijós" of *Aureo Throno Episcopal* and two other festivals, one in 1793 in Porto, featuring a dance by "nove americanos pretos da mesma idade [de oito anos]" (Lara 187) [nine American blacks of the same age, eight years old], and another in Conceição, Minas Gerais, in 1801, with "uma tropa de pequenos caboclos. Eram todos crianças, muito vivos e ligeiros, pintados de urucum e bem ensaiados, de maneira que imitavam perfeitamente os verdadeiros caboclos" (187) [a troupe of little *caboclos*. They were all children, very lively and quick, painted with *urucum* and well rehearsed, such that they perfectly imitated true *caboclos*]. For other examples of Afro-Brazilian festive performances involving Amerindian elements, see Dewulf, "From Moors" 15–17.

22. Pereira cites from the anonymous *Relação dos obsequiosos festejos, que se fizerão na Cidade de S. Sebastião do Rio de Janeiro, pela plausível notícia do Nascimento do Sereníssimo Senhor Príncipe da Beira, o Senhor D. José* (Lisbon, 1763). Lara includes

much of this citation in *Fragmentos setecentistas* but attributes it to *Epanafora festiva* (189, 345–3346nn37–38).

23. The birth of José, prince of Beira, was also celebrated with "solemne festividade" in Vila Rica, Minas Gerais, over a period of fifteen days, after which the city council requested reimbursement for the expenses in a letter to the king, "como sempre forão as festividades de tão soberanos objectos, e feita por huma das Cameras deste Continente mais fiel, e obediente a Vossa Magestade" [as has always been done for festivities with such sovereign purposes, and having been done by one of councils of this Continent most loyal and obedient to your Majesty]. This is the first in a series of three letters emitted on June 16, 1762, attempting to minimize the council's expenses on festivals and processions, including Corpus Christi: "Representação dos oficiais da Camara de Vila Rica, felicitando pelo nascimento do Principe da Veira, e solicitando o ressarcimento da despesa feita nesta ocasião," doc. 48; "Representação dos oficiais da Camara de Vila Rica, contra as despesas feitas nas procissoes e festividades que se celebravam na Matriz do Ouro Preto, pedindo que a Camara não fosse obrigada a elas assistir," doc. 49; "Carta dos oficiais da Câmara de Vila Rica contra a obrigação da despesa com a celebração religiosa pelas irmandades, solicitando ordem para por fim a este abuso," doc. 50, all in Minas Gerais, caixa 80, AHU.

24. Calmon's *Relação das Faustissimas Festas* (1762) was published by the same prolific official printer as *Aureo Throno Episcopal* (1749), Miguel Manescal da Costa, Impressor do Santo Officio. Hallewell reports that the Impressão Régia took over Mansecal's press in 1768 (18).

25. Oneyda Alvarenga refers to *talheiras* as antecedents of *baianas* (white-dressed mulatto women of Bahia) and suggests that *quicumbis* are the Indians who ambush the royal guard in this performance (in Calmon 31n32). On *quicumbis*, see also Dewulf, "From Moors" 15–16. The *quicumbi* dance is also described in detail in Ribeiro's *Summa triunfal* (37–38).

26. Lara observes that blacks and mulattos were barred from the goldsmith profession and that the goldsmiths may have simply sponsored the *reinado* that was performed by blacks; however, the white goldsmiths were more likely the performers, as the text's emphasis on disguise suggests ("Significados cruzados" 75). Marina de Mello e Souza, on the other hand, argues that the king and his court, musicians, and dancers must have been blacks who were familiar with the African King coronation festivals (263).

27. Kiddy compares the Julião images and the mulatto Carijós of *Aureo Throno Episcopal* with "caboclinhos" who perform in Our Lady of the Rosary festivals in northern Minas Gerais today (131–133). The editor of Calmon's account, Oneyda Alvarenga, notes that "deste e similares Reinados de Congos é que devem ter nascido os *Quilombos* e os *Caboclinhos* nordestinos, projeção adulta dos *meninos índios* no Reinado. O diminutivo induz à hipótese: por que *Caboclinhos*, se o bailado é de adultas?" (31n32) [from this and similar King of Congo festivals are where the *quilombos* and *caboclinhos* of northeaestern Brazil must have been born, an adult pro-

jection of the "little Indians" of the kingship. The diminuitive raises the question: why *caboclinhos*, if the dance is of adults?].

28. On the appropriation of Vespucci's iconography in the travel account of Ludovico de Varthema, see Leitch 140 and Voigt and Brancaforte; on "ethnographic interchangeability" in European representations of otherness, see Mason 40.

29. See also Tinhorão, *As festas* 112.

30. For a list of the black brotherhoods active in Minas Gerais, see Mulvey, "Black Brothers," 277–279. The Black Brotherhood of the Rosary is by far the most common, but she includes several others.

31. On tribute as a form of social humiliation, see Seed 72–90.

32. See Ribeiro's *Summa Triunfal*.

33. Beyond the "point by point correspondences in the regalia, musical instruments, and choreographies" that evince cultural continuities between Brazil and the kingdom of Kongo, Fromont stresses the similar "use and articulation of European and African elements. . . . In election festivals, men and women of central African origin and heritage did not simply borrow the regalia and imitate the pageantry of the colonial establishment. They used insignia and ceremonials according to well established and deeply meaningful practices of combination and reconfiguration that characterized the Kongo visual vocabulary of power and prestige" ("Dancing" 194–195). The Kongo elite's strategic mixture of African and Christian discourses and iconographies—discussed more thoroughly in Fromont's *Art of Conversion*—are part of what Linda Heywood and John Thornton call "Atlantic Creole" culture (49–108).

34. Like the mulatto Carijós, the *caboclo* is, Browning asserts, a figure that "resists racial classification" ("Daughters," 91). See also her *Samba* 24. Dewulf discusses theories connecting the European folkloric tradition of "wild men" and "Indian" performances in the festivals of Iberia, Brazil, and New Orleans ("From Moors" 20–23).

35. For other discussions of the diverse possible origins of the Mardi Gras Indians, see Lipsitz 102–103 and Roach 192–194.

36. In an argument that could be extended to the mulatto Carijós, Lipsitz states that for the Mardi Gras Indians, "the Indian imagery held important symbolic meaning . . . to see the identification with Indian culture as more a matter of choice than a matter of blood lines hardly lessens its significance" (104).

37. On the use of *carijó* to denote enslaved Indian, see John Monteiro 166 and Resende, "'Brasis coloniales'" 229. Through the use of both terms, "mulatinho" and "carijó," *Aureo Throno Episcopal* diminishes, perhaps intentionally, any assertion of free status.

38. This translation is mine.

39. Luiz Geraldo Silva has called the eighteenth century a passage "da festa barroca à intolerância ilustrada" (271) [from the Baroque festival to Enlightenment intolerance], ending in a time of repression of the black brotherhoods and their festivals.

40. Marina de Mello e Souza cites a similar case prohibiting the election of black kings in Bahia in 1729 (234–236). For other examples of prohibitions of black festivals in general and of the coronation of African kings in particular, see Quintão 114–121.

41. Castro's 1771 petition includes fifteen examples of the authority wielded by the elected black kings, demonstrating clearly that the festival was not supporting the slave system, as Antonil would have it (in *Cultura*), but posing a threat to it: "Tem mostrado a experiência que, depois de ser rei algum escravo, é tal a sua presunção que não servem mais a seu senhor com satisfação, o que será sendo forros: todos os pretos os ficam tratando sempre como reis velhos" (in Andrade n.p.) [Experience has shown that, after some slave has been king, his presumption is such that he no longer serves his master with satisfaction—let alone if they are freedmen; all the blacks continue always treating them as old kings].

42. The sixty-six-page document complains about the brotherhoods' usurpation of authority by carrying out activities, including festivals, without the proper approval or supervision, and specifically mentions their "pride and arrogance" in their manner of participating in Corpus Christi processions; "Representação dos vigários colados das igrejas paroquiais do bispado de Mariana a D. Maria I, na qual expõem a corrupção e desordem que grassam nas ordens terceiras e irmandades de pretos e pardos de Minas, com grande prejuízo da igreja, da Real Fazenda, do Padroado Régio e da conservação dos povos," Minas Gerais, caixa 138, doc. 6, AHU.

43. "Representação que expuseram os vigários colados das igrejas," May 21, 1795, Minas Gerais, caixa 140, doc. 24, AHU. On this document see D. Ramos 169.

44. "Representação dos vigários colados das igrejas paroquiais do bispado de Mariana a D. Maria I"; after 1793, February 28, Minas Gerais, caixa 138, doc. 6, AHU.

45. The letters and documents concerning this case, some of them cited by Resende and Langfur in their article, span from 1769 to 1773 and can be found in Minas Gerais, especially caixa 103, documents 5, 6, 8, 62, 66, and 87, AHU. In a letter from Lisbon in 1773, Francisco Ribeiro da Silva is referred to simply as a "réu" (defendant); Minas Gerais, caixa 104, doc. 71, AHU. On the conflictive relationship between Ribeiro da Silva and Bishop Manuel da Cruz, despite the transparent effort to win his favor through the publication of *Aureo Throno Episcopal*, see Ávila 2:631–632.

46. Lara stresses the contestatory dimensions of both the black brotherhoods' processions and the *festas de reis congos* [Congo king festivals]: "Nas cidades portuguesas da América, a presença constante da escravidão e o grande contingente populacional de negros, pardos e mulatos faziam com que os significados negros da coroação de reis ficassem em evidência, amedrontando os olhares brancos e senhoraias. Ao invés de servirem como mais um elemento de reativação do poder real e metropolitano, o reinado dos Congos . . . assim como as procissões das irmandades negras, podiam também ser vistos e entendidos justamente em sentido oposto" (*Fragmentos* 116) [In the Portuguese cities of America, the constant presence of slav-

ery and the large black and mulatto population made the black meanings of the coronation of kings evident, frightening the white, seigneurial gaze. Instead of serving as another element in the reactivation of royal, metropolitan power, the reign of the Congos . . . as well as the processions of black brotherhoods could also be seen and understood in exactly the opposite sense].

47. In "From Moors" Dewulf concludes his discussion of the possible connections between Mardi Gras Indians and the performance of Moors and Indians in the Iberian world with a reminder: "Transculturalism has long been misunderstood as a loss of purity, a form of decadence or even submission to the colonizer. Time and again, scholars have narrowly reduced anti-colonial resistance to the attachment to pre-colonial traditions and failed to understand that, in many cases, the appropriation and reinvention of the idiom of the colonizer was a much more effective strategy in dealing with colonial aggression" (41).

48. The church was built by "os mesmos Pretos . . . a sua custa" [the same blacks . . . at their own expense], as stated in its *compromisso*; Minas Gerais, caixa 45, doc. 40, chapter 1, AHU. Another branch of the Black Brotherhood of the Rosary in Vila Rica was the Irmandade de Nossa Senhora do Rosário do Alto da Cruz da freguesia de Nossa Senhora da Conceição de Antônio Dias de Vila Rica; Minas Gerais, caixa 157, doc. 42, AHU.

49. The petition is dated January 21, 1769, and entitled "Consulta do Conselho sobre requerimento dos oficiais da Irmandade de Nossa Senhora do Rosário dos Homens Pretos, filial da Matriz de Nossa Senhora do Pilar de Vila Rica, pedindo confirmação da area concedida pela Camara daquela Vila," Minas Gerais, caixa 94, doc. 6, AHU.

50. Such an interpretation was likely shared by the white population of Vila Rica, as we may glean from a comment by the *procurador*: "O menor mal, seria desconsolarem-se os pretos inflamados na sua devoção, e fatigados do seu trabalho; e ainda os mesmos brancos das Minas, faltos de Luzes, não havia de parecer bem, pagar tão mal a estes confrades" [The least bad thing would be for the blacks, inflamed in their devotion and exhausted in their work, to lose hope; and repaying so poorly these confraternities would not even seem well to the same whites of Minas, who don't know any better]; "Consulta do Conselho," Minas Gerais, caixa 94, doc. 6, AHU.

51. Although I do not yet know of other instances in which a black brotherhood sponsored a book's publication, the activity aligns with Joanna Brooks's argument that corporate bodies such as black Masonic lodges and churches sponsored publications and thus "provided key institutional venues for black entry into the public sphere of print" (82). Like the black Catholic lay brotherhoods in the Iberian context, black lodges and churches were venues for "collective incorporation"— a key principle of "black counter-publicity" (75). They used charters, like *compromissos*, "as a means of declaring and securing their autonomy from white regulation," and they sponsored other publications that reflect "a collective subject and a cohesive political community" (82).

52. Hoonaert reads *Triunfo Eucharistico* in the context of the repressive measures of 1709 and 1720 taken in response to attempted rebellions in Minas Gerais, thus ascribing the triumph exclusively to the powerful: "A procissão toda ensinava: cada qual no seu devido lugar, respeitando as leis impostas pelos fortes e poderosos, pois o 'triunfo' é deles" (50–51) [The procession showed everything: each one in their rightful place, respecting the laws imposed by the strong and powerful, since the "triumph" is theirs].

53. Indicative of the tendency to privilege the white author of the account, Luciano de Oliveira Fernandes mistakenly attributes the dedication to Simão Ferreira Machado instead of the Black Brotherhood of the Rosary in a recent book on *Triunfo Eucharistico*: "Mas é na *dedicatória a N. Sª do Rosário*, que precede a *prévia alocutória*, que o autor evidencia a intenção de utilizar-se do registro escrito para perpetuar a memória acerca do evento" (19, emphasis in the original) [But it is in the *dedication to Our Lady of the Rosary*, which precedes the *prior address*, that the author evinces the intention to use the written register to perpetuate the memory of the event]. Rather, this intention should be ascribed to the black brothers to whom the dedication is attributed.

54. The other words printed in red—"Da Senhora do Pilar," "Simam Ferreira Machado," "Lisboa Occidental," and the year of publication—are in a smaller font. The visual connection between the Eucharist, Villa Rica and the Rosary is perhaps not coincidental. The Brazilian city and the Rosary brotherhood are highlighted as the main object of praise (over the white author and church) or—from the perspective of the printer and bookseller—as selling points of the text, along with the religious subject matter.

55. Borges emphasizes the role of clergy in the black brotherhoods, particularly in the realm of writing. She hypothesizes the involvement of chaplains in the authorship of *compromissos* generally (70–71), and she particularly emphasizes the role of Father Bernardo Madeira, chaplain of the Igreja do Rosário do Alto da Cruz, another chapter of the Black Brotherhood of the Rosary in Vila Rica in the expulsion of white members from that chapter of the brotherhood in 1773, the year of the *Triunfo Eucharistico* festival (105). Borges finds that most *compromissos* of black and *pardo* brotherhoods restricted the positions of judge, scribe, treasurer, and attorney (*procurador*) to whites, "sob a alegação de que os negros não sabiam ler nem escrever" (109) [under the allegation that blacks did not know how to read or write]. Borges does cite the example of the statutes of a *pardo* brotherhood that restricted those roles to *pardo* members. The Black Brotherhood of the Rosary of Caquende's *compromisso* prescribes in its chapter 3 that whites be elected to the positions of scribe, treasurer, and *procurador* but does not specify the same for the office of judge. Dillon uses the term "a-literate" rather than "illiterate" to underscore that the lack of literacy is "less the result of failure than force" (*New World Drama* 265n27).

56. Boschi uses *Triunfo Eucharistico* as an example of cooperation between distinct social groups and "inégavel prova de deferência dos senhores brancos para com seus escravos" [undeniable proof of the white masters' deference toward their

slaves], but the expulsion of white members of the other Rosary chapter in Vila Rica in the same year as the publication of *Triunfo Eucharístico* suggests that we can also find at that time the conflicts and disputes that Boschi attributes to the later period (*Os leigos* 152).

57. Two of these involved the brotherhood of Nossa Senhora do Rosário, in Vila Rica in 1750 and Sabará in 1803, both concerning precedence in processions (Boschi, *Os leigos* 233).

58. "Requerimento dos homens pardos da Confraria de São José de Vila Rica das Minas, solicitando o direito de usar espadim à cinta," Minas Gerais, carta 73, doc. 20, AHU. Dantas reads this and other petitions as part of the efforts of members of black brotherhoods to use "existing rhetoric, institutional resources, and practices of social categories and distinctions to negotiate their place and privileges in Mineiro society" (3).

59. "Requerimento do juiz e mais irmãos da Irmandade de Nossa Senhora do Rosário dos Pretos, de Vila Rica, solicitando licença régia para por em livro o Compromiso da referida Irmandade," Minas Gerais, caixa 45, doc. 40, AHU.

60. On the requirement to seek court approval of statues after 1765, see Boschi, *Os leigos* 118, and M. Souza 185.

61. Lopes describes it as "um livro encadernado em veludo, tendo de prata cinzelada as cantoneiras e duas imagens de Nossa Senhora do Rosário, apresentando também iluminuras" (194) [book bound in velvet, with grooved silver in the corners and two images of Our Lady of the Rosary, along with illuminations].

62. On illustrated festival books in Europe, see Watanabe-O'Kelly 14.

CONCLUSION

1. Although this was a celebration of the royalist cause, public festivals did not "lose their role in the performance of social identities after independence," writes François-Xavier Guerra. "Ceremonial oaths of loyalty to Fernando VII all over Spanish America in 1808, the oaths of loyalty to the American juntas in 1810, the celebrations around foundational acts of independence (like the May festivals of Buenos Aires, for example, already in 1811), the celebrations of military victories, when victorious armies entered 'liberated' cities in triumph—all indicate the continued centrality of public ritual in the political culture of the period" (9). On modern festivals as stages for the performance and negotiation of social identities, see Goldstein as well as Guss, *Festive State*.

2. Introducing the chapters he wrote after his father's death in 1735, Diego Arzáns explains that one such individual "pretendió con mano poderosa quitar los escritos y también la vida a mi padre porque en la posteridad y en particular en España no tuviesen noticia de sus delitos" (3:401) [tried with a powerful hand to take away the writings as well as the life of my father so that in posterity, and especially in Spain, they would not have notice of his crimes]. See also the "Informe remitido

al Consejo de Indias por Bernabé Antonio de Ortega y Velasco, vecino de la Villa Imperial de Potosí, en cuanto a su *Historia* escrita de la fundación de aquella Villa," included in Hanke and Mendoza (xxxvi–xxxvii). Hanke and Mendoza explain that Arzáns's narrative was well known to his compatriots and was made public through the incorporation of his tales into sermons on numerous occasions (xxxix).

3. Brown writes, "Some carried their mita service as both a grievous burden and a badge of royal honor. During Inca times, an ayllu secured its right to land under the Inca through its tribute and labor service to the state. Indians maintained the same perception following the conquest: the Spanish king rewarded their payment of tribute and mita labor with the right to hold and use land. By sending its annual levy of mitayos to Potosí, an ayllu gained a special status vis-à-vis the king" (77). Brown cites an early nineteenth-century case in which a group of *mitayos* on their way to Potosí seized "food and animals from local Indians and Spaniards on the grounds that the goods were necessary for their royal service. Witnesses claimed the mitayos said their service made them 'worth as much as the king'" (77).

4. Mumford underscores the "preservation aspects" (184) of the campaign of general resettlement that created the provinces from which *mita* workers were drawn and the ways it contributed to strengthening rather than lessening the role of caciques.

5. In the central chapter dedicated to Potosí's festivals (part 1, book 10, chapter 1), Arzáns writes of the "costosas galas de sus matronas, doncellas y damas" [costly galas of her matrons, maidens and ladies], the "trajes riquísimos de las mestizas" [very rich costumes of the mestizas], and the "trajes a su usanza de las mujeres indias, aquellas famosas (nombradas *vinchas* en su idioma) con que cubrían sus cabezas, tejido de perlas, aljófar y piedras preciosas" [costumes in their manner of the Indian women, those famous headbands (called *vinchas* in their language) with which they cover their heads, woven with pearls and precious stones], all of which contributed to the former festive grandeur of Potosí (2:322).

6. Joanna Brooks describes African Americans' engagement with the print public sphere as collective bodies: "Blacks thus entered the public sphere, not with the negative identity of the disinterested individual citizen, but through positive collective incorporation" (73).

Works Cited

Abercrombie, Tom. *Pathways of Memory and Power: Ethnography and History among an Andean People*. Madison: University of Wisconsin Press, 1998.

Acosta, José de. *Historia natural y moral de las Indias*. 1590. Ed. Edmundo O'Gorman. 3rd edition. Mexico City: Fondo de Cultura Económica, 2006.

———. *Natural and Moral History of the Indies*. Ed. Jane E. Mangan. Trans. Frances M. López-Morillas. Durham, NC: Duke University Press, 2002.

Acosta de Arias Schreiber, Rosa María. *Fiestas coloniales urbanas (Lima-Cuzco-Potosí)*. Lima: Otorongo, 1997.

Aguiar, Marcos Magalhães de. "A evolução da vida associativa em Minas colonial e a sociabilidade confrarial negra." *Sociedade Brasileira de Pesquisa Histórica: Anais da XXI Reunião, Rio de Janeiro, 2001* 21 (2002): 225–236.

Barba, Álvaro Alonso. *Arte de los metales en que se enseña el verdadero beneficio de los de oro, y plata por açogue*. Madrid: Imprenta del Reyno, 1640.

Amaral, R. Joviano. *Os pretos do Rosário de São Paulo*. São Paulo: Edições Alarico, 1954.

Anderson, Benedict. *Imagined Communities: Reflections on the Origin and Spread of Nationalism*. London: Verso, 1983.

Andrade, Carlos Drummond de. *Drummond, testemunho da experiência humana*. N.d. Projeto Memória. http://www.projetomemoria.art.br/drummond/obra/prosa_ensaios-e-cronicas.jsp.

Antonil, André João. *Brazil at the Dawn of the Eighteenth Century*. Trans. Timothy J. Coates and Charles R. Boxer. North Dartmouth, MA: Tagus Press, 2012.

———. *Cultura e opulencia do Brasil por suas drogas e minas*. Lisboa: Deslandesiana, 1711. Reprint, Recife, Brazil: Imprensa Universitária da Universidade Federal de Pernambuco, 1969.

Arzáns de Orsúa y Vela, Bartolomé. *Historia de la Villa Imperial de Potosí*. 3 vols. Ed. Lewis Hanke and Gunnar Mendoza. Providence, RI: Brown University Press, 1965.

————. *Tales of Potosí.* Ed. R. C. Padden. Trans. Frances M. López-Morillas. Providence, RI: Brown University Press, 1975.

Aureo Throno Episcopal, collocado nas Minas do Ouro, ou Noticia breve da Creação do novo Bispado Marianense, da sua felicissima posse, e pomposa entrada do seu meritissimo, primeiro Bispo, e da jornada, que fez do Maranhão, o excellentissimo, e reverendissimo Senhor D. Fr. Manoel da Cruz. 1749. Reprinted in *Resíduos seiscentistas em Minas: Textos do século do ouro e as projeções do mundo barroco.* Vol. 2. Ed. Affonso Ávila. Belo Horizonte: Centro de Estudos Mineiros, 1967. 335–592.

Ávila, Affonso. *Resíduos seiscentistas em Minas: Textos do século do ouro e as projeções do mundo barroco.* 2 vols. Belo Horizonte: Centro de Estudos Mineiros, 1967.

Bakewell, Peter. *Silver Mining and Entrepeneurship in Seventeenth-Century Potosí: The Life and Times of Antonio López de Quiroga.* Albuquerque: University of New Mexico Press, 1988.

Bakhtin, Mikhail. *Rabelais and His World.* Trans. Hélène Iswolsky. Bloomington: Indiana University Press, 1984.

Bandeira, Manuel. *Crônicas da província do Brasil.* Ed. Júlio Castañon Guimarães. São Paulo: Cosac Naify, 2006.

Barrio y Lima, Lorenzo Felipe de la Torre. *Arte o Cartilla del Nuevo beneficio de la plata en todo genero de metales frios y calientes: Hallado por D. Lorenzo Phelipe de la Torre, Barrio, y Lima, Dueño de minas en el Assiento de San Juan de Lucanas de la Provincia de este mismo nombre en el Reyno del Perú.* Lima: Antonio Joseph Gutierrez de Zevallos, 1738. Reprint, Madrid: Juan de Zuñiga, 1743.

Barros, João de. *Decada primeira da Asia de Ioão de Barros: Dos feitos que os portugueses fezerão no descobrimento & conquista dos mares & terras do Oriente.* 1552. Lisbon: Antonio Gonçalvez, 1628.

Barros, João Borges de. *Relação Panegyrica das honras funeraes que às memorias do muito alto, e muito poderoso senhor rey fidelissimo D. João V, consagrou a cidade da Bahia, corte da America portugueza.* Lisbon: Sylviana, 1753.

Bataille, Georges. *The Accursed Share: An Essay on General Economy.* Vol. 1: *Consumption.* New York: Zone Books, 1991.

————. "The Notion of Expenditure." *Visions of Excess: Selected Writings, 1927–1939.* Ed. Allan Stoekl. Trans. Allan Stoekl with Carl R. Lovitt and Donald M. Leslie Jr. Minneapolis: University of Minnesota Press, 1985. 116–129.

Bauer, Ralph. *The Cultural Geography of Colonial American Literatures.* Cambridge: Cambridge University Press, 2003.

Bermúdez-Gallegos, Marta. "Atahuallpa Inca: Axial Figure in the Encounter of Two Worlds." *Amerindian Images and the Legacy of Columbus.* Ed. René Jara and Nicholas Spadaccini. Minneapolis: University of Minnesota Press, 1992. 607–628.

Betanzos, Juan de. *Suma y narración de los Incas.* Ed. María del Carmen Martín Rubio. Madrid: Ediciones Polifemo, 2004.

Bezerra, Janaína Santos. "Pardos na cor e impuros no sangue: Etnia, sociabilidades e lutas por inclusão social no espaço urbano pernambucano do XVIII." PhD diss., Universidade Federal Rural de Pernambuco, Recife, 2010.

Bigelow, Alison. "Mining Empire, Planting Empire: The Colonial Scientific Literatures of the Americas." PhD diss., University of North Carolina, Chapel Hill, 2012.

Bonet Correa, Antonio. "La fiesta barroco como práctica del poder." *El arte efímero en el mundo hispánico.* Mexico City: Universidad Nacional Autónoma de México, 1983. 45–78.

Borges, Célia Maia. *Escravos e libertos nas irmandades do Rosário: Devoção e solidariedade em Minas Gerais–Séculos XVII e XIX.* Juiz de Fora, Brazil: Editora Universidade Federal de Juiz de Fora, 2005.

Boschi, Caio Cesar. "Irmandades, religiosidade e sociabilidade." *História de Minas Gerais.* Vol. 2. Ed. Maria Efigênia Lage de Resende and Luiz Carlos Villalta. Belo Horizonte: Autêntica; Companhia do Tempo, 2007. 59–75.

———. *Os leigos e o poder (irmandades leigas e política colonizadora em Minas Gerais).* São Paulo: Ática, 1986.

Boxer, C. R. *The Golden Age of Brazil, 1695–1750: Growing Pains of a Colonial Society.* Berkeley: University of California Press, 1962.

Brading, D. A. *The First America: The Spanish Monarchy, Creole Patriots, and the Liberal State, 1492–1867.* Cambridge: Cambridge University Press, 1991.

Brásio, António. *Os pretos em Portugal.* Porto, Portugal: Divisão de Publicações e Biblioteca, Agência Geral das Colónias, 1944.

Brescia, Rosana, and Sulamita Lino. "O teatro de tradição ibérica na América Portuguesa na primeira metade do século XVIII: Arquitectura e repertório." *European Review of Artistic Studies* 4.1 (2013): 31–53.

Brito, Francisco Tavares de. *Itinerario Geografico com a verdadeira descripção dos Caminhos, Estradas, Rossas, Citios, Povoaçoens, Lugares, Villas, Rios, Montes, e Serras, que ha da Cidade de S. Sebastião do Rio de Janeiro Atè as Minas do Ouro.* Seville: Antonio da Sylva, 1732.

Brooks, Joanna. "The Early American Public Sphere and the Emergence of a Black Print Counterpublic." *William and Mary Quarterly.* 3rd series. 62.1 (2005): 67–92.

Brown, Kendall. *A History of Mining in Latin America.* Albuquerque: University of New Mexico Press, 2012.

Browning, Barbara. "The Daughters of Gandhi: Africanness, Indianness, and Brazilianness in the Bahian Carnival." *Performing Hybridity.* Ed. May Joseph and Jennifer Natalya Fink. Minneapolis: University of Minnesota Press, 1999. 79–95.

———. *Samba: Resistance in Motion.* Bloomington: Indiana University Press, 1995.

Burga, Manuel. "El Corpus Christi y la nobleza inca colonial. Memoria e identidad." *Los conquistados: 1492 y la población indígena de las Américas.* Ed. Heraclio Bonilla. Bogotá: Tercer Mundo Editores; Ecuador: FLACSO, Libri Mundi, 1992. 317–328.

———. *Nacimiento de una utopia: Muerte y resurrección de los Incas.* 2nd ed. Lima: Universidad Nacional Mayor de San Marcos/Universidad de Guadalajara, 2005.

Burkhart, Louise. "Pious Performances: Christian Pageantry and Native Identity in Early Colonial Mexico." *Native Traditions in the Postconquest World.* Ed. Eliza-

beth Hill Boone and Tom Cummins. Washington, DC: Dumbarton Oaks Research Library and Collection, 1998. 361–381.

Cahill, David. "Sponsoring Popular Culture: The Jesuits, the Incas, and the Making of the Pax Colonial." *Journal of Iberian and Latin American Studies* 6.2 (December 2000): 65–88.

Calancha, Antonio de la. *Crónica moralizada (páginas selectas)*. La Paz: Artística, 1939.

Calmon, Francisco. *Relação das Faustissimas Festas, que celebrou a Camera da Villa de N. Senhora da Purificação, e Santo Amaro da Comarca da Bahia pelos augustissimos desposorios da serenissima senhora D. Maria Princeza do Brazil com o serenissimo senhor D. Pedro Infante de Portugal*. Lisbon: Miguel Manescal da Costa, 1762. Reprint, *Relação das Faustíssimas Festas*. Ed. Oneyda Alvarenga. Rio de Janeiro: Edições FUNARTE/INF, 1982.

Camões, Luís Vaz de. *Os Lusíadas*. Lisbon: Antonio Gonçalvez, 1572. Biblioteca Nacional de Portugal, http://purl.pt/1.

———. *The Lusiads*. Trans. William C. Atkinson. London: Penguin, 1952.

Campos, Maria Verônica, and Luciano Raposo de Almeida Figueiredo, eds. *Códice Costa Matoso: Coleção das notícias dos primeiros descobrimentos das minas na América que fez o doutor Caetano da Costa Matoso sendo ouvidor-geral das do Ouro Preto*. 2 vols. Belo Horizonte: Centro de Estudos Históricos e Culturais, Fundação João Pinheiro, 1999.

Cardim, Pedro. "Entradas solenes: Rituais comunitários e festas políticas, Portugal e Brasil, séculos XVI e XVII." *Festa: Cultura e sociabilidade na América Portuguesa*. Vol. 1. Ed. István Jancsó and Iris Kantor. São Paulo: Hucitec, Editora da Universidade de São Paulo, FAPESP, Imprensa Oficial, 2001. 97–124.

Castello, José Aderaldo, ed. *Movimento academicista no Brasil, 1641–1820/22*. Vol. 3. São Paulo: Conselho Estadual de Cultura, 1974.

C'est la deduction du sumptueux ordre plaisantz spectacles et magnifiques theatres dresses, et exhibes par les citoiens de Rouen ville Metropolitaine du pays de Normandie, A la sacree Maiesté du Tres christian Roy de France, Henry Secōd Rouen, France: Jean le Prest for Robert le Hoy and Jean du Gord, 1551.

Chang Rodríguez, Raquel. *Hidden Messages: Representation and Resistance in Colonial Andean Drama*. Lewisberg, PA: Bucknell University Press, 1999.

Chartier, Roger. "Text, Printing, Reading." *The New Cultural History*. Ed. Lynn Hunt. Berkeley: University of California Press, 1989. 154–175.

Church Missionary Society. *A Dictionary of the Yoruba Language*. Lagos: Church Missionary Society Bookshop, 1913.

Cobo, Bernabé. *Inca Religion and Customs*. Trans. Ronald Hamilton. Austin: University of Texas Press, 1990.

Cole, Jeffrey A. *The Potosí Mita, 1573–1700: Compulsory Indian Labor in the Andes*. Stanford, CA: Stanford University Press, 1985.

Columbus, Christopher. *Select Letters of Christopher Columbus, with Other Original*

Documents, Relating to his Four Voyages to the New World. Trans. and ed. R. H. Major. 2nd ed. London: Hakluyt Society, 1870.

Corro y Zegarra, Juan del. *Instrucción y forma de beneficiar metales de plata.* Lima: n. p., 1677.

Cross, Harry E. "South American Buliion Production and Export 1550–1750." *Precious Metals in the Later Medieval and Early Modern Worlds.* Ed. J. F. Richards. Durham, NC: Carolina Academic Press, 1983. 397–423.

Cummins, Thomas B. F. *Toasts with the Inca: Andean Abstraction and Colonial Images on Quero Vessels.* Ann Arbor: University of Michigan Press, 2002.

———. "We Are the Other: Peruvian Portraits of Colonial *Kurakakuna*." *Transatlantic Encounters: Europeans and Andeans in the Sixteenth Century.* Ed. Kenneth J. Andrien and Rolena Adorno. Berkeley: University of California Press, 1991. 203–231.

Cunha, Luiz Antonio Rosado da. *Relação da Entrada que fez o Excellentissimo, e Reverendissimo Senhor D. F. Antonio do Desterro Malheyro, Bispo do Rio de Janeiro, em o primeiro dia deste prezente Anno de 1747, havendo sido seis Annos Bispo do Reyno de Angola, donde por nomiaçaõ de Sua Magestade, e Bulla Pontificia, foy permutado para esta Diocesi.* Rio de Janeiro: Antonio Isidoro da Fonseca, 1747. Reprint. Coimbra: Biblioteca Geral da Universidade, 1973.

Curcio-Nagy, Linda. *The Great Festivals of Colonial Mexico City: Performing Power and Identity.* Albuquerque: University of New Mexico Press, 2004.

Dantas, Mariana L. R. "Black Brotherhoods and the Negotiation of Social Identity in Colonial Minas Gerais." Unpublished ms.

Dean, Carolyn. *Inka Bodies and the Body of Christ: Corpus Christi in Colonial Cuzco, Peru.* Durham, NC: Duke University Press, 1999.

de la Torre, Juan. *Aclamacion festiva de la muy Noble Imperial Villa de Potosi, en la dignissima promocion del Excmo. Señor Maestro Don Fray Diego Morzillo, Rubio, y Auñon, Obispo de Nicaragua, y de la Paz, Arçobispo de las Charcas, al Govierno de estos Reynos del Perù por su Virrey, y Capitan General, y Relacion de su viage para la Ciudad de Lima.* Lima: Francisco Sobrino, 1716.

Dewulf, Jeroen. "From Moors to Indians: The Mardi Gras Indians and the Three Transformations of St. James." *Louisiana History* 56.1 (2015): 6–41.

———. "Pinkster: An Atlantic Creole Festival in a Dutch-American Context." *Journal of American Folklore* 126.501 (2013): 245–271.

Díaz, María Elena. "Writing Royal Slaves into Colonial Studies." *Repensando el pasado, recuperando el futuro.* Ed. Verónica Salles-Reese. Bogota: Ed. Pontificia Universidade Javeriana, 2005. 253–269.

Díez Borque, José María. "Relaciones de teatro y fiesta en el Barroco español." *Teatro y fiesta en el barroco: España e Iberoamérica.* Ed. José María Díez Borque. Seville: Ediciones del Serbal, 1986. 11–40.

Diccionario de autoridades. Diccionario de la lengua castellana, en que se explica el verdadero sentido de las voces, su naturaleza y calidad, con las phrases o modos de hablar, los

proverbios o refranes, y otras cosas convenientes al uso de la lengua . . . *Compuesto por la Real Academia Española.* Real Academia Española, Madrid. 1726–1739. http:// web.frl.es/DA.html.

Dillon, Elizabeth Maddock. "Coloniality, Performance, Translation: The Embodied Public Sphere in Early America." *Transatlantic Traffic and (Mis)Translations.* Ed. Robin Peel and Daniel Maudlin. Lebanon: University of New Hampshire Press, 2013. 177–196.

———. *New World Drama: The Performative Commons in the Atlantic World, 1649–1849.* Durham, NC: Duke University Press, 2014.

Dines, Alberto. "Aventuras e desventuras de Antônio Isidoro da Fonseca." *Em nome da fé: Estudos* In Memoriam *de Elias Lipiner.* Ed. Nachman Falbel, Avraham Milgram, and Alberto Dines. São Paulo: Editora Perspectiva, 1999. 75–89.

Discurso histórico e político sobre a sublevação que nas Minas houve no ano de 1720. Ed. Laura de Mello e Souza. Belo Horizonte, Brazil: Sistema Estadual de Planejamento, Fundação João Pinheiro, Centro de Estudos Históricos e Culturais, 1994.

Du Biscay, Acarate. "An Account of a Voyage up the River de la Plata, and Thence over Land to Peru. With Observations on the Inhabitants, as Well Indians and Spaniards; the Cities, Commerce, Fertility, and Riches of That Part of America." *Voyages and Discoveries in South America. The First up the River of Amazons to Quito in Peru, and back again to Brazil . . . by Christopher D'Acugna. The Second up the River of Plata, and Thence by Land to the Mines of Potosi. By Mons. Acarete. The Third from Cayenne into Guiana, in Search of the Lake of Parima, Reputed the Richest Place in the World. By M. Grillet and Bechamel.* London: Samuel Buckley, 1698.

Epanafora Festiva, ou Relacaõ Summaria das Festas, com que na cidade do Rio de Janeiro Capital do Brasil se celebrou o Feliz Nascimento do Serenissimo Principe da Beira Nosso Senhor. Lisbon: Miguel Rodrigues, 1763.

Estete, Miguel de. "Relación que del descubrimiento y conquista del Perú hizo el capitán Miguel de Estete al Supremo Consejo de las Indias." *Historia de los Incas y conquista del Perú.* Ed. Horacio H. Urteaga. Lima: Imprenta y Librería Sanmartí, 1924. 3–56.

Fernandes, Luciano de Oliveira. *Alegorias do Fausto: O* Triunfo Eucarístico *e a Igreja Matriz de Nossa Senhora do Pilar de Ouro Preto.* Ouro Preto, Brazil: Universidade Federal de Ouro Preto, 2009.

Fernández de Castro, Jerónimo. *Eliseo Peruano. Solemnidades heroicas y festivas demonstraciones de jubilos, que se han logrado en la muy Noble y muy Leal Ciudad de los Reyes Lima . . . en la aclamacion del excelso nombre del muy alto . . . Don Luis Primero N. S.* Lima: Francisco Sobrino, 1725.

Fernández de Castro Andrade y Portugal, Pedro Antonio. "Carta del Conde de Lemos a S. M. sobre la Mita de Potosí." *Pareceres jurídicos en asuntos de Indias (1601–1718).* Ed. Rubén Vargas Ugarte. Lima: N.p., 1951. 155-165.

Fiestas triunfales que consagró el 2 de agosto de 1812 la fidelísima Imperial Villa de Potosí

al invicto general americano el Sr. Mariscal de Campo Don José Manuel de Goyeneche. Lima: Imprenta de los Huérfanos, 1812.

Figueiredo, Luciano Raposo de Almeida. "Estudo crítico: Rapsódia para um bacharel." *Códice Costa Matoso: Coleção das notícias dos primeiros descobrimentos das minas na América que fez o doutor Caetano da Costa Matoso sendo ouvidor-geral das do Ouro Preto.* Ed. Maria Verônica Campos and Luciano Raposo de Almeida Figueiredo. 2 vols. Belo Horizonte: Centro de Estudos Históricos e Culturais, Fundação João Pinheiro, 1999. 1:37–154.

Filho, Melo Morais. *Festas e tradições populares do Brasil.* Brasília: Senado Federal, 2002.

Flor, Fernando R. de la. *Barroco: Representación e ideología en el mundo hispánico.* Madrid: Cátedra, 2002.

Flynn, Dennis O., and Arturo Giráldez. "Born with a 'Silver Spoon': The Origin of World Trade in 1571." *Journal of World History* 6.2 (1995): 201–221.

Fromont, Cécile. *The Art of Conversion: Christian Visual Culture in the Kingdom of Kongo.* Chapel Hill: University of North Carolina Press for the Omohundro Institute of Early American History and Culture, 2014.

———. "Dancing for the King of Congo from Early Modern Central Africa to Slavery-Era Brazil." *Colonial Latin American Review* 22.2 (2013): 184–208.

Fuchs, Barbara. *Exotic Nation: Maurophilia and the Construction of Early Modern Spain.* Philadelphia: University of Pennsylvania Press, 2009.

Furtado, Júnia. "Desfilar: A procissão barroca." *Revista Brasileira de Historia* 17.33 (1997): 251–279.

Galeano, Eduardo. "The Splendors of Potosí." *I Am Rich Potosí: The Mountain That Eats Men.* By Stephen Ferry. New York: Monacelli, 1999. 15–18.

García Pabón, Leonardo. "Indios, criollos y fiesta barroca en la *Historia de Potosí* de Bartolomé Arzáns." *Revista Iberoamericana* 172–173.61 (1995): 423–439.

Garcilaso de la Vega, El Inca. *Comentarios reales de los Incas.* Ed. Aurélio Miró Quesada. 2 vols. Caracas: Ayacucho, 1976.

———. *La Florida del Inca.* Ed. Sylvia Lynn Hilton. Madrid: Historia 16, 1986.

———. *The Florida of the Inca.* Ed. and trans. John Grier Varner and Jeannette Johnson Varner. Austin: University of Texas Press, 1951.

Geertz, Clifford. *Negara: The Theatre State of Nineteenth-Century Bali.* Princeton, NJ: Princeton University Press, 1980.

Gisbert, Teresa. "Art and Resistance in the Andean World." *Amerindian Images and the Legacy of Columbus.* Ed. René Jara and Nicholas Spadaccini. Minneapolis: University of Minnesota Press, 1992. 627–677.

Goldstein, Daniel M. *The Spectacular City: Violence and Performance in Urban Bolivia.* Durham, NC: Duke University Press, 2004.

Grafe, Regina, and Alejandra Irigoin. "A Stakeholder Empire: The Political Economy of Spanish Imperial Rule in America." *Economic History Review* 65.2 (2012): 609–651.

Graubart, Karen B. "'So color de una cofradía': Catholic Confraternities and the Development of Afro-Peruvian Ethnicities in Early Colonial Peru." *Slavery and Abolition* 33.1 (2012): 43–64.

———. *With Our Labor and Sweat: Indigenous Women and the Formation of Colonial Society in Peru*. Stanford, CA: Stanford University Press, 2007.

Guaman Poma de Ayala, Felipe. *El primer nueva corónica y buen gobierno* (1615). *The Guaman Poma Website*. Digital Research Center of the Royal Library, Copenhagen, Denmark. http://www.kb.dk/permalink/2006/poma/info/en/frontpage.htm.

Guerra, François-Xavier. "Forms of Communication, Political Spaces, and Cultural Identities in the Creation of Spanish American Nations." *Beyond Imagined Communities: Reading and Writing the Nation in Nineteenth-Century Latin America*. Ed. Sara Castro-Klarén and John Charles Chasteen. Baltimore, MD: Johns Hopkins University Press, 2003. 3–32.

Guss, David. *The Festive State: Race, Ethnicity, and Nationalism as Cultural Performance*. Berkeley: University of California Press, 2000.

———. "Whose Skin Is This, Anyway? The Gran Poder and Other Tales of Ethnic Cross-Dressing." *ReVista: Harvard Review of Latin America* 13.3 (Spring 2014): 8–13.

Habermas, Jürgen. *The Structural Transformation of the Public Sphere: An Inquiry into a Category of Bourgeois Society*. Cambridge, MA: MIT Press, 1989.

Hallewell, Laurence. *Books in Brazil: A History of the Publishing Trade*. Metuchen, NJ: Scarecrow, 1982.

Hanke, Lewis. *The Imperial City of Potosí: An Unwritten Chapter in the History of Spanish America*. The Hague: Martinus Nijhoff, 1956.

———. *The Portuguese in Spanish America, with Special Reference to the Villa Imperial de Potosí*. N.p., 1962.

Hanke, Lewis, and Gunnar Mendoza. "Bartolomé Arzáns de Orsúa y Vela: Su vida y obra." *Historia de la Villa Imperial de Potosí*. By Bartolomé Arzáns de Orsúa y Vela. Vol. 1. Ed. Lewis Hanke and Gunnar Mendoza. Providence, RI: Brown University Press, 1965. xxvii–clxxxii.

Harris, Max. *Aztecs, Moors, and Christians: Festivals of Reconquest in Mexico and Spain*. Austin: University of Texas Press, 2000.

Heywood, Linda, and John Thornton. *Central Africans, Atlantic Creoles, and the Foundation of the Americas, 1585–1660*. Cambridge: Cambridge University Press, 2007.

Holanda, Sérgio Buarque de. *Visão do Paraíso: Os motivos edênicos no descobrimento e colonização do Brasil*. São Paulo: Companhia das Letras, 2010.

Hoonaert, Eduardo. *Formação do catolicismo brasiliero, 1550–1800*. Petrópolis, Brazil: Vozes, 1974.

Inch C., Marcela. "Libros, comerciantes y libreros: La Plata y Potosí en el Siglo de Oro." *La construcción de lo urbano en Potosí y La Plata (Siglos XVI-XVII)*. Ed. An-

drés Eichmann and Marcela Inch C. Sucre, Bolivia: Ministerio de Cultura de España, Archivo y Biblioteca Nacionales de Bolivia, 2008. 419–535.

Irigoin, Alejandra, and Regina Grafe. "Bargaining for Absolutism: A Spanish Path to Nation-State and Empire Building." *Hispanic American Historical Review* 88.2 (2008): 173–209.

Jancsó, István, and Iris Kantor, eds. *Festa: Cultura e sociabilidade na América Portuguesa.* 2 vols. São Paulo: Hucitec, Editora da Universidade de São Paulo, FAPESP, Imprensa Oficial, 2001.

Jordan, Annemarie. "Images of Empire: Slaves in the Lisbon Household and Court of Catherine of Austria." *Black Africans in Renaissance Europe.* Ed. T. F. Earle and K. J. P. Lowe. Cambridge: Cambridge University Press, 2005. 155–180.

Kagan, Richard L. *Urban Images of the Hispanic World, 1493–1793.* New Haven, CT: Yale University Press, 2000.

Kantor, Iris. "Entradas episcopais na Capitania de Minas Gerais (1743 e 1748): A Transgressão Formalizada." *Festa: Cultura e sociabilidade na América Portuguesa.* Vol. 1. Ed. István Jancsó e Iris Kantor. São Paulo: Hucitec, Editora da Universidade de São Paulo, FAPESP, Imprensa Oficial, 2001. 169–180.

Kiddy, Elizabeth. *Blacks of the Rosary: Memory and History in Minas Gerais, Brazil.* University Park, PA: Penn State University Press, 2005.

Lane, Kris. "'The Ghost' of Seventeenth-Century Potosí: An Autopsy." Paper for the American Historical Association meeting, New Orleans, LA, Jan. 6, 2013.

Langfur, Hal. *The Forbidden Lands: Colonial Identity, Frontier Violence, and the Persistence of Brazil's Eastern Indians, 1750–1830.* Stanford, CA: Stanford University Press, 2006.

Lara, Silvia Hunold. *Fragmentos setecentistas: Escravidão, cultura e poder na América portuguesa.* São Paulo: Companhia das Letras, 2007.

———. "Significados cruzados: Um reinado de congos na Bahia setecentista." *Carnavais e outras f(r)estas.* Ed. Maria Clementina Pereira Cunha. Campinas, Brazil: Editora Unicamp, 2002. 71–94.

———. "O teatro do poder em perspectiva: Festas públicas dinásticas no Brasil setecentista." *Ritualidades latinoamericanas: Un acercamiento interdisciplinario/ Ritualidades latino-americanas: Uma aproximação interdisciplinar.* Ed. Martín Lienhard. Madrid: Iberoamericana; Frankfurt: Vervuert, 2003. 107–119.

Las Casas, Bartolomé de. *Historia de las Indias.* Vol. 1. Madrid: M. Ginesta, 1875. https://archive.org/stream/historiaindiaso1casarich#page/n5/mode/2up.

Lavallé, Bernard. *Las promesas ambiugas: Ensayos sobre el criollismo colonial en los Andes.* Lima: Pontificia Universidad Católica del Perú, Instituto Riva-Agüero, 1993.

Leitch, Stephanie. *Mapping Ethnography in Early Modern Germany: New Worlds in Print Culture.* New York: Palgrave Macmillan, 2010.

Lipsitz, George. "Mardi Gras Indians: Carnival and Counter-Narrative in Black New Orleans." *Cultural Critique* 10 (1988): 99–121.

Lopes, Francisco Antônio. *Os palácios de Vila Rica: Ouro Preto no ciclo do ouro*. Belo Horizonte: N.p., 1955.

López Cantos, Ángel. *Juegos, fiestas y diversiones en la América española*. Madrid: Editora MAPFRE, 1992.

MacCormack, Sabine. "History, Historical Record, and Ceremonial Action: Incas and Spaniards in Cuzco." *Comparative Studies in Society and History* 43.2 (2001): 329–363.

———. "Time, Space, and Ritual Action: The Inka and Christian Calendars in Early Colonial Peru." *Native Traditions in the Postconquest World*. Ed. Elizabeth Hill Boone and Tom Cummins. Washington, DC: Dumbarton Oaks Research Library and Collection, 1998. 295–343.

Machado, Ignacio Barbosa. *Historia Critico-Chronologica da Instituiçam da Festa, Procissam e Officio do Corpo Santissimo de Christo no Veneravel Sacramento da Eucharistia* Lisbon: Francisco Luiz Ameno, 1759.

Machado, Simão Ferreira. *Triunfo Eucharistico, Exemplar da Christandade Lusitana na publica exaltaçaõ da Fé na solemne Trasladaçaõ do Divinissimo Sacramento da Igreja da Senhora do Rosario, para hum novo Templo da Senhora do Pilar em Villa Rica, Corte da Capitania das Minas*. Lisbon, 1734. Reprint, *Resíduos seiscentistas em Minas: Textos do século do ouro e as projeções do mundo barroco*. Vol. 1. Ed. Affonso Ávila. Belo Horizonte: Centro de Estudos Mineiros, 1967. 131–283.

Mancuso, Lara. *Cofradías mineras: Religiosidad popular en México y Brasil, siglo XVIII*. Mexico City: Colegio de México, 2007.

Mangan, Jane. *Trading Roles: Gender and Ethnicity in Colonial Potosí*. Durham, NC: Duke University Press, 2005.

Manrique, Jorge. *Coplas de don Jorge Manrique, Translated from the Spanish*. Trans. Henry Wadsworth Longfellow. Boston: Allen and Ticknor, 1833.

Maravall, José Antonio. *La cultura del barroco: Análisis de una estructura histórica*. Barcelona: Editorial Ariel, 1975.

———. *Culture of the Baroque: Analysis of a Historical Structure*. Trans. Terry Cochran. Minneapolis: University of Minnesota Press, 1986.

———. "Teatro, fiesta e ideología en el barroco." *Teatro y fiesta en el barroco: España e Iberoamérica*. Ed. José María Díez Borque. Seville: Ediciones del Serbal, 1986. 71–95.

Mason, Peter. *Infelicities: Representations of the Exotic*. Baltimore, MD: Johns Hopkins University Press, 1998.

Mauss, Marcel. *The Gift: The Form and Reason for Exchange in Archaic Societies*. Trans. W. D. Halls. London: Routledge, 1990.

Mazzotti, José Antonio, ed. *Agencias criollas: La ambigüedad 'colonial' en las letras hispanoamericanas*. Pittsburgh, PA: Instituto Internacional de Literatura Iberoamericana, 2000.

Medinaceli, Ximena. "Potosí y La Plata: La experiencia de la ciudad andina." *La construcción de lo urbano en Potosí y La Plata (siglos XVI-XVII)*. Ed. Andrés Eich-

man and Marcela Inch C. Sucre, Bolivia: Ministerio de Cultura de España, Archivo y Biblioteca Nacionales de Bolivia, 2008. 5–145.

Megiani, Ana Paula Torres. "A escrita da festa: Os panfletos das jornadas filipinas a Lisboa de 1581 e 1619." *Festa: Cultura e sociabilidade na América Portuguesa*. Vol. 2. Ed. István Jancsó and Iris Kantor. São Paulo: Hucitec, Editora da Universidade de São Paulo, FAPESP, Imprensa Oficial, 2001. 639–653.

———. *O rei ausente: Festa e cultura política nas visitas dos Filipes a Portugal (1581 e 1619)*. São Paulo: Alameda, 2004.

Merrim, Stephanie. *The Spectacular City, Mexico, and Colonial Hispanic Literary Culture*. Austin: University of Texas Press, 2010.

———. "Spectacular Cityscapes of Baroque Spanish America." *Literary Cultures of Latin America: A Comparative History*. Vol. 3. Ed. Mario J. Valdés and Djelal Kadir. New York: Oxford University Press, 2004. 31–57.

Mesa, José de, and Teresa Gisbert. *Holguín y la pintura altoperuana del virreinato*. La Paz: Alcadía Municipal, 1956.

Mexía de Fernangil, Diego. "Egloga intitulada el Dios Pan en loor del Santísimo Sacramento de la Eucaristia dirigida a D. Diego de Portugal del consejo del Rey Nuestro Señor y Presidente en la Real Audiencia de Charcas. Epístola y Dedicatoria." *Manuscritos peruanos en las bibliotecas del extranjero*. Vol. 1. Ed. Ruben Vargas Ugarte. Lima: Talleres Tipográficos de la Empresa Periodística, 1935. 79–92.

———. *El Dios Pan*. In *De nuestro antiguo teatro*. Ed. Rubén Vargas Ugarte. Lima: Universidad Católica, 1943. 1–26.

———. *Primera parte del Parnaso Antartico, de obras amatorias. Con las 21 Epistolas de Ovidio, I el in Ibin, en tercetos. Dirigidas a dõ Iuan de Villela, Oydor en la Chãcilleria de los reyes. Por Diego Mexia, natural dela ciudad de Sevilla, I residente en la de los Reyes, en los riquissimos Reinos del Piru*. Seville: Alonso Rodriguez Gamarra, 1608.

———. Prologue to *Segunda parte del Parnaso antartico de divinos poemas*. In *Biblioteca hispano-americana*. Vol. 2. Ed. José Toribio Medina. Santiago, Chile: Fondo Histórico y Bibliográfico José Toribio Medina, 1959. 88–91.

Mignolo, Walter. "El mandato y la ofrenda: *La descripción de la ciudad y provincia de Tlaxcala*, de Diego Muñoz Camargo, y las relaciones de Indias." *Nueva Revista de Filología Hispánica* 35.2 (1987): 451–484.

Millones, Luis. "Las ropas del Inca: Desfiles y disfraces indígenas colonials." *Revista de Crítica Literaria Latinoamericana* 21.41 (1995): 51–66.

Mills, Kenneth. *Idolatry and Its Enemies: Colonial Andean Religion and Extirpation, 1640–1750*, Princeton, NJ: Princeton University Press, 1997.

Mimoso, João Sardinha. *Relacion de la real tragicomedia con que los padres de la Compañia de Iesus en su Colegio de S. Anton de Lisboa recibieron a la Magestad Catolica de Felipe II de Portugal, y de su entrada en este Reino, con lo que se hizo en las Villas, y Ciudades en que entrò*. Lisbon: Jorge Rodrigues, 1620.

Mínguez, Víctor. "Los 'Reyes de las Américas': Presencia y propaganda de la mo-

narquía hispánica en el Nuevo Mundo." Ed. Agustín González Enciso and Jesús M. Usunáriz Garayoa. *Imagen del rey, imagen de los reinos: Las ceremonias públicas en la España Moderna (1500–1814)*. Pamplona, Spain: Ediciones Universidad de Navarra, 1999. 231–257.

Molina, Crístobal de. *Account of the Fables and Rites of the Incas*. Trans. Brian S. Bauer. Austin: University of Texas Press, 2011.

Monteiro, John. *Negros da terra: Índios e bandeirantes nas origens de São Paulo*. São Paulo: Editora Schwarcz, 1994.

Monteiro, Rodrigo Bentes. *O rei no espelho: A monarquia portuguesa e a colonização da América 1640–1720*. São Paulo: Editora Hucitec, 2002.

Morães, Rubens Borba de. *O bibliófilo aprendiz*. São Paulo: Companhia Editora Nacional, 1975.

More, Anna. *Baroque Sovereignty: Carlos de Sigüenza y Góngora and the Creole Archive of Colonial Mexico*. Philadelphia: University of Pennsylvania Press, 2012.

Mulryne, J. R., Helen Watanabe-O'Kelly, and Margaret Shewring, eds. *Europa Triumphans: Court and Civic Festivals in Early Modern Europe*. 2 vols. Aldershot, VT: Ashgate, 2004.

Mulvey, Patricia. "Black Brothers and Sisters: Membership in the Black Lay Brotherhoods of Colonial Brazil." *Luso-Brazilian Review* 17.2 (1980): 253–279.

———. "Slave Confraternities in Brazil: Their Role in Colonial Society." *The Americas* 39 (1982): 39–68.

Mumford, Jeremy Ravi. *Vertical Empire: The General Resettlement of Indians in the Colonial Andes*. Durham, NC: Duke University Press, 2012.

Nebrija, Antonio de. *Gramática de la lengua castellana*. Ed. Antonio Quilis. Madrid: Centro de Estudios Ramón Areces, 1989.

Ocaña, Diego de. *Un viaje fascinante por la América Hispana del siglo XVI*. Madrid: Studium ediciones, 1969.

Ovid. "Among the Getae." *Tristia*. Book 5.7. Trans. A. S. Kline. *Poetry in Translation*. 2013. http://www.poetryintranslation.com/PITBR/Latin/OvidTristiaBk Five.htm.

Padden, R. C. "Editor's Introduction." *Tales of Potosí*. By Bartolomé Arzáns de Orsúa y Vela. Ed. R. C. Padden. Trans. Frances M. López-Morillas. Providence, RI: Brown University Press, 1975. xi–xxxvi.

Pagden, Anthony. "Identity Formation in Spanish America." *Colonial Identity in the Atlantic World, 1500–1800*. Ed. Nicholas Canny and Anthony Pagden. Princeton, NJ: Princeton University Press, 1987. 51–93.

Paiva, José Pedro. "Etiqueta e cerimônias públicas na esfera da Igreja (Séculos XVII-XVIII)." *Festa: Cultura e sociabilidade na América Portuguesa*. Vol. 1. Ed. István Jancsó and Iris Kantor. São Paulo: Hucitec, Editora da Universidade de São Paulo, FAPESP, Imprensa Oficial, 2001. 75–94.

———. "A Liturgy of Power: Solemn Episcopal Entrances in Early Modern Europe." *Religion and Cultural Exchange in Europe, 1400–1700*. Ed. Heinz Schilling and István György. Cambridge: Cambridge University Press, 2006. 140–161.

————. "Public Ceremonies Ruled by the Ecclesiastical-Clerical Sphere: A Language of Political Assertion (16th-18th Centuries)." *Religious Ceremonials and Images: Power and Social Meaning (1400–1750)*. Ed. José Pedro Paiva. Coimbra, Portugal: Centro de História da Sociedade e da Cultura, Palimage Editores, 2002. 415–425.

Pereira, Sonia Gomes. "A representação do poder real e as festas públicas no Rio de Janeiro colonial." In *Barroco: Actas do II Congresso Internacional*. Porto, Portugal: Universidade do Porto, 2004. 663–678. http://ler.letras.up.pt/uploads /ficheiros/7520.pdf.

Pérez de Hita, Ginés. *Historia de las guerras civiles de Granada*. Paris: Iago Cotinent, 1660.

Piersen, William D. *Black Yankees: The Development of an Afro-American Subculture in Eighteenth-Century New England*. Amherst: University of Massachusetts Press, 1988.

Pita, Sebastião da Rocha. *Breve Compendio e Narraçam do funebre espectaculo, que na insigne Cidade da Bahia, cabeça da America Portugueza, se vio na morte de El Rey D. Pedro II de gloriosa memoria, S.N.* Lisbon: Valentim da Costa Deslandes, 1709.

Polo de Ondegardo, Juan. *Informaciones acerca de la religión y gobierno de los Incas*. Ed. Horacio H. Urteaga. Vols. 3-4 of *Colección de libros y documentos referentes a la historia del Perú*. Lima: Librería Sanmartí, 1916-1917.

Quintão, Antonia Aparecida. *Lá vem o meu parente: As irmandades de pretos e pardos no Rio de Janeiro e em Pernambuco (Século XVIII)*. São Paulo: Annablume, FAPESP, 2002.

Quisbert Condori, Pablo Luis. "Servir a Dios y vivir en el siglo: La vivencia de la religiosidad en la ciudad de La Plata y la Villa Imperial." *La construcción de lo urbano en Potosí y La Plata (siglos XVI-XVII)*. Ed. Andrés Eichman and Marcela Inch C. Sucre, Bolivia: Ministerio de Cultura de España, Archivo y Biblioteca Nacionales de Bolivia, 2008. 273–414.

Rama, Ángel. *The Lettered City*. Ed. and trans. John Charles Chasteen. Durham, NC: Duke University Press, 1996.

Ramos, Donald. "O quilombo e o sistema escravista em Minas Gerais do século XVIII." *Liberdade por um fio: História dos quilombos no Brasil*. Ed. João José Reis and Flávio dos Santos Gomes. São Paulo: Companhia das Letras, 1996. 164–192.

Ramos Sosa, Rafael. *Arte festivo en Lima virreinal (siglos XVI-XVII)*. [Spain]: Junta de Andalucía, 1992.

Real Academia Española. *Diccionario de la lengua española (DRAE)*. 23rd ed. 2014. http://www.rae.es.

Reginaldo, Lucilene. *Os Rosários dos Angolas: Irmandade de africanos e crioulos na Bahia setecentista*. São Paulo: Alameda Casa Editorial, 2011.

Reis, João José. "Identidade e diversidade nas irmandades negras no tempo da escravidão." *Tempo* 2.3 (1996): 7–33.

Relação das festas que a residença de Angolla fez na beatificação do beato Padre Fran^{co} de Xavier da Companhia de Jezus. Angola: Apontamentos sobre a ocupação e início do es-

tabelecimento dos portugueses no Congo, Angola e Benuela extraídos de documentos históricos. Ed. Alfredo de Albuquerque Felner. Coimbra, Portugal: Imprensa da Universidade, 1933. 531–544.

Relação das Festas, que fez a camara da Villa Real do Sabará na Capitanía de Minas Geraes Por occasião do feliz Nascimento da Serenissima Senhora Princeza da Beira. Lisbon: Regia Officina Typografica, 1794.

Relación de la grandiosa fiesta que el señor gobernador D. Luís de Andrade y Sotomayor, alcalde ordinario de la Imperial Villa de Potosí hizo á la renovación del Santísimo Sacramento á 4 de marzo de 1663. Seville: E. Rasco, 1899.

Resende, Maria Leônia Chaves de. "'Brasis coloniales': Índios e mestiços nas Minas Gerais setecentistas." *História de Minas Gerais: As Minas Setecentistas.* Vol. 1. Ed. Maria Efigênia Lage de Resende and Luiz Carlos Villalta. Belo Horizonte, Brazil: Autêntica, 2007. 221–249.

———. "Gentios brasílicos: Índios coloniais em Minas Gerais setecentista." PhD diss., University of Campinas, 2003.

Resende, Maria Leônia Chaves de, and Hal Langfur. "Minas expansionista, Minas mestiça: A resistência dos índios em Minas Gerais do século do ouro." *Anais de História de Além-Mar* 9 (2008): 189-213.

Ribeiro, Soterio da Sylva. *Summa Triunfal da nova, e grande celebridade do Glorioso, e invicto Martyr S. Gonçalo Garcia.* Lisbon: Pedro Ferreira, 1753.

Riva-Agüero, José de la. *Obras completas.* Vol. 2. Lima: Instituto Riva-Agüero, 1962.

Roach, Joseph. *Cities of the Dead: Circum-Atlantic Performance.* New York: Columbia University Press, 1996.

Robins, Nicholas A. *Mercury, Mining, and Empire: The Human and Ecological Cost of Colonial Silver Mining in the Andes.* Bloomington: Indiana University Press, 2011.

Rodríguez Garrido, José A. "La égloga *El Dios Pan* de Diego Mexía Fernangil y la evangelización en los Andes a inicios del siglo XVIII." *Memoria del III Encuentro Internacional sobre Barroco: Manierismo y Transición al Barroco.* Pamplona, Spain: Fundación Visión Cultural, Universidad de Navarra, 2011. 307-319.

Romero, Carlos. "Una supervivencia del Inkanato durante la colonia." *Revista Histórica* 10 (1936): 76–94.

Rostworowski, María de Diez Canseco. *History of the Inca Realm.* Trans. Harry B. Iceland. Cambridge: Cambridge University Press, 1999.

Ruiz, Teófilo. *The King Travels: Festive Traditions in Late Medieval and Early Modern Spain.* Princeton, NJ: Princeton University Press, 2012.

Russell-Wood, A. J. R. "Black and Mulatto Brotherhoods in Colonial Brazil: A Study in Collective Behavior." *Hispanic American Historical Review* 54.4 (1974): 567–602.

———. *The Black Man in Slavery and Freedom in Colonial Brazil.* New York: St. Martin's, 1982.

———. "Centers and Peripheries in the Luso-Brazilian World, 1500–1808." *Negotiated Empires: Centers and Peripheries in the Americas, 1500–1820.* Ed. Christine Daniels and Michael V. Kennedy. New York: Routledge, 2002. 105–152.

Salgado, Mathias Antonio. *Oraçaõ Funebre nas exequias do fidelissimo rey, e senhor D. João V celebradas pelo senado da Camara da Villa de S. João de ElRey, nas Minas Geraes da America Portugueza.* Lisboa: Francisco da Silva, 1751.

Salgado, Mathias Antonio, and Manoel Joseph Correa e Alvarenga. *Monumento do agradecimento, tributo da veneração, obelisco funeral do obséquio, relação fiel das reais exéquias, que à defunta majestade do fidelíssimo e augustíssimo Rei o Senhor Dom João V dedicou o Doutor Matias António Salgado, vigário colado da matriz de Nossa Senhora do Pilar de São João del-Rei oferecida ao muito alto, e poderoso Rei Dom José I Nosso Senhor.* Lisboa: Francisco da Silva, 1751. Reprint, *Movimento academicista no Brasil, 1641–1820/22.* Vol. 3, part 2. Ed. José Aderaldo Castello. São Paulo: Conselho Estadual de Cultura, 1974. 225–256.

Santa Maria, Frei Agostinho de. *Santuario Mariano, e historia das imagens milagrosas de Nossa Senhora, e das milagrosamente apparecidas, que se veneraõ em todo o Bispado do Rio de Janeyro, & Minas, & em todas as Ilhas do Oceano . . . ao Exc. Sr. D. Luis Joseph Thomas Leonardo de Castro.* Vol. 10. Lisbon: Antonio Pedrozo Galram, 1723.

Santiago, Camila Fernanda Guimarães. *A Vila em ricas festas: celebrações promovidas pela Câmara de Vila Rica (1711–1744).* Belo Horizonte, Brazil: Editora C/Arte, FACE-FUMEC, 2003.

Santos, Beatriz Catão Cruz. *O Corpo de Deus na América.* São Paulo: Annablume, 2005.

Santos, Corcino Medeiros dos. "As festas religiosas nas areas de mineração: Minas Gerais e Alto Peru." *A festa: Comunicações apresentadas no VII Congresso Internacional A Festa, Lisboa, 18 a 22 de novembro de 1992.* Coord. Maria Helena Carvalho dos Santos. Vol. 2. Lisbon: Universitária Editora, 1992. 479–508.

Saunders, A. C. de C. M. *A Social History of Black Slaves and Freedmen in Portugal, 1441–1555.* Cambridge: Cambridge University Press, 1982.

Scarano, Julita. "Black Brotherhoods: Integration or Contradiction?" *Luso-Brazilian Review* 16 (1979): 1–17.

———. *Devoção e escravidão: A Irmandade de Nossa Senhora do Rosário dos Pretos no Distrito Diamantino no século XVIII.* São Paulo: Companhia Editora Nacional, 1975.

Schultz, Kirsten. "*Sol oriens in occiduo:* Representations of Empire and the City in Early Eighteenth-Century Brazil." *Portuguese Colonial Cities in the Early Modern World.* Ed. Liam Matthew Brockey. Burlington, VT: Ashgate, 2008. 223–248.

Schwartz, Stuart. "The Formation of a Colonial Identity in Brazil." *Colonial Identity in the Atlantic World, 1500–1800.* Ed. Nicholas Canny and Anthony Pagden. Princeton, NJ: Princeton University Press, 1989. 15–50.

———. "The King's Processions: Municipal and Royal Authority and the Hierarchies of Power in Colonial Salvador." *Portuguese Colonial Cities in the Early Modern World.* Ed. Liam Matthew Brockey. Burlington, VT: Ashgate, 2008. 177–204.

———. *Slaves, Peasants, and Rebels: Reconsidering Brazilian Slavery.* Urbana: University of Illinois Press, 1992.

Scott, James C. *Domination and the Arts of Resistance: Hidden Transcripts.* New Haven, CT: Yale University Press, 1990.

Seed, Patricia. *American Pentimento: The Invention of Indians and the Pursuit of Riches.* Minneapolis: University of Minnesota Press, 2001.

Shelley, Kathleen, and Grinor Rojo. "El teatro hispanomericano colonial." *Historia de la literatura hispanoamericana.* Vol. 1. Ed. Luis Iñigo Madrigal. Madrid: Cátedra, 1982. 319–352.

Silva, Luiz Geraldo. "Da festa barroca a intolerância ilustrada: Irmandades católicas e religiosidade negra na América portuguesa (1750–1815)." *Repensando el pasado, recuperando el futuro.* Ed. Verónica Salles-Reese. Bogota: Ed. Pontificia Universidade Javeriana, 2005. 271–287.

Soares, Mariza de Carvalho. *Devotos da cor: Identidade étnica, religiosidade no Rio de Janeiro, século XVIII.* Rio de Janeiro: Ed. Civilização Brasileira, 2000.

Souza, Laura de Mello e. *Desclassificados do ouro: A pobreza mineira no século XVIII.* Rio de Janeiro: Ed. Graal, 1982.

———. "Festas barrocas e vida cotidiana em Minas Gerais." *Festa: Cultura e sociabilidade na América Portuguesa.* Vol. 1. Ed. István Jancsó and Iris Kantor. São Paulo: Hucitec, Editora da Universidade de São Paulo, FAPESP, Imprensa Oficial, 2001. 183–195.

———. *O sol e a sombra: Política e administração na América Portuguesa do século XVIII.* São Paulo: Companhia das Letras, 2006.

Souza, Marina de Mello e. *Reis negros no Brasil escravista: História da festa de coroação de Rei Congo.* Belo Horizonte: Editora da Universidade Federal de Minas Gerais, 2002.

Spalding, Karen. *Huarochirí: An Andean Society under Inca and Spanish Rule.* Stanford, CA: Stanford University Press, 1984.

Strong, Roy. *Art and Power: Renaissance Festivals, 1450–1650.* Berkeley: University of California Press, 1973.

Sweet, James. *Domingos Álvares, African Healing, and the Intellectual History of the Atlantic World.* Chapel Hill: University of North Carolina Press, 2011.

Taylor, Diana. *The Archive and the Repertoire: Performing Cultural Memory in the Americas.* Durham, NC: Duke University Press, 2003.

Tinhorão, José Ramos. *As festas no Brasil colonial.* São Paulo: Editora 34, 2000.

———. *Os negros em Portugal: Uma presença silenciosa.* Lisbon: Editorial Caminho, 1988.

Toledo, Francisco de. *Disposiciones gubernativas para el Virreinato del Perú, 1569–1574.* Trans. María Justina Sarabia Viejo. 2 vols. Seville: Escuela de Estudios Hispano-Americanos, 1986.

Toribio Medina, José. *La imprenta en Lima (1584-1824).* 4 vols. Santiago: Impreso en casa del autor, 1904-1907.

Trindade, Raimundo. *Arquidiocese de Mariana: Subsídios para sua historia.* 2 vols. Belo Horizonte: Imprensa Oficial, 1953–1955.

Vargas Ugarte, Rubén, ed. *Concilios limenses (1551–1772)*. 3 vols. Lima: Tipografía Peruana, 1951–1954.

Velázquez, Isidro. *La entrada que en el reino de Portugal hizo la S.C.R.M. de Don Philippe*. N.p.: Manuel de Lyra, 1583.

Venâncio, Renato Pinto. "Os últimos carijós: Escravidão indígena em Minas Gerais; 1711–1725." *Revista Brasileira de História* 17.34 (1997). 165-181. http://dx.doi.org /10.1590/S0102-01881997000200009.

Vilches, Elvira. *New World Gold: Cultural Anxiety and Monetary Disorder in Early Modern Spain*. Chicago: University of Chicago Press, 2010.

Voigt, Lisa. "Creole Patriotism in Festival Accounts of Lima and Potosí." *Romance Notes* 45.2 (Winter 2005): 159–169.

———. "Imperial Celebrations, Local Triumphs: The Rhetoric of Festival Accounts in the Portuguese Empire." *Hispanic Review* 79.1 (Winter 2011): 17–41.

———. "Spectacular Wealth: Baroque Festivals and Creole Consciousness in Colonial Mining Towns of Brazil and Peru." *Creole Subjects in the Colonial Americas: Empires, Texts, Identities*. Ed. Ralph Bauer and José Antonio Mazzotti. Chapel Hill: University of North Carolina Press for the Omohundro Institute of Early American History and Culture, 2009. 265–290.

Voigt, Lisa, and Elio Brancaforte. "The Traveling Illustrations of Sixteenth-Century Travel Narratives." *PMLA* 129.3 (May 2014): 365–398.

Von Germeten, Nicole. *Black Blood Brothers: Confraternities and Social Mobility for Afro-Mexicans*. Gainesville: University Press of Florida, 2006.

Watanabe-O'Kelly, Helen. "The Early Modern Festival Book: Function and Form." *Europa Triumphans: Court and Civic Festivals in Early Modern Europe*. Vol. 1. Ed. J. R. Mulryne, Watanabe-O'Kelly, and Margaret Shewring. Hampshire, England: Ashgate, 2004. 3–18.

Zighelboim, Ari. "Colonial Objects, Colonial Subjects: Cultural Strategies of Vicregal Peru's Inca Nobles, circa 1675–1825." PhD diss., Tulane University, 2007.

———. "The Painter, the Poet, the Bishop, and the Viceroy: Reflections on Potosí's Self-Image, circa 1716." Unpublished ms., December 13, 2012.

Zugasti, Miguel. "Teatro recuperado en Charcas: Dos loas olvidadas de Fray Juan de la Torre (OSA) a la entrada del Virrey Diego Morcillo en Potosí, 1716." *El teatro en la Hispanoamérica colonial*. Ed. Ignacio Arellano and José Antonio Rodríguez Garrido. Madrid: Iberoamericana; Frankfurt: Vervuert, 2008. 295–321.

Index

try into Lisbon of, 11–12; funeral cer-
emonies for, 166n21
Philip III (king of Spain; King
Philip II of Portugal), 8, 10, 157n4,
183n44; and celebration of marriage
to Margaret of Austria, 183n44; en-
try into Lisbon of, 2–3, 7, 11, 13, 118,
124, 151–152, 157n4; funeral ceremo-
nies for, 16, 25, 35–37, 40–41, 47
Philip IV (king of Spain; King
Philip III of Portugal), 36, corona-
tion celebrations of, 16, 25, 35, 37,
40–41, 106, 157n4
Pita, Sebastião da Rocha, *Breve Com-
pendio e Narraçam do funebre especta-
culo*, 62–63, 71
poetry, 97–98; competitions, 76, 78–80
policia, 68, 172n28
Polo de Ondegardo, Juan, 90–92, 99
Portugal, Diego de, 98, 102
Portugal, Pedro de Almeida, 136
Portuguese, in Potosí, 31, 41, 160n28,
165n13
potlatch, 152
Potosí, Imperial Town of (Villa Impe-
rial de Potosí): as boomtown, 5, 7, 23,
99; compared to Minas Gerais, 11–
12, 15, 59, 61, 64, 66, 72–73, 80–81, 83,
123–124; decline of, 26–28, 32, 35, 37,
43, 45–46, 60, 77; diverse population
of, 5–6, 8, 13; festivals in, 7, 16–17,
22, 25, 26, 28–31, 33, 36–37, 40, 42–
50, 56–57, 87–88, 91–96, 102, 105–120,
121–122, 152–155; grandeur of, 23–24,
26, 49–50. See also *cabildo*, of Potosí;
Cerro Rico de Potosí; *mita*; War of
Vicuñas and Basques
poverty, 76, 140, 173n39, 186n62
print illustrations, 147
printing presses, 190n24; prohibited in
Brazil, 142, 168n1
processions, 7, 15, 21, 24, 40, 44, 67–
68, 72, 87–88, 90–91, 94, 110, 112–

113, 120, 121, 124, 127, 132, 140, 145,
155; of African sovereigns, 122, 126,
134; Corpus Christi, 29, 57, 69, 91–
94, 101–104, 111, 175n5; disputes over,
195n57; of Inca sovereigns, 106, 109–
111, 119, 182n41, 183n44, 183n47
Provincial Council of Lima: First (1551–
1552), 29, 89; Second (1567–1568), 89–
90, 99, 175n2; Third (1582–1583), 88–
89, 94, 175n2
publication, 17–18, 57, 124, 147, 153; per-
missions required for, 54–55, 77;
sponsorship of, 81, 137, 141–143, 146,
148, 152, 155, 163n42, 172n34, 193n51
public sphere: embodied, 3, 154; print,
141, 152, 154, 158n8, 193n51, 196n6. *See
also* performative commons
public transcript, 14, 92, 103–104, 113,
123, 149, 161n34, 161n35, 162n38
public utility, 140–142

Quechua, 102, 111, 184n50
quicumbis, 129–130, 134, 190n25
Quispe, Agustín, 114, 185n56

*Real tragicomedia del descubrimiento y
conquista del Oriente* (anon.), 2, 8–10
rebellions, 62–64, 70, 136, 152, 194n52.
See also Santos, Felipe de; Tupac
Amaru rebellion
Recife, 127, 134, 189n19
reciprocity, 2, 48, 152, 168n36
refining. *See* amalgamation
reinados dos congos, 129–131, 190n27,
192n46. *See also* African sovereigns,
coronation festival of; *congados*; *festa
dos reis congos*
Relaçaõ da Entrada (Luiz Antonio Ro-
sado da Cunha), 53–56
Relação das Faustissimas Festas (Fran-
cisco Calmon), 129, 132
Relação dos obsequiosos festejos (anon.),
189n22